The Essential Guide to Business for Artists and Designers

The Essential Guide to Business for Artists and Designers

2nd edition

Alison Branagan

Bloomsbury Academic
An imprint of Bloomsbury Publishing Plc

B L O O M S B U R Y

Bloomsbury Academic

An imprint of Bloomsbury Publishing Plc

50 Bedford Square London WC1B 3DP UK 1385 Broadway New York NY 10018 USA

www.bloomsbury.com

BLOOMSBURY and the Diana logo are trademarks of Bloomsbury Publishing Plc

First edition published in 2011 This edition published in 2017

© Alison Branagan, 2011, 2017

Alison Branagan has asserted her right under the Copyright, Designs and Patents Act, 1988, to be identified as Author of this work.

All rights reserved. No part of this publication may be reproduced or transmitted in any form or by any means, electronic or mechanical, including photocopying, recording, or any information storage or retrieval system, without prior permission in writing from the publishers.

No responsibility for loss caused to any individual or organization acting on or refraining from action as a result of the material in this publication can be accepted by Bloomsbury or the Author.

Every reasonable effort has been made to trace copyright holders and to obtain their written permission for the use of copyright material. The Author and Publishers apologize for any errors or omissions in the copyright acknowledgements contained in this book, and would be grateful if notified of any corrections that should be incorporated in future reprints or editions of this book.

Please note content in regard to self-employment, legal matters and taxation is correct at the time of print.

Due to the UK exiting the European Union in 2016, if an EU or non-EU citizen is reading this book beyond

January 2019, please use the links provided to check for any revisions to the right to trade in England and its

devolved powers: Scotland, Wales and Northern Ireland.

British Library Cataloguing-in-Publication Data

Names: Branagan, Alison, author.

Title: The essential guides to business for artists and designers / Alison Branagan.

Description: Second edition. | London; New York: Bloomsbury Academic,
an imprint of Bloomsbury Publishing Plc, 2017. | Includes bibliographical
references and index.

Identifiers: LCCN 2016025278 | ISBN 9781474250559 (paperback) | ISBN 9781474250566 (ePDF) | ISBN 9781474250573 (ePub) Subjects: LCSH: Art--Vocational guidance. | New business enterprises--Management. | BISAC: ART / Business Aspects. | BUSINESS & ECONOMICS / Small Business.

Classification: LCC N8350 .B67 2017 | DDC 707--dc23 LC record available at https://lccn.loc.gov/2016025278

ISBN: PB: 978-1-4742-5055-9 ePDF: 978-1-4742-5056-6 ePub: 978-1-4742-5057-3

Library of Congress Cataloging-in-Publication Data

A catalog record for this book is available from the Library of Congress.

Typeset in 9.5 on 14pt FS Me Regular

Designed by Susan McIntyre Illustrations © Tim Bradford 2011, 2016 www.timbradford.co.uk

Cover design: Irene Martinez Costa Cover image © Tumanyan/Shutterstock

Typeset by Saxon Graphics Ltd, Derby
Printed and bound in China

Contents

Foreword		6
Acknowledgements Introduction		7
		9
1.	Making creativity pay	15
2.	How to make a living	30
3.	Overview of business start-up	45
4.	Money management	65
5.	Business planning	93
6.	Building networks	111
7.	Self-promotion	130
8.	Funding and sponsorship	155
9.	Creative crimes	172
10.	Confidence and negotiation tactics	205
11.	Records, tax and basic bookkeeping	222
12.	Websites, blogs and social media	250
13.	Innovation and future trends	267
14.	Ideas for growth	281
App	pendix 1: Business knowledge exercises	300
App	pendix 2: Answers to the costing and pricing quiz	
ir	n Chapter 4	309
Glossary		313
Useful organisations		326
Quotation credits		335
Index		338

Foreword

In 1966 I started at the Royal College of Art, London. At that point my ambition was to become an artist. By my second year of study I had gravitated towards industrial design, and by the third I was developing a landing craft for Rotork, an engineering company.

Since then I've worked as an engineer, making things that solve problems. Although I'm not a businessman (actually I'm not entirely sure what a businessman is), I've had to learn the skills to run a company by necessity. I've discovered that much of it is actually common sense – there is certainly no need for a suit and briefcase!

Today I have an expert team helping me run the business, so I can spend more time developing our new technology. But when I first started out with the Ballbarrow, and then the vacuum cleaner, I didn't have the luxury of such support. I learned by doing – the best way to learn. Whether that was developing an idea through an iterative process, trying my hand at sales, or working out how to fund the manufacture of my machines.

Despite the years of uncertainty and financial worries, going it alone was the right thing to do. I'd encourage anyone with a good idea to do the same and to put your skills as artists and designers to good use. It will be hard, but just knowing where to start helps: whether it's securing a loan, promoting a show, or filing a patent.

In the years since this book was first published, the world has changed. It is more connected, technology has moved at pace, there is more competition and, I'm afraid, there is more copying. For business, design and engineering that brings tremendous opportunities but also new threats. It is imperative to cut through the clatter and jargon of business, and remain steadfast in realising your idea. That's what we try to do every day at Dyson and I challenge you to do the same.

Sir James Dyson

Acknowledgements

Firstly, I wish to acknowledge the pioneering work of David Butler and the Artists Information Company in raising awareness of business skills within the visual arts sector.

I would like to thank my commissioning editor Linda Lambert for commissioning this book, and also to give credit to the photographers Karl Grupe, Warren King, Tas Kyprianou, Silvia Lozza, Mark Nolan, John Sturrock, Jamie Trounce, Ursula Underhill and Yeshen Venema for their huge contributions to this project.

Special thanks go to consultants Jenny Bloy, Alison Britton, Trevor Burgess, Karl Grupe, John Foster, Alana Pryce, Tony Laws, MediVisas UK LLP, Harley Miller, Davida Saunders, Molly Beck, Ariadne Godwin, Frances Arnold, Clara Herberg, Nigel Rees 'Quote Unquote', Silverman Sherliker LLP, Rebecca Skeels, David Stubbs, Peter Town, Damien Borowik, and Alana Biviano of BVN Creative. Kind thanks also to Robert Gallagher and Joan Branagan.

Further, most valued contributions came from Caterina Izzo, Riikka Puustinen and Matthew Machin, plus photographs kindly donated by The Freelancer Club, Crafty Fox Market, The Goldsmiths' Centre and Company, Cockpit Arts, Central Saint Martins and Dyson.

Further acknowledgement must go to Kensington and Chelsea College, City University, Central Saint Martins College of Art and Design, and the Association of Illustrators, for giving me the opportunity to teach creative business and enterprise courses.

Finally, I am indebted to John Naylor for his advice and consistent support.

Introduction

'After Beyond the Fringe had been on Broadway, my father asked if I knew what I really wanted to do ... In a sense I still don't.'

Jonathan Miller (1934–), artist, writer and director

Welcome to the second edition of *The Essential Guide to Business* for Artists and Designers, which aims to help any artist or designer set themselves up in business, whether as self-employed, as a partnership or as a company. Since the last edition (and its various revisions) the contours of the visual arts and creative industries have significantly changed. To acknowledge this, I have combined the original essential knowledge areas and enterprise skills content with new chapters acknowledging future trends, innovation and growth.

I hope that the readers who have recently started a business, or who are in the midst of planning to do so, will find the practical advice outlined in this book helpful.

It's worth bearing in mind this is only a business start-up book. To gain more in-depth knowledge about a particular industry sector, readers should explore the recommended texts and links.

Pace of change in today's business environment

Since the financial crash, earning a living from art and design activities has become more uncertain. The commissioning of this second edition is a response to the evolving challenges that are faced by recent arts graduates, as well as those who graduated several years ago. Innovations, especially in regard to digital technologies, have revolutionised the ways in which people interact, consume and trade with one another.

Global business opportunities

Due to innovations such as social media, apps, Skype, Paypal, online portfolio portals, and inexpensive website and blogging software it is now possible to trade on a global basis in a couple of minutes, as long as you have a reasonable internet or Wi-Fi connection.

Working with new technologies, eShops and social media

It is now possible to trade even from small towns and villages located some distance away from capital cities such as London, Paris or New York. It used to be the case that you had to be in a major cultural hub to seek opportunities. Now, new technologies, eStores and social media have opened up new markets which were previously extremely costly and difficult to access. For more on these subjects please refer to Chapters 12, 13 and 14.

Business beginnings

If you are currently a student, you may not be aware that art and design graduates are three to four times more likely to set up in business or register as self-employed than graduates from any other sector. It's possible that you haven't received much guidance about how to earn a living after graduation. I know from my own painful experience of being a naïve novice, starting out in the marketplace, that without good advice, artists and designers can struggle to generate sufficient income, and can be easily ripped off by unscrupulous opportunists.

The intention of this book is to help you make informed decisions about your business, avoid elementary mistakes and earn a decent living from your creativity. In different countries around the globe traditions and cultures will vary, as will some legal aspects. Though broadly speaking, wherever you are, all readers will be starting off on a similar journey.

Useful information for the reader

This book is designed for a universal readership. Therefore, please spend a few moments reading the following explanations of key phrases and terms.

Birmingham School of Art. Institutions of the imagination: at art school we all dream of success, but how do we make it a reality?

Key phrases

The most common phrase in this book is 'artists and designers'. This is a general description referring to all fine or commercial artists, designer-makers, traditional or contemporary makers, interior, graphic, product and industrial designers, also architects, inventors, illustrators, animators, image-makers, film-makers or photographers.

When my comments apply specifically to a particular discipline, I'll use, for example, 'sculptor', 'furniture designer' or 'documentary photographer'.

Business terms

I refer to 'arts or artists' as opposed to 'commercial arts/artists or creatives', the reason being that certain sectors of the visual arts are less commercially oriented then others. There are some

creatives, such as fine artists, who are more focused upon their own personal practice and are thereby disconnected to some extent from the marketplace. They may supplement their profits from commissions and sales to collectors with additional income from part-time employment. I use the term 'arts practitioner' to refer to such visual and applied artists, who prefer not to use the term 'business' when describing their activities.

Alternatively, when I occasionally employ the phrase '**creative businesses**' I mean artists or designers who are more comfortable with the idea that they are running a business, whether as self-employed/freelance (a sole trader), together with others (in a partnership), or as a director of their own company (private limited company). Tech entrepreneurs or team enterprises often prefer to refer to themselves as 'micro-enterprises', for instance.

Commercial creatives, such as illustrators and graphic designers, usually work to a brief. They may embark on their own occasional 'authorial projects', but mainly generate income from meeting the demands of clients.

It's worth noting that although you might think of yourself as a non-commercial arts practitioner, if you occasionally sell work or undertake other freelance work such as facilitating children's art workshops, then you should have some formal 'trading status'

Business beginnings, first steps for artists, makers and designers

such as being registered as self-employed with HM Revenue and Customs (HMRC; formerly known as the Inland Revenue). For more detail please refer to Chapters 3 and 11.

Creative products and services

Due to the vast creative output of the different sectors, I refer to physical artwork or objects (e.g. paintings, furniture, prototypes, textiles, photographs) mainly as the 'product'. Although this strips the work of its philosophical, academic, innovative or even emotional associations, for which I apologise in advance, it was a necessary step to avoid the text becoming too cumbersome to read. Equally, in describing different practical skills such as mould-making, animation for leisure software or teaching private art classes, I use the term 'service'. So please apply your own definitions to the phrase 'creative products and services'.

I hope that the reader will be able to find their own method in using this book, while accepting that it's attempting to embrace a broad spectrum of creative people and practices.

As certain words may warrant further explanation, there is a selective **glossary** of technical, business, financial and legal jargon. Readers will also find a list of useful British, American, Canadian, Australian and Brazilian organisations located towards the end of this book. Additional resources, such as important websites and recommended reading, are listed at the end of each chapter.

Featured artists and designers

This book includes eleven featured artists and designers representing different disciplines. Making the choice of who to include was extremely difficult. A mere eleven visual artists cannot possibly represent all the diverse interests of the visual arts. However, I hope the profiles provide some typical examples of how some creative practitioners earn their living. The featured creatives represent a cross section of commercial, traditional, contemporary, market-led, experimental, innovative and poetical enterprises. They hail from countries from around the world, including Australia, Canada, France, Ireland and Great Britain.

The majority of the contributors have been running their businesses for ten years or more, several have been trading for fewer than five years, and one has just started. Many of them have studied at regional art and design colleges. Three have previously completed their art studies in their countries of origin. One company, which is an example of business growth, has now set up a new branch of their business in New York, in the US.

Though all the current profiled artists and designers have attended a British, Irish, European, Canadian or Australian art college, this is not a prerequisite to success in every sector of the visual arts and creative industries. It's possible to prosper in particular fields with no academic qualifications at all.

In summary

Every reader's business will be unique. Earning a living from any enterprise requires a great deal of effort and understanding of how your particular industry works. This guide is only an overview of how to start a creative business, although it includes diagnostic tools, mind maps and useful business exercises. It is still necessary for readers to attend talks and courses, and to seek further advice concerning their own individual ventures.

Making creativity pay

'Irrespective of talent, chances among those who choose to become artists are unequally distributed. The myth that talent is all that counts prevents the gathering of accurate information about what is required in this profession in order to stand a chance.'

Hans Abbing (1944–), artist and economist

There has been much analysis in the last ten years of the relationship between creativity and economics, together with studies exploring fees, pricing and market demand for products and services across the whole spectrum of the visual arts. Research includes surveys of daily rates charged by freelance commercial artists and designers, as well as comparative studies of salaries. If you are interested in reading these reports, please see some of the key papers listed at the end of this chapter.

We'll look further into the detail of calculating retail or gallery sales prices and what level of professional fees you can charge for your creative services in Chapter 4. However, before rushing ahead, let's analyse some of the current difficulties that many arts practitioners or creative businesses face.

Why can creatives become poor?

'I have no money at all: I live, or am supposed to live, on a few francs a day ... Like dear St Francis of Assisi I am wedded to Poverty: but in my case the marriage is not a success.'

Oscar Wilde (1854–1900), playwright and wit, from a letter, 1899

Firstly, some sectors of the arts have a greater commercial advantage than others. These include publishing, gaming, television, music, commercial photography and illustration, all of which have traditionally been far better rights-managed than the fine and applied arts sectors, though arguably this has now started to break down.

By 'rights-managed' I mean these sectors have stipulated payments in the shape of licensing copyright and the payment of royalties to authors, creators and small production companies. These are fully established within those industries.

By contrast, the majority of fine artists, sculptors and other designer-makers are more reliant on selling 'objects' or working for a 'daily rate' than on being able to generate wealth by licensing the reproduction of artwork or products through printing, replication or manufacture. Currently, however, due to new online services such as 'print on demand', many creatives are beginning to merchandise some of their designs by having images transferred or digitally printed onto a range of products. For further detail, please refer to Chapters 7 and 13.

Secondly, in the commercial domain there are many well-paid jobs and freelance opportunities for animators and architects, as well as graphic and product designers. Yet it's still extremely rare to find full-time vacancies for illustrators, film-makers, photographers and fine or applied artists. Rates of pay for employed and freelance work within the arts and public sectors are poor in comparison with the commercial sector. Since the financial crash, particular sectors within the visual arts have found it a struggle to survive. I hope very much that by the time this book is in print well-paid opportunities will have returned, especially to sectors such as sculpture, jewellery, illustration and photography.

I recall an established figure in the arts declaring that low pay within the arts was not a problem, and that there were other rewards to be had in working for arts organisations. It's easy to make such a comment, but the truth is that long-term experience of being overworked and underpaid creates a poverty trap. Being poor isn't a romantic idyll. It's stressful, and means living in substandard housing, relying on public transport, counting every penny, and having no safety net if things should go wrong.

Poverty is a real issue among arts practitioners who fail to realise that we live in an economy based on market demand. Visual artists must continually generate earnings so that a decent level of income can be achieved; there is only a small (if significant) minority of creatives who have the benefit of wealth inherited through family, spouse or a previous career.

Making creativity pay

While there are those who derive a financially viable and sustainable income from their creativity, there are also many talented and hardworking artists and designers who live well below the poverty line. There are a combination of reasons for this, among which are: a lack of business awareness, money management problems and insufficient demand for their products or services.

The crux of the problem with many arts practitioners lies in an idealised notion of what being a professional artist or designer is. They can often fail simply from not being given specific financial and legal advice at the start and key stages in their careers.

My own experience in my mid-twenties affected me financially as I didn't understand how to agree royalty payments or negotiate commercial contracts. In another instance I spent months on an illustration, only to have it rejected on delivery. Had I known of the Association of Illustrators' (AOI) terms and conditions, the client would still have been legally obliged to pay me fifty per cent of the fee.

Artists and commercial creatives who haven't learned how to approach and work with clients, or who don't understand about contract law or what to charge, can be repeatedly taken advantage of, and will not be properly paid for years.

Another factor that can damage a creative business is being uninformed about risk. A client of mine failed to secure proper 'goods in transit' insurance for a large object. The van crashed, leaving him liable for £20,000. It took him five years to pay off a bank loan on top of other business overheads for this costly mistake.

Important opportunities do not turn up every day. It's vital to execute large commissions properly, minimising your personal

liability while maximising income. More examples of other types of errors that can easily be avoided are mentioned in further chapters.

What history tells us

Since the nineteenth century there have been dramatic changes in attitudes to the arts. One effect is the division of the arts into separate disciplines, which caused a shift from cultivating 'artisanship' to focusing more on distinct forms of practice. Art school education has changed dramatically between the late nineteenth century and the present day.

There has been a deliberate move away from the idea of art and crafts being 'trades' represented by guilds, and towards them becoming 'professions' represented by professional bodies. Yet the arts and commercial arts today are closer to the nineteenth-century idea of trades and to the original 'artisan' approach than is generally acknowledged.

Hans Abbing, in his groundbreaking book Why Are Artists Poor? The Exceptional Economy of the Arts, delved deep into the history of arts and crafts. He takes the reader on a journey through various arguments concerning artists in the present day and the complex environment in which they have to operate.

In the collaborative publication *Handmade in Britain*, the history of crafts is explored with a focus on important objects from the Victoria and Albert Museum, London, and profiles of established contemporary makers.

Artists' London: Holbein to Hirst, by Kit Wedd, Lucy Peltz and Cathy Ross, provides us with a rare insight into how artists in different eras ran their businesses, travelling back even further to mid-sixteenth-century London. Portrait painting in the eighteenth century is described as a collaborative affair, which included the commissioned artist and a cast of assistants, with walk-on roles for artisans painting background scenery, drapery, lace and hands (always a problem) and the participation of other extras in the form of models, framers and gilders. The artisan knew that if he was to turn a profit, he had to subcontract work to other tradesmen and not try to do everything himself.

Today's issues

The vast majority of art history books only offer a narrow view of artists' economic situations, focusing more on the art than on how the artist earned a living. But it's impossible to live on fresh air. There has to be money coming from somewhere for you to have a reasonable standard of living. You may be fortunate and have an income or allowance coming in, but if not you need to figure out how to make enough to sustain yourself.

Let's take a quick snapshot of the financial situation of artists and designers both past and present:

- Dutch post-impressionist painter Vincent Van Gogh lived on an allowance from his younger brother Theo, who incidentally was an art dealer, yet he could not sell his older brother's work!
- Filippo Tommaso Marinetti, the famous Italian futurist, inherited a vast fortune from his father, which enabled him to pursue a bohemian adventure as a poet and agent provocateur.
- Barbara Hepworth, the British abstract sculptor, was an extremely talented student and won a number of scholarships and awards which helped her to study, work and travel abroad.
- Yves Klein, the French conceptual artist, taught judo as his main source of income almost until his death.
- Joseph Beuys, the German conceptual artist, was originally an air pilot in the Second World War and later supported himself by becoming a lecturer.
- René Magritte, the Belgian surrealist painter, designed wallpaper before his paintings began to sell.
- Vivienne Westwood, the British fashion designer, spent many years working as a primary school teacher before setting up in business with the late Malcolm McLaren.
- James Rosenquist, the American pop artist, worked as a commercial artist painting billboards before he made gallery sales.
- Beryl Cook, the British populist painter, ran a pub and a theatrical boarding house before achieving gallery representation later in life.

- Wayne Hemingway, the British designer, spent several years selling second-hand clothes on a stall in Camden Market in London before having enough money to set up his first boutique.
- Jeff Koons, the American conceptual artist, worked and earned a great deal of money as a commodities trader in Wall Street before pursuing his venture as a controversial artist.
- Tracey Emin, the British biographical artist, worked as a youth tutor for Southwark Council before courting the attention of the art world.

Where's the money?

There are many different types of creative businesses. Some sell their creative products online, through chain stores or small boutiques. Others make a very good living from taking on contract work from other businesses, such as advertising agencies, fashion houses or corporate firms. Many arts practitioners earn money by selling artworks at exhibitions and pitching for public and private commissions. A large proportion of artists find they can generate regular income from running workshops and demonstrating art materials at expos while retaining a part-time job.

Innovation versus market demand

Art education develops creativity, problem-solving skills and the ability to conceptualise. It gives students the freedom to experiment and learn new skills. By contrast the marketplace, for a number of commercial artists, art practitioners and designers, can be more like a straitjacket. For instance, if you secure a dealer or an agent, they will expect your style and subject matter to be consistent for many years, as it takes time to build a market for your work. I've met several fine artists who've had to cease painting for a year or so in order to break free of contracts with dealers. Designer-makers and craftspeople can also be easily overwhelmed by the repetitiveness of the work required to continually supply stockists.

Such situations can be easily avoided if you are prepared for the cold realities of business. If you wish to manufacture and sell your own products and services, then you'll have to undergo a change of mindset and embrace learning more about how your industry works. For the majority of artists and designers who wish to practise or trade there are few options. It's highly unlikely that some mystical person will suddenly knock on your door and offer to organise your life and provide introductions to hordes of eager clients – these are things you have to take charge of yourself.

Debunking the discovery myth

'Business Art is the step that comes after Art.'

Andy Warhol (Andrew Warhola; 1928–1987), artist

Unfortunately, there's still a prevailing myth among arts graduates that, during degree shows, fairs and exhibitions, employers, buyers or agents will magically appear in a puff of sparkly stardust and sign them up. Students can thus be disappointed with their experience of degree shows and industry showcasing events.

It's vital to prepare for major showcasing opportunities by inviting buyers and attracting press attention. Many art and design students and emerging creatives generate excitement and funding for their final year degree or pop-up shows by running a crowdfunding campaign (for more information please also refer to Chapters 8 and 13).

As you will see later in Chapter 6, in the building networks mind map, there are obvious and sometimes invisible forces at work regarding certain individuals' journeys to recognition. There are many routes to financial success in this life, but making it to the top in any industry is dependent on a mixture of factors, including the essential ingredient of good luck!

The Essential Guide to Business for Artists and Designers

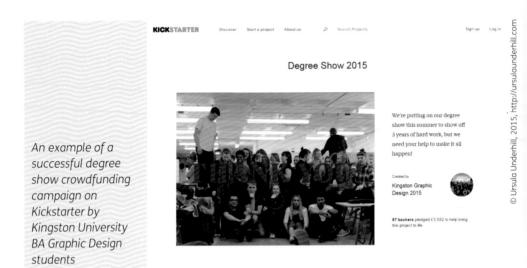

Don't forget your major cities

If you've attended a regional art and design college it could be in your best interests to persuade fellow students or the head of department to showcase degree show work in London. If not, it could be advantageous to come to London either for further study on a diploma or MA course, or at least for regular visits. Despite recent developments in national and global communications, no capital city or major art centre can be ignored in any artist or designer's life plan, as this is where the majority of agents, dealers, critics, stylists, galleries, fashion houses, boutiques, publishers, advertising agencies, art schools, art and design bodies and public museums are based.

However, since the financial crash many independent businesses and organisations have merged. Quite a few art dealers, for instance, can no longer afford bricks and mortar galleries and instead trade via art fairs and their own websites. Though the powers of the internet may dazzle us, it's still worth considering that the richest portion of the UK population, who have the funds to commission and collect artefacts from artists and designers, continue to have homes in London, or to the immediate west and south of the capital.

The importance of planning and preparation

If you are currently studying at college in either your second or third year, it's advisable to plan your own marketing campaign as a group effort. If you are in your third year, it's wise to have a meeting in the October before your summer degree show. It's best to start at least eight months before any kind of showcasing event, whether a degree show or other exhibition in a gallery or design fair.

The earlier you start contacting the media, clients or potential employers the better. It's still possible to do a reasonable amount of promotion two to three months before a show, especially via social media, but it's unlikely that you will gain any magazine features in the large-circulation style monthlies or design periodicals within such a short timeframe. For example, a June issue is likely to be printed in the first week of April or even earlier.

A mini marketing plan and tips appear in Chapter 7. Don't just rely on others to do the marketing for you. Even if you are working in a team, no one but yourself will have your best interests in mind.

A degree show at Central Saint Martins, London

Invite industry contacts

It's likely that your industry contacts may already be going. If not, they may be delighted to see your show. Always be prepared to arrange to meet potential employers, agents, buyers or clients at other times during the course of the exhibition. Remember that key players in the visual arts are inundated by these types of requests, especially in the times before major fairs and degree shows.

Try not to be too disappointed if particular contacts don't show on the night. Always ring up the next day and see if they'd still like to visit the show later in the week. If they're still too busy, perhaps ask if you can visit them after the show has ended. This will give you an opportunity to present your portfolio or sample products and cultivate sales or commissions. Even in this email age, there is nothing like making a bit of effort and going to talk to people. However, be prepared for the fact that agents may expect to see a website, blog or online portfolio before wishing to see you in person. Degree shows, gallery exhibitions and design fairs are crucial showcasing events. Make the most of them.

Developing an entrepreneurial outlook

'Live out your imagination not your history.' Stephen Covey (1932–2012), business guru

If you're fortunate enough to find an enjoyable, well-paid job, then stick with it. It's possible, especially in the design field, to have a fulfilling and eventful career, with progression from junior to senior positions.

However, many artists and commercial creatives are unable to obtain the luxury of a tailor-made professional career within one company or institution. As mentioned earlier, many sectors within the creative industries do not provide opportunities for full-time employment. Nevertheless, you should expect, with a little perseverance, to find creative part-time employment relevant to your discipline. A part-time job is essential, as it acts as a regular income stream on which to fall back if earnings from your early days of self-employment are unreliable.

If you wish to develop your own creative products and services, or pursue an artistic practice, then the world of full-time employment won't be for you, though bear in mind that having some previous industry experience can be usefully applied to your own business.

The difference between 'market-led' and 'innovative' enterprises

Most businesses in the world are market-led; they supply a demand. On the other hand, most emerging artists and designers are more innovative in their ambitions. So in order to make money they have to adopt an entrepreneurial outlook.

The word 'entrepreneur' derives its root from the French words 'entre', between, and 'prendre', to take, meaning to undertake; the word entreprendre for example still means 'to set about' something. Modern dictionaries define the word in two ways: firstly as a person whose venture carries some degree of risk, and secondly as a 'go-between or intermediary', such as an agent or dealer who acts as a link between the artist and the marketplace.

All creative people are really entrepreneurs. They develop new ideas, artworks, products or services and then try to cultivate interest in them and develop a market.

The importance of research

A common mistake of many artists and designers is the failure to undertake sufficient market research. The most successful entrepreneurs in business undertake research and don't simply rely on gut instinct.

I've met postgraduate students, often on MA courses, who have spent long periods developing a product without checking the patent or registered design lists published on the Intellectual Property Office's website (www.gov.uk/ipo). I remember one student in particular, who had spent a year developing a product. In a chance conversation I asked him if he had done any basic checks before proceeding. He had not. On checking the patent register, he discovered that a UK company had filed the invention several years earlier. They had trademarked the product and it was on sale.

This demonstrates how a lack of research, or not undertaking simple checks, can mean that a great deal of time, energy and money are wasted. For more information on intellectual property (IP), please refer to the resources section in Chapter 9 for useful organisations in the UK, Europe, US, Brazil, Canada and Australia.

Cultivating entrepreneurial skills

An entrepreneurial model of enterprise is the hardest type of business to get off the ground. The reason is that entrepreneurs require not only hard cash to invest in their business, but also develop new markets for their innovative products and services. Dogged persistence in pursuit of goals is nothing new to the artist or designer. Artists, like entrepreneurs, are willing to sacrifice creature comforts, their time, social life and sleep in order to bring ideas to a market which is often not ready to accept or buy in to the creative vision. (Does any of this sound familiar?)

To be entrepreneurial, you don't need only generic business skills and a detailed understanding of legal matters, but rather a whole gamut of qualities, attributes, behaviours and skills. In the visual arts, you have to go out and find or make your own opportunities. This is why developing contacts and having the confidence to approach agents or pitch proposals to buyers are essential skills.

Other entrepreneurial qualities

Another facet of developing an entrepreneurial outlook is flexibility and responsiveness to change. While UK art schools foster creativity, it's often with a 'mono focus'. By this I mean that many arts graduates find it difficult to explore possibilities outside their own discipline. In other countries, the visual arts culture is much broader than our own, with artists and designers working across several disciplines, comfortably mixing private with public, and commercial with non-commercial projects.

These days, thanks to social media, creatives are exposed to art, design and the moving image from countries around the globe like never before. I believe this is beginning to challenge the current status quo. These visual influences are around us every

day and we absorb them. This is changing our relationship to our own practice and how we create our products and services.

It is my belief that if you are a creative person then in order to thrive and prosper it is essential to acquire the ability to change direction. There could be many reasons why you should change discipline and find a different route. For instance, it could be that the market for your business is too small, that there's insufficient demand, that you can't earn decent fees or that technological advancement is making your skills obsolete.

Be free of restrictions

Entrepreneurs are great believers in trusting their instincts, so if you feel drawn in a new direction, then explore it. Remember that Francis Bacon, the British painter, originally trained in furniture design. The British designer-maker Andrew Logan spent many years studying architecture, before realising that the profession was not for him. The American film-maker and writer Rebecca Miller earlier trained as a painter. Various British musicians and singer-songwriters first studied at art school, including Jarvis Cocker, Lady Gaga (Stefani Germanotta), M.I.A. (Mathangi 'Maya' Arulpragasam), as well as the late Freddie Mercury, Ian Dury and David Bowie.

So be bold. If you feel it's right, just throw those paintbrushes away! If you are unhappy with the discipline you have trained in, don't be frightened or worried about what others may think if you want to change. You haven't failed or given up. All you are doing is just undertaking something new.

Therefore let go of any idealised vision of working in a garret, living on Smarties and mugs of herbal tea. Forget the notion of being discovered. But most importantly of all, if you desire to earn your living outside the confines of secure employment, then acquiring practical enterprise skills is the only realistic alternative.

Web and graphic designer

Alana Biviano

Alana Biviano is an Australian web and graphic designer. She studied communication and design at Swinburne University. She started as a freelance designer when still a student and then went onto work as an in-house designer at the group buying website, Scoopon. During this time, she gained valuable industry experience and learned a number of skills including website management, finished art, animation and an understanding of copyright.

Alongside her job, and during her business start-up period, she expanded her knowledge of business by attending a number of short courses in web design, social media marketing and entrepreneurship. She then set up BVN Creative, a boutique design and marketing studio. in Melbourne in 2012.

One client gradually increased to a handful, and soon Alana was working with several emerging and established brands; this has since grown into an international client base.

Alana's design and marketing service is exceptional in terms of visual impact and technical function, which are exemplary of good design. Her portfolio can be viewed at www.bvncreative.com.au.

Her five essential tips are:

1. Have a professional, up-to-date online presence

It's vital for creatives to have a well-designed online portfolio that is easy to navigate and responsive to different devices, especially smartphones. A content management solution such as WordPress makes this affordable and achievable.

2. Look out for freelance jobs

Visit job websites and subscribe to their social media, RSS or email notification feeds, and respond to freelance positions as soon as they become available. Lots of individuals and small businesses often post opportunities on Gumtree's job section, so this could be worth a visit.

3. Share your work

Get your work out there as often as you can! Ensure you have two or three regularly updated social media pages. Sign up to portfolio showcase websites like Behance (www.behance.net) and The Loop (www.theloop.com.au) and link back to your website.

4. Stay current

The internet is constantly changing and effective marketing channels are always evolving. Stay in the loop with what's current, keep building on your skills and find new ways to expand your business by seeking advice or attending short courses.

5. Be personable

While the quality of work you produce is important, it's also about the service you offer and how easy you are to work with. Aim to please your most loyal clients, even if that means putting in fifteen minutes of pro-bono work every now and then.

RESOURCES

Research and downloads

'Fees and Payments for Artists' and 'Paying Artists Research' Reports 1 & 2 (2013), published by the Artists Information Company, www.a-n.co.uk/research (subscription service/ many useful articles available without needing to subscribe)

Paying Artists, Valuing Art, Valuing Artists – Securing a Future for Artists in the UK, www.payingartists.org.uk

Artquest, money section, www.artquest.org.uk

The Scottish Artists' Union, www.sau.org.uk/rights/pay

Artists' Union England, www.artistsunionengland.org.uk/

Do It Yourself: Cultural and Creative Selfemployment for Hard Times, edited by Martin Bright and Barbara Gunnell (July 2009), www.artscouncil.org.uk

'The Contribution of Arts and Culture to the National Economy', by the Centre for Economics and Research (May 2013), www.artscouncil.org.uk

More news, resources and reports on the Arts Council website, www.artscouncil.org.uk

The Pricing Survey is only available to members, www.theaoi.com

Various freelance fees, guides and tools, www.londonfreelance.org (part of the NUJ website)

Association of Photographers' fee calculator, www.the-aop.org/information/usage-calculator

The Major Players survey, www.majorplayers.co.uk/

Creative Pool Salary Guide, http://creativepool.com/

Creative Review magazine, the Money Issue, www.creativereview.co.uk/cr-blog/2012/december/cr-january-the-money-issue/

Design Week salary surveys and free online calculator, plus other articles in Design Week, www.designweek.co.uk

Coroflot design salary guide, www.coroflot.com/designsalaryguide

Drapers salary survey, www.drapersonline.com

Breaking the Mould: How Etsy and Online Craft Marketplaces are Changing the Nature of Business, by Benedict Dellot, www.thersa.org

The Craft Blueprint: A Workforce Development Plan for Craft in the UK (June 2009); The Visual Arts Blueprint: Towards a Better-valued Sector (November 2009), www.ccskills.ora.uk

Consuming Craft, and Craft in an Age of Change (February 2012), and various other new reports, including Measuring the Craft Economy (October 2014) by TBR, www.designweek.co.uk

Creative Industries Economic Estimates (Statistics Release), full statistical release every January, Department for Culture, Media and Sport, www.gov.uk (search for 'culture')

A Creative Block? The Future of the UK Creative Industries, The Work Foundation (December 2010), Benjamin Reid, Alexandra Albert and Laurence Hopkins, www.theworkfoundation.com

The Creative Industries in London, Working Paper 70, GLA Economics (October 2015), Lara Togni. To view more reports on culture and the creative industries visit www.london.gov.uk/ qla-economics-publications

Risky Business (October 2011), Demos, by Helen Burrows and Kitty Usher, www.demos.co.uk

Books

Why are Artists Poor? The Exceptional Economy of the Arts, Hans Abbina

(Amsterdam: Amsterdam University Press)

Handmade in Britain, Joanna Norman

(London: V&A Publishing)

The Artists' Yearbook 2010–2011, Elinor Olisa (London: Thames and Hudson) (unfortunately this is the last edition of this publication)

Playing to the Gallery, Grayson Perry

(London: Particular Books)

Children's Writers' and Artists' Yearbooks,

(London: Bloomsbury Publishing)

The New Economy of Art, edited by Gilane Tawadros (London: DACS/Artquest)

Artists' London: Holbein to Hirst, Kit Wedd, Lucy Peltz and Cathy Ross (London: Merrell Publishers)

Writers' and Artists' Yearbooks (London: Bloomsbury Publishing)

How to make a living

'To become skilled requires, personally, that one be obedient.' Richard Sennett (1943–), author and professor of sociology

Art schools encourage students to focus on developing a practice, a recognisable style, and an interest in particular themes or subject matter. Conceptual thinking is nurtured across many disciplines. Once the brain has been stimulated in this manner, it can become more difficult to concentrate on one activity at a time.

No artist or designer has ever managed to execute all their ideas within their lifetime. To attempt numerous projects at any one time can result in frustration and slow progress. Success can only be achieved by being selective and having a clear focus.

This chapter is about helping you to achieve focus and to become more aware about how to make a living.

Achieving focus

'My success, if any, has come incrementally. It's not an overnight thing. I'm very glad of that because it's all very digestible. You have the confidence to say I want to work at my own pace, pick and choose the things I want to do, and screen the things coming in which could be a diversion.'

Cornelia Parker (1956-), artist

Many artists and designers experience other factors that affect their perception of time in relation to money, such as emotional involvement with their work or the equally mixed blessing of obsessive perfectionism. It's best to learn, sooner rather than later, that these qualities have to be reined in when running a creative business.

Learning to make professional judgements

As mentioned in the previous chapter, the eighteenth- and nineteenth-century artisan understood the relation between learning a skill and applying it practically in terms of earning a living.

From my early interviews with artists and commercial creatives who were making large sums of money from their businesses, I observed how they had developed a professional detachment from commissions and projects, and simply viewed them as jobs, to be managed efficiently, priced accurately and done well.

Developing focus

Some artists and designers have huge ambitions, which demand exceptional focus and energy. To achieve progress, it is best to concentrate on only one or two activities at a time. Cut down on distracting newsfeeds, app chat and social media.

If you tend to take too much on, here are some suggestions for how to rein yourself in:

- Take on a part-time job, and on free days prepare work for a show and organise a small marketing campaign.
- Secure a paid contract to run regular art or craft workshops, while undertaking commissions.
- Rent a market stall two days a week, and spend the rest of the week making stock and supplying products to other retail outlets.
- Set up a full-time business, manufacturing and establishing a market for a small range of two to three products. Once established this will quickly need to be expanded to a wider selection of products.

Nothing is worth bankruptcy

The artist Delacroix once said that artists who seek perfection in everything achieve it in nothing. Perfectionism can contribute to a permanent state of financial embarrassment. Creatives commonly stay up all night working on portfolio images or other

projects in search of perfection. Attention to detail and aspiring to do the best you can are both necessary, but must be balanced within the scope and resources of a project. Otherwise you can end up working for less than nothing. This preoccupation with detail has much to do with the perception of the maker.

It pays to be selective

There will always be opportunities and shows in which you can participate (such as those listed on art and design portals), social media requests for interns or volunteers, and numerous unpaid exhibitions, some of which may not generate any sales or press attention at all. Certain types of opportunity, unless you are merely looking for experience, can simply sap your time and resources and not be worth the effort involved. So it pays to be selective.

Before investing any time or money in a group show, decide whether it's worth the risk. I would suggest checking back catalogues and contacting previous exhibitors. Phone them up (avoid social media or email, as you are more likely to get an honest answer verbally) and ask them if they made any money or gained any orders from the event in previous years before committing yourself.

In your early years after leaving college, it's wise to gain some experience of showcasing and other arts-related opportunities, such as gaining an internship, or working as an artist's assistant. If a project is unpaid, then unless it will be good for your CV, helps you to acquire new skills, or bring you into contact with your favourite artist, designer or photographer, then it could simply be an unnecessary distraction.

Avoid working on art projects for free (if you can)

If offered 'no fee' project work, there is an excellent response you can fall back on, which may help to improve the offer. It goes something along the lines of, 'Yes I am very interested in the project. However, I'm unable to take part without a fee, or some form of remuneration (at least assistance with expenses). So please do come back to me if you manage to get a bit more funding.'

You may find some time later that if the interested parties really do desire your involvement then they will offer to pay a fee,

or at least provide you with basic costs. If they don't, then it's likely they will simply contact another applicant. Most arts or design organisations will take anyone on if they offer their time for free. If there's nothing in the opportunity which is of significant value to your career, such as raising your profile, gaining vital contacts or progressing on to paid work, then don't do it.

However, it has to be said that many visual arts graduates spend years working hard for free. There is a volunteer culture within the arts, due to an oversupply of graduates keen to gain experience.

You might have noticed the #NOFREEWORK campaign on Twitter started by the Freelancer Club in London. For several years after the economic crash there was – and to some extent still is – a pressure to do work for free. 'Mates rates' with friends are fine, swapping or trading products for services or vice versa is also a good way to make progress. Always try to get something out of a 'no fee' opportunity, such as your first client endorsement for your website or a good reference.

Difficult choices

It's essential to gather your thoughts and prioritise activities. This can be difficult when it means you can't do everything you would like to do. Many artists and designers find this extremely painful, which is why they often make slow progress, as they spread themselves too thinly. Another problem is the failure to devote a realistic amount of time to activities or projects.

Learning how to focus requires obedience and self-discipline. It helps if your environment is ordered and tidy. Confusion in your home or personal life can affect your ability to make decisions. There will always be distractions that might knock you off course, but try not to be distracted by small irritations, and concentrate on making the most of valuable opportunities.

Selfemployment and paid employment

'To be a teacher is my greatest work of art.'

Joseph Beuys (1921–1986), conceptual artist

It's possible to be employed and self-employed at the same time. However, if you are an employee of a large firm and have specialist skills – say, in software design – it's worth checking your employment contract. Most firms, especially those working in specialist areas of design such as architecture or technology, for instance, do not approve of employees running any kind of business outside their employment, especially if it's similar in nature to, and therefore in direct competition with, the job you do for them.

In the vast majority of cases, it's quite acceptable to have a part- or full-time job and run your own business on days when you're not working for your employer. In a commercial sector where there is a plethora of well-paid work opportunities, more options will then be open to you. You could either work full-time and build a professional career within the industry, or set up in business.

If you are one of the many who finds difficulty in securing well-paid part- or full-time employment, then you'll have to set up a business, either 'freelancing' (taking on contract work) or a 'business' (selling products and services), either on a part- or full-time basis.

Pay gaps

In addition to the well-publicised pay gap between men and women generally, there are, as mentioned previously, large differences between the fine and commercial arts and the public and private sectors. The financial crash has also held salaries back, as numerous *Design Week* salary surveys demonstrate. The Crafts Council's 2012 'Consuming Craft' survey also found that the most popular price range for makers' work was actually lower than ten years previously.

Why work part-time?

So should you get a job or not? If you intend to be self-employed or to set up a company, unless you have generous benefactors, you need a regular income source, at least during the first few months. So it may be beneficial to you in the long run to find a part-time job, especially if it's related to your field.

Is teaching in art schools the answer?

A huge number of art and design graduates wish to enter into part-time lecturing roles at art and design colleges. This is a highly competitive marketplace, with few fractional posts available. The University of the Arts in London, for example, has over three hundred applications for any advertised job.

It's also worth realising that people who secure lecturing jobs at art colleges usually gain posts by word-of-mouth recommendation. You have to be proactive to obtain teaching work, and you have to really want to do it. If you are a graduate, then stay on good terms with your lecturers to increase your chances, and consider sending tutors an occasional letter every six months or so, informing them about interesting developments in your work. Your practice and experience of running a creative business will inform your teaching. Achieving recognition in the outside world is vital to securing any teaching position.

It's worth knowing that it's often possible to gain work from heads of departments and short-course managers by proposing ideas to them.

Gaining adult teaching qualifications

A further consideration is that new graduates to the lecturing profession are now required to obtain a 'Postgraduate Diploma in Learning & Teaching for Higher Education', either before or after they take on a post. It is advisable to either check the job application form or contact the college or university's human resources department, and confirm which qualifications they accept. Most adult or further education colleges now offer new employees appropriate training. However, if you're only undertaking occasional visiting tutor work, then gaining a qualification probably won't be necessary.

There are currently several recognised teaching qualifications in adult, further and higher education. To discover more about the latest developments and qualifications required for adult and further education lecturing posts, visit the 'Institute for Learning' website (www.ifl.ac.uk). Anyone new to teaching short courses at universities or colleges after 2001 may find they are obliged to obtain new certificates in the 'lifelong learning' sector, as well as

as undertaking a form of preparation for teaching and development known as 'professional formation'.

Positions are usually advertised in the *Times Higher Education Supplement* and website, on the *Guardian* website or job alerts sent by email, or on the college's website. Alternatively, you can search on www.jobs.ac.uk. Before rushing to apply, check the job specification.

Lecturing at any level is now a relatively poorly paid profession in comparison with the private sector. The hourly rate ignores the fact that a high level of administration and preparation may also be required. After tax, it's unlikely you will be working for much more than £15 per hour.

Internships

Work experience in art and design organisations or businesses can be an essential stepping stone to greater things. When considering you for a job or internship, many businesses, especially in fashion, will look at any social media feeds provided, so it's important to be on LinkedIn and to maintain a professional blog in tune with the brand or organisation you wish to work for.

Sometimes, as you may be aware, interns can be exploited, working long hours for nothing more than travel expenses. To avoid turning into an unpaid employee, I would suggest that the length of your internship be fixed. Towards the end of the period, request a reference to use in gaining further employment. Then, if the organisation can't offer you any paid work, gracefully exit at the end of your agreed term. If you do stay on for a while, seek a reference in any case, especially if you've bonded well with your current manager.

Gaining self-employment status can be useful during this time. If you have had a successful internship and your employers know you intend to gain trading status, they may be willing to offer the occasional paid day's work, or even a freelance contract.

Try not to end up in a cycle of endless internships. You must use them as part of your professional development and work experience. Continue to apply for paid positions while you are an intern, as having a current role – even an unpaid one – can significantly improve your chances of gaining a job. Please note

that at the time of writing employment law is being examined to see how interns can be better protected from unscrupulous employers; more information and guidance on this matter can be found on the Student Room website (www.thestudentroom. co.uk).

Importance of business and enterprise skills

'One of the big failings of art schools is that students aren't given any teaching on how to survive as a one-person business, which is what it is.'

Stuart Pearson Wright (1975-), portrait painter

There is an enormous amount to learn about setting up and running a successful business. This can be achieved by attending courses and workshops, and seeking out professional (visual arts/creative industry) advisers. There are four key areas which I would recommend investigating.

Professional development

- Basic publicity materials and CV
- Managing an exhibition
- Planning a marketing campaign
- Arts and studio administration
- Working in teams
- How to undertake a commission.
- Applying for funding and sponsorship
- Philosophy and art/design theory
- Teacher training
- Health and safety
- Basic introduction to self-employment
- Work experience and apprenticeships

Business theory and knowledge

- Introduction to business start-up
- Developing a brand and marketing materials
- Social media, websites, blogs and crowdfunding
- Professional bodies and networks
- Market research
- Unique selling point
- Intellectual property, contracts and insurance
- Business planning
- Money management
- Financial planning and cash flow
- Tax, National Insurance (NI), filing a tax return, and bookkeeping

Practical enterprise and interpersonal skills

- Vision generation
- Networking, both face-to-face and online
- Working in teams and leadership
- Presentation skills
- Presenting via Skype and making short films
- How to sell
- Imaginative self-promotion
- Negotiation tactics
- Creative thinking (problem solving)
- Risk assessment and taking risks
- Innovation and trend forecasting

Big business

- Advanced business and financial planning
- Applying for loans, ambitious crowdfunding or pitching for investment
- Taking on pop-up shows, trade fairs or premises
- Protecting and exploiting IP, including trademarks
- Contract law, terms and conditions, insurance, and health and safety
- Company formation and regulations
- Import/export, e-commerce and consumer contract regulations
- Manufacturing, distribution, CAD, software and licensing
- Online strategies and emerging technologies
- Employing people and setting up a payroll system
- Tax, National Insurance (NI), VAT, and accounting software

Professional development – the basics

Professional development is something all artists and designers should understand. A number of elements described here are beginning to be added into many undergraduate art and design programmes.

Artists and designers really have to master most of the professional development menu before going on to start their own business. This will be far harder to achieve if there is little or no provision for professional development within your degree syllabus, or post-graduation. I hope this book will assist you by filling in some of these knowledge gaps.

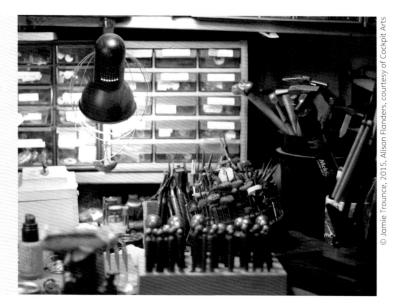

It can take time to set up your first studio or workshop

Business theory and knowledge

Business skills are acquired by learning about the four essential knowledge areas listed on pages 37–38, as well as basic business theory. Many business start-up courses are quite generic and not particularly suitable for creative people. Try to find courses that are aimed towards the visual arts or creative industries.

Practical enterprise and interpersonal skills

Enterprise, interpersonal skills and entrepreneurship are more about being confident, being able to judge and take risks and being able to practically apply business know-how.

Big business

Big business is for people who have the desire to grow a large enterprise. The scale of growth involved in this level of enterprise makes it only suitable for creatives who really enjoy the business side of creativity and who have a commercial product with either a lucrative niche or mass-market appeal.

The four key areas named earlier are not universally agreed art business rules. They are simply my view on which topics are vital to any growing enterprise. These skills and knowledge areas can.

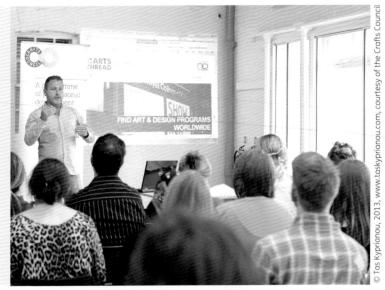

A Crafts Council maker development event in Rochester

> be acquired in different ways, not just through attending courses You may pick up valuable experience from an internship, reading books and periodicals, or in real life through trial and error.

> As your business expands you might hire in expertise from web designers, accountants, business advisers, solicitors and marketing consultants. If your business is growing into a larger enterprise you may choose to team up with people with complementary skills or, when you can afford to, employ them.

Agents and dealers

Many artists and designers seek representation from galleries, dealers or agents. This is an extremely competitive market. A top illustration agent told me he has about twenty enquiries every week via email (that's over a thousand per year). This can accelerate to a thousand emails per week during the summer. These figures are similar to the number of enquiries that established London galleries receive.

It's still traditional for fine artists, sculptors and designer-makers to send out information packs as well as contacting galleries via phone and email. Unfortunately, only a minority of UK artists and designers obtain professional representation.

Some commercial creatives, such as illustrators, have several different agents, one representing their advertising interests, another for editorial commissions. Agents and dealers also work not only in specific sectors but also by territorial limits, for instance, representing the artist's interests in the UK only, the US only, Japan only, or worldwide, etc.

Being unrepresented

Try not to be disheartened if you fail to attract interest from an agent or dealer. Even if you have representation, it's not guaranteed that your agent will be able to provide you with a constant flow of sales or commissions. Many artists and designers who have agents still work part-time, create their own products, showcase online and generate direct commissions. Moreover, sometimes the working relationship with an agent isn't an easy one. There are some pretty unscrupulous people out there masquerading as agents when they are simply crooks.

Attracting interest

What can help to impress agents and dealers is if you have won awards for your artwork or products, or have succeeded in building up a number of clients or opportunities yourself.

If you do manage to secure a big opportunity such as a lucrative advertising contract, then it is worth contacting appropriate agents to see if they would be willing to represent you on a one-off basis. They will then undertake all negotiations for you, but will take a commission of up to 30–40% (this percentage is only appropriate for large-scale deals such as advertising and for work outside your own country) for their time and business acumen in closing the deal. Paying commission to an agent is worth it if the opportunity brings in tens of thousands of pounds.

Remember, if you come to public attention, through being featured in industry periodicals, hosting a stand at an art or design fair, or through winning or being shortlisted for prizes, then agents will come to you. If you've been turned down by agents in the past, don't give up hope. Keep trying to find new ones and making fresh approaches.

For more information on agents and dealers please see Chapter 10, and the list of professional associations in the useful organisations section at the end of this book.

A few tips to keep you out of trouble

- Always check with professional bodies or other advisers before signing any kind of contract agreement.
- If approached by an unknown agent or dealer, don't blindly accept their offer of representation. There may be other more established agents in the field who are also interested in your artwork and products.
- Should you have several people representing you, or different ways of making money from your creative

- business, then any conflicts of interest have to be thought through. For instance, if you are trading online and selling products in shops or galleries, the retail prices should be the same in both outlets.
- The ease with which members of the public and businesses alike are able to find artists and designers online means that the relationship now has to be built on trust, as the customers have not met the creative face-to-face.

In summary

To be successful in the visual arts and creative industries requires a great deal of physical and mental energy. Adopting a more flexible approach to work opportunities is essential if you wish to earn a living. In the visual arts there are openings everywhere, but you may not recognise them as such. This can be due to what you perceive as the 'right' type of project. In the commercial art and design worlds there are many avenues you can explore, and to succeed you might have to be more open-minded.

As mentioned earlier obtaining a part-time job while you start a creative business can be helpful. Understanding more about business, and protecting and exploiting intellectual rights is vital (please refer to Chapter 9). Securing representation is not essential, though it can make life a great deal easier.

Bespoke wall coverings and mural designer

Annette Taylor-Anderson

Annette Taylor-Anderson is a British surface designer. She studied textile design and surface decoration at the University of East London. After completing her degree in 2005, she set up her business ATADesigns (Annette Taylor-Anderson Designs) in 2006.

In 2011, Annette and interior designer Adrienne Chinn won the best wallpaper award at the Design & Architecture Awards by Design et al. Annette's wallpapers and murals have been published in prestigious magazines such as Wallpaper, Boutique Hotelier magazine, Boutique Design, Elle Decoration and World of Interiors.

Over the years, Annette's work has gone from strength to strength as she has focused on wall coverings and mural collections for the corporate hospitality market and private customers, both in the UK and overseas. Her clients include RPW Design Ltd for the Marriott County Hall Hotel and the Qbic Hotel. She has also hosted stands at trade shows in London, Paris and New York.

To view Annette's products visit www.atadesigns.com.

Her five essential tips are:

1. Seek expert advice

You may find starting a business isn't as easy as first anticipated, especially if you've little business or industry knowledge. To make your way in business join a professional association.

2. The importance of networking

In the early years, it's essential to network as much as possible through social media, tradeshows and specific business events. View networking as promoting yourself and meeting new contacts, who can spark unexpected opportunities.

3. Stay focused

It's very easy to jump from one idea to another, as I did in my first years of trading. For instance, I had numerous products including wallpaper, mugs, lampshades and fabrics. I was trying out new ideas because it was easy for me to design without understanding the long-term effects of juggling too many lines, and I was struggling to manage the business properly. It's not a bad thing to try things out, but to move forward you need to focus.

4. Select manufacturers

Undertake research into manufacturers, visit them and find out what services they offer. It's essential to develop relationships with manufacturers so that they can fully understand your requirements. It's worth spending time prototyping or making samples before committing yourself to large-scale production.

5. Understand your market

Test-market sample products at trade shows. This will help you to ascertain demand and will give you the opportunity to make design refinements and adjustments to pricing.

RESOURCES

The Artists Information Company, www.a-n.co.uk

Artquest, www.artquest.org.uk (useful articles about self-employment and business start-up)

Adult teacher-training qualifications

Check with the AE, FE or HE institution concerned about what type of qualification you require before applying to any course.

City and Guilds, www.cityandguilds.com University and College Union, www.ucu.org.uk The Institute for Learning, www.ifl.ac.uk The Higher Education Academy, www.heacademy.ac.uk

Internships

There are a number of web-based news services where internships and other voluntary opportunities are advertised. A free or paid subscription may be required.

www.artscouncil.org.uk
www.artsadmin.co.uk
www.arts-consultants.org.uk
www.fashioncapital.co.uk
www.talentcircle.org/sessions/new
www.mandy.com
www.gumtree.com
www.craigslist.co.uk
www.enternships.com
www.thestudentroom.co.uk
www.ratemyplacement.co.uk
www.designiswork.org

Careers research

www.thecreativesociety.co.uk www.prospects.ac.uk

Creative Graduates, Creative Futures, by L. Ball, E. Pollard and N. Stanley (January 2010), www.employment-studies.co.uk

Contact your university enterprise and employability services

See also Twitter and Facebook pages, e.g. @UCACareers @CareersUAL

Academic jobs

The Times Higher Education Supplement, https://jobs.timeshighereducation.com/

The Times Education Supplement, www.tes.com/jobs/

www.jobs.ac.uk

The Guardian jobs portal, https://jobs. theguardian.com/jobs/higher-education/

Creative economy

www.thecreativeindustries.co.uk http://creativeconomy.britishcouncil.org

Agents and dealers

www.illustratorsagents.co.uk
www.theaoi.com
www.greetingcardassociation.org.uk
www.slad.org.uk
www.vaga.co.uk
www.artquest.org.uk/articles/view/galleries_
and_agents
www.the-aop.org/find/agents

Books

Please also refer to the books listed in Chapter 1 Making Sense of Business: A No-nonsense Guide to Business Skills for Managers and Entrepreneurs, Alison Branagan (London: Kogan Page)

Blink, Malcolm Gladwell (London: Penguin) Outliers, Malcolm Gladwell (London: Penguin)

Tipping Point, Malcolm Gladwell (London: Abacus)

Master Key to Riches, Napoleon Hill (London: Vermilion)

The Craftsman, Richard Sennett (London: Penguin)

59 Seconds: Think a Little, Change a Lot, Richard Wiseman (London: Pan Macmillan)

Did you Spot the Gorilla? Richard Wiseman (London: Arrow Books)

The Luck Factor: The Scientific Study of the Lucky Mind, Richard Wiseman (London: Arrow Books)

Overview of business start-up

'I didn't spend three years doing a photography degree to bloody end up answering somebody else's telephone all day.' Gulnur Mustafa Nafi (1979–), photographer

The comment above from a professional photographer brings home the fact that learning about business should be embraced rather than ignored.

If a suitable job doesn't materialise after you choose to become a professional creative then the prospect of setting up in business must be seriously considered. Self-employment isn't for everyone, but unfortunately you might not have any choice. Most film-makers, photographers, illustrators, and fine and applied artists have to be self-employed, otherwise they can't earn any income from their creative products and skills.

Why set up in business?

'Artists live in an imperfect world where affairs of the heart must sometimes be compromised with business.'

Sara Genn (1972–), artist and songwriter

Many arts practitioners and other professionals within the art and design spectrum come to an uneasy acceptance that to earn a living you must trade.

If you don't have any contacts in the art and design sector, then things will not simply happen for you. Learning about business is only one piece of the 'what-you-have-to-know' cake. To earn a living in the visual arts, you need a change of mindset.

Wishful thinking or a passion for art isn't enough to put food on the table. In fact that's why the artist William Blake's wife, Catherine, would place an empty plate on the dining table, to remind her husband to earn some money from engraving and printing business flyers.

Moving into the professional world

In the commercial world, artists and designers have to learn about self-management. Over the last eighteen years I've given hundreds of lectures in art schools and very rarely did they start on time. In the outside world, any lateness on the part of employees or freelancers is not tolerated for long.

But why should I register as self-employed or set up a limited company?

The reason is that if you're selling products, supplying services, undertaking commissions or working as a freelancer for the odd few days, then you are indeed trading and should register as self-employed. There is no *de minimis* amount for registering as self-employed. You still have to register, even if you are making a loss.

At what one point should I register as self-employed or set up a company?

As soon as you decide you wish to start trading. Especially if you have started to spend money on the business. However, it's advisable to register as soon as you start making sales or receive payment from your first invoice. Legally you have to register for self-assessment by 5 October in the business's second year, e.g. if you start trading between 6 April 2017 and 5 April 2018, you should register as self-employed, at the latest, before 5 October 2018.

What is PAYE?

If you've been officially taken on as a casual, part-time or full-time employee, then your income tax and National Insurance is deducted at source, using the system known as PAYE – Pay As You Earn.

What's not PAYE?

Anything else outside official employment that results in money in your pocket in the form of cash, cheques or digital payments into your bank account is a taxable source of income. If you fail to register as self-employed in the second year of your business and continue to put money in your pocket or in a savings account, that constitutes tax evasion, which is a criminal offence. If (or more likely, when) HMRC discover you are trading without being registered, you're likely to be fined and to receive a demand for backdated income tax payments.

If HMRC discover that you are working for an organisation or business as a freelancer without registering as self-employed, then it's not just you who will be liable for missed income tax and National Insurance contributions. The organisation concerned can also be served with a hefty fine. Depending on the length of tax avoidance, the business may be liable for National Insurance contributions on your earnings.

Important information

It's unlikely you will get into trouble if you have just been a bit naïve and have only received odd payments here and there. However, if you are starting to sweat a bit while reading this, seek advice from an accountant or business adviser with creative industry experience. If you've been trading for more than twelve months, then you need to register as a new business; please see step seven on page 53 and the links in the resources section. If you're not registered and have been selling work or undertaking other freelance activities for eighteen months or more, again you should contact an accountant. It is likely you will be fined by HMRC, and will have to go back in time and unearth what you have earned and also what relevant expenses may be claimed.

Should you be in a bit of a mess, I would always advise paying a professional to help with any communication with HMRC. If you do find yourself in this situation, don't worry about it. Accountants are quite accustomed to solving this kind of problem. See step seven in the next section and read Chapter 11.

It really isn't worth trading without registering. You're a professional person and therefore, like everyone else who wishes

to earn their own living, you need to comply with the law. Register yourself as a business (e.g. as self-employed/sole trader) and get yourself out of the black market.

Seven steps to selfemployment

'If you are to succeed, then you have to accept that you will be working in a competitive market, where only the most dedicated and responsible artists will come out well.' Harley Miller (1934–), entrepreneurial artist

These seven steps to self-employment form a short overview to help you understand the process of setting up as self-employed, often referred to as self-assessment.

Step one: research

Everybody who sets up a business has to undertake research in their own way.

It's beneficial to develop a commercial mindset, even if you are a fine art graduate and your work is quite ephemeral or poetic. You need to find some kind of market demand for your creative products and services, or adapt them to activities that will generate income. Art practitioners whose work is conceptual or philosophical in nature may find that they could be more suited to working in advertising, or alternatively in the community – in arts organisations and schools. Other creatives, such as illustrators or designers, may prefer to firmly root themselves within a market, and to develop a recognisable style, collection or range of products.

Approaches to research can be wide-ranging. Here is a list of useful suggestions:

- Attend business start-up courses, workshops or other talks.
- Find out what help is available from local art and design organisations, enterprise agencies, innovation hubs or support networks.
- Join art/design/business networks and professional bodies.
- Subscribe to industry periodicals, blogs, social media feeds or online portals to assist you in your search for opportunities.

- Do your best to make friends in the industry.
- Read articles or books about how other artists and designers have succeeded in business.
- Find established artists or designers who might be willing to offer you some feedback on your portfolio and future ambitions.
- Collect examples of creative businesses' marketing materials.
- Find out about agents, dealers, boutique owners, art and product buyers.
- Make up samples of your products and see if owners or buyers in stores would be interested. (Product on-demand websites such as Art Rookie might be useful – www.artrookie. co.uk.) Conduct research by asking a number of buyers what sort of products and goods they are looking for.
- Investigate industry-sector art books, catalogues, awards, prizes and scholarships.
- Visit art, craft and design retail and trade fairs or other creative festivals.
- If appropriate, try to test the market by selling your products on a market stall or through 'sale or return' with retailers.
- Explore the possibility of undertaking further training and learning new skills.
- Avoid relying solely on social media for your research, as things can tend to appear marvellous online, when in reality this might not be always be the case.

Step two: unemployment (not mandatory!)

At the time of writing, the UK benefit system is changing. We are in a transitional phase where benefits such as the Jobseeker's Allowance are merging into a new benefit called 'Universal Credit'. Universal Credit is replacing working tax credits, unemployment and housing benefit. Some areas of the country are still on the older system, which lets you claim Jobseeker's Allowance, work fewer than sixteen hours a week and declare ad hoc self-employment income.

The new system (which may change) may possibly support businesses in their first year of trading. In the second year, if you are not earning enough from your enterprise on a regular basis, then to continue with your Universal Credit claim you may have to undertake weekly 'job searches', as Universal Credit does not recognise businesses with a low turnover. These changes could have serious implications for most visual artists. Please see links in the resources at the end of this chapter, but the guidance notes at the present time are woefully thin and lack clarity. These new rules may not come into force, if at all, until 2017 or later.

Whichever system is operating in your town, borough or region, it will be a 'work search'-based benefit, not a longer term business subsidy. If you end up claiming either of these benefits, it might be worth asking your Job Centre adviser about any new enterprise allowance or self-employment schemes available. Usually these schemes last for the best part of a year, with 'trainees' writing a business plan and then legally 'trading', with a gradual reduction of benefits over six months.

Who can claim unemployment or other state benefits in the UK?

If you are a UK national (or have gained British citizenship), have 'leave to remain', or are a European (i.e., EU) citizen, you might be able to claim benefits if allocated a National Insurance number. In most cases, EU citizens are eligible for benefits, but there are some restrictions. For more information about the current rules on entitlement post UK Brexit, please visit www.gov.uk/browse/benefits/entitlement.

If you are a non-EU citizen, then it's unlikely that you will be able to claim any state funds. If unsure, check your visa status with the Job Centre, talk to the Tax Credit Helpline, or if necessary contact the Home Office.

Step three: seeking advice and writing a business plan

As you can see from the simple mind map on pages 100–101, business planning for most self-employed people does not need to be complicated. The plan outline in Chapter 5 is a useful tool to help you plan your business. Some kind of plan is crucial to understanding what you're doing and how much it will cost. Business plans are essential, allowing business advisers to see

quickly what market research has been undertaken, and whether you're ready to start.

Equally, if you plan to work as a partnership or form a company, you and your partner should have an agreed vision for the business and share the responsibility of putting the plan into practice.

A useful tip: when applying for a bank loan it's advisable to use the bank's own software rather than the template provided in Chapter 5.

With the interference of technology, such as apps and social media, it can be tempting to start your business by simply reacting to opportunities. But it is important to make a proper plan. The route may change as you get going, but it is vital that you avoid running your arts practice or design business in a chaotic manner. Chaos brings with it many problems of its own, and though all businesses have chaotic periods, this shouldn't be the default setting!

What's important to remember about writing a business plan is that it is teaching you not only how to prepare for starting out, but also to continue to plan your business day-to-day, week-to-week, month-to-month, and for years to come.

Student taking notes during the Seven Steps talk

Step four: gaining funding

You may be fortunate and have some savings, or generous family and friends who will either give you some money or lend you sufficient funds to purchase or hire the resources you require. If friends and family are unable to help, or you simply wish to be independent, then in the absence of grants you'll have to apply for a bank loan or other types of investment such as crowdfunding.

After setting up your business bank account (see next step), you can apply for a loan from your bank. The business plan usually indicates that you'll be investing in the venture yourself. Therefore, if you require £3,000, you would ideally be able to put in £1,000. If turned down by the bank, then I would advise contacting your local enterprise agency for further information about other government-supported lending schemes. For more information about loans and alternative sources of fundraising such as Kickstarter, please refer to Chapters 8, 13 and 14.

Step five: opening a business bank account

In the UK, a business bank account isn't required if you're registered as self-employed and only earning small sums. However, as soon as money starts to come in, pop down to your local high street and pick up a selection of business bank account packs; these may also be available as downloadable apps or PDFs. Look through them all and decide which one is best for you. During the first 12–24 months they usually offer free banking, i.e. no bank charges. They may also offer other deals, such as free software, business start-up books or access to free advice.

Opening a business account is part of running a professional business – trading from a personal account is at best amateurish. New rules have been brought in by HMRC, which mean they have more powers to look into your affairs and spot-check your records. If you have a business bank account, it becomes that much more difficult for HMRC to investigate your personal current account.

Before you contact the bank, either in person or online, it's a good idea to be registered on the electoral roll. The bank will credit check you and may ask for some proof of trading, such as a few pages of accounts or a business card. If you're not on the

electoral roll or have a poor credit rating, this could be a barrier to you opening a business account.

If you're suffering from credit problems, you may still find that there are some accounts suitable for you; in the UK, try the Royal Bank of Scotland or the Foundation Current Account with NatWest. At the time of writing, due to the economic crisis most banks require £100 to be deposited in the account; it used to be £50, and of course it may return to this more reasonable sum in the future. For more on business bank accounts, check with the bank directly and read Chapter 11.

Step six: seeing an accountant and bookkeeping

Most artists and designers dislike the tedium of keeping records – but it has to be done. It's best to learn at the outset about keeping accounts and tax regulations. Most accountants offer an initial free consultation. Maintaining regular records of income and expenses is a legal requirement. In the early years, doing your own book-keeping will give you more understanding of your financial affairs.

In the future, when you're earning a decent amount of money, hire an accountant or local bookkeeper to do your accounts. This will free up personal creative time, albeit at some cost. For more information about bookkeeping and online systems, please read Chapter 11.

Step seven: registering with HMRC

When ready, it is important to register with HMRC, and gain a selfemployment number, also known as a self-assessment number or UTR (unique taxpayer reference). In the UK it's free to register as self-employed.

The process is simple, if you are registering for the first time, visit www.gov.uk/new-business-register-for-tax to register as self-employed.

If you are currently registered for self-assessment for other purposes, e.g. investments, income from property, or if you have been self-employed before, then you will still be required to register as self-employed but will retain the same UTR number. Visit www.gov.uk/set-up-sole-trader/register.

Class 2 National Insurance

The way Class 2 NI is collected has changed. It is now collected at the end of the year as an annual payment, as part of self-assessment (tax return). If your net profits are less than the defined threshold you will not need to pay NI contributions. Please refer to Chapter 11 and www.gov.uk/self-employed-national-insurance-rates for more detail.

Class 2 NI is a personal tax on being self-employed, just as Class 1 is for employees. So this will need to be paid from your personal bank account, not your business account.

Informing the local or borough council

If you register your home as a business address then you do not need to inform the council unless:

- You plan to convert part of your home, e.g. build an extension or convert a garage into a studio, workshop, office or gallery exclusively for business use.
- You wish to attach or paint a sign on your home advertising your business.
- You wish to have a separate entrance to the area that is exclusively for business use.
- You plan to have people, e.g. clients or customers, coming to your house for business purposes.

Other questions of entitlement

If I'm from outside the European Union, can I set up in business in the UK?

If you are a non-EU citizen, it is possible to set up as self-employed or form a company in the UK. However, this will normally involve a minimum investment of £200,000 of your own money. You must be a 'genuine entrepreneur' and be able to provide a comprehensive business plan. Contact enterprise support at your university for information on other Tier 1 visas, such as Graduate Entrepreneur, Entrepreneur or Exceptional Talent Visas. Please note at the time of print, the rules for current EU migrants living and those planning to trade in the UK, (post UK Brexit) may be as stated in step seven, or after 2018 may change to a new points-based immigration or business visa system.

Overseas (non-EU) students

If you're a non-EU citizen and here on a Tier 4 student visa, you can only work as an employee and have no rights to set up a business. You are normally limited to working part-time, for a maximum of either ten or twenty hours per week (check the regulations for your personal circumstances). For some courses of study, for example those provided by a private university, you are not permitted to work at all.

Gaining British citizenship

After ten consecutive years of legal stay in the UK on a student visa you can apply for settled status and residency, though there is no guarantee that this will be automatically granted. Your leave must be deemed as being 'continuous'. Normally 'breaks' in residence of six months or more will reset the clock to zero. Once you have settled status you can then go on to apply for British citizenship, provided you have no criminal convictions.

British citizenship can also be gained through marriage. Once married, and having successfully applied for the relevant Leave to Remain or Leave to Enter, you can set up a business in the UK. Please note, that it is illegal to marry a British subject simply to gain citizenship. Marriages and civil partnerships to those from outside the EU are monitored by immigration officers.

Other visas

It is no longer possible to apply as a 'skilled migrant' to set up as self-employed in the UK. The only way you can do this is either as a 'settled' person (i.e. someone with permanent residence), or as an investor or entrepreneur. This will involve a minimum investment of £200,000, or £50,000 of your own money.

It's becoming more difficult for UK-based arts organisations to invite non-EU artists to Britain for short periods to collaborate or make artwork. Applicants who fall under this category should apply under the 'Tier 5' arrangements.

However, if you're a non-EU resident and wish to visit the UK from time to time, for business meetings or to attend trade fairs, you might consider going into business in your own country and

applying for a 'business visitor's visa'. Make contact with the British Embassy in your own country to find out more.

You should not be too concerned if you are currently studying in the UK but find that you can't trade in the UK after graduation. Much business is conducted via the internet these days, and you can still visit Britain regularly if you hold a business visitor's visa, with validity available for up to ten years in some cases.

Please note that regulations frequently change, so you'd be well advised to obtain further information from a UK immigration solicitor or the Home Office. For the latest information go to www.gov.uk/government/organisations/uk-visas-and-immigration.

Other business structures

'Artists are often excellent businessmen. They have to be. Otherwise they do not remain artists.'

Alexander Young Jackson (1882–1974), painter

This section provides a brief outline of various types of legal statuses open to UK-based businesses. Most of the provisions concerning self-employment are described in this book.

Have a go at walking first

I would strongly urge readers of this book, unless taking on high levels of financial risk, to start out as self-employed, i.e. being a sole trader. In the future, as the business grows, you could set up a private company. It's common for creatives to retain their self-employment status and set up in business with others, such as forming a limited company or partnership.

Never rush into trading with others formally. It's wise to trial working as a team enterprise for a few months before making any long-term commitments. Before forming any partnership or company, even if it's just an experiment, seek the advice of a solicitor and have a working agreement drawn up. Should you wish to establish a more advanced form of business such as a partnership or company, then seek advice from an accountant, solicitor or business adviser.

In sectors such as television, theatre, animation, film, music, events, media, gaming and leisure software, it is usual to set up production companies. However, there are specific tax and intellectual property rules unique to these sectors, so before you do anything, it's best to obtain advice from a specialist accountant and intellectual property lawyer. Other types of enterprises that have an educational, cultural or environmental purpose are usually set up by artists or performers, who tender for funding from local authorities and other charitable sources to run community projects. These are usually termed 'social enterprises' or 'not-for-profit' companies, as the main motivation in setting up this form of business is providing a social service rather than pursuing personal financial gain. For more information, please refer to Chapter 14.

Working for yourself

When you work for yourself you have immense freedom. It can be lonely, though. If in the future you decide to work with others, it's essential to realise that you won't be able to get your own way all the time.

Sole trader (self-employed)

Registering as a sole trader is relatively straightforward. A drawback is that the self-employed are exposed to more liabilities and have no asset protection, e.g. for your own home or car. One advantage is the simple registration system with HMRC.

Working with others

Finding other artists and designers to team up with is a good idea. In the early days you may encounter some problems, but don't let this put you off working with others.

It is wise in any joint venture that rights should be clearly established in legal agreements drawn up by a solicitor. Don't attempt to make your own. The ownership and control of future intellectual property rights has to be agreed. In the absence of such an agreement, difficulties will arise should there be any falling out between parties. Remember, Sir James Dyson lost his rights to the Ballbarrow for many years, as he signed his patent over to a company rather than retaining it under his own name.

Collectives

Collectives are informal associations between self-employed creatives, in which members pool their resources and talent for projects, commercial ventures, pop-up shops and exhibitions. Successful collectives tend to develop into registered private companies, with the option of using model rules developed by Co-operatives UK or by local Co-operative Development Agencies (CDAs). Other structures and options are available.

Partnership

It's essential to have a 'deed of partnership' drawn up by a solicitor when planning to go into business with others. As with being self-employed, partners are personally – and in this case jointly – liable for any debts owed by the business and other partners. Partnerships have to be registered with HMRC.

Limited partnership, limited liability partnership

These structures are similar to, but with significantly more advantages than, a partnership, such as limited personal liability. They are slightly more complex, with more rules concerning internal administration and organisation. Such types of partnerships must register their details at Companies House.

Private limited company

When you set up a company either as a sole director or with others, you can register your company online via www.gov. uk/register-a-company-online, though I would recommend engaging the services of an accountant before doing so. A 'shareholders' agreement' should be drawn up by a solicitor, agreeing roles and responsibilities. Limited companies are registered with Companies House. There is much to learn when setting up this form of business, though your personal assets are protected, limited companies are heavily regulated. For more guidance please refer to Chapter 14.

Forming a not-for-profit organisation

There are many different routes to forming a cultural or social enterprise. Many businesses with these types of structures will be

eligible for grants from regional development agencies, local councils, arts bodies and trusts.

Voluntary organisation (unincorporated organisation)

With a voluntary organisation there is no need to register anywhere, though a constitution does have to be drawn up by a solicitor. Unincorporated organisations or 'community groups' are independent and self-governing. Committee members work on behalf of the community and not for financial gain. Again, funding may be obtainable from local sources.

Company limited by guarantee, community interest company

These are two different structures that are useful for cultural, social and educational purposes. Community interest companies (CICs) have strong social aims, though are more about 'trade' than providing beneficial educational community projects. Both of these types of businesses can apply for grants and funding. All not-for-profit companies have to register with Companies House. For more detail please refer to Chapter 14.

Business start-up checklist

This diagnostic tool (overleaf) will help you to professionally research and plan your business.

Don't give up!

If you find that you can't answer many of the questions on the business start-up checklist, or you simply give up, then you must undertake some serious research on these topics, especially if you have already started trading. This book will help with most of the answers. By the time you've read the final chapter you'll be able to fill in this diagnostic tool much more confidently.

If you've lots of comments in answers to the questions, then you are doing extremely well. Even most people who have been in business for several years can't answer all of these important questions.

BUSINESS START-UP CHECKLIST

- Of which professional bodies, clubs, unions or societies are you a member? E.g. college alumni, Design and Art Direction, BECTU, the AOP, etc.
- Are you a member of any business or legal protection organisation? E.g. Federation of Small Businesses, chamber of commerce, local enterprise club, ACID, Design Protect, etc.
- 3. Do you have a mentor or business adviser?
- 4. Do you have an accountant?
- 5. Do you have a solicitor or access to legal advice through your membership of another organisation?
- 6. Do you subscribe to any key periodicals, in print or online? E.g. Design Week, Crafts, Creative Review, Ceramic Review, Drapers, a-n web subscription, etc.
- 7. Do you subscribe to, follow or have you joined any creative network or professional association's social media page or blog? E.g. Arts News, Arts Jobs, Arts Digest, Creativepool, Design Boom, Creative Boom, Artquest or Own-it newsletters, etc.

- 8. Do you have your own website and/ or blog, business social media deeds or pages?
- 9. Do you showcase your work or CV/ portfolio on any other website? E.g. local Arts Council web portal, Axis web, Art Finder, AOI portfolios, iSpot, D&AD Talent pool, Coroflot, Behance, Aquent, Bouf, Vimeo etc.
- 10. What promotional materials do you have? E.g. professional quality images of your artwork/products, professionally printed business cards and stationery, brochures, catalogues, leaflets or flyers, a guide pricelist, downloadable PDF brochures.
- 11. If you are already starting to freelance, work to commission or sell products, have you registered as selfemployed (with HMRC) or set up a company (with Companies House)?
- 12. Have you set up a business bank account?
- 13. Do you have public liability insurance? If you have, does your public liability insurance cover all of your activities? Have you thoroughly read the policy? Do you require other insurance such as product, equipment, professional indemnity, legal expenses insurance or 'all risks' insurance?

- 14. Have you set up your own bookkeeping system, in a cash ledger in hardcopy or using software such as Excel spreadsheets or online systems such as Xero or FreeAgent?
- 15. Do you know when the tax year ends? When does income tax and national insurance have to be paid? Can you fill in a self-assessment form (also known as a tax return)?
- 16. Have you undertaken any kind of business start-up course, marketing course, enterprise skills course or financial planning (money management) training?
- 17. Can you list three to five other practitioners or creative businesses similar to your own in the borough or region? If so, how do these potential competitors differ from your own? What is special or unique about your art practice or creative business?
- **18.** Have you written a business plan, marketing plan or action plan for the next twelve months?
- 19. Have you identified who your customers, clients or collectors will be? If so, who are they, where are they and how will you communicate with them?

- **20.** Have you undertaken any kind of risk assessment to do with your future business ideas?
- **21.** Do you understand the intellectual property rules to do with business or brand names?
- **22.** Are you familiar with the basics of relevant intellectual property rules such as copyright, design right, trademarks and patents?
- 23. Are you familiar with other relevant key laws? E.g. general contract law, licensing, health and safety, COSHH, environmental legislation, packaging regulations, CE marking, fibrecontent labelling and Consumer Contracts regulations.
- 24. Do you have a good understanding of professional fees, commercial rates, and what the market can stand regarding costing and pricing?
- 25. Regarding vision, what kind of 'event' or 'lucky break' do you need to take your business on to the next level?

Jewellery designer and maker

Monique Daniels

Monique Daniels is a British jeweller based in London. She studied silversmithing, goldsmithing and jewellery at the University for the Creative Arts in Rochester, graduating in 2013. Shortly afterwards she was accepted onto the prestigious Goldsmiths' Setting Out programme based at the Goldsmiths' Centre, near Hatton Garden; where she received intensive industry training, exhibition opportunities and access to workshop space.

In 2014 she was awarded NexGem in the fifth Professional Jeweller Hot 100 and also received an award in the Goldsmiths' Craftsmanship and Design Awards. She was also selected after the New Designers: One Year On show for a curated exhibition, Masters of Modern Jewellery at Beetles+Huxley held in Mayfair, London.

Monique designs and makes her jewellery collections and bespoke pieces from her own starter studio in the Goldsmiths' Centre. Her exquisite gallery can be viewed online at www.moniquedaniels.co.uk.

Her five essential tips are:

1. Start-up programmes

Industry, university or business support programmes can really help you to make the transition from being a student to becoming a professional practitioner. They can assist you in getting started and give you a clear idea of what you want to achieve.

2. Wise up

Be aware that some art colleges still don't prepare you properly for life after graduation. When starting out as an artist or designer, as

well as your creative verve there are many responsibilities that will fall on your shoulders. It's a lot to take on, so be prepared!

3. Environment

Having a shared studio space or workshop when starting up is an invaluable experience. I was lucky to have shared facilities in my first year of business; it taught me so many things and it's inspiring to be part of a creative hub of like-minded individuals.

4. Branding

Having high-quality, attractive photographs is vital to showcase your work across a range of print and online mediums. It's worthwhile investing time in planning your overall look and styling. Create a vision for your identity – a distinctive, simple logo or mark. This will represent your brand, and is a key motif that needs to be applied to all your publicity materials.

5. Memberships

Professional bodies provide useful advice and an accolade for your business. It's a good way to discover more about your industry. They can help you raise your profile and advise on other important matters, such as how to protect your artwork, products or designs.

RESOURCES

Government organisations

All government departments and services are hosted at www.gov.uk.

Contact your local Job Centre Plus office for information about entitlement to benefits.

Telephone: 0345 604 3719 Text phone: 0345 608 8551

www.gov.uk/contact-jobcentre-plus

www.gov.uk/universal-credit www.gov.uk/working-tax-credit www.gov.uk/child-tax-credit

UK Disability Benefit Enquires, www.gov.uk/disability-benefits-helpline

HM Revenue and Customs (HMRC). This is where you register as self-employed or as a partnership, and complete a self-assessment. HMRC also publish a number of small guides and leaflets.

HMRC general helpline telephone: 0300 200 3504

www.gov.uk/register-for-self-assessment/self-employed

www.gov.uk/set-up-sole-trader/register www.gov.uk/new-business-register-for-tax

If you are currently registered for selfassessment and need to register as selfemployed, search for 'CWF1' at www.gov.uk.

Government information related to setting up a business, www.gov.uk/browse/business

For EU citizens or those from the European Economic Area you may need to prove you have the right to work in the UK. This is called a registration certificate; it currently costs £65 and can be found here: https://www.gov.uk/government/publications/apply-for-a-registration-certificate-as-a-qualified-personform-eea-qp. (Equally you may not need this, so please check before registering.)

UK Home Office. For advice about business visas for people on temporary visas, and for general immigration enquiries about work permits.

Telephone: 020 7035 4848 Text phone: 020 7035 4742

www.gov.uk/government/organisations/

home-office

www.gov.uk/government/organisations/uk-visas-and-immigration

MediVisas, LLP UK Visa and Immigration Specialists, www.medivisas.com

Research

Market Research Society, www.mrs.org.uk www.scavenger.net www.cobwebinfo.com (useful condensed fact sheets)

Enterprise agencies

Find your local enterprise and creative/cultural agencies, www.nationalenterprisenetwork.org

Creative business support

http://uk.moo.com/startup-business-toolkit/ www.startupdonut.co.uk www.thedesigntrust.co.uk www.hiddenart.co.uk www.designsponge.com www.alisonbranagan.com

Regional support

Northern Ireland, Scotland and Wales have similar resources

Northern Ireland Business Telephone: 0800 1814422

www.nibusinessinfo.co.uk, www.detini.gov.uk

Business Gateway (Scotland) Telephone: 0845 609 6611 www.bgateway.com

Cultural Enterprise Office (Scotland) www.culturalenterpriseoffice.co.uk Telephone: 0333 999 7989 www.scottish-enterprise.com

Business Wales

Telephone: 03000 6 03000 http://business.wales.gov.uk/

The Prince's Initiative for Mature Enterprise (Prime). An organisation that supports people over the age of fifty, or who have a disability, who wish to set up in business.

www.primecymru.co.uk (Wales)

RESOURCES

Business and disability

www.shapearts.org.uk www.gov.uk www.princes-trust.org.uk

Royal National Institute for the Blind (RNIB) has a long list of business support agencies on their website

Telephone: 0303 123 9999

Sources of information about forming UK-based companies and co-ops

Companies House. This is where you register your business as a company, whether a private limited company or one limited by guarantee. Telephone: 0303 1234 500

Private Company Registration www.gov.uk/limited-company-formation/ register-your-company www.gov.uk/register-a-company-online Co-operatives UK, www.uk.coop

National Council for Voluntary Organisations www.ncvo-vol.org.uk www.ncvo.org.uk

Social enterprise, not-for-profit businesses

www.socialenterprise.org.uk www.can-online.org.uk www.sel.ora.uk (for London)

Community interest companies, www.gov.uk/ government/organisations/office-of-theregulator-of-community-interest-companies

Miscellaneous enterprise

The Scottish Artists' Union, www.sau.org.uk Artists' Union England, www.artistsunionengland.org.uk/ www.fromyourdesks.com

Affordable business advice sessions from the author of this book.

Alison Branagan Creative Consultancy alison@alisonbranagan.com www.alisonbranagan.com Twitter @alisonbranagan Search for business and enterprise short courses taught by Alison Branagan at Central Saint Martins, London, at www.arts.ac.uk/csm.

Rooks

Fashion Designer's Resource Book, Samata Angel (London: Bloomsbury)

How to Create Your Final Collection: A Fashion Student's Handbook, Mark Atkinson (London Laurence Kina)

Setting up a Successful Jewellery Business, Angie Boothroyd (London: A&C Black)

A Pocket Business Guide for Artists and Designers, Alison Branagan (London: A&C Black)

Becoming A Successful Illustrator, Derek Brazell and Jo Davies (London: Bloomsbury)

The Architect in Practice, David Chappell and Andrew Willis (10th ed.) (Oxford: Wiley-Blackwell)

Turn Your Talent into a Business: A Guide to Earning a Living from Your Hobby, Emma Jones (Hampshire: Harriman House)

Design, Create, Sell: A Guide to Starting and Running a Successful Fashion Label, Alison Lewy (Hampshire: Harriman House)

How to Set Up and Run a Fashion Label, Toby Meadows (London: Laurence King)

Beyond The Lens, Terry O'Neill (foreword) (4th ed.) (London: The AOP)

Peepshow, Peepshow Collective (Coventry: Index Books)

Setting Up a Successful Photography Business, Lisa Pritchard (London: Bloomsbury)

How to Run a Successful Design Business, Shan Preddy (Farnham: Gower)

Graphic Design: A User's Manual, Adrian Shaughnessy (London: Laurence King)

The BIID Interior Design Job Book, Diana and Stephen Yakeley (London: RIBA Publishing)

Bloomsbury's imprint Fairchild has produced a number of specialist business art and design books for recent graduates and emerging professionals.

Money management

'This is a credit crisis, not a creative crisis.'

John Galliano (1960–), fashion designer

It's possible that the effects of the global financial crisis will continue to reverberate for many more years. Many readers may have suffered financially due to a reduced number of opportunities. Though I hope that those who have suffered from these adverse conditions will return to a prosperous outlook by 2020.

History has shown that hardship doesn't prevent artists and designers from having ideas. However, insufficient income will eventually frustrate any ambition. A total deficiency of funds makes it impossible to do anything properly. A decent level of income is required for a reasonable quality of life, which is vital for physical and psychological well-being.

I'm afraid I can only give a brief introduction to the subject of this chapter, which is about managing your money and costing products. I advise readers to develop their knowledge further by reading the texts and visiting the websites recommended at the end of this chapter. There is no quick fix where costing and pricing is concerned. Most creative businesses are in niche markets. Calculations can be extremely complicated – especially for commercial creatives when quoting for licensing rights or 'reuse' fees – but I hope this chapter will give you a starting point.

Basic calculations

'Your pictures would have been finished a long time ago if I were not forced every day to do something to earn money.'

Edgar Degas (1834–1917), artist, from a letter, 1877

Many artists have a distant relationship with the concept of making money. They're uncomfortable with the idea of pricing and selling work they may still be emotionally attached to. Unfortunately, artists and designers operate in a highly competitive field. If you're keen to learn more about what to charge, then it's advisable to seek advice and study the pricing quides mentioned at the end of Chapter 1.

To be in with a chance, unless you're established in your field, your products and services have to be priced in relation to what the market can stand. There is a huge difference between costing and pricing time and 'market rates'. Artists, designers and commercial creatives must grasp several concepts before beginning to cost their time, materials and other expenses.

Key money-management areas

- Understanding the value of time
- Calculating a Personal Survival Budget
- Working out realistic business start-up costs
- Keeping track of ongoing expenses (cash flow/accounts)
- Constructing a budget and working within it
- Finding out about trade and retail pricing
- How to quote commercial fees for commissions/projects
- Being able to draft a basic cash-flow projection
- Profit and sales forecasts (if appropriate)
- Running a business account properly

What happens if I don't make much money from my business?

In the UK, as in many parts of the world, if your earnings from self-employment or as a company director are low, you can claim help with housing costs and other benefits, but it is becoming more difficult to do so. Many artists and designers have claimed

state aid, though most gloss over the fact. It's refreshing when established creatives talk openly about difficult periods in their lives. (For more information on this, please turn to Chapter 8.)

A number of money-management and 'keeping out of trouble' tips are covered in this chapter, and throughout the rest of this book.

A few tips to keep you out of trouble

- It's essential to manage your financial dealings professionally.
- You must clearly understand what your earnings are.
- If you're hazy about what your income and expenses are, you will not be able to plan for the future properly, or claim in-work support benefits.
- Note the date of registration with HMRC, as this is when official records start, though accounts may have actually started some months before. Make sure bookkeeping is done regularly.
- Avoid leaving completing tax returns until just before the 31 January final HMRC deadline. The consequence of procrastination is being unprepared for sudden tax demands.
- If you manage your money properly, you won't get behind with tax payments.
- Have a contingency fund for tax payments to avoid getting into debt.
- Avoid taking out loans to pay any tax owed.
- Open a business account. Then business and personal finances can be better organised.

Don't become a mug

Being unprofessional, such as by accepting cash payments without issuing an invoice or recording income in your accounts, can expose you to what at best can be described as uncomfortable arrangements with dubious 'clients'. Once you start entering the 'for cash' economy and not invoicing clients professionally, it will be difficult to charge market rates in the future.

Where to begin?

To start with, calculate a Personal Survival Budget. The 'PSB' is an estimate of what your personal outgoings are for a year. This can be difficult to do, and first drafts of Personal Survival Budgets can

be a bit vague. All financial planning at the beginning of any venture is a combination of research, gaining feedback and guesswork. In your first two years in business you will need to revisit some of the exercises covered in this chapter and the next.

An example of a Personal Survival Budget

To begin with, add up all your personal expenses over the year. This can be difficult. Remember, there are 52 weeks in the year, 12 calendar months, but 13 x 28-day periods. I have removed Class 2 National Insurance from the PSB, as though this is a personal tax for the self-employed, it is now collected as part of self-assessment/annual tax return and no longer as a monthly payment.

EXPENDITURE	Amount payable and frequency of payment					
		Quarterly £/\$/€	Monthly £/\$/€	4 Weekly £/\$/€	Weekly £/\$/€	Tota £/\$/€
Mortgage or rent			600			7,200
Council tax and water rates	1,000					1,000
Gas and electricity			40			480
Personal and property insurance	210					210
Food and housekeeping					30	1,560
Clothing			50			600
Telephones			50			600
TV licence	150					150 520
Entertainment					10	
Newspapers, magazines, clubs etc.			10			120
Car – tax						
Car – insurance						
Car – service and maintenance						
Car – fuel, oil, parking etc.				***************************************		120
Children – presents, maintenance etc.	120			***************************************		240
Savinas plans		***************************************	20	***************************************		240
Debt repayments (credit cards, agreements)				•••••		1,200
Travel card/Oyster			100			1,200
Other						
Other						
TOTAL EXPENDITURE						14,000
ESTIMATED INCOME (NON-BUSINESS)						
Income from family/partner						
Income from part time job						
Other						
TOTAL INCOME (NON-BUSINESS)						
ANNUAL SURVIVAL INCOME REQUIRED						14,000

Example of a Personal Survival Budget (PSB)

At the bottom of the spreadsheet there is room for 'other non-business income'. This could be a salary from a part-time job, income from a spouse, or perhaps rent collected from a lodger. If money is coming in from sources unrelated to your business, then subtract it from your total personal expenditure.

For example, if you're in full-time work, your salary should be covering all your basic personal outgoings. So enter your total salary (after tax) under 'non-business income' at the bottom of the PSB, and then deduct this amount from your personal total expenditure. You should find that your earnings from the job cancel out the calculation. This means you won't need to 'draw' money from your business at the beginning if you're starting off as self-employed in your spare time. 'Drawings' are monies taken from your business to live on.

If you find that your personal expenses are not completely covered by your salary, and you end up with a negative figure, then if your calculations are accurate you must have credit-card debts or be living on an overdraft!

Eventually, if you reduce your hours and work part-time, you will have to 'draw' money out of the business to live on. If, for instance, you have a part-time job and are also self-employed, then it may end up as a 50/50 situation: half your livelihood is subsidised by wages and the other half by self-employment.

Don't be daunted by the figures. Remember, as mentioned earlier, if you're self-employed or you have a mix of employed and self-employed work, and you're on a low income, there may be a subsidy available in the form of benefits either from HMRC (tax credits), the state (Universal Credit) or your local council (housing benefit).

This exercise is the first step in understanding money management.

Start-up costs, ongoing or reinvestment costs

If you're about to set up your business, then undertake thorough research into what has to be spent. You might have a number of items such as basic tools, mobile phone, laptop, and software already. If this is the case then start-up costs will be very low, especially if neither premises nor a vehicle are required.

For readers who are already trading, there will always be ongoing costs and periods of reinvestment in the business, e.g. for rebranding, a new website, updating software, registering designs or a trademark, extra training and so on. Therefore, instead of thinking about start-up costs, consider whether your business requires a revamp.

Failure to regularly inject money into a business will gradually slow it down over time. Stale branding, an 'unresponsive' blog or website, outmoded software packages, old equipment, a lack of investment in updating your own skills – each and every one of these factors can have an impact.

Underinvesting or spending money on the wrong things can destroy a business before it even gets started. Marketing, branding and legal matters are key areas where it's easy to make big and costly mistakes.

So don't rush in to setting up until you have enough money to cover the basic costs, such as insurance, marketing materials, prototyping (if appropriate), professional photography, and legal or business advice.

Filling in your business start-up costs

Don't be afraid of adding up all the figures – you need to know what your outlay is. A sensible way to cut down on start-up costs is to start trading from home. Think about what's essential and what isn't.

Some questions you can ask if faced with enormous start-up costs

- Do you really need a studio or workshop?
- If you're desperate for a studio could you share the cost, or hire space for short periods of time?
- Is there a local innovation hub, university or business incubation centre you could use at low cost, or where you could gain access to free hot-desking facilities?
- If you're dreaming of owning a shop, could this be a longer-term goal? Wouldn't it be better to start trading online, try a pop-up shop or sell from market stalls, at local fairs and festivals?
- Is buying all that expensive equipment necessary at the outset?

How much business time is there in a year?

As you can see from this chart, after adding up all the days off you have about 220 days of business time. By 'days off' I mean the days you spend on other activities such as having a rest or doing household chores, looking after children, going to the gym and other leisure activities such as going on holiday or visiting friends.

How much time will I have if I work in my part-time job one day a week?

If I have 220 days of business time, how is it spent?

As you can observe in this cake chart, there are several areas of activity required to start a business and keep it going. Notice the dark purple segment for selling products and services is money-making time and the orange segment for creativity and manufacturing. If you don't have money pressures, then you can afford to spend more time experimenting and making your creative products. This is great if you wish to establish a creative business as a lifestyle or hobby business. If you plan a more serious art practice with poetic ambitions or wish to design high-end products, then you will need to put more time aside for experimentation, research and development.

In the beginning, how will I use my time?

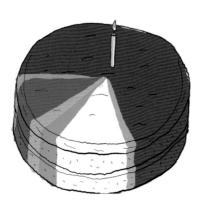

As you can see from this cake chart, if you would like to earn money from being an artist or designer in the early months and years of a business you will have to dedicate a large amount of time to promotion, networking and marketing if you are going to attract clients, customers or collectors. Equally in the business development section you might be looking for inspiration, attending a short course or learning about new creative software, equipment or tools.

On how many of these days should I be aiming to make money?

If you do wish to earn a living or grow a profitable business, then a large proportion of the 220 days of business time will have to be spent generating money. As you earn money, it's worth reinvesting it in the business by outsourcing tasks such as bookkeeping, or by taking on an assistant. This will free up more time for creative/making and money-making time.

You always cost your products based on the making time, the more speedy and cost effective the manufacturing is, the more likely the chance of making a decent profit. You may concentrate your money-making, i.e. selling, at set times of the year as in the intense period leading up to Christmas or, making sales and taking orders during other major selling opportunities such as large retail or trade fairs.

Why can some creatives become poor?

A common problem for most artists and designers is spending far too many days dedicated to the creativity segment. Creativity is the verve of any visual artist, but you must keep one eye on the bank balance and make sure that money is being generated on a regular basis. Any creative enterprise can go wrong, as you can see from this final cake chart. If insufficient time and effort is put into planning, securing your next paid job, marketing and networking, then you might find your income streams will gradually fade away.

It is also worth considering how you can spread your costs of creation, production or manufacture. Often the first piece you make in a new collection or body of work costs a lot in terms of time and investment in materials. Sometimes you have to write this off, unless various materials, tools or machines you may have purchased can be used to create the rest of the pieces.

The number of days spent working for a daily rate could be reduced if you manage to create high demand or an exclusive niche market for your creative products or services. This will mean you can charge more substantial fees. Alternatively, being able to receive regular royalty payments from licensing your copyright, designs, patents and even your trademark in the future to other businesses is another way to generate income. If you can break into licensing your rights, this can provide a labour-free source of income.

There is often an argument put forward that you should not think about time when setting prices, as it is about 'what' you do rather than how long it takes. I accept part of the argument, especially if you have an exceptional product or talent. However, no business can ignore the finite amount of business time and resources available. The question needs to be addressed of whether the artist or designer is aiming their artworks, creative products or services at the correct market, or if there is simply insufficient market demand. As you can see from the cake charts, you might have less time than you think.

Professional fees and pricing

"And what do I owe you?" she asked. "Five thousand francs," he answered. "But it only took you three minutes," she politely reminded him. "No," Picasso said. "It took me all my life."

From Selling the Invisible by Harry Beckwith (1949–), marketing guru

Costing and pricing is not simply about time. The art of making money is also related to other factors. The costing and pricing quiz on page 90, at the end of this chapter, gives an insight into different approaches to fees, salaries and pricing across the arts, illustration, fashion design, craft and photography.

I have included a couple of examples below to help you gain a sense of how rates and fees can be worked out. For more guidance please refer to the resources listed at the end of this chapter, and also those in Chapters 1 and 5.

Some thoughts on costing and pricing

- When finalising your trade prices or final retail sale prices, you need to bear in mind that the costs of materials, fuel, postage and other services can increase.
- Though you yourself might not be VAT-registered, it is highly likely that your stockists or commercial galleries will be, which will push up your final retail sale prices to the buying public. For more on this see further on in this chapter, and also Chapters 11 and 14.
- Market demand: if everyone wants your creative products or services, put your prices up – but do it slowly.
- For a specialised skill, services can be charged at a premium rate.
- The same is true for exclusive, niche, rare, unique, bespoke, limited edition or handmade products or artworks.
- Large-scale manufacture and buying materials in bulk can minimise costs and maximise profit margins.
- Particular styles, unless they are classic, go in and out of fashion.
- Changing fashions and trends mean that picking the right moment to enter the market is crucial.
- Don't be afraid of making a quick buck, tailoring products to tie in with seasons, trends and events, e.g. Christmas, Valentine's Day, Mother's Day, local festivals, the Olympics, officially forecasted fashion or interior design trends, etc.
- Protect your intellectual property by asserting rights and licensing copyright, and registering designs, trademarks and inventions.
- Endorsements are a great boon to your business. They
 can come from a variety of sources: a prestigious art
 school, gallery, sponsor, stockist, client list, networks,
 brand critic or celebrity.
- Taking a risk with product development, innovation, research and experimentation requires both time and money to undertake. Making new work or products can pay off in the long term.

Creative services

Fees for the provision of design services are charged by an hourly or daily rate – for example, £180 per day, £250, £400, £500, £1,000 per day, etc. Most freelancers rarely generate income on more than 150 days per year, so this is why our calculations are based on 150 days. To cost time you base your calculations on the production time, e.g. creating a commissioned design. You may end up costing on fewer or more days depending on whether your business is full or part-time and what the demand is for your services. The fee you earn for commissioned design work, if you have no other income, has to cover the costs of your personal life and also subsidise other business activities such as administration time, which needs to be done to keep the business going. How to calculate tax is explained further in Chapter 11. Please note that the following two examples are using the National Insurance thresholds for 2016 -2017 and the current rate for Income tax 2017–2018.

Costing of time only

Example 1: A self-employed graphic designer

£200 x 150 days = £30,000

£30,000 minus annual business expenses of £10,000 leaves £20,000 (net profit)

£20,000 minus £14,000 PSB (drawings of £14,000) = £6,000 surplus

For readers ready to understand how this is taxed on partial 2017–2018 rates:

Profits/drawings (PSB) of £14,000 plus the £6,000 surplus = £20,000 (net profit)

Assuming you have no other income, the first £11,500 of profit is income tax-free (this is your estimated Personal Tax Allowance, PTA)

£20,000 minus £11,500 PTA = £8,500 net profit

Income tax at 20% of £8,500 is £1,700

Class 2 National Insurance (NI) is £145.60 (£2.80 per week x 52 weeks) (2016-2017)

Class 4 NI is £1,074.60 (9% of profits over £8,060) (2016-2017)

(Class 4 NI is worked out as £20,000 minus £8,060 = £11,940 x 9% = £1,074.60)

The total tax liability on net profits of £20,000 is £1,700 (income tax) + £145.60 (C2 NI)

+ £1,074.60 (C4 NI) = £2,920.20

This means you will have successfully been able to live on £14,000, and after the income tax is paid you'll have a surplus of £3,079.80 (£6,000 – £2,920.20 [all tax] = £3,079.80). This £3,079.80 may be put into a savings account, blown on a few treats, or reinvested in the business.

Tips for quoting fees

There are a number of matters to consider when deciding what fees to charge. Will you have a daily rate plus expenses? A half-day rate? Or will you charge hourly? Equally you may just quote for a whole commission or job as a lump fee and just hope you have estimated the amount of work involved accurately. This skill of calculating duration will come with experience. When copyright issues are involved it can get complicated; ideally you should try to have an 'origination' fee and keep the 'licence' for the usage of the art or design work as a separate arrangement. However, many creatives will just quote combining the origination and usage as one fee. It's important not to rush when quoting fees; think it all through – but don't leave the client hanging on too long!

Licensing copyright, design right, trademarks and patents

Detailed guidance about licensing can be gleaned from patent/IP solicitors, industry reports, research published by professional bodies, and online. I highly recommend Simon Stern's book, *The Illustrator's Guide to Law and Business Practice* (see the resources at the end of this chapter), which is the best introduction to licensing copyright and contract law for UK creatives that has ever been written. Although his book is designed for illustrators, it's suitable for most artists and designers.

For further information about licensing rights, please read Chapters 9, 10, 12 and 14.

Creative products

When trying to cost products that you make yourself, you have to take into account that there is a limit to how many products can be produced in a day, week, month, etc. As well as working out a 'Personal Survival Budget', materials, labour and other costs have to be factored in. So how many days a week are you making on

and how much can be achieved and made during this time? In the basic example below, we are calculating based on roughly two days of making. Remember, as mentioned in the last example, the costing of time has to be based on the time it takes to make, produce or manufacture your work. As the money earned in relation to output needs to cover all other personal and business expenses.

The **trade** or **wholesale price** is the price at which you sell your products to shops, whereas the **retail price** is what a shop (or you) will charge to the public. You need to think through what a realistic or viable retail price to the customer could be. Retail pricing can be marked up to between 100% and 250% of the trade price, or even 300% for high-end stores. It is important to conduct market research by finding out what similar types of products are selling for in your target stores and markets. Remember, a proportion of profit has to be included in the trade price when taking orders from stores, otherwise the venture is unviable; for further explanation, see below.

The example below is simplified so that you can get the gist of working out very basic costing and pricing.

Costing of time and product

Example 2: A self-employed product maker

100 days a year are spent making products

On each day five products are made (assuming it takes over an hour to make each product)

100 days x 5 products = 500 products per year

The maker's Drawings/Personal Survival Budget is £14,000 per year

There are also a number of expenses, materials, electric power, etc.

£14,000 divided by 500 products = £28 each (as a proportion of the PSB)

For each product there is a £10 cost for material/other costs, overheads, etc. (this equates to £5,000 of direct and indirect business costs per year)

Then we add £12 as a bit of profit factored into the trade price, and to allow for tax payments and other reinvestment costs, as outlined in the previous example

Therefore, the product's trade price is £50

- It's likely a retailer would sell this product to the public at a final retail sale price of between £120 and £200 (including VAT)
- If the product maker has stockists, the price on the product maker's website has to be the same as in the shops
- If the product maker sells all 500 products made in a year, $500 \times £50 = £25,000$ per year will be generated
- They will use this £25,000 to pay themselves £14,000 (PSB), and to cover business expenses of £5,000 spent through the year and tax payments totalling £3,020.20 (based on combined rates)
- Remember, assuming you have no other income, the **total tax liability** on **net profits** of £20,000 is £1,700 (income tax) + £145.60 (C2 NI) + £1,074.60 (C4 NI) = £2,920.20 (2016–2017 NI rates and 2017–2018 income tax rates)

This means, as in the previous example, you will have successfully been able to live on £14,000, and after the income tax is paid you'll have a surplus of £3,079.80 (£6,000 – £2,920.20 [all tax] = £3,079.80). This £3,079.80 may be put into a savings account, blown on a few treats, or reinvested in the business.

This is a simplified example to help you understand some elementary principles. It's worth getting used to thinking backwards in pricing. However, don't cost your products without concern for what customers are willing to pay. It doesn't matter how brilliant your product is: if it's unrealistically priced, very few people will buy it.

In the beginning, you won't be able to compete on price with established design brands, but to build any manufacturing business it's essential to consider how to make your products within a realistic time and budget.

When you're starting to develop a range of products or a collection, it's likely that material and other costs will be more expensive than first anticipated. Many designers like to keep all manufacturing within the UK. If you want to do the same, it can be difficult to fulfil and make profits on substantial orders. If you discover that your products are attracting more interest and that you have to fulfil larger orders, then outsourcing services or taking on staff is the only option. Otherwise you will continue to run an unprofitable business and struggle with completing orders on time.

However, it is worth mentioning that there is an increasing movement towards contemporary craft pieces and products being made in England, Great Britain or the UK, for which the consumer is willing to pay a bit more to support local makers. Equally there are more local initiatives, such as 'Made in London' and 'Made in Brighton'.

The confusing terms applied in pricing

The subject of pricing work is more complicated than the three examples shown below, but hopefully they will act as a starting point in helping you to work out a final selling price.

From an artist or maker's point of view, the term 'commission' should really be referred to as the 'mark-up', which is the relationship between what the artist would like from the gallery for their work (i.e. the trade price) and the final selling/retail price.

The 'mark-up' from an artist's point of view is the proportion of the mark-up added to the trade or artist's price by the dealer, for sale or return selling opportunities with boutiques or galleries.

Please note 'mark-up' is not the same as 'commission on sales' or 'profit margin'; these different terms can be confusing. A gallery or shop would view this situation of selling a piece of contemporary art or craft differently as a 'profit margin' or 'commission on sales'; see the vase example overleaf to understand how this is worked out. It's common for galleries to take between a 30% and 50% share of sales. Variables would include matters such as who paid for the frames, how much the artist has contributed to the costs of promotion, etc.

Please note that for ease of understanding I have left VAT out from these examples.

It can be easy to confuse the meaning of the terms 'markup' and 'commission'

How to Calculate Mark-up

A painting

£400 retail price tag o £200 mark-up, • £200 trade/artist's price

(Please note, there are special VAT margin and retail schemes, through which galleries and shops can reduce their final VAT percentage in the retail price. Please refer to the bag example on pages 87, 193 and 292.)

So what proportion is £200 mark-up of the original trade or artist's price of £200?

'A' in the following calculation equals the mark-up.

$$\frac{A}{100}$$
 × trade/artist's price of £200 = £200 mark-up

$$A \times £200$$
 trade price = £200 mark-up \times 100

$$A = \frac{£200 \text{ mark-up} \times 100}{£200 \text{ trade price}}$$

$$A = 100\%$$

So a mark-up of £200 on the original trade/artist's price of £200 makes a sales price of £400; this equals a mark-up of £100% from the artist's viewpoint.

However, a gallery would view this as a 'commission on the sales price', a 'profit margin' or a 50% share of sales. Please see the vase example.

(Please note: the full retail sales price including VAT might be £440 – £480.)

'Profit margin' and 'commission on sales' are calculated differently from 'mark-up'

What does the term 'profit margin' or 'commission on sales' mean from a gallery, boutique or shop's point of view?

As mentioned in the previous example, 'profit margin' or 'commission on sales' are terms used in retail to describe the percentage of the margin (the difference between the trade and retail prices) to the retail or final gallery selling price.

The amount that shops or galleries charge also takes into account issues such as a viable price point for artworks, products or collections. Sometimes dealers, gallery or boutique owners are open to negotiation on pricing and sometimes they aren't!

How to Calculate Profit Margin

A vase

£150 retail price tag • £75 margin o £75 trade/artist's price

So what proportion is a £75 margin of the final retail price of £150?

'B' in the following calculation equals a net profit margin.

$$\frac{B}{100}$$
 × £150 retail price = £75 margin

 $B \times £150$ retail price = £75 margin \times 100

$$B = \frac{£75 \text{ margin} \times 100}{£150 \text{ retail price}}$$

B = 50%

So a £75 margin equals a profit margin of 50% from the retailer's point of view.

To work out the commission on sales, calculate as follows. Using the same figures, a gallery takes a 50% profit share in sales, i.e. a 50% commission on sales.

Final sales price £150 \times 50% = £75.

So the gallery will take £75 as commission on sales.

(Please note: the full retail sales price including VAT might be £180 – £200.)

Is there an easier way?

Yes! If you are not good with mathematical equations or formulas, use a calculator with a profit margin application or download a profit margin app from Google Play Store or iTunes.

Seriously though, many makers just multiply their trade price by 2, 2.4, 2.5 or 3 to find a retail price. However, this can depend on the type of retail outlet that is buying and selling your artwork or creative products, e.g. a smaller shop may just multiply the maker or designer's trade price by 2, or perhaps even less, then add VAT to make a final retail sales price for the buying public.

When selling at trade price to larger stores they may multiply the trade price by 2.4 or 2.5, and then add the VAT, as they have more overheads. If you multiply your trade price by 2.5, for instance, this is equivalent to a 150% mark-up from your maker's perspective but 60% profit margin or commission on sales from a retailer's viewpoint. Prestigious stores such as Harrods, Harvey Nichols or Selfridges may need an even higher percentage than this, and many makers have to squeeze their trade price to fit with the stores' margins and price points.

Multiplying your trade price by 2, 2.4 or 2.5 can be an easier option

How to Calculate a Retail Price Using Multiplication

A bag

£120 +VAT retail price tag • £60 trade/artist's price

An easier way to calculate a retail price

A small crafts gallery using a special VAT margin scheme (MS)

Non VAT-registered maker's trade price of £60

£60 trade/artist's price x 2 = £120 retail price (not including VAT)

£120 retail price + £12 VAT (MS) = £132 total retail price

From the maker's perspective, a £120 retail price before VAT is a 100% mark-up on a £60 trade price, whereas the gallery would view this as a 50% profit margin or a 50% commission on the sales price.

(Please note: the full retail sales price including VAT might be rounded to £135 – £150.)

This can be difficult at the beginning, but it depends where your market is; will it be mainly individual items sold through small boutiques and galleries or substantial manufacturing runs supplying larger stores?

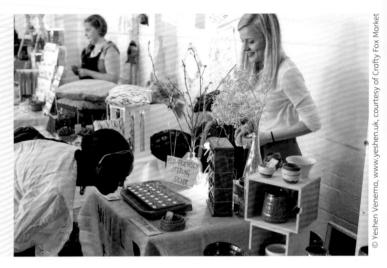

You need to think through what a realistic trade and retail price will be

At a trade fair, for instance, you will need to provide a trade and recommended retail price guide. When exhibiting individual collections with small boutiques or galleries you might find prices are set by agreement, often upon a sale or return basis. The best way to find out is to visit trade fairs and talk to owners of small outlets directly.

You can find more exercises in Appendix 1.

The illustrator, writer, animator, artist (utility man)

Tim Bradford

Tim Bradford is a British author and editorial illustrator. He studied English and film at the University of East Anglia. After graduating, he worked in various jobs including copywriting, surveying and as a picture librarian.

Tim's freelance career took off when he started contributing words and pictures to When Saturday Comes magazine. He also worked as a technical writer for Amateur Photographer magazine.

Over the last fifteen years he's published several books, and has had cartoons commissioned by the *Observer* and *Guardian* newspapers. Now married with three children, he juggles his work with childcare.

You can view Tim's trajectory at www.timbradford.co.uk.

His five essential tips are:

1. One big goal

I have to work on a variety of projects or I'll go mad, but I sometimes make the mistake of trying to achieve too many things. Decide what each day will be about, then throw yourself into that job.

2. Plan ahead

If time is tight you need to take a long-term approach to personal projects if they're ever to come to fruition. The Japanese idea of *kaizen* – daily actions allowing incremental progress towards the completion of each project – can be a valuable tool. Obviously this doesn't really work if your deadline is tomorrow.

3. Downtime

I sometimes feel I should be working every minute of the day. This is bad thinking. Every now and then you should leave your desk and get out – go to a café, have a walk, go sketching – anything to clear your head, really.

4. Say yes – sometimes

I hate the exploitative modern phenomenon of creative people being expected to work for free – for 'exposure'. That said, doing stuff in your local community or for charities that you support can be a good thing, and also a chance to experiment a bit.

5. Networking

I hate networking. But I do like 'going for a pint with other procrastinating creative types and discussing things like pen nibs, art, who would play us in a film, mad dreams and having a good moan'. It's how you frame it, I suppose.

When I was a child my favourite footballer was Leeds United's Paul Madeley, the Utility Man. He could play in most positions on the pitch but was an expert defender. I always loved his versatility. Without being too conscious about it, I've become a kind of creative version of the utility man.

A COSTING AND PRICING QUIZ

- 1. How much do artists get paid for exhibitions in public galleries and museums?
- 2. For designer-makers, what is the most popular price range for their products?
- 3. What is a freelance photographer's daily rate?
- **4.** What is an acceptable daily rate for a ten-hour day as recommended by BECTU for a costume maker working on a TV advert?
- **5.** What is the average daily rate for a junior freelance designer? Also, what would an annual salary be according to the Major Players Report?
- **6.** What is the average annual salary for a junior fashion designer inside London and outside London?
- 7. How much would an illustrator get paid for the front cover of a mass market UK magazine?
- 8. How much do jewellery designers charge for a commission?
- **9.** What are the hourly PAYE rates for lecturers working in adult, further and higher education?
- **10.** What is the UK national minimum hourly wage if you are twenty-one years of age or over?

RESOURCES

For information about fees, see the industry reports listed at the end of Chapter 1 and contact your professional body.

National Union of Students, www.nus.org.uk (if you are a student or subscribe to an industry periodical, make the most of the discounts open to you)

Useful cash flow and other budgeting and start-up cost Excel sheets

Greater London Enterprise, www.glestartup. co.uk/start-up-loans-business-planning-docs.php Prince's Trust, www.princes-trust.org.uk/help-foryoung-people/tools-resources/business-tools/ business-plans

Office templates for PSB and other calculators, https://templates.office.com/en-gb/Budgets
Office templates for cash flow forecast and other calculators, https://templates.office.com/en-gb/templates-for-Excel

Skilledup, www.skilledup.com/articles/best-freeexcel-templates-dashboards (50+ free Excel templates)

Money management

The Financial Conduct Authority (FCA), www.fca.org.uk/ www.moneyadviceservice.org.uk/en (free money management calculators and advice) www.bbc.co.uk/moneybox www.guardian.co.uk/money

Budget and savings advice

www.confused.com www.gocompare.com www.moneysavingexpert.com www.moneysupermarket.com

Pricing and fees

There are many online blogs, noticeboards and forums where artists and designers discuss what to charge. Please also refer to the resources at the end of Chapter 1.

Artnet, www.artnet.com (prices and art auction news)

Art Monthly (periodical), www.artmonthly.co.uk (regular features about art auctions and salerooms)

www.craftscouncil.org.uk (see research reports listed in Chapter 1)

www.a-n.co.uk/ (search on google for a-n's sample fees and day rates)

www.a-n.co.uk/resource (full access for subscribers only)

www.theaoi.com (full access for subscribers only)

www.the-aop.org/information/usage-calculator www.creativereview.co.uk (see the Money Issue and CR blog)

www.creativepool.com (design salary guide and survey)

www.coroflot.com/designsalaryguide (design salary guide)

www.designweek.co.uk (salary survey and calculator)

www.majorplayers.co.uk/major-blog/salarysurvey-2015.html

www.graphicdesignforums.co.uk www.creativeskillset.org www.videoforums.co.uk

www.bectu.org.uk/advice-resources/rates

Pensions

www.gov.uk/browse/working/state-pension

Debt

Step Change, www.stepchange.org Telephone: 0800 138 1111

National Debt Line, www.nationaldebtline.org Telephone: 0808 808 4000

Manufacturing

Join the LinkedIn group 'Made in the UK' www.alibaba.com www.gov.uk/topic/business-enterprise/ manufacturing www.letsmakeithere.org/ Mike Smith Studio, www.mikesmithstudio.com (design and fabrication service)

RESOURCES

Books

Please also refer to the books recommended at the end of earlier chapters and also chapter 14. Entrepreneurship, Creativity and Organisation: Text, Cases and Readings, John K. Kao (New Jersey: Prentice Hall) Finance on a Beermat, Stephen King, Jeff Macklin and Chris West (London: Random House) Making It, Chris Lefteri (London: Laurence King) The Illustrator's Guide to Law and Business Practice, Simon Stern (London: The AOI) Manufacturing Processes for Design Professionals, Rob Thompson (London: Thames and Hudson)

Please note that details of tax rates and allowances given in this chapter are estimates and are subject to change. Please visit www. gov.uk/hmrc for the latest rates.

Business planning

'I had reservations about making art a business, but I got over it.'

Mary Boone (1951-), New York art dealer

Before starting a business it's advisable to think carefully about what you wish to achieve – as you can see from the simple plan for self-employment (see pages 100–101), mind mapping is a useful tool to aid memory and clarify your thoughts. This mind map divides research activities into four themes: exploring market demand, self-promotion, money management and legal issues.

The importance of business names

'It's worth remembering that you will have to live with your chosen name for a long time. Also, in years to come you might change the nature of your business so you don't want to be saddled with a name that is inappropriate.'

Adrian Shaughnessy (1953–), designer and writer

Before picking up a pen to start drafting your own map or plan, an important decision to make is whether to trade under your own name or a business name. The regulations concerning business, company names and trademarks are complicated and often misunderstood.

If you're trading under your own name – for example, Alison Branagan – that's usually fine. However, if you wish to trade and happen to be called Damien Hirst, Vivienne Westwood or Pablo Picasso, I would consult with an intellectual property lawyer.

A business name is anything else, e.g. Alison Branagan Studio, Branagan Design, Super Pink Fashions, Big Elephant Productions, Blanks Gallery, etc. If you are trying to think up a business name, I would have a look at www.start.biz to check to see if your proposed name isn't already listed as an existing business via official directories or registered as a company.

To check if a business name has already been registered as a trademark, you need to examine the trademark register on www.gov.uk/ipo. The online search system has become more complicated, so you may need to seek specialist advice on this matter. A good IP lawyer should be able to offer you a free initial opinion. For more on trademarks, please read further on in this chapter.

Maker's mark

Before we go on, let's discuss the important matter of the maker's mark. Artists, designers and craftspeople have always marked their work with a signature, monogram or symbol, whether with a paintbrush, pen, pencil, stitch, ceramic transfer, engraving tool, punch or stamp. Film-makers' names are usually included in the credits at the beginning and end of a film, while present-day commercial creatives often embed metadata into image files or in the form of an 'IP tag', which contains a tiny URL, QR code and watermark logo embedded into a document or image.

Your signature is an asset. If, later in the life of an artwork, an auction house can't tell who made a work, then the artists, printmakers or sculptors concerned won't benefit from resale rights.

Orphan works (new revisions to UK copyright law)

New regulations regarding orphan works (OW) are now law in the UK. The Enterprise and Regulatory Reform Act (2013) decrees that artworks, illustrations, books and photographs which are 'orphaned', i.e. the original creator or copyright holder cannot be found, can now be licensed to others.

This is called Extended Collective Licensing (ECL), which means that an existing or new organisation will be set up, which will offer licences to individuals or businesses upon a commercial and non-commercial basis, for more detail please refer to page 260. This revision directly affects all UK-based creators. The EU Orphan Works Directive (2012), passed by the European Parliament, has similar objectives. American artists and writers have thus far successfully fought off the 'Orphan Works Bill' in the US.

To avoid your digital works being used without your permission, make sure they are identifiable, by embedding your name and meta or IP tags (See Chapter 8, page 168 and Chapter 12, pages 259–260). It's vital that on all art and design works there is a signature, monogram or maker's mark somewhere on the work. All artists and designers should always seek a credit accompanying any reproduced work. It's also advisable to include a statement on any website along the lines of 'All artwork is copyright of the artist and may not be reproduced without permission.'

Maker's mark and hallmarks

All UK jewellers, gold and silversmiths must register at an assay office and purchase a maker's mark in the form of a steel punch (or software for applying marks with a laser). The Assay Office has branches in London, Birmingham, Sheffield, Edinburgh and Mumbai.

A hallmark is a combination of the maker's mark, a metal fineness number and an Assay Office mark. Other optional marks include the traditional fineness symbol, date mark, trademark/logo, Fairtrade mark, special commemorative marks, and the Convention Common Control Mark (CCM). Unless specifically exempted, all gold, silver and platinum articles offered for sale in the UK must be hallmarked.

Growth of the trademark

Artists' and designers' names and their signatures can be trademarks. Damien Hirst has registered a trademark of his name in a vast number of categories. Banksy's name and tag are also registered. If you're a fashion designer, it is fundamental that you trademark your own name, signature or business name (as it appears on the label!). The fashion business ASOS (AS Seen On Screen) has a trademark of their name as a graphic interpretation, whereas the fashion designer Zandra Rhodes has registered her actual signature.

It's worth noting that you can only fully protect a business, company or domain name by registering the business name, signature, logo or image with the Intellectual Property Office via www.gov.uk as a UK trademark. Other national registers in Europe and around the world can provide global protection.

Trademarking has become an essential tool for securing your mark in the commercial marketplace. Your brand or name is not safe unless it is trademarked. Equally many artists, designers and especially micro-enterprise tech start-ups have run into serious problems when they have not undertaken proper legal checks on words, images, shapes and phrases. It can be both financially and commercially disastrous when an original trademark holder makes a challenge, especially if they are a large and powerful organisation. Look up the story about the word 'here' in regard to 'Nokia' and the 'LowdownApp'.

The next battleground in regard to protecting names and phrases on social media may be the hashtag '#'. Please read more on trademarks in Chapter 9.

Domain names and social media

Before setting up all your social media business accounts and buying a domain name e.g., .com, it's a good idea to check that the name is not already a registered company or trademark by consulting www.gov.uk/companieshouse and the government's trademark register at www.gov.uk/ipo. However, the latter is difficult for a novice to use, so try using the free search on www. uktrademarkregistration.com. To be absolutely sure, seek advice from an art and design legal service or an intellectual property lawyer.

The selection of an easy-to-remember social media and web domain name, business name and eye-catching branding are important matters to get right. If you decide to trademark your own name or business name, understanding the following sections is crucial. (Please also view the resources section at the end of this chapter and also Chapter 9 for those based in the US, Brazil, Canada, Australia and mainland Europe.)

Before registering a UK-based business with HMRC, make some checks

When registering as self-employed or as a partnership with HM Revenue and Customs (HMRC), it's worth understanding that they don't check your business name registration with Companies House or the trademark register. It's now a legal requirement for you to check that it is not already being used as a business name, whether locally or elsewhere in the UK, or registered as a limited company.

What's the big deal about using a name already in use?

It would be foolhardy to trade under the same business name as a local or well-established art or design business. It would cause confusion in the marketplace. The other trader may sue you under copyright law for 'passing off' your business as theirs. Remember, the date that you register a business name with HMRC is the date that it is officially in use.

Registering as self-employed with the same business name as a currently registered limited company could similarly be a disaster. A company name is a separate right, though a registered company can sue a sole trader with the same business name if the company has previously registered their name with Companies House even if the sole trader has registered as self-employed with HMRC. The company will have a right to sue if there is any risk of confusion between the recently established business' name and their own. A risk simply not worth taking.

Additional checks must be made against the trademark register www.gov.uk/ipo to determine that your business name is not already registered in exactly the same categories of goods and services as that of another business – for example, don't set up a fashion label with the name 'Gap'!

UK company names registered with Companies House

If you're planning to use your business name as part of the name of a limited company, you should be aware that Companies House also don't make any checks to see if a proposed name is already a registered trademark. It's especially important that you avoid setting up a company with the same name as a currently registered trademark. Trademark owners, if they spot a company

registered with the same name, can within one year after the date of a company registration, via Companies House, request that the company changes their name. Refusal will result in legal action being brought against the new company. Even after that date they still have a right to challenge your use of the name.

Registered trademarks with the UK Intellectual Property Office

Nowadays it's advisable for artists and designers who wish to trade either under their own name or a business name to try to gain registration of the name and any branding, text stylisation or logo associated with it at the earliest possible date.

I have met many commercial creatives, designers and designer-makers who decided to put off protecting their business identity because of the expense. In this world it is far better to struggle to pay for a business or brand name to be protected by a trademark early on, rather than lose your rights to protect and exploit a name. A trademark is king – that's all you have to remember.

If trademark registration fails, which can happen for all kinds of reasons, it's likely you can continue to trade using TM (trademark). Most businesses use TM while waiting for registration to come through, or if the name has been rejected for registration, or if they can't be bothered to register their name. Only when you have registered a trademark can you legally use the ® and then stop using TM.

More about registering a trademark is covered in Chapter 9.

Why do I need a business plan?

'Having a business plan is essential when applying for loans or funding. It's also an invaluable tool for focusing your mind on important issues before plunging in.'

Barclay Price (1945–), author, arts consultant and former Chief Executive of Arts & Business Scotland

It's foolish for anyone to start a business without first learning how their ideas can be turned into a profitable enterprise. Many artists and designers have never written a formal business plan. It's worth considering that without an understanding of the basics of money management, legal matters and marketing, you will falter at some point. Many creatives would actually be financially better off if they were able to analyse and map their progress.

A business plan demonstrates to yourself and to others both market demand and financial viability. Writing a plan will help you understand what you are doing, and it is helpful when seeking advice to have a document summarising your intentions. But if writing a formal plan doesn't appeal to you, then start by sketching a mind map to help you make an action plan.

Starting any type of business is a risk, and it may not succeed. To minimise the chances of failure it is essential to undertake business planning and gain feedback on your proposals.

The first thing when developing any kind of project or venture is to invest in an A1 year planner. This will help you to organise and prioritise tasks.

How to write a business plan

'My father's business expanded more quickly than his working capital. One Christmas Eve, as I was told, certain payments due did not mature, and he found himself unable to pay his men's wages.'

From The Village Carpenter (1937) by Walter Rose (1871–1960)

This quotation underlines the problems that can occur in business. Business planning and regularly reviewing a cash-flow forecast can help raise your awareness of risk. Reflecting on your plans will help you prepare for such difficulties through the devising of a contingency plan. This chapter provides you with a template to help you structure a business plan. Many creative people find it difficult to put things into words. This must be overcome if progress is to be made.

Remember, businesses can focus upon selling a range of products and services, or have a number of income streams from several activities, e.g. commercial design projects, commissions, royalties, licensing rights, teaching, private tuition, residencies, project management, consultancy, etc.

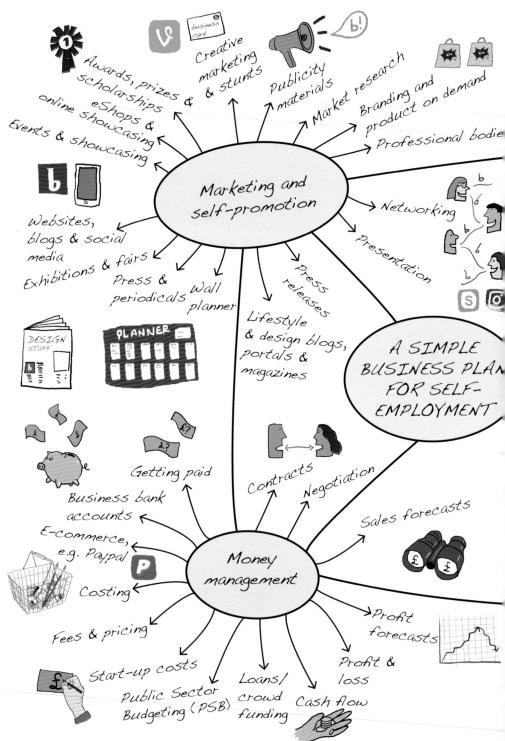

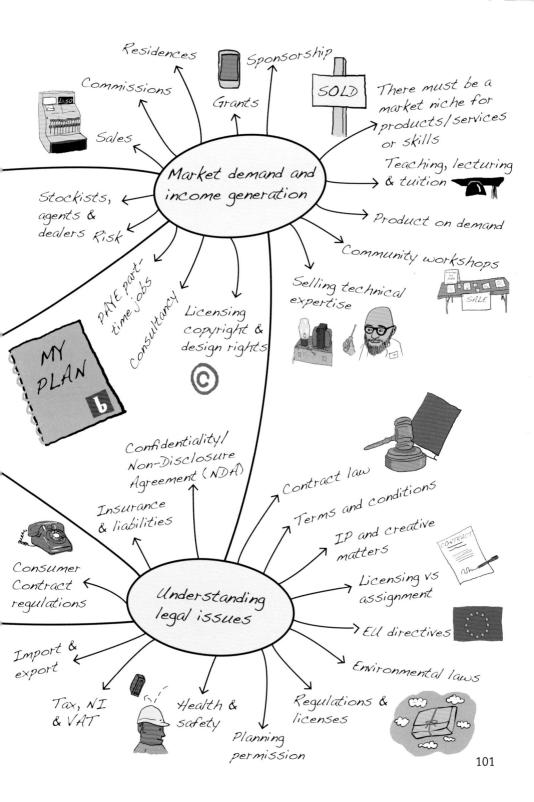

Business plan template for artists and designers

The front cover

The front cover of your business plan should include your name and an image of your work. It should also state:

- Your own name or business name, website, blog, business social media and email address
- Whether you are a sole trader, a partnership or a company
- What you are, e.g. artist, animator, fashion designer, photographer, etc.

Business structure/name/description

The plan should state:

- Your own name or a business name
- Whether you are a sole trader, a partnership or a company
- What you are, e.g. artist, animator, fashion designer, photographer, etc.

Address

Write down your business address, which you either plan to register, or have already registered with HMRC or Companies House. This could be your home, shop, office, studio or workshop.

Summary

Outline the proposed venture, how much finance has to be raised and how you propose to do this. Though this appears as the first heading in the plan, it's actually the last to be written – after the whole plan has been thought through. It's at this point that you should mention any major risks and how they can be minimised.

Aims and objectives

These will depend on what the venture is, but, for example, for self-employment as a 'sole trader' you will need to outline short-term (first few months), medium-term (next few years) and long-term (five to ten years) objectives. Set realistic targets. Many business training courses follow the SMART formula – specific, measurable, achievable, realistic, timed/targeted – when setting goals.

Full description of products and services

List the creative products to be sold and the services provided. Write a simple overview. Avoid too much detail; including photographs, images or embedded links could be useful.

Product and service development plans

Summarise development plans for your business or project. These could include:

- How products will be sold and distributed
- Any plans you have to set up an eCommerce website
- Outlining further skills or training that may be necessary
- Describing any courses that could be completed before the business is set up
- Any planned expansion of the business premises or product range, etc.

People

Write a few sentences about who is involved in the project and what roles they play.

Legal matters and regulations

Outline the key legal matters concerning your business. These could include:

- Health and Safety at Work Act 1974 and revisions
- Terms and conditions
- Contracts, order forms, licensing agreements, etc.
- Copyright and design rights, trademarks, patents
- Fibre-content labelling
- British, European, American or International Standards
- Consumer Contracts regulations (formerly Distance Selling regulations)
- Product and public liability insurances, professional indemnity, etc.

SWOT box

Take stock of your strengths, weaknesses, opportunities and threats (SWOT). (Remember, the person who reads your plan may be unfamiliar with the context of your business idea.) Develop an

action plan showing how you intend to build on strengths and opportunities by combating threats and weaknesses.

PESTLE box

This exercise is designed to help you think at a deeper level about your business in relation to outside influences and trends. Please read Chapter 14 for more detail and an example on page 284.

Timescale

Explain how long the project will take. You may wish to make a plan showing, for example, what will happen, as well as when and where.

Premises

A short description is required of where the business will be located and in what type of venue, e.g. business incubation centre, office, studio, retail unit, pop-up shop, home, etc. You may wish to rent business premises. If so, debate the pros and cons of doing so.

Resources and equipment

Outline the resources and equipment you have, then list what has to be rented, borrowed or purchased.

Market

Provide a brief overview of your industry sector. Include various market segments within the industry, with a particular focus on how they could impact on your business. Be sure to include any new products or other developments that could benefit or damage your business prospects.

Identify the competition. Indicate how your unique selling point (USP) will differentiate you from them. Define who your customers are – there may be several categories: individuals, buyers, audiences, readership, clients, collectors, agencies and other businesses.

Here are a few pointers:

- Location/occupation outlining where customers and clients live or work
- Income how much they are likely to spend as well as their age, gender, lifestyle and interests
- Other creative or non-creative businesses you could supply
- Arts organisations, schools, colleges or local councils that might require your services.

Trends and fashions

Write a few lines about any research supporting your plan, such as information about colours, textures, materials, shapes, technology and innovation. For more on this refer to Chapter 13.

Marketing plan

Describe your marketing and self-promotion strategies. Outline what is special about your enterprise in comparison with others. Include the following, if appropriate:

- Image, styling and brand identity
- Websites, blogs and use of social media
- Business cards and stationery
- Creative marketing and publicity stunts
- Editorial feature coverage and paid advertising
- Databases, mail merge, newsletters (Mailchimp)
- Mail-outs, presentation packs, leaflet drops, posters, etc.
- Private views, product launches, fashion shows and trade fairs
- Networking

Costing and pricing

Outline how costs, fees, quotes, prices and profit margins will be calculated.

Finance

State in the plan how much money you have to invest in the business and where the rest is coming from. Any calculations must show whether borrowing money is required and if so, how it will be paid back.

Other financial information

- Application for grants
- Offers of sponsorship
- Crowdfunding
- Personal survival budget/drawings
- Start-up costs
- Cash flow and profit forecasts for the first year
- Sales forecasts
- Profit and loss forecasts for the first year
- Other sources of income, e.g. part-time job, bank of mum and dad, tax credits, etc.

Confidentiality

If your business plan contains commercially sensitive ideas or other information relating to patents or design-right issues, ask readers to sign a confidentiality agreement or to agree to a secure file transfer service, e.g. Creative Barcode. (Please refer to page 94 earlier on in this chapter and also Chapters 9 and 10.)

For more information about business planning, see the resources at the end of this chapter or pick up a business planning quide from any high-street bank.

Cash flow

As this book is an introduction to business start-up we will only focus on the basics of financial planning, in the form of cash flow. A cash flow forecast is based on a mix of research and guesswork. It's a method of predicting when money is due to flow into your business account and out again.

Cash out

To start with, draft your start-up and ongoing expenses for the year ahead. This can be difficult but you must try. From your research you know roughly what your start-up costs will be. You can estimate on a monthly basis what you'll need to 'draw' from the business to live on. Other 'cash out' expenses such as travel and mobile phone usage can also be entered across the year.

A Beginner's CASH-FL	I-FLOW FORECAST	RECAS	! =											
	Pre Start £/\$/€	April £/\$/€	Mαy £/\$/€	June £/\$/€	July £/\$/€	August £/\$/€	September £/\$/€	October £/\$/€	September October November December $E/S/\mathfrak{E}$ $E/S/\mathfrak{E}$ $E/S/\mathfrak{E}$	December £/\$/€	January £/\$/€	February £/\$/€	March £/\$/€	Total £/\$/€
OPENING CASH BALANCE		(2,030)	(1,940)	(1,750)	(1,160)	230	1,320	1,310	280	1,050	170	(260)	260	1
Sales Workshops Other project work/commissions Owner's capital Bank loan Grant Other	2,500 1,500 500	200	400	400	600 400 1,000	800	200	009	1,400 200 600	400 400 300	1,000	800 400 1,000	600 1,000 1,000	6,500 4,600 4,900 3,100 1,500 500
TOTAL CASH IN	4,500	700	400	800	2,000	1,800	1,200	009	2,200	1,100	1,400	2,200	2,600	21,200
CASH OUT		C	C	C	C	C	C			C	C	C L		
Purchases/materials Premises (rent_rates_light_heat)		00	00	20	00	00	20	300	100	20	200	20	200	1,350
Telephone Insurance Engineers	100	20	20	20	20	20	20	20	20	20	20	20	20	700
Professional bodies/business	1,000	6												1,000
advice Stationery	250	700												200
website, internet & general marketing Softward	1,920													1,920
Sortware Art & design periodicals Other – Other –	2,160	10	10	10	10	10	10	10	10	10	10	10	10	130 2,160
OPERATING EXPENSES SUBTOTAL	6,530	310	110	110	110	110	110	360	160	110	260	110	110	8,800
Equipment & other capital expenditure Loan & financing repayments Owner's drawings			100	100	100	100	1000	100	100	600 100 1,170	100	100	1,170	600 1,100 8,920
TOTAL CASH OUT	6,530	310	210	210	610	710	1,210	1,630	1,430	1,980	1,830	1,380	1,380	19,420
NET CASH FLOW FOR PERIOD	(2,030)	06	190	290	1,390	1,090	(10)	(1,030)	077	(860)	(430)	820	1,220	1,780
CLOSING CASH BALANCE	(2,030)	(1,940)	(2,030) (1,940) (1,750) (1,160)	(1,160)	230	230 1,320	1,310	280	1,050	170	(260)	260	1,780	

Example of a cash flow forecast

A beginner's cash flow forecast, for example, shows that in the first few months she's still in full-time work and is running the business in her spare time. You can see her 'drawings' gradually increase as the year goes by after she switches to part-time work.

Cash in

After drafting a guesstimate of expenses, you'll find that cash flow software will add up the figures and show you monthly and annual running costs. Then turn your attention to income, i.e. 'cash in'. Enter any grants, loans or savings coming into your business account. Consider how much monthly income has to be generated to cover monthly outgoings. Set yourself some targets. This may appear complicated at first, but give it a go!

Why is cash flow important?

All financial plans start with a bit of guesswork. It's then a matter of regularly revisiting your cash flow forecasts – especially in the first two years of trading – making revisions and calculating more accurate forecasts. Failure to master the art of managing cash flow can lead to financial problems similar to those of Walter Rose's father, who found he was unable to pay his suppliers and himself.

Big payments in six months' time are meaningless if you don't have enough cash coming in to keep going. Imagine that money is fuel. You need fuel to keep your business operating; without regular supplies, at some point it will simply conk out. Keeping an eye on your cash flow will help you foresee such problems, giving you time to take preventative steps such as staggering large payments, giving yourself a temporary pay cut, or asking for more money up front.

Cash flow software can be downloaded from the internet for free or provided by an accountant or bank. Before starting your business, I would advise you to attend an introductory workshop on financial planning at a local college or enterprise agency.

Visual arts consultancy

Karl Grupe and Julia Massey-Stewart

Karl Grupe is a Canadian-born, London-based commercial photographer. In the first edition of this book he was a self-employed commercial photographer beginning a new venture called The Mango Lab, in partnership with Julia Massey-Stewart.

Karl shoots editorial, advertising and stock images. His wife Julia is a documentary photographer, producing material for annual reports and advertising.

The Mango Lab specialises in delivering courses in photography, media and visual storytelling. The partnership was formed as they observed sudden changes in the world such as large-scale corporate redundancies, the democratisation of photography and the emergence of powerful competitors providing online microstock services. Karl and Julia reacted to these changes by transitioning from purely producing photographs to forming a visual communications consultancy.

To view more about The Mango Lab's consultancy visit www.themangolab.co.uk. Their five essential tips are:

1. Plan man, plan

Business planning is critical to growth. Plan for the day, week, month, quarter, year, and even three or five years ahead. Trust it as your rudder through the turbulence of business.

2. Embrace maths

Every entrepreneur must come to terms with competition being fast and fierce.
Understanding your web traffic through Google Analytics or examining a graph of your monthly income helps you to adapt and compete. Learning how to create and read metrics can feel overwhelming, but numbers

© Tas Kyprianou, 2015, www.taskypriano

are the truth behind your efforts. Learn to love them

3. Small is beautifully nimble

Enjoy being small. You are finely tuned into every cell of your business body. Self-employed or micro-enterprise, these are your exciting times. Nimble allows you to react and adjust quickly to market movements. Your voice is more personal; you are at your most authentic with your clients.

4. Love your partner

Collaboration creates obvious multiple opportunities, from expense sharing to double income generation. But being in business with a spouse or family member can mean spending more valuable time with them. Consider it a fringe benefit in your journey.

5. Shake some hands

SEO advice can be the snake oil of our time. Certainly there are success stories regarding the rapid growth of popular blogs and social media personalities. However, don't disregard old school business etiquette. Be proactive: attend events outside your industry to stir the pot, give talks, create a push. Forget about the 'like' 1 button for a day and instead take someone out for lunch, get out there and shake some hands.

RESOURCES

Please note the organisations and websites listed in previous chapters. For more industry information contact your professional body. Many art and design associations offer publications and workshops that are available to non-members. See the useful organisations section at the end of this book.

Lawyers for your business

A scheme to give businesses a free half-hour with a solicitor, www.lawsociety.org.uk

Hallmarking

Birmingham Assay Office,
https://theassayoffice.co.uk/
Sheffield Assay Office,
www.assayoffice.co.uk/
Edinburgh Assay Office,
www.edinburghassayoffice.co.uk
London Assay Office, www.thegoldsmiths.co.uk/
welcome-to-the-assay-office/
British Hallmarking Council,
www.gov.uk/government/organisations/britishhallmarking-council
The Goldsmith's Company,
www.thegoldsmiths.co.uk

UK guidance on business and company names

https://www.gov.uk/choose-company-name

Orphan works

PLUS Registry, www.plusregistry.org (registering ensures a persistent link to your contact information and online images)
Creative Barcode, www.creativebarcode.com (online IP tagging service)

Trademarks

Intellectual Property Office, www.gov.uk/ipo (free trademark search but complicated)
UK Trademark Registration, www.
uktrademarkregistration.com (free trademark search engine)

Business name search

National Business Register, www.start.biz (no free trademark search option)

Advice

For free business events, visit www.bstartup.com, www.greatbritishbusinessshow.co.uk

Sources of professional advice

Federation of Small Businesses, www.fsb.org.uk (membership organisation providing legal and tax advice)

British Library, www.bl.uk (most towns and cities have a local or regional business library; contact your local authority for details)

Template Non-Disclosure Agreements https://www.gov.uk/government/publications/non-disclosure-agreements

Chartered Institute of Marketing, www.cim.co.uk Chartered Institute of Public Relations, www.cipr.co.uk

Institute of Practitioners in Advertising, www.ipa.co.uk (for agencies only, not individuals) Institute of Consulting, www.iconsulting.org.uk National Federation of Artists' Studio Providers, www.nfasp.org.uk

Royal Institute of Chartered Surveyors, www.rics.org/uk (provides useful information online about taking on commercial property)

Books

earlier chapters and at the end of Chapter 9
Mind Map Book, Tony Buzan and Barry Buzan
(Essex: BBC Active)
The Photographers at Work: Essential Business
and Production Skills for Photographers in
Editorial, Design, and Advertising, Martin Evening
(San Francisco: New Riders/Peachpit)
Intellectual Property Law (Law Masters Series),
Tina Hart, Linda Fazzini and Simon Clark

(Hampshire: Palgrave Macmillan)

Please also refer to the books recommended in

Building networks

'If I myself and several friends didn't starve to death in London, it was thanks to Daubigny.'

Claude Monet (1840-1926), artist

This is Monet's acknowledgement of the help that artist Charles-François Daubigny gave him, for it was Daubigny who helpfully introduced Monet and Pissarro to the art dealer Paul Durand-Ruel, thus rescuing them from destitution.

Networking isn't the modern activity we think it is. It's vital for emerging artists and designers to step out of their comfort zone; for example, if you're currently a second or even third-year student, I would urge you to make contact with local artists, designers, other creative businesses and more established figures within the arts. The earlier relationships are formed within your industry, the better. As interdisciplinary graphic designer Vince Frost says in the third principle of *Design Your Life*, 'stretching yourself beyond your comfort zone will grow your mind.'

The artist-entrepreneur Damien Hirst spent several years single-mindedly going to London parties and private views. Of course, this approach to profile-raising may not suit everyone, but there's a lot of truth in the art director Paul Arden's assertion that 'It's not what you know, it's who you know.' I've had students walk out of my lectures in the past, believing that it's their creative talent alone that will bring them fame and fortune. It isn't. Success is achieved by meeting the right people at the right time, and being championed by particular people of influence. Your own talent and ability are only part of the equation.

This chapter covers how to start making paper business plans a reality, by actually going out and meeting potential collectors, clients and customers.

The importance of networking

'Eighty percent of success is turning up.'
Woody Allen (1935–), comedian, actor, writer, film director

After the degree shows have been taken down, it can be an extremely strange time for students. What will you do next? Do you:

- stay in the city where you trained?
- return home?
- go to live in London, New York, Paris or another major international city?
- try to find work?

Most people who study in a major cultural centre like London usually stay there. It's often said that over fifty per cent of all UK artists and designers live in London or the south-east of England. In a recent Creative Industries Report by Lara Togni (GLA Economics, October 2015) over fifty per cent of the creative businesses and employees in a majority of the sectors are based in London.

It's difficult to move to a new town or city, especially if you don't know anyone based there. It's easy to become isolated without friends or contacts. This is why it's vital to maintain relationships with your current friends. If you're taking the bold step of moving to a new town, then make new friends by attending evening courses, or joining local business or art clubs.

Networking

Wherever you decide to live, the capital city can't be ignored. With the advancement of email, Skype and social media it's possible to maintain and develop relationships with people from around the world without much effort. However, the virtual world will never replace the benefits to be gained in the physical one.

There are relatively few occasions when the opportunity arises to meet established artists and designers. There may be only an odd moment to catch a potential contact's attention. Therefore, be prepared before visiting any fair, expo, event, private view or conference.

SOME TIPS

Don't...

- ignore people at any social, educational or business function. Try to pluck up the courage to start and sustain a conversation.
- fiddle about with your mobile phone; turn it off.
- get drunk at your degree show or other business networking opportunities.
- turn up drunk, either.
- bring acquaintances to prestigious events. They may become a distraction.
- cling to walls hoping people will make their way to you.
- stuff your business cards in purses or wallets. Dog-eared cards will do you no favours.
- waffle on and on about yourself.
- hog people for ages and ages.

Do...

- make an attempt during and after graduation to attend events.
- go to events and meet new people regularly.
- get your hair done, brush your teeth and take mints to keep your breath fresh.
- smile and ask people about themselves.
- have business cards, in a metal or plastic card holder.
- have images of artwork and products stored in your smartphone, iPad or tablet, or in a pocket-sized A5 portfolio in your baa.
- move on tactfully from one person or group to another.
- write notes on people's business cards as an aide-memoire.
- chase up important offers with a phone call or email.
- follow new contacts on social media, or make LinkedIn or friend requests.
- if someone expresses the desire to see more of your work, phone them up after a day or so to arrange an appointment or see if they would like a PDF portfolio or to look at your website. You may have the opportunity to invite them to your forthcoming exhibition or studio event. But avoid phoning on Monday mornings and Friday afternoons.

How to navigate networks

'He didn't get in with the right people. He missed the wave.' Billy Childish (Steven Hamper; 1959–), artist (Stuckist)

These are Billy Childish's comments about his brother Nick Hamper's lack of attention from the art world. Childish has achieved worldwide notoriety, though he never acquired any qualifications in art. In contrast, his brother studied for many years at both the Slade and the Royal College of Art.

Unfortunately, this is a huge problem in the art and design world. I've met many artists and designers who are brilliant, yet who struggle to survive financially. It often isn't made clear at college or university how important it is to connect with others, in particular to join or start an influential movement or collective, as Childish did.

If you honestly believe your creative artwork and products are just as good as those getting all the attention, then remember there's a lot of luck and perseverance involved. When developing any arts practice or creative business you should try to obtain constructive criticism about your work from those more established than yourself. No artist or designer became successful without listening to others and adapting their work in relation to feedback. Though it is equally fair to say no one should be overly reliant on social media to seek a sense of direction, have the confidence to find your own voice.

Other barriers to progress may be the failure to gain a lucky break, or not having the confidence to knock on doors.

Engage with others

I have recently noticed a dramatic deterioration in the art of conversation. For instance, when creatives arrive for conferences or workshops, it has become normal not to speak or say 'hello' to the person next to them. Delegates and students just sitting there in silence or gazing at smart phones. No fresh relationships can be formed by behaving in this way. It's vital to engage in a bit of a chat and interact with others.

This recent phenomenon might have something to do with the growth of communication by email, texting and social media. Working alone as they do, artists and designers can become used to being silent. It's worth remembering that quiet people tend not to get very far in the arts or business worlds. It is essential to be responsive in real-time social situations, to engage and build rapport with others: talk to people in the queue at your local art shop, anywhere, everywhere.

The psychologist Richard Wiseman, in his books *The Luck Factor*, *Did You Spot the Gorilla?* and *59 Seconds: Think a Little, Change a Lot*, has proved that being more relaxed and willing to engage people in conversation improves your chances of success.

If you don't know what to say to people, you need to go out and do things, read more about your industry and what interests you, so that you can bring up subjects or experiences which you can chat about.

I once witnessed a fashion student trying to find out something on Google using her mobile phone, while sitting in the middle of a fashion department with numerous fashion tutors milling around. Not once did she think of actually asking any of the staff some questions. I couldn't believe what I was seeing! In the end I encouraged the student to engage with one of the fashion tutors; he promptly gave her a whole pack of notes on the subject, which were left over from an earlier lecture. Try to engage with people – you never know what will come of it.

How to connect

When I came to London it took me a while to realise that I wasn't going to succeed in gaining stable representation from a gallery, so I began to approach hundreds of organisations and enter competitions. What I didn't know at the time was that my presentation wasn't good enough. In spite of this, though, I would say that from a hundred cold calls, I received three positive responses, which generated a couple of thousand pounds in work and sales. However, what I really needed were introductions to industry contacts, but the problem at the time was that I didn't know who they were.

Now it is much easier to find potential clients and contacts by looking at the 'about us' section on business' or organisation's websites, useful networks such as LinkedIn and professional bodies.

Getting it right with email

- It's essential these days to have a professional email account.
- If you don't have an email account, with your broadband supplier – say, Virgin Media or BT Internet – then sign up with Gmail, but it is better that you use your broadband supplier's email package, as this is more secure and emails can be more safely stored.
- Free email accounts like Hotmail, Windows Live Mail, Yahoo and Gmail are useful but they can be unreliable, especially if you don't empty the inbox regularly. Email messages from potentially important contacts or clients can be lost due to full inboxes or rejected emails. The sender will often not have time to chase up bounced emails. Many businesses and universities actually have a block on web-based email accounts, so if you are seeking work experience or your first contract, it's likely that your email will never even have been received, never mind looked at.

- Join useful organisations and information services. Most now communicate with members or subscribers through a blog, newsletter or social media.
- If you're an Apple Mac user (post-2012), invest in an iCloud email address.
- Avoid writing emails in 'lighthearted' fonts, such as Comic Sans, or with the 'caps lock' button on, and make sure emails are spell-checked.
- Compose and design a professional signature and insert it into all outgoing emails. Include your address, postcode, telephone number, website, blog, or other web presences and links to business social media, e.g. your Twitter or Instagram feed.
- If potential clients ask for a PDF portfolio, then email them a PDF.
 Avoid emailing a jumble of untitled JPEGs, TIFFs and GIFs at all costs.
- Add a well-designed signature to your email template, with a link to your website or blog.

A common error

I have encountered a great deal of stubbornness from artists and designers about giving up free internet webmail accounts. Believe me, they do you no favours. This kind of solely web-based communication, printed on business cards with a mobile telephone number as the only contact number, give the impression of transience. Hotmail-type addresses are OK for private use. However, such email addresses don't build trust or convey a professional image. It's important when moving to the business realm to take yourself seriously and create a professional-looking email, website or blog and social media address. For more on this subject please visit Chapter 12.

Does this look like the business card of a professional artist?

Your networks are developing now

The creative networks mind map (see pages 122–123) shows how art schools, professional bodies, art and design periodicals or portals, shops, galleries, studios, clubs and agents are interrelated.

If you are at art college, your tutors will know influential people in the art and commercial worlds, such as art dealers, directors and critics. Try not to fall out with any of your lecturers or technicians (especially technicians!), as word of mouth is the most likely method of securing opportunities.

Identify key players

Undertake research in your field. Find out who the agents, agencies, dealers, art directors, buyers, critics, journalists and

stylists are and how to make contact with them. If you don't know who they are, how can you make progress?

It can be useful to gain work experience by being an assistant to established artists and designers in their studios, fashion houses or companies. As mentioned earlier, avoid being taken advantage of. What you have to do is find ways of courting interest from people who could help your career or give exposure to your products.

Get yourself invited

Try to get yourself on as many directories, Facebook groups, eNewsfeeds and mailing lists as you can. If you're not on the invitation list, then it's worth trying to gatecrash events. This may not work for ticketed events or for venues that are security-conscious. However, sometimes you have to take a risk and blag your way in!

Get an introduction

Try to get an introduction either at actual events or through an email sent by a colleague, tutor or friend. It's easier to get on people's radar if you are endorsed by someone they know well or respect. Even a social media introduction can help. We will be covering more about this topic in Chapters 10 and 12.

Pubs and private clubs

One must not underestimate the power of socialising with people, wherever this may be. Private clubs such as the Groucho, the Hospital, the ICA, the Dover Arts Club and the Chelsea Arts Club in London are where many opportunities are found. These organisations can be very expensive and difficult to join, but it can be worth it if you can manage it. Around the world there are cafés, bars and pubs which are particularly frequented by artists and designers, and these can be another way of meeting like-minded people.

Professional associations or bodies

Sometimes it's a matter of what you can do for a membership body more than what it can do for you. Many students are disappointed when they join a professional body, as they may have an unrealistic view of its purpose. Associations can be expensive and will not solve all of your problems or act as a magic gateway to success. They exist to support creative businesses and practitioners.

Make the best use of the organisation's website. Often as part of your membership you will receive a directory listing or portfolio page. Professional bodies like the Association of Illustrators or the Association of Photographers have email news alerts, blogs, newsletters, guidance on legal matters, training, workshops, social media links on profiles, opportunities and sponsor competitions. Virtually every professional arts body is a not-forprofit affair, so they often rely on membership fees, sales of guides, selling tickets to workshops, and grants.

It's also good to consider the benefits of belonging and contributing to a body with a brilliant network of members. Perhaps put yourself up for election to the board of trustees, or offer to run a workshop, or submit a short article to the group's blog, eNewsfeed or magazine.

Presently you're not obliged in the UK visual arts sector to be a member of an organisation if you don't wish to be. However, I thoroughly recommend joining at least one professional organisation that represents your discipline or area of trade, at least during the early years after graduation. Being a member is an important step in creating networks. For more information, see the list of professional bodies, many with overseas membership, in the useful organisations section at the end of this book.

If you are currently a student, check with your tutors to see if your college is a member of a key professional body; you may have access to some resources for free!

Private views and networking events

Talking to people at events can be difficult, especially if you're alone and don't know anybody. If possible, go to events with a friend. If unaccompanied, it's really a matter of practice to overcome nerves and engage people in conversation. A good time to approach others is when they're looking at a painting or

The Essential Guide to Business for Artists and Designers

A Freelancer Club open-top bus networking event in London

product. Simply ask the viewer what they think, or just make an interesting observation and they will respond.

Business networking

Moving from networking in the art and design sphere to general business networking is like entering a totally different world. In socialising with peers everyone is visually literate, as a rule, and will understand the language, concepts and reference points in contemporary art and design practice. In business, this will not be the case.

It's worth considering that many future clients, customers and collectors will be entrepreneurs, small businesses or corporate firms. Some may be local; others will be based elsewhere in the country or world. Many, but not all of these people, won't respond well to technical design jargon, or dense artistic philosophy or theory. Find a way of speaking about your creative products and services intelligently, without alienating customers by talking over their heads.

Every artist and designer needs the business community. Joining local or regional enterprise networks can be an excellent way to make connections with other businesses.

Expos, workshops and conferences

When you go to such events, whether for a day or several days, it can be an exhausting experience. So make sure your energy levels are high before taking part. If you can't attend in person, for a reasonable fee you might be able to have business flyers included in delegate packs or inserted into guides.

I know a very successful design entrepreneur in London who has built his list of clients and suppliers from visiting, speaking at, advertising and exhibiting his creative products at conferences.

Awards

Winning prizes can attract exciting new opportunities and progress your career. However, prestigious and high-profile awards can be very costly to enter. If you've taken part in student awards, have won or been a runner-up, then carry on with this strategy after graduation. Build on this success. Try not to be put off from entering competitions because the entry fees are expensive.

Entering competitions or prizes isn't for everyone, but it can be worth it. To gain attention from potential commissioners or simply to raise your profile you have to take a punt and enter industry awards. To find out more about awards, read your periodicals, check with your professional body and consult the resources listed in this book.

Magazines

It's essential to subscribe to or borrow several art and design periodicals every month. I would highly recommend, even if you are a student, that you make time to read a number of art and design periodicals, view reputable online blogs or creative/cultural news portals.

Art school libraries usually subscribe to a number of magazines and journals. Periodical and industry websites are trustworthy sources of information, trends, opportunities and industry developments.

Many artists and designers promote themselves to potential new clients by gaining exposure in editorial features – for example, by winning awards, gaining prestigious commissions or launching new products. To find out more about getting free media exposure see the next chapter, on self-promotion.

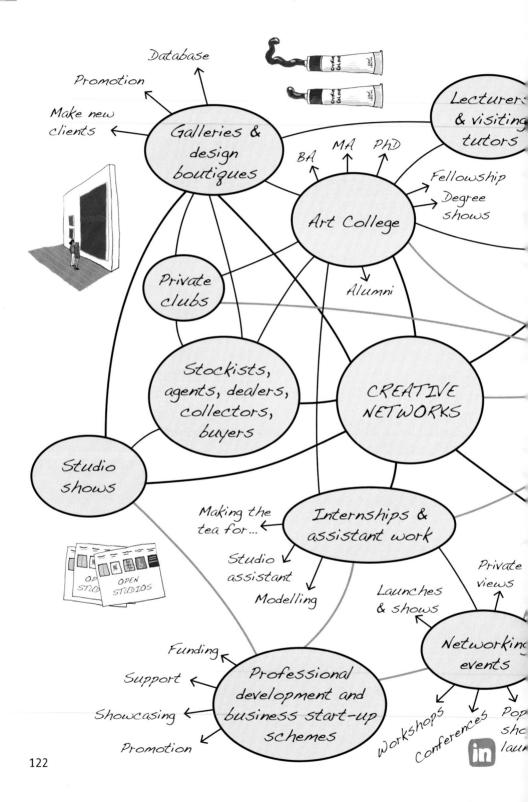

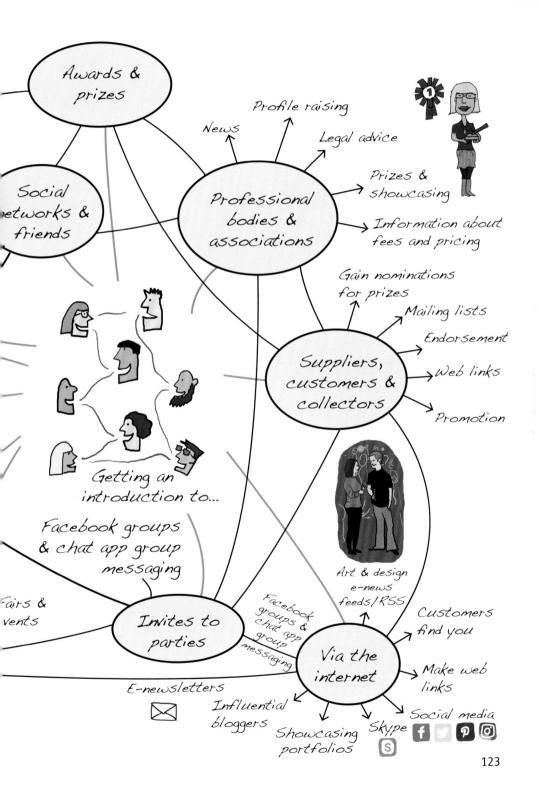

Virtual networking and showcasing

'The threads of connections run everywhere and to unexpected places.'

Susan Griffin (1943-), essayist and screenwriter

Using social media to network or showcase artwork and products is essential. Speak to any artist or designer over the age of thirty-eight about how life was pre-Photoshop, pre-home printers, predigital, pre-scanner, pre-web, pre-email and pre-social media! To gain any kind of exhibition or opportunity you had to have expensive duplicate 35mm slides made of your work, a carefully typed CV, a statement, price list and covering letter, all weighed at the post office, with an enclosed stamped addressed envelope, so that by law businesses and organisations were obliged to return your precious materials and slides. Such was the expense of it all that artists and designers could only afford to do so much per month.

The twenty-first-century artist or designer who now seeks attention from a gallery, buyer or client simply has to include a web link to a showcasing website, or tweet, message or email a PDF portfolio, and that's it. Click Flickr, click Behance, click Coroflot, or click ArtFinder to be viewed instantly by anyone in the world. This is a completely different experience from the use of slides and catalogues twenty years ago. It's vital for any older artists and designers who still do not fully engage with the web to get their heads out of the sand and learn about social media and digital technology.

For those who had taken many years out to look after children or elderly relatives and wish to relaunch their design business or arts practice, then it's vital to catch up with contemporary presentation styles.

Please read more on social media in Chapter 12.

Communication

It's important to develop a presence both in print and online, combining different methods of communicating such as making calls, visiting clients and sending marketing materials through the post.

Try not to rely too much on social media or sending unsolicited emails alone. Many agents, dealers, art directors, critics and journalists are snowed under with emails, and often get so busy they will only click on emails they are expecting or those from colleagues or regular clients. They can't cope with the number of emails they receive, so persisting with this approach will only annoy them.

If you still decide to target people by email, phone them up first, to check they would like to receive your images, a PDF portfolio or a direct link to your online gallery, collection or portfolio. Make sure JPEG images are low-res, load quickly, and feature in the body of a very brief email, thus making an immediate impact on the viewer. Always check the agency, business or dealer's website to see if phoning in is OK – sometimes they only accept enquiries by email. If approaching by phone is acceptable, you will find many deskbound respondents are actually quite relieved when the phone rings, as it gets them away from their computers for a few minutes.

Many creatives these days rely far too much on social media, which may not be the instant solution they expect it to be. It is worth considering that social media might not be the right channel for your target market. Go on, pick up the phone and talk to a potential client or contact for a change.

Develop a self-critical eye

A hot topic often debated in the art and design media is the matter of editorial skills. The reason why I believe editorial skills are declining is, as already mentioned, the fact that twenty years ago the preparation of slides to gain opportunities was extremely expensive. Artists and designers had to think long and hard about what to reproduce and why.

Now with the ease and speed of digital technology, creatives are not only able to make and reproduce numerous images at no cost, but they can showcase them instantly online. Speedy uploads, without proper consideration, can make a creative practice or product range appear weak or confused. Being able to make editorial decisions is vital and demands a period of intelligent contemplation and concentration.

The Essential Guide to Business for Artists and Designers

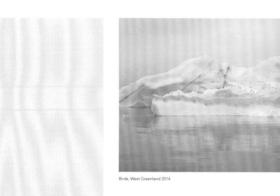

e melt, East Greenland 2014

Edges, East Greenland 201

The opening page of a professional PDF portfolio

Ice & Light - The art of icebergs

Riikka Puustinen (MA, FRGS) photographs icebergs in Greenlandic wilderness. She cultivates observational skills, environmental awareness and appreciation of nature through photographs and a series of talks. Riikka sees icebergs as raw, remote and endangered sculptural art of nature, which she wishes to communicate to wider audiences through exhibitions and publications. Contact: Riikka Puustinen

Address:

Riikka Puustinen www.greatexperiment.uk

Over the years I've met many illustrators and photographers preparing portfolio submissions. They couldn't decide what to leave out. Equally many artists, designers and photographers are showing far too many images online. Poor editorial decision making can give rise to problems during interviews or when working on creative briefs.

Recently an artist sent me a PDF portfolio with forty-nine images; this is far too many. A two-to-five-page PDF with between three and nine images, a short profile, contact details and website address is sufficient.

A few thoughts

- Think very carefully before putting images online.
- Being selective can make a stronger impact.
- Make sure all images are of a professional standard.
- Check that images relate to one another as a group, body or narrative.
- Just because a piece of work is old, doesn't mean it should be dumped.
- Remember your images will always be new to the viewer.

Free showcasing

There are so many ways to get your work viewed online for free. Some might argue that having your own domain-named website is now unnecessary. However, the vast majority of visual artists would agree it's still necessary to have your own website, as you may wish to use it for a number of purposes such as selling products, blogging and advertising events, as well as protecting your name on the internet.

There are now dozens of social networking websites, and hundreds of showcasing spaces and online galleries. But you need to think about the following:

- Who is looking at these portals and websites?
- Who judges what is included in these online galleries, shops or portfolios?
- Will you sell anything?
- Is it the right place for you?

At the end of this chapter I have listed some key online galleries, agents, social media networks, eShops, eNewsfeeds, showcasing and portfolio portals which are trusted and well-managed.

Try to showcase your images on high-profile and reputable showcasing or agency websites. Avoid spending time profiling yourself and your products on websites that are badly designed or which demonstrate no sense of editorial judgement or quality control.

It is also worth bearing in mind that websites like Flickr, Coroflot, YouTube, Facebook and Twitter may not always be free.

RESOURCES

Global social networking and microblogging websites

If you are a student, before leaving college, or even afterwards, check if there's an alumni network you can join www.facebook.com www.twitter.com (microblog) www.plusgoogle.com (photos, videos, links) www.flickr.com (images) www.pinterest.com www.instagram.com www.bebo.com (TV, media) www.reddit.com (entertainment) www.linkedin.com (professional) There are a huge number of networking sites for the over-fifties; I suggest searching on Google

Arts and design portals and eNewsletters

www.artscouncil.org.uk (arts news and arts jobs)
www.artsadmin.co.uk (arts digest)
www.kweekweek.com
www.artrabbit.com (news)
https://the-dots.co.uk/
www.creativeboom.co.uk (news and magazine)
www.benchpeg.com
www.fashioncapital.co.uk
http://chinwag.com

Online and social networking clubs

http://weareshesays.com/ www.makerhood.com https://thefreelancerclub.co.uk www.youngcreativecouncil.com

Showcasing and web portals

Although the following headings are disciplinespecific, please note that some platforms do cross over into different disciplines.

Remember to contact your local council, arts officer and regional arts council – they usually have some form of art directory service.

Students and graduates

www.the-fine-art-collective.com/ www.degreeart.com www.artsthread.com (for students and graduates)

Art networks and showcasing

www.a-n.co.uk (to find local art networks, search for the 'National Artists' Network', NAN) www.artquest.org.uk (search for 'promotion and networks') www.axisweb.org www.artfinder.com www.rhizome.org www.re-title.com www.riseart.com www.newbloodart.com www.eyestorm.com www.thedigitalartist.com www.theaoi.com (see 'awards' and 'portfolio' sections) www.creativehotlist.com http://altpick.com www.folioplanet.com www.contact-creative.com www.concretehermit.com www.illustrationfriday.com www.theispot.com www.nationalmediamuseum.org.uk www.aidb.com/ http://thecreativefinder.com/ www.thefilmnetwork.co.uk

Film, TV, animation and games showcasing

www.newwebpick.com

http://ffffound.com

https://vine.co/

www.vimeo.com (animation and film)
www.youtube.com (animation and film)
https://shootingpeople.org (film)
www.mandy.com
www.datascope.co.uk
www.gamesindustry.biz
www.edge-online.com
www.develop-online.net
http://thewomensroom.org.uk/ (media directory)

RESOURCES

Design networks and showcasing

www.behance.net www.coroflot.com www.aquent.co.uk www.theloop.com.au www.creativepool.com http://designerscouch.org www.bouf.com https://monogi.co.uk/ www.designdirectory.co.uk www.culturelabel.com https://craftcentral.org.uk www.archiportale.com http://designboom.com www.mad.co.uk www.youngcreators.net www.lookbook.nu www.asos.com www.silkfred.com/ www.designtaxi.com

Applied arts networks and showcasing www.craftscouncil.org.uk/directory www.designnation.co.uk www.craftanddesigncouncil.org.uk www.contemporarybritishsilversmiths.org/http://crafthaus.ninq.com/

www.notonthehighstreet.com www.notjustalabel.com www.etsy.com www.folksy.com www.misi.co.uk www.fab.com www.made.com www.ukhandmade.co.uk www.madebyhandonline.com/

Business networks and associations

www.taforum.org (trade body search) Design Business Association, www.dba.org.uk

Books

How to Win Friends and Influence People, Dale Carnegie (London: Vermilion) (a classic book about networking, still the best ever written) Wannabe, Jamie Kennedy (London: Aurum Press) (a true story of how an actor became his own agent to gain roles)

Online Marketing for your Craft Business, Hilary Pullen (Newton Abbot: David & Charles)

Self-promotion

'I had a tutor who said the new currency of our century isn't money, it's attention. Attention is what changes people's lives.'

Mary Portas (1960-), retail guru and author

Many artists and designers feel uncomfortable about the idea of marketing their work. If this is the case for you, then I would recommend accepting that self-promotion is simply another creative activity.

In this chapter I'm going to give a structured outline of self-presentation and how to plan a basic media campaign. I will identify which promotional materials are required, when and by whom.

Selfpresentation

'Sometimes even I think I don't have anything to wear.'

Dame Vivienne Westwood (1941–), fashion designer

Appearance and presentation are important. People often make up their minds about others in just a few seconds. Much of business in all industry sectors is built on trust. Having a professional email address, ringing clients, arriving at appointments on time and being reasonably well-groomed will increase the likelihood of success even before the first handshake.

A common error

A number of artists and designers suffer from being far too much in the centre of their own universe, often out of sync with the pace of the business world. To participate in it, it's essential to be responsible, to think of others and be able to work as part of a team. It is vital to build up a reputation for being reliable and trustworthy.

Chaotic last-minute cancellations of appointments by email or text with 'sorry I can't make it' are highly unprofessional, and to be avoided at all costs. Social skills and manners are essential in any form of work. It never appears to occur to some, unless a deposit is secured, that a booking is an agreement.

When making arrangements to meet others, you must be aware that other participants, clients or advisers may have turned down last-minute opportunities themselves to see you. It can be especially annoying for others if you only inform them of your sudden unavailability by a cursory text or email. This creates the impression of disorganisation and unreliability. Time is valuable. Wasting other people's time will put them off working with you. It usually contributes to your being quietly dropped.

On arrival

Try to observe the social politeness of being punctual. Never rush or walk into meetings holding a mobile phone; you will appear distracted and self-absorbed. During meetings or when attending talks, never turn your phone on, check messages, start texting or take photographs of the speaker (unless there is permission to do so) during their presentation, as it can be extremely discourteous and off-putting.

Body language

Whether making presentations, meeting clients or being interviewed, it's vital to maintain an upright posture. It is a bad habit to adopt slouched standing or sitting positions. This could be a symptom of spending too much time working on laptops, hunched over workbenches or scrolling on a smartphone. It's possible to relax either seated or standing with a straight back. Confidence is communicated not just by talking, but also by the way you sit, stand and greet people.

Confident and unconfident postures

I recall a confidence workshop with a group of children's illustrators, the majority of whom sat with their feet pushed back under their chairs, the heels pointing outwards, their toes pointing inwards. Their shoulders were hunched and their hands were either clenched together or pushed in between their thighs. This is like the posture of a nervous child. Many other postgraduate artists and designers adopt similar poses, especially during interviews.

Such a posture is submissive and looks strange. If you appear stressed during any form of presentation situation, then the client or interviewer will gradually become uncomfortable. This type of body posture is that of an unconfident person. It won't help you gain an opportunity or aid negotiation.

Voice

Developing a creative business or practice in the visual arts means attending interviews, giving talks and presentations, and pitching for funding or sponsorship. If you suffer from terrible nerves then I would urge you to attend a public speaking course, or listen to the speeches of former US President Barack Obama, whose unhurried delivery lends strength to his words.

A common problem among visual artists is that they speak far too quickly. This is especially the case when they're nervous. This could be due to the fact that they think in images and use more words than are necessary. To maintain this customary speed, they take short, shallow breaths. But it's crucial to slow down, so that the listener can absorb what's being said and respond appropriately. Long bursts of rapid speech make it difficult to develop rapport.

For example, when you ring someone up or meet them, don't just say 'Hello' and immediately launch into introducing yourself. Say 'Hello', and then pause. Let the other person have time to react!

Language

In major UK cities and overseas, English may not be people's first language. In a situation where English is spoken, it can be unclear whether those for whom English is their second or even third language fully grasp what is going on. They may speak English more fluently than they can understand it. Others can understand English better than they speak it. They may be reluctant to admit that they don't understand what is being said, so you need to encourage interaction to check comprehension.

Presentation tips

- Keep your back straight and shoulders down.
- Avoid pointing your toes inwards.
- Place your feet about ten centimetres apart and make sure they are straight, not angled.
- Don't clench your hands, or force them in between your thighs.
- Maintain eye contact with the whole panel or audience.
- Slow down your speech.
- Pause, instead of uttering 'ums' and 'errs'.

Basic publicity materials

'In the future everybody will be famous for fifteen minutes.'

Andy Warhol (Andrew Warhola; 1928–1987), artist

Readers of this book may have to undertake regular promotion for all manner of reasons. Some may wish to raise their profile in the media and increase awareness of their creative products and services. Others may focus time and resources on promoting a handful of events per year, such as hosting stands at fairs, exhibitions, major product launches or performance events.

The trick with self-promotion is not to rush the development of frontline print and online marketing materials. Many artists and designers tend to focus excessively on the creative process and fail to allow enough time for presentation and advertising. The whole approach to marketing a creative business or practice requires a high level of professionalism. For important shows and events it may be worth hiring in PR expertise.

A key feature of your marketing plan is identifying who your audience is, then deciding how to communicate with them. It's easy to make mistakes in promotion. For example, a feature or banner advert in *a-n Magazine* will reach your peers. However, if you're trying to sell products, an approach to the weekend

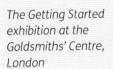

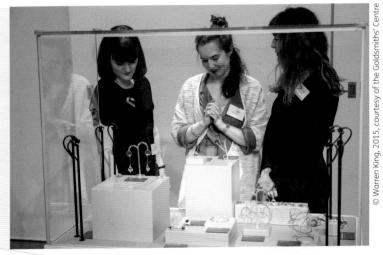

broadsheet supplements – e.g. the Guardian, Telegraph or Sunday Times – will be more appropriate.

The materials included in the following marketing checklist may take months or years to assemble in their entirety. You must prepare yourself fully for any engagement with the media. A lack of preparation can ruin any marketing campaign.

Marketing checklist

Photographs and mini films

- If possible, have them taken by a professional photographer.
 This is especially important for reproduction in catalogues, lookbooks, on business cards or postcards, or in magazines.
- For web-based images it's possible to use your own photographs. However, there is a limit to how much patching up can be done with Photoshop.
- Have a good-quality portrait head and shoulders shot taken.
- Make sure you also have a stunning, intriguing or dramatic photo of yourself or your creative product, artwork, event or service.
- Include photos of yourself in a studio/workshop space, standing next to your creative products, working at the computer, designing, weaving, painting, etc.
- Take a number of well-thought-through photographs of recent or important artworks/designs/products, and have these digitally formatted for both print and web quality.
- Have versions in greyscale for black and white print purposes. Some magazines, such as Art Monthly, still print in black and white. Marketing materials for large events are often printed in monochrome, e.g. just blue or just orange, etc. Even some websites prefer images or photographs in varying tones of one colour.
- Always be selective with photographs.
- Think about scale and sizing in regard to use, e.g. a portrait shot for social media use as icons and avatars.
- Make short mini films for your website or blog to encourage viral marketing and sharing on social media.

One-page curriculum vitae or promotional flyer It's important for artists and designers to have three types of CV: one for employment, one for freelance opportunities, and an edited A4 version for showcasing purposes.

Showcasing CV – a few tips

This type of CV should be used when applying for exhibitions and competitions, and should be available as a downloadable PDF on your website or in your email signature. Infographic CVs are now extremely popular; good places to look for ideas are Behance, Coroflot or Pinterest, or conduct a Google image search, e.g. CV design ideas, CV inspiration, creative CVs.

- Commercial creatives often take a few more risks with their CVs, for example, having them printed on packaging, embroidered on cushions or knitted scarves, illustrated on trainers, made into miniature books, YouTube CV films, etc.
- As well as Behance and Pinterest, take a look in Creative Review – they regularly showcase 'selfpromotional' items made by designers and illustrators.
- Inject a sense of style and design format into a CV. Make sure you have a digital version available as a PDF.
- It's important to remember if you are sending your CV to an agency, they may require it as a simple
 Word document with a plain white background due to their data search systems.

- Please note that for fine artists, printmakers or sculptors approaching more traditional art dealers and galleries, on the whole the convention is not to include images within a CV but attached as separate sheets.
- Include clear contact details your home or studio address and phone numbers. Write a brief profile or statement about your design/ artwork/products or current projects.
- If you're applying for a design job, then a mission statement may be required, but don't include a mission statement on an A4 showcasing CV.
- After any art qualifications, list the awards and prizes you have received, then any exhibitions and commissions.
- List your major achievements in sections, with the most recent first.

- If your products are in high-profile stores and collections, or if you have worked for high-profile businesses, then include stockists, collections or a client list.
- List web presences and your own website and blog if you have one, and your LinkedIn profile address.
- Use strong, sharp, clear thumbnail images. Be selective – three to five images is enough.

- CVs in paper format can be presented in good quality acetate wallets or folders.
- You may wish to include on separate sheets, selected quality colour inkjet prints of two to three artworks/products.
- Alternatively, create a high-quality A6, A5 or A4 profile flyer or leaflet, including portrait photo, profile, micro CV and images of your artwork or products.

Many creative businesses may wish to move away from 'describing the course of life', and develop stylish brochures or flyers instead. Commercial creatives usually have a short biography and a few A4 image sheets/PDF portfolio to send to clients.

Marketing statement

This should be short and sweet, brief and to the point. It sums up (as best you can) what you are doing, why and how, in between twenty-five and a hundred words. Such statements are used for press/media releases, leaflets, brochures, commercial event listings and for gallery desks. Concentrate on the relationships between theme, materials, technique and style.

Artist/design statement

A longer and more refined statement, exploring more academic or philosophical themes, e.g. technical aspects, methods, issues, ideas, etc. It considers 'creative strategies' – that is to say, the relationship between form and content (artists) or form and function (designers).

These statements explain your practice to an audience. Be prepared to change and adapt statements for different opportunities.

Usually an artist's statement runs to between one and three hundred words. It's placed next to your work in a public gallery, library or museum. Professional art and design journalists will require a copy if they're writing in-depth articles for visual arts periodicals or broadsheet newspapers/online features.

Marketing copy

This is required by designer-makers wishing to place their creative products and services in style publications, feature pages, catalogues or online stores. An image of the product accompanies the copy. The product appears as a cut-out with a white or black background, or is placed in a relevant environment such as a gallery, trendy apartment or garden, or is worn by a model.

This commercial copy appears as a mini sales pitch. Style magazines, blogs or portals are about fashion, retail, trends and consumerism. For ideas on how to write copy, look at magazines like Grand Designs, the IKEA catalogue or influential Instagram feeds. See how products similar to your own are presented.

listings, and send

them press releases

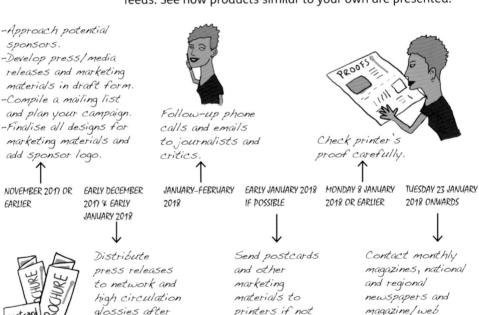

Marketing timeline showing a mini marketing campaign

already done so!

glossies after

journalists first.

contacting

Develop an engaging blurb based on your unique selling point (USP). Summarise what is special about your product. Think about form, how the product/artwork is made, what types of materials are used, its purpose and why customers should buy it – and include any eco benefits!

Websites, blogs and online media

Use websites, blogs, social media and email for making direct links to press releases, CV, images, gallery, info, stockists, profile or biog, blogs, selling, etc. To read more on this subject please turn to Chapter 12.

Getting free press

Kathleen Hills, who is profiled in this book (see page 170), has never spent a penny on advertising. She's managed to gain media exposure by contacting magazine editors, stylists and web portals directly. Many magazines, e-zines and popular bloggers are always eager for news and content as 'features' or 'editorial' material.

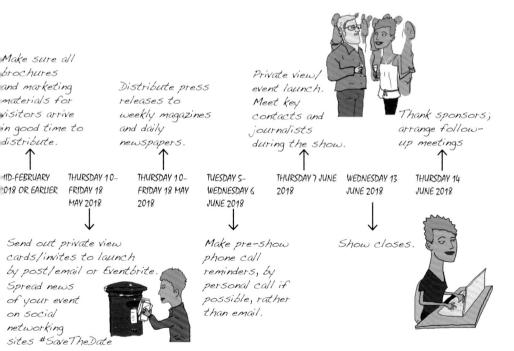

Always check copy and print deadlines.

Press/media releases

To gain free press, a media release must convey news. The table on page 142 includes regular feature-page themes covered by style and interior design magazines. Think about which categories fit your creative products. For instance, one month your product may be included in a magazine as part of a 'living space' feature, then the next as part of a 'gifts under £50' piece, and on another occasion simply because it's yellow and fits in with a colour scheme.

Press releases aren't really necessary to gain the odd spot in a magazine 'wish list'. If you're a newcomer to gaining press, then in the early days, before relationships are made with stylists and journalists, it may be wise to issue a release featuring your product as news – giving a specific angle, e.g. product launch, award-winning, new graduate – in order to attract attention.

You do require releases for fairs, exhibitions, workshops, shows, publicity stunts and product or business launches. Local newspapers will feature interesting stories for free, but they will also need good-quality images sent by email that they can reproduce in their paper or on their online portal.

Please note, the table on page 142 is not an exhaustive study of the entire output of lifestyle and consumer magazines, but simply a guide to help you think about how your creative products and services could fit into different editorial themes.

Be careful about copyright issues with regard to photographs. Make sure you own the copyright to any photos (i.e. you took them yourself) or, if they are someone else's work, that you have been assigned the copyright, they are 'rights cleared' or that you have the photographer's permission to use them. Always remember to credit the photographer.

Press releases should be short and punchy, explaining what, where and when. Include contact telephone numbers, appropriate social media and email details. Make sure an informed person will always be available to answer any calls.

Convert media releases into PDFs and have a press page on your website where journalists can download images and other content.

To see examples of press releases online, simply visit established artists' and designers' websites, Google 'press release', or #pressrelease #mediarelease #savethedate on Twitter with the name of a particular event. Observe how others construct their releases and make them stand out. Your press release needs to capture the attention of a busy blogger, journalist or editor. Spending time experimenting with making the content and layout more interesting will pay off in the long term.

Remember, as mentioned in Chapter 1, you must distribute notices and announcements in good time, as many magazines have very early editorial and advertising deadlines.

Invest in media guides and plan well ahead

For any UK arts or design marketing campaign I would always recommend purchasing a recent edition of the *Arts Press Directory* published by Arts Media Contacts. This is now available as part of a subscription package which can be a worthwhile investment, as their services deal with every aspect of issuing press releases, including named contacts and copy deadlines, thereby saving you a great deal of time and energy. For those with no budget, take a look at The Design Trust, the London Art Map, Artquest and Enterprise Nation websites.

The marketing timeline on pages 138–139 demonstrates that planning a marketing campaign requires the coordination and production of numerous marketing materials. Remember, the earlier you start the better. Make your own timeline for your next show by drawing a line with key deadlines and tasks on a long piece of paper, such as inexpensive wallpaper lining. Then transfer these dates for sending releases and other activities onto a wall planner or personal computer.

Feature Pages	Object Themes	Key Themes	Space	New	Тор	Bargain	Festive/Seasonal
Editorial	Size,	Innovation,	Storage solutions,	Galleries,	Best Pick,	Restoration,	Spring clean,
News,	Big, small.	#Apps,	Space savers,	Agencies,	Star buys,	Reclaim, Recycle,	Fresh look,
Letters,	Materials, glass,	Technology, CAD	Boxes, shelves,	Boutiques,	#Best voted,	Up-cycle,	New range,
Opinion,	wood, textile,	& Coding	Cupboards,	Online shops,	Best Web Picks,	Solves a	Next season,
Back page,	paper, etc.	3D Printing	Garden office, etc.	Portfolio sites	Top Free Apps.	problem, #Free	Just out, etc.
The Wish List, Objects of desire, The It List, What We Like	Hobbies, How to make, Learn to Home baking, Creative time, Craft kits, etc.	Green products, #Eco #Ecology, Ergonomics, Sustainability Save energy. Ethics, etc.	Design features on public space, Urban planning, Community. Home/domestic, Work, office, etc.	Degree shows, Graduates Ones to watch, Rising stars, Emerging	#Trending Awards, Short list, Nominated, Best Campaigns, Top Brands, etc.	Second hand, (Pre-loved) Auctions, Bargain Hunt, Money savers, Good value, etc.	Party Season, What to wear, Our top tips, #Gifts, #Presents, #Idealgift.
Interviews,	Vintage, Retro,	Fashion, style,	Rooms,	What's hot?	100 Power List	Gifts under	Festivals
Spot feature,	Classic,	vintage, retro,	Lounge,	New trends,	Next Generation	£100, £50,	Major Cultural
Comment, etc.	Contemporary.	classic, etc.	Bedroom, etc.	Trend Forecast	Best Gift Shops	£30, £10, etc.	Events/Art/Design
Articles,	Shape, form,	Reader, Exclusives, Recommends, Suggestions, Chance to Win.	Outdoors,	Product or	Top Design	Opening or	Valentines Day,
News,	Function,		Indoors,	Collection	companies,	Launch offer,	Mothers' Day
Columns,	Round,		Open space,	Launch,	Stylists,	Stunts, e.g.	Fathers' Day,
Feature spreads,	Square,		Upstairs,	First show,	Designers,	RCA Postcard	Birthdays,
Stockists, etc.	Pyramid, etc.		Downstairs, etc.	New Projects.	Websites, etc.	Exhibition, etc.	Special Events.
Profiles ,	Lightweight,	#Health	Conversions, Architecture, Extensions, Re-Vamps, Interior makeovers.	Markets,	Top 50 Design	Special offers to	Anniversaries
#Artists,	Smooth,	Beauty,		Boutiques,	Agencies,	Subscribers,	e.g. Jubilee,
#Makers,	Texture,	Spa treatments,		Pop-up shops,	Top 50 fashion	Customers,	Births/Deaths,
#Photographers,	Pattern,	Cosmetics,		Agencies,	Blogs,	Extras, e.g. free	Weddings,
#Designers, etc.	Transparent, etc.	Glamour, etc.		Galleries, etc.	#Winner	patterns,	WW1, WW2, etc.
Up & coming Fairs, Exhibitions, Events. Competitions.	Colour, Shades, Tones, Hues, Palette, etc.	Mood, Light, dark, rich, cool, warm, hot, tropical, calm, exciting, etc.	Gardens Garden gadgets, Ornament, Allotments, Grow Your Own.	Celebrity, Critic/Journalist, Blogger, Reviews & endorsements	Top tips, Top 10, Top 50, Top 100, Our fab 5.	Sales, Discounts 20% off, Voucher Codes, Barter, Swops!	Summer themes, travel, beach, holiday, sun, fun, relaxation, children's activities, etc.
Accessorises Millinery, Jewellery, Footwear, etc.	Chairs, Lamps, Cushions, Rugs, etc.	Auctions, Art Market, Overseas Fairs, Shows, etc.	Public Art, Architectural, Commissions, Urban/Guerrilla Art	Latest gossip, What's on? Go See! Click to win	Top Brand, Best Voted, Our Favourites, Endorsements.	Make your own, Mend or modify, Salvage & DIY, etc.	Cultural and religious festivals -Halloween, Christmas, Easter, Ramadan, etc.

Examples of magazine themes covered by print and online design periodicals, lifestyle blogs and magazines

When planning a media campaign it's wise to plan well in advance

If your show opens on Thursday 7 June 2018 you may wish to gain coverage in the monthly lifestyle glossies, industry magazines and other media in May and June 2018. In most large-scale events, such as your degree show and major trade shows, a great deal of marketing is done to promote the event by the organisation's marketing department. However, they may not select your artwork, creative products or services to feature in the campaign. It's likely you will have to approach the media directly to gain coverage of your stand or display space.

If you're marketing your own show, either individually or as part of a team, you have to be prepared to start as early as possible. The secret to success is to plan what you are doing thoroughly from the outset.

It can be wise to start before Christmas for events opening the following spring or summer. If you seek to gain coverage in the large-circulation glossies, e.g. *Vogue* and *Elle Decoration*, they work four to five months ahead. Other major monthlies, such as the *World of Interiors*, work three to five months ahead. Even many guides distributed weekly with national newspapers, such as the *Guardian Guide*, may work three to four months in advance.

You could still gain coverage on the web, in smaller-circulation industry periodicals, and in weekly, regional and local press if you started a campaign in mid-February 2018 for May 2018 coverage.

It's also vital to consider how you will communicate with potential visitors or guests to your event or show. I personally think it is still worth the effort to post items such as private view invitations, though this is now increasingly done via email, Eventbrite or social media, mainly due to the huge cost of postage. Making the effort to phone as many people as you can leading up to your launch or private view can pay dividends.

As you can see from the marketing timeline on pages 138–139, roughing out your timeline on a long piece of paper can help you organise a more refined schedule and marketing plan.

Cockpit Arts, open studio event in Holborn, London

Key art and design fairs

The following table shows the key art and design fairs in the UK and around the globe. There are many other fairs hosted throughout Britain and overseas. To find out more information about up-and-coming events see the resources listed earlier and in the useful organisations section at the end of the book.

It's always advisable, for market research purposes, to visit open studios, trade and retail fairs. If you wish to exhibit at a fair or festival it's wise to visit in the season or year before you wish to exhibit, to check that it's the right fair for you to take part in.

Business cards and postcards

- Make sure business cards and postcards are well-designed, using text, graphics or a high-quality image.
- Consider the dimensions: in the UK after cutting cards are 5.5cm x 8.5cm, whereas in the US they are often slimmer and wider at 5cm x 9cm.
- Have at least one postcard made of your work, and always have postcards made of award-winning artwork or products.
- Standardise your design format for all marketing materials including stationery, invoices, brochures, order forms, CV, blog, social media banners and website.

- For small runs of handmade gilded or embossed heavyweight paper cards, try contacting a local wedding invitations supplier, or specialist art printer.
- When reproducing images on business cards and postcards for shows, fairs or mail-outs, always use a professional printer.
- Include your website, address, phone numbers, Skype and professional social media details such as Twitter, Instagram and LinkedIn

For more about business cards, please refer to Chapter 6 (page 117) and Chapter 12 (page 256).

Key art and design fairs

	,	3. 1		
Name of Event	Location	Sector	When	Website
SPRING				
Affordable Art Fair	London/Global	Art, prints, sculpture and photography	March	www.affordableartfair.co.uk
Ideal Home Show	London	Interiors, gifts and furnishings	March	www.idealhomeshow.co.uk
The Knitting and Stiching Show	Birmingham/ London	Wool, yarns & creative crafts	March	www. theknittingandstitchingshow. com
Country Living Magazine Spring Fair	London	Design, applied arts and traditional crafts	March	www.countrylivingfair.com
Milan Design Week	Italy	International Art and Design Festival	April	www.milandesignagenda.com/
London Independent Film Festival	London	Film	April	www.liff.org/
Art17	London	Art	May	www.artfairslondon.com/
Art Cologne	Germany	Modern & Contemporary Art	May	www.artcologne.de/
Grand Designs Live London	London	Interiors, applied arts and design	May	www.granddesignslive.com
Collect: International Art Fair for Contemporary Objects	London	Hi-bred design product and applied arts	May	www.craftscouncil.org.uk
Premiere Vision	Paris/New York/ Sao Paulo	Fashion, design, manufacturing, fabrics and yarns	Spring/ Autumn	www.premierevision.com
The Venice Biennale	Venice	International Arts and Culture Festival	May – November	www.labiennale.org/

The Essential Guide to Business for Artists and Designers

Name of Event	Location	Sector	When	Website
SUMMER				
London Graduate Fashion Week	London	Fashion	June	www.gfw.org.uk
Pulse	London	Applied arts, fashion, gifts and misc.	June	www.pulse-london.com
Home & Gift	Harrogate, Yorkshire	Interiors, fashion, gifts and stationery	June	www.homeandgift.co.uk/
D&AD New Blood	London	Product and graphic design, illustration, animation and image-making	June	www.dandad.org/en/ new-blood/
Royal Academy of Art Summer Exhibition	London	Paintings, drawings, prints, sculptures and architectural models	June to August	www.royalacademy.org.uk
Basel Art Fair	Basel/Hong Kong/Miami	Contemporary Art	January	www.artbasel.com/
Art In Action	Oxfordshire	Art	July	www.artinaction.org.uk
New Designers	London	Applied arts, commercial art and design	July	www.newdesigners.com
AOI Awards	London	Illustration	July/Aug	www.theaoi.com/awards/
AUTUMN				
London Design Festival	London	Design	September	www.londondesignfestival.com
100 Percent Design	London	Applied arts, design and materials	September	www.100 percent design.co.uk
Tent London	London	Interior products	September	www.tentlondon.co.uk
Top Drawer	London	Applied arts	September	www.topdrawer.co.uk
Decorex International	London	Interior design, fabrics and accessories	September	www.decorex.com
International Jewellery London	London	Jewellery	September	www.jewellerylondon.com
Autumn Fair	Birmingham	Home and giftware	September	www.autumnfair.com
British Art Fair	London	Art	September	www.britishartfair.co.uk
Design Junction	London/New York/Milan	Lighting, furniture and accessories	September	http://thedesignjunction.co.uk/
Goldsmiths' Fair	London	Jewellery and silversmithing	September/ October	www thegoldsmiths.co.uk
Maison & Objet	Paris/US/Asia	Interior design, soft furnishings, decoration and lifestyle	September	www.maison-objet.com
BFI London Film Festival	London	Film	October	www.bfi.org.uk
Frieze Art Fair	London	Contemporary Art	October	www.friezeartfair.com
Great Northern Contemporary Craft Fair	Manchester	Contemporary craft and homewares	October	www.greatnorthernevents. co.uk/

Name of Event	Location	Sector	When	Website
Affordable Art Fair	London	Art, prints, sculpture and photography	November	www.affordableartfair.co.uk
Designers Block	London/Global	Film, illustration, image-makers and design	November	www.verydesignersblock.com
SOFA	Chicago	Sculptural objects, functional art and design	November	www.sofaexpo.com/
Country Living Magazine Christmas Fair	London and Glasgow	Design, applied arts and traditional crafts	November	www.countrylivingfair.com
Made Brighton, Made London	Brighton/ London	Craft and design	Oct/Nov	www.brighton-made.co.uk/ www.madelondon.org/
Spirit of Christmas	London	Design, toys & stylish gifts	November	www.spiritofchristmasfair.co.uk
WINTER				
Dazzle	London/ Edinburgh	Jewellery	August/ December	www.dazzle-exhibitions.co.uk/
National Craft & Design Fair	Dublin	Art, applied arts and design	December	www.nationalcraftsfair.ie
Vintage Festival	London/ Glasgow	Celebrating all things vintage 1920s -1980s	December	www.vintagefestival.co.uk/
London Art Fair	London	Art	January	www.londonartfair.co.uk
The January Furniture Show	Birmingham	Furniture	January	www.januaryfurnitureshow.com/
Domotex	Hannover	Floor and carpet materials	January	www.domotex.de/home
Heimtextil	Frankfurt/Global	Home and Contract textiles	January	http://heimtextil. messefrankfurt.com/
Top Drawer	London	Applied arts and misc.	January	www.topdrawer.co.uk
Spring Fair	Birmingham	Home and giftware	January	www.springfair.com
London Fashion Week	London	Fashion	February	www.londonfashionweek.co.uk
Pure London	London	Fashion	February	www.purelondon.com
Ceramic Art London	London	Ceramics	February	www.ceramics.org.uk
Ambiente	Frankfurt	Homeware, interiors, gifts and jewellery	February	http://ambiente. messefrankfurt.com/
The Surface Design Show	London	Materials for architecture and interior design	February	www.surfacedesignshow.com/
The Clerkenwell Design Week	London	Furniture, lighting, products and jewellery	May	www.clerkenwelldesignweek. com/

Invest in good quality print, digital and online marketing materials

Catalogues, brochures and leaflets

- Concentrate on good-quality design. Include marketing statements or copy.
- Avoid printing prices on any marketing materials. Keep trade and retail prices separate, as A5 or A4 paper inserts.
- Check the spelling and grammar. Get all materials proofread!
- Include your website, address, phone numbers, Skype and professional social media details such as Twitter, Instagram and LinkedIn.

Print and online portfolios

- More contemporary portfolios now take the form of a black 'box' with a white interior, available in various sizes with or without fine, clear, high-tech seamless acetate wallets.
- There are also smart leatherbound display portfolios in A2, A3, A4 and A5 size with clear, modern high-tech acetate sleeves.
- Bin any old plastic zip folders with thick old-fashioned wallets.
- Never use black sugar paper as a backing in a professional portfolio.
- Try not to stuff a portfolio. Keep it selective: twelve to eighteen images are usually sufficient.

- Store portfolios carefully, away from damp or dusty environments.
- Make a PDF version with selected images for emailing or available to download from your signature or website.
 Equally, you may also have an online portfolio on a web portal such as Behance. More on this in Chapter 12.

Creative marketing

'Don't be grey.'

Alex Brownless (1970-), co-director of Arts Thread

Creative marketing takes many forms, from imaginative publicity stunts to sending promotional artefacts to art buyers and directors, either in the post or via social media. Artists and designers have always used publicity stunts to attract attention, for the launch of manifestos, exhibitions, as well as an act of ethical protest.

The quote above is from Alex during a talk at my Entrepreneurship Summer School at Central Saint Martins; he was saying be bold, don't be afraid to stand out and be remembered.

Celebrated figures in art and design history have succeeded in creating a strong personal identity by adopting curly moustaches, stripy tops or pink hair, or by crossdressing, all as memorable motifs.

Others have created their own publicity stunts, such as Yves Klein producing his own newspapers, faking catalogues, selling invisible paintings and turning gallery visitors' urine blue. Some may recall Alfred Hitchcock's regular cameos in his own movies or the famous floating of a wax effigy of the director down the Thames.

There are several UK artists today who have courted notoriety through refining the art of the publicity stunt – the likes of Banksy, Mark McGowan (The Artist Taxi Driver) and Paul Kindersley. In 2003, when Banksy started performing early stunts by planting 'new' exhibits in London museums, it was obvious that his strategy would make him his fortune.

On 25 July 2009, the *Guardian* reported an interesting solution to non-payment from a gallery. When the artist threatened the

owner with a pavement protest outside the gallery, wearing an 'unpaid artist' sandwich board, the debt was suddenly paid.

The advertising world, as well as entrepreneurs like Sir Richard Branson, have always used publicity stunts, which are usually cheap to produce, as part of their marketing strategies.

Stunts are press and internet-friendly. Before performing your stunt, always send a press release to journalists beforehand and gently engage them in an entertaining way on social media (avoid any kind of bombardment). If you're relatively unknown, it's unlikely the press will turn out. If no press arrive, take high-resolution digital photos and make a short film of the stunt and immediately transfer files or email your photographs to your contact or the news/picture desk. Equally you can tweet out your story and upload it to YouTube.

Football freestyler John Farnworth helps to publicise a charity art auction at Sotheby's

As well as a number of websites listed in the resources, *Creative Review* always has news about the latest stunt-like adverts on TV, as well as featuring creative marketing ideas. David Lee, editor of *Jackdaw* magazine, is much more cynical about art stunts, and regularly writes a short exposé column in his magazine.

Visual artist

Rob Pepper

Rob Pepper is a British artist with a BA in fine art from Birmingham Institute of Art and Design. Alongside his art practice he is also Vice Principal of the Art Academy in London.

He started off selling work at Camden Market. Since then he has exhibited his line drawings, paintings and designs in a variety of public spaces and galleries around the world. His recent commissions include a series of huge tapestries for Park View Group in Beijing, drawing the Queen's Diamond Jubilee Flotilla on the River Thames and official designs for the London Mayor's Legacy List of the Olympic Park.

You can view Rob's commissions and paintings at www.robpepper.co.uk.
His five essential tips are:

1. Be original

Try to be imaginative when it comes to designing publicity materials. This can be achieved by experimenting with traditional printing techniques alongside using modern technology. I've discovered that adding a splash of bespoke printing to my invitations really helps in attracting attention.

2. Regularly find a critic

Find someone or a group of people who you trust and who can give constructive feedback. They must be able to tell you if a piece isn't any good, without battering your ego. There is a big void after you leave college and it can be lonely, so make sure you meet regularly, giving yourself a deadline to work to.

3. Discover the art of presentation

When visiting galleries, art fairs and boutiques, observe how products are displayed. Presentation is all about telling an audience that what they are looking at is important. Whether it's a pile of bricks, a urinal or an unmade bed, the artist or art director has considered where an item is placed, and how it's mounted and lit.

4. Keep in touch

Keep a database of all your contacts, and update it as often as you can. Let people know what you've been up to a few times a year with an eNewsfeed or by sending postcards. When promoting exhibitions, invite everyone you know as well as industry contacts. If potential clients don't come the first few times, be persistent – but not a nuisance; eventually some will turn up.

5. Be newsworthy

Be creative when taking on opportunities. If there's a story behind a project that will be of interest to the media, then that can be another excellent reason to do it.

For information on online showcasing, see Chapter 6

Printers

Most printers will be happy to send you a free sample pack before you place an order

www.printing.com (good standard quality) www.urbanprinting.co.uk

http://uk.moo.com (stylish fun)

www.bladerubber.co.uk (ink stamps made from drawings)

www.beaconpress.co.uk (eco)

www.paperbackpaper.co.uk/

www.st-ives.co.uk (*Creative Review*'s printers)
Fabpad, www.uel.ac.uk/fabpad/ (digital printing
onto banners. materials and canvas)

Specialist printing, finishing and sundries

Use an internet search engine or contact www. fineart.co.uk to locate a local fine art printer

www.solways.co.uk

www.lasercraft.co.uk

www.fedrigoni.co.uk

www.snazzybags.com

www.cyberpac.co.uk

www.progresspackaging.co.uk/

www.photobox.co.uk

www.awesomemerchandise.com

www.lasercraft.co.uk

www.mcgowansprint.co.uk (digital enhancement)

Presentation

www.paperchase.co.uk www.muji.co.uk or .com

Online print on demand image books

www.blurb.com www.lulu.com www.myphotobook.co.uk www.bobbooks.co.uk

Portfolios

www.londongraphics.co.uk www.silverprint.co.uk www.plasticsandwich.co.uk www.brodiesportfolios.com/homes.html

Marketing

Arts media directories and database services

Arts Media Contacts.

www.artsmediacontacts.com (check out their free press planner, a simplified version of the marketing timeline in this chapter)

Art Map London,

http://artmaplondon.com/artmap/add-event/

Artquest, www.artquest.org.uk/

The Design Trust,

www.thedesigntrust.co.uk/

top-design-craft-journalists-bloggers-media-tofollow-on-twitter/

Enterprise Nation,

www.enterprisenation.com/blog/

how-to-write-and-send-a-press-release-

successfully/

Art Monthly Gallery Map London,

www.artmonthly.co.uk/magazine/site/

london-gallery-map

The Press Association,

www.pressassociation.com (resources and links

to press release distributers)

London Calling, www.londoncallingarts.com (leaflet distribution; check out the 'Total London'

service), telephone: 020 7275 7225

Eventbrite, www.eventbrite.co.uk (online event promotion and booking system)

Artupdate, www.artupdate.com/en/

Creative Tourist, www.creativetourist.com (north-west England)

Creative North Yorkshire.

www.creativenorthyorkshire.com (north-east England)

Arts Marketing Association, www.a-m-a.co.uk Writers' and Artists' Yearbook, www. writersandartists.co.uk

Industry directories

These are guides and subscription services that give you details of art buyers and commissioning agencies.

The AOI, www.theaoi.com (UK; provide useful commissioning contact details for members) File FX, www.filefx.co.uk/wp/ (global) Adbase Inc., www.adbase.com (US) www.agencyaccess.com (US) BikiniLists, www.bikinilists.com (global, by country)

Workbook, www.workbook.com (US)

Art and design fair information

Excel, www.excel-london.co.uk
Business Design Centre, www.
businessdesigncentre.co.uk
Olympia, www.olympia.co.uk
Wembley, www.wembley.co.uk/
The Truman Brewery, http://trumanbrewery.com
The National Exhibition Centre, www.thenec.
co.uk

Graduate Fashion Week, www.gfw.org.uk London Fashion Week, www.londonfashionweek. co.uk

Pulse, www.pulse-london.com
Top Drawer, www.topdrawer.co.uk
100% Design, www.100percentdesign.co.uk
Art Quest, www.artquest.org.uk/opportunities/
fairs (up-and-coming art and design fair news)

Open studios

www.craftanddesign.net/open-studios/ organisers/ http://nfasp.org.uk/

Event supplies

www.aeo.org.uk www.market-stalls.co.uk

Stunts

www.markborkowski.co.uk/ http://mashable.com (guerrilla marketing) www.taylorherring.com/blog (stunt of the day) www.creativereview.co.uk www.thejackdaw.co.uk

Campaigns

www.change.org (online petition system with press support)

www.gofundme.com (raising funds and attracting attention for social or personal ambitions)

Alana Pryce PR, www.alanapryce.co.uk; info@ alanapryce.co.uk; mobile: 07940 420 631 (marketing advice service for artists and designers)

Blog, press and social media resources

It's essential that you familiarise yourself with these resources. Sometimes blogs work so well for creative businesses that they abandon their traditional press or news archive section. However sometimes they don't generate any real interest at all.

www.wetransfer.com (free large file transfer)
www.dropbox.com (free file storage and sharing)
www.mailchimp.com (e-newsletter system)
www.bitly.com (for shortening links)
www.wordpress.org
www.typepad.com
www.tumblr.com
www.blogger.com
www.mashable.com

Books

The Fame Formula: How Hollywood's Fixers, Fakers and Star Makers Created the Celebrity Industry, Mark Borkowski (London: Pan)
Improperganda (Art of the Publicity Stunt), Mark Borkowski (London: Vision On)
Effective Writing Skills for Public Relations, John Foster (London: Kogan Page)
Writing Skills for Public Relations: Style and Technique for Mainstream and Social Media, John Foster (London: Kogan Page)
Freelance Photographer's Market Handbook (London: BFP Books)
Flaunt: Designing Effective, Compelling and

Memorable Portfolios of Creative Work, Bryony Gomez-Palacio and Armin Vit (Texas: Under Consideration LLC)

A Smile in the Mind: Witty Thinking in Graphic Design, Beryl McAlhon, David Stuart, Greg Quinton and Nick Asbury (revised and expanded edition) (London: Phaidon) Copywriting: Successful Writing for Design. Advertising and Marketing, Mark Shaw (2nd ed.) (London: Laurence King) Installing Exhibitions: A Practical Guide, Pete Smithson (London: A&C Black) How to Create a Portfolio and Get Hired: A Guide for Graphic Designers and Illustrators, Fig Taylor (London: Laurence Kina) How to Make It as an Advertising Creative, Simon Veksner (London: Laurence King) The Guardian Book of April Fool's Day, Martin Wainwright (London: Aurum) 101 Extraordinary Investments: Curious, Unusual and Bizarre Ways to Make Money, Toby Walne (Hampshire: Harriman House) Propaganda: Power and Persuasion, David Welch (London: British Museum)

Funding and sponsorship

'It is so difficult to mix with artists! You must choose businessmen to talk to, because artists only talk of money.'

Jean Sibelius (1865–1957), composer

There are numerous ways to secure funding for projects, research, equipment and exhibitions. The secret of obtaining money, support or resources from grant-awarding bodies, trusts, banks, business sponsorship or crowdfunding is to start as early as possible, sometimes months or even years ahead of planned events.

When you're trying to obtain assistance, whether as an individual, a group or an organisation, filling in application forms, compiling proposals and writing bids for local or regional government funding requires a great deal of skill and patience. Presentation, clarity and understanding the eligibility criteria for such ventures are paramount.

At the time of writing, the UK and the rest of the world are still recovering from recession. Readers must bear in mind that to secure assistance in difficult times other, more unconventional approaches to gaining resources might have to be considered.

How to get a loan

'Painting is easy. The hard part is paying for the frame.'

Andrew Toos (1958–), cartoonist

Before considering taking out a loan, it's vital to understand why it's required and how much investment is needed. Market research, assessing market demand, calculating costs, predicting cash flow and learning about legal issues are all key elements in underpinning any application for a loan.

Being successful in gaining a loan requires a great deal of legwork. It can be helpful to consult friends and relatives who run businesses for advice, especially if they've previously borrowed money from banks.

It's important to realise that bankers aren't of the same mind as the British Film Institute (BFI), Arts Council, or Crafts Council administrators, as they judge on different criteria. Though small awards from these bodies can be useful for set projects and enable artists and designers to move forward. Giving small sums to individuals or organisations who don't understand how to sustain a practice as a business in the long term, or know how to build an organisation, can be a complete waste of time. Small awards can simply raise aspirations to an unrealistic level, especially if the venture can't become self-sufficient or profitable.

Many readers may already have £30,000 or so of student loan and as a result will tend to reject the idea of taking on further debt. You might have to be prepared to borrow further, or to seek crowdfunding investment. It's worth bearing in mind that failure to adequately invest in a business will inevitably lead to disaster. If you can't afford to do it properly, then leave it six months and concentrate on finding new ways to stabilise and improve current finances.

UK banks

If you have only a small amount of savings available and you can't obtain a grant or support from your parents to set up in business, then applying for a loan may be the only option, since grants for start-ups are becoming few and far between.

As mentioned in Chapter 3, taking out a business loan from a local bank will require you to open a business account and write a business plan. If you're struggling to write a plan, seek guidance from advisers at local enterprise agencies or innovation centres.

Your plan must convince the bank manager that you can repay any monies loaned with interest. Usually, loans are repaid monthly over a set period of time. It's customary that the lender will give the borrower two months' grace before the first loan instalment is repaid.

For more information about business plans refer back to Chapters 3 and 5, and for bank accounts, see Chapter 11.

UK government-backed loans

Local enterprise agencies or www.gov.uk/browse/business (UK & England), Business Wales, Northern Ireland Business, or Gateway (Scotland) will have up-to-date information about government schemes. They can advise about grants to partially fund overseas trade fairs, or direct you to local business support and other loan schemes.

Other business support organisations, as well as your local enterprise agencies, may also run various loan schemes, where business advice is included as part of the deal. If you decide to go for one of these programmes you will need to develop a detailed cash flow forecast, which you may find difficult to complete. If you are willing to work hard on the financials it's more likely that you will succeed in business. For more on funding and investment, please refer to Chapter 14.

UK credit unions

If the idea of applying for a loan from a bank doesn't appeal, then you could try a local credit union. Credit unions are community banking schemes. To be eligible to borrow, you also have to save. The minimum amount of saving is usually £10 per month. Some credit unions can only loan you three times the amount you have saved; others will issue straight loans of several thousand pounds.

Credit cards and private loan companies

Try not to become entangled with private loan companies. Where possible, avoid using credit cards to fund business expenditure, particularly if you have no business plan. High interest rates and default fines can become an expensive long-term burden, which can quickly lead to huge debts and wreak havoc on credit ratings.

Crowdfunding

Funding an arts or business venture by pitching online is hugely popular at the present time. Please refer to Chapter 13 for more detail.

Applying for grants and sponsorship

'As far as a sponsor is concerned, the visual arts is the ideal running mate. It is fashionable and visible, but cheaper than sport.'

From The Tastemakers (2001), by Rosie Millard (1965–), journalist, broadcaster and author

Applying for grants, loans or sponsorship can take many weeks and months to complete. It is highly likely that the first application for any form of grant funding will be rejected, but it's essential not to be put off, and to be persistent in reapplying.

The approach must be focused, and any documents or images included must be to the highest professional standard. It's better to be selective and to target efforts on two or three applications rather than dozens.

UK grants

Common errors include presenting too many different ideas or applied art forms in one application, with poorly constructed statements. If you're not very good at writing, seek professional help. Buying in help from time to time will generate more money in the long term. To apply for grants from the BFI, Arts Council or Crafts Council you usually have to be an EU citizen, a UK national, or to have gained British citizenship.

Application forms for substantial grants are effectively mini business plans in disguise. They're all quite generic in format, and some are unnecessarily complicated. The application forms may ask for projected profits or other financial calculations, with which you might be unfamiliar. To complete them satisfactorily you may require input from others.

Various organisations provide free or affordable advice and workshops on applying for grants. Short summaries of recent successful applicants' proposals can be found on the BFI, Arts Council and Crafts Council websites. If unsuccessful on your first attempt, try to gain feedback from the funders before resubmitting.

Are awards and grants taxable?

Most grants are viewed as taxable income by HMRC where you're already running a business. This is particularly the case if the award or grant relates to your area of trade. This includes entering an art or design competition and winning a cash prize.

However, some grants enabling people to develop business ideas, rather than to aid their existing business, are free from taxation. It's always worth clarifying whether or not a grant is exempt from income tax once you have been notified of a successful application.

Entering for awards or competitions is termed 'a venture in trade'. If you haven't started your business yet and you enter a competition, then the income won't be taxable.

Sponsorship

In the economic downturn business sponsorship can be hard to come by, but it is still worth pursuing. A template letter of sponsorship is shown overleaf. This is a model I have given out to many students over the last eighteen years. I know various artists and designers who've been successful in gaining up to £1,000 and more in support from businesses by basing a letter on this structure.

Sponsorship works in two ways

One approach, by sending letters, is to ask for small sums of money or specific materials – say, £50, £200 or £500, or other resources such as rolls of paper, pots of paint, frames, expensive materials, assistance with research or product development, or smaller things like drinks for guests, services in kind and so forth. Emailing a request is only appropriate if you know the recipient well, or as a follow-up to a previous conversation. Never send unsolicited email requests, as they're likely to be ignored.

Template letter of sponsorship

Use business/organisation's letter-headed paper.
Don't forget the date.
Name, title, position, and address of person to whom you are sending the letter.
Dear
We are/I am abased (insert your location, e.g. London) artist(s)/photographer(s)/designer(s)/business. We are/I am exhibiting our/my (e.g. awarding-winning/latest/innovative/artwork/range of products) in/at (state event and venue). The exhibition/event (title) will open with a private view/corporate/event launch on (start date) and will run until the (end date) at the (state venue's name and address).
This (use 'hook line'/title) show hosts a collection of work/designs/objects (e.g. paintings/soft furnishings) that explores/captures (state unique selling point phrase). (Then state any other interesting information such as the role of other funders/agencies/hosts/partners.)
At present we are/I am devising a marketing and publicity strategy that will include catalogue/poster/press releases being sent to (state newspaper/media/local/regional/national, etc.) in (state name of town/city; e.g. London-wide publications).

Adverts promoting the event will be placed in (e.g. art or design periodicals/and other magazines). We/I or (state event organisers) will also be inviting (state vast number of people invited, VIP and honoured guests) to the private view/ corporate/event launch and (quote numbers/other info) will attend the event/show during the (X number of days) it is open. (Remember to link, as best you can, the type of media to public/marketing/product image of sponsor.)
(The next bit is up to you. Remember these are rough guidelines. Select relevant items only.)
We are/I am looking for sponsorship from (state business name of local/national firms) in the form of goods/finance, towards the promotion of the event/posters/catalogue/display ware/ framing/materials/wine/refreshments for the private view/event launch, etc.
We all/I would be extremely grateful for your support and will ensure (state business name) is/are fully credited in the gallery/ display space/exhibition stand/publicity/press release/private view cards/posters and thanked for your donations/gifts. (Remember, if you're asking for large amounts of money, you can invite them to attend the event launch or invite them as a 'special' or 'honoured' guest or offer free passes or tickets).
Yours sincerely,
(Remember to sign with a high-quality pen such as a fountain pen – avoid cheap biros. If sending by email, add a full email signature and embed links to other supporting materials or website.)
(Name of artist(s)/designer(s) with BA or MA letters if appropriate)

The alternative course is to secure one or two big sponsors donating significant amounts – £5,000, £50,000, or even £100,000 – towards the whole event. An approach to a large corporation requires a hefty, carefully structured and presented proposal. This will require meeting potential sponsors and possibly a formal presentation.

If you decide to approach multiple sponsors, check that they are compatible – for example, if you manage to secure sponsorship from a vodka company for one part of a project, they may not be happy to find out that a rival firm is also supporting the event.

Approach by letter

You can approach businesses and organisations by email, but I think it is far better to make an approach on letter-headed paper. Enclose a draft press release and other supporting materials such as photographs or prints. This letter is really designed to enlist small amounts of support in the form of money, materials, equipment or other miscellaneous items.

Make sure you know who to write to. Is it the business owner or the marketing/PR manager?

How do I find out more about obtaining business sponsorship?

Arts & Business is an organisation that encourages sponsorship of the arts. They also provide training days on how to write sponsorship proposals.

What sponsors expect

The sponsor will expect that the audience for your event is similar to their own customer demographic and profile, and also that your image fits with their brand value and identity. Goldsmiths degree shows, for example, have been sponsored in previous years by Absolut Vodka, an edgy brand very much associated with younger consumers.

To gain sponsorship, there has to be the promise of advertisement, in all probability through featuring the company's logo or trademark. The reason why you need to start approaching sponsors early is to allow sufficient time for obligations to the

sponsor to be fulfilled, especially if they're substantial investors. Larger sponsors' logos have to appear on all marketing materials. Events vary in nature, and this affects the marketing materials produced. Read on for a shortlist.

Logos or names of major sponsors/funders must appear on:

- Press releases
- Posters and postcards
- Tickets and programmes
- Websites, blogs and social media
- Advertising, brochures, flyers and catalogues
- Large banners.

Most press campaigns start at least eight months before an event. If you're looking for sizeable donors for an event in 2018, it's not unrealistic to start approaching companies in 2017 or earlier. It may take large firms a while to decide whether they're going to offer support – this is why a long lead-in time is vital (see the marketing timeline on pages 138–139).

Remember, major sponsors should be invited to private views or launches.

This list below has been compiled from various sources, including Artquest, the Arts Council and the Arts & Business Sponsorship Manual, which may be available through a local arts organisation or your library.

What a major sponsorship proposal should contain

- A covering letter short and to the point.
- A summary of who you are and what you do.
- A summary of who your supporters are.
- A description of the project, including images.
- Who you believe your audience/market to be. Students? Collectors? Local business people?
- Publicity and identity if you have a website, make sure it's up to date.
- An outline of the benefits to the sponsor, i.e. what's in it for them.

- The size of donation you are asking for, including VAT if applicable.
- If you have contacted Arts & Business and have been assisted in some way, you should mention them.

Smaller amounts

It's possible to gain small amounts of funding and resources right up until a few weeks or days before the event. If sponsorship comes in late, it might be possible to include the sponsor's details on last-minute press releases sent to local newspapers and weekly magazines. The names of smaller sponsors can be displayed on a sign placed on your stand or in the gallery and they can be thanked via social media.

Acknowledgements could be added to floor plans or pricelists. Supporters can also be given press coverage retrospectively in any post-marketing activities.

Remember to write thank you letters to all the sponsors after the event. The best way to secure long-term funding is to build good relationships not only with sponsors, but with your patrons and customers. When running a project or event's social media feed, steer away from posting any content that distracts from your theme, e.g. commenting on politics.

The early days

I would advise making your initial approach to local businesses for smaller sponsorship requests between four and nine months before the event. Before writing or emailing them try to speak to the marketing or PR department, or directly to the owner if a small business.

Alternative fundraising strategies

'August And the streets are paved with pavement artists.' Hovis Presley (1960–2005), poet

If you're currently an art student, you will depend upon additional income to further your studies and mount a good degree show. You might be a recent graduate looking for funding to set up a business, develop a portfolio, make a film or stage an exhibition. Perhaps you're a fine artist working in the community arts sector, seeking support for small projects with social and educational benefits.

Whatever the reason for needing money, if you're on a low income, it can be worth spending time investigating state benefits and other less obvious forms of funding.

UK benefits

There are currently several types of benefit that you might be entitled to. However, several benefits, including tax credits, Jobseeker's Allowance and housing benefit, will merge together after 2018 in the new Universal Credit scheme.

Working and child tax credits

Tax credits are a benefit administered by HMRC. They're nothing to do with your local council or Job Centre. They are for people who are self-employed, in PAYE employment or a combination, as long as you working for at least thirty hours per week. At the time of writing the whole system of claiming tax credit is slowly merging into Universal Credit.

Please note, most people living in the UK can claim tax credits, though at the present time this is being reviewed for new EU migrants. However, there are certain exceptions for non-EU residents and restrictions for people with particular types of visas.

To find out more, and whether you can claim, visit www.gov.uk/ working-tax-credit/overview or talk to your local Citizens' Advice Bureau (CAB). If you've been on a low income for a few years and haven't claimed, you could be losing money. When applying for any kind of benefits always retain a copy of the completed form before you post the original application form or file online.

Local councils

UK housing benefit and regional council tax support schemes are currently claimed from your local council to help pay your rent or mortgage interest. At the moment (2016) most people on low incomes can claim housing benefit if they are self-employed, in PAYE employment or a combination.

If you're self-employed and have been awarded this benefit, and remain on a low income, it's usual to refresh your claim either annually or every six months. I've met many artists and designers who could have been a few thousand pounds better off per year if only they claimed housing benefit and council tax relief.

In order to claim, you need to take in or post to the housing benefit office, unless specified otherwise, originals of the following documents:

- Your last tax return (if you have previously filed one with HMRC). The previous tax year's bookkeeping, summaries and it can be particularly helpful, but not essential to, have audited accounts from an accountant as they can carry more weight. If you're only a few months into self-employment they will look at your current situation, and income earned in the previous tax year. If possible, take along the letter that you will have received from HMRC, informing you what tax is owed for the previous tax year, if any.
- Six months of business and personal bank statements.
- If you're claiming either working or child tax credits, bring in the HMRC calculation sheet and reference number.
- If you're in part-time employment, any P60s you received at the end of the last tax year, along with three months of payslips.
- A rent book or tenancy agreement/mortgage payment details.

Where possible, it's best to go in person with your original documents to meet with housing benefit or Universal Credit officers, as they will make copies. They will now sometimes accept paper copies or documents by email, such as your tax return or salary slips, as these might only exist in digitised form. Application forms for housing benefit and council tax relief can be picked up from their offices or downloaded from your local council's website.

Claiming benefits does take a bit of effort, but if you can't be bothered with bureaucracy then making a go of a business isn't going to work either. If you do qualify for benefits, then it's probable that you can't afford to pass them up.

Department of Work and Pensions/Job Centres

As mentioned in Chapter 3, when income is minimal it's possible to claim state benefits. At the current time of writing, benefit entitlement for the self-employed and part-time employees is changing radically. It's important when dealing with Job Centre advisers that you declare self-employed work, always showing the full financial details, including the fee, with all relevant expenses deducted to show net profit.

Charities, trusts and foundations

The Association of Charitable Foundations is a useful source of information about grant-making bodies. Equally it's now easier to find sources of funding by searching on Google, Turn2us or Artquest. There are hundreds of trusts out there supporting a wide range of causes. Some charities support educational activities, some research, while others will fund travel costs or childcare or other basic subsistence.

If you're currently a student and in financial difficulty, contact your student welfare officer or union and find out if there are any charitable foundations that you could apply to. Equally you could post on Go Fund Me to attract donations to pay fees or support your progress. Refer to Chapters 13 and 14 for more detail.

Time banks and barter

As mentioned in Chapter 4, try to find other creatives or professionals who would be willing to exchange products or skills. I encouraged one artist to swap signed prints in return for web design. I knew a carpenter who did a few odd jobs for an accountant in return for

completing his tax return. There are a number of official time banks and barter schemes around the country.

Design and Artists' Copyright Society (DACS)

Register for your resale rights and put in an annual claim for 'Payback' from DACS. UK artists and designers can receive money from Payback if they've had photographs, images of artwork or photos of products reproduced in publications or the media. The registration process for Payback and filling in the paper or online application form are straightforward.

Resale rights are a percentage of the resale price of artworks, sculptures, limited edition prints, collages, photographs, or unique traditional craft or applied art pieces such as tapestries, textiles, jewellery, furniture, glass and ceramics. For the maker to benefit, artworks and one-off pieces have to be resold though a dealer, agent or auction house. This right lasts your entire life and for seventy years after your death. See the DACS website for registration, more information and a full list of eligible artefacts. For more detail, please refer back to the beginning of Chapter 5, on makers' marks and orphan works.

Street entertainment

Pavement drawing, busking, performance or being a living statue can all be lucrative ways of making extra cash. HMRC classifies these activities as 'street entertainment'. The coins dropped into your hat are a taxable form of income, as there's a 'profit-seeking motive'. Earnings should be entered into your accounts.

Before doing anything like this, it's best to check with the local council whether there any by-laws that prohibit these activities or require a street trader's licence. As a wise precaution (if not a mandatory requirement in order to secure a licence), I would also take out public liability insurance.

I would suggest that if you're allowed to trade as a street entertainer in your local area then it might be an idea to set up with a friend who's also interested in having a go, as the streets are not as safe as they used to be. During the few years in which I did it while attending art school, I collected many stories with which to entertain my friends. However, there were a few nasty

Pavement drawing or street entertainment can be an alternative route to raising some funds

incidents, so be prepared to deal with the odd problem if undertaking any form of street entertainment. There are also some new regulations which may affect street entertainers; please refer to Chapter 9 for more detail.

Other money-spinners

- Raising money by selling raffle tickets prizes could include artworks, prints and products (this is also a good way of collecting contacts if you invite people to write their email address on your copy of the ticket)
- Holding art and design auctions
- Adding on workshops to exhibitions, for children or adults
- Charging or asking for donations for wine at private views
- Car boot sales
- Selling art merchandise: badges, T-shirts, mugs, tote bags, postcards and greetings cards
- Auctioning unwanted personal possessions on eBay.

Please note, if you're holding a raffle you may require a licence and should contact your local council for more details.

Product designer

Kathleen Hills

Kathleen Hills is a British designer who originally studied graphic design and then worked in publishing before moving into floristry. She set up and ran two flower shops in London before deciding to return to college. Her first degree was in ceramic design from Central Saint Martins, after which she gained an MA from the Royal College of Art.

Kathleen designs slip-cast bone china lighting. These products are sold via her website and selected retailers. She regularly takes part in trade shows such as Design Junction, Clerkenwell Design Week, 100% Design and Maison et Objet.

You can view her products and stockists at www.kathleenhills.co.uk.

1. Go for sponsorship

While studying at the RCA I spent time at Wedgwood, where they helped me with the production of my first three products. This experience was vital in setting up my business. Take advantage of any sponsorship opportunities available while you are studying.

2. Find a good manufacturer

I visited manufacturers in Stoke-on-Trent and looked for a company that I could develop a good, long-term, working relationship with. Finding good quality manufacturers that will support your business is essential.

3. Invest in good photography and get media coverage

Interior design magazine or design portal stylists or editors are usually very approachable, often working to tight

deadlines and always looking for new products and designers to introduce. Invest in good photography, strong clear images, and prepare marketing copy. Be prepared to email high-res images and prose at very short notice. Delays in getting these materials to editors may cost you opportunities.

4. Be creative in your approach to promoting your work

As well as gaining free exposure in the media through the feature pages, try to get your work into high-street shop windows. This can be done by approaching the store's visual merchandising designer or manager.

5. Make use of all your skills

Having worked in graphics, I understand the importance of branding. The flower shop taught me to create displays for the window and shop space, great practice for designing exhibition spaces. Working in publishing helped me to understand what the media wants. This experience enabled me to generate free publicity in the form of editorial coverage. You may not realise it, but you probably have lots of skills you can apply to your business.

Grants

Directory of Social Change, www.dsc.org.uk (publish several fundraising directories for individuals and organisations)

www.grantsforindividuals.org.uk

UK Trade and Investment, www.gov.uk/ government/organisations/uk-trade-investment (helps businesses break into overseas markets; for self-employed people or companies that have been trading for over eighteen months they can often provide grants towards attending trade fairs overseas, e.g. the Milan Design Fair)

The Association of Charitable Foundations, www.acf.org.uk www.turn2us.org.uk

Other useful websites

www.trustfunding.org.uk www.governmentfunding.org.uk www.j4b.co.uk/default.aspx www.artquest.org.uk (under 'Funding' section) www.dacs.ora.uk www.artsadmin.co.uk www.artscouncil.ora.uk www.craftscouncil.org.uk www.creativeengland.co.uk www.gov.uk/business-finance-support-finder Enterprise Investment Scheme, www.hmrc.gov.uk/eis/ www.thedesigntrust.co.uk www.nesta.org.uk www.shapearts.org.uk www.artistsbond.co.uk (places for forty artists per year; seek legal advice before applying)

Sponsorship

Arts & Business

http://artsandbusiness.bitc.org.uk www.aandbscotland.org.uk www.aandbcymru.org.uk www.artsandbusinessni.org.uk Hollis PR publish the Hollis Sponsorship & Donations Yearbook (local library only), www.uksponsorship.com

Crowdfunding

For information about crowdfunding, see the resources in Chapter 14

Information about loans

www.abcul.org (credit unions) www.shell-livewire.org/ https://www.gov.uk/start-up-loans www.nationaenterprisenetwork.org www.culturalenterpriseoffice.co.uk/ (support for Scotland)

https://unltd.org.uk/ (for social entrepreneurs) www.creativeindustryfinance.org.uk

Free advice about benefits or debt problems

Citizens' Advice Bureau, www.citizensadvice.org.uk For help with paying for dental and prescription costs in the UK, apply for a HC2 certificate, www.nhs.uk Tax credits, www.gov.uk/benefits-credits/tax-creditsax

Voucher Codes

www.moneysupermarket.com/vouchers/ www.vouchercodes.co.uk www.myvouchercodes.co.uk

Barter

www.bartercard.co.uk www.timebank.org.uk www.letslinkuk.net www.free2collect.co.uk

Free

www.freecycle.org www.free-stuff.co.uk www.latestfreestuff.co.uk/

Books

The Tastemakers: UK Art Now, Rosie Millard (London: Scribner)

Creative crimes

'If business is not for you, then the art world is not for you.'

Tracey Emin (1963–), artist

Some readers may recall Tracey Emin saying this before the start of a famously heated interview with John Humphrys back in 2004 on BBC Radio 4's *Today* programme. At the time, I found it a startling and shocking statement. But having given it due consideration over the years I now think that Emin made an extremely astute observation.

The business world, be it art or commercial, requires candidates to possess a mental toughness and a clear understanding of legal and financial matters.

Just about every artist and designer I have met over the last decade is falling foul of the law in some way. But failure to comply with British, European Community, US or international standards could have terrible consequences for you and your customers.

The art and commercial worlds aren't for everyone. However, if you wish to manufacture and sell creative products and services, even on a part-time basis, then it's vital to learn about the legal and regulatory requirements that govern your specific area of trade.

The laws pertaining to the creative industries and the visual arts are of such a magnitude that they can't be covered in their entirety in this chapter. The creative crimes mind map (see pages 176–177) is a visual summary of the key areas of law and current regulations.

It's worth bearing in mind that a vague or loose grasp of the law can actually be worse than knowing nothing at all. It's advisable to take advice from a solicitor or lawyer who has a proven track record in your particular sector. Indeed, it's sensible when establishing any kind of business to form good relations with a firm of solicitors.

As the UK voted to leave the European Union in 2016 all regulations will stay in place for a number of years to come. It's likely that due to globalisation we will need to continue to comply with these regulations in order to trade with independent European countries after 2019.

Protecting and exploiting intellectual property (IP)

'Intellectual property, potentially, is more valuable than any tangible thing you can imagine.'

Trevor Baylis CBE (1937–), inventor

As you can see from the mind map on pages 182–183, intellectual property rights (IPR) are a series of rights, both moral and financial, that govern artists, designers, inventors and businesses/brand-name rights.

At the time of writing there is no global standardisation of IP rights, and the laws that govern them vary from one country to another. However, there are various international agreements in place, such as the Berne Convention and the Madrid Protocol, which do recognise other countries' IP laws.

The European Union is working towards harmonising a set of IP rights that would ensure protection across Europe. EU design rights, trademark and patent registration systems already exist. However, the European parliament is now in the process of forming a new EU-wide copyright framework, and individual European countries are either complying or slowly harmonising these new directives with their own IP laws.

UK copyright regulations are also regularly reviewed. By the end of the next decade it is likely that significant changes will have taken place in this area of the law.

In recent years, a number of Intellectual Property Enterprise Courts (IPEC) have been established across European cities, including here in London.

Now let's clarify the basics

Moral and financial rights

When you create a painting, a lamp, a bagless vacuum cleaner or a unique brand, you have created two sources of value: the physical object and the 'intellectual rights' to the use underlying or enabling that object. For instance, when you finish a painting, you have both the painting itself and the 'copyright' in it. You can decide to sell the painting but retain the copyright. Equally you can license or sell (assign) the copyright, while keeping the original painting.

Moral rights govern issues such as the right of paternity, that is to say, the right to be acknowledged as the author. Financial rights recognise the labour involved in the creation of an object, and also the right to be paid for the reproduction of artworks or creative products.

UK copyright ©

This is an artistic right governing the rights of artists, designers, photographers, film-makers, musicians, writers and performers. It is automatic and in most cases lasts for life, plus a further seventy years after the author's death.

It is worth understanding that you are the owner of your own copyright unless you have created something in the capacity of an employee, in which case it's usually the employer who owns the copyright in all your creative output. When you're self-employed, it's vital to retain ownership and avoid 'assigning' or selling rights.

If you're creating artwork or products with other artists and designers, then before you begin working make sure any contract you receive is thoroughly checked by an IP solicitor. If there's no written contract, then it's advisable to seek legal advice about IP matters before collaborating on any joint project. Otherwise, at some later date it's likely that disputes will arise between the parties about ownership and control of rights.

Protecting copyright online

It is extremely important that you think very carefully before presenting concepts, artwork, photographs or designs online. At the present time most social media platforms such as Twitter, Instagram, Facebook and YouTube take a universal license on anything you post online. Some social media providers are stripping metadata from digital files which is actually in breach of WIPO (World Intellectual Property Organization) guidelines. As mentioned on page 94 in Chapter 5, try to retain some form of author recognition; this could be a combination of any of the following: embedding meta tags into any images posted online, watermarking and embedding the © symbol plus any maker's mark, name or logo, keeping the image size restricted and minimised to 72 dpi, or inserting IP tags. For more information on IP tags, search online, visit e.g. www.creativebarcode.com or seek recommendations from your professional body or other trusted industry source. Please also refer to Chapters 12 and 14.

For interesting updates to copyright, the Intellectual Property Office (IPO) have produced a number of business guides and copyright notices for artists, designers, makers, photographers, film-makers and even those using 3D printers. IP law has been strengthened recently, so for instance if you are making sewing or knitting patterns the instructions would gain copyright protection as a 'literary work' and any illustrations would be protected under copyright as 'artistic works'.

Freelance photographers may be interested to know that under revisions to 'fair dealing' as a defence, UK bloggers for instance can no longer take images from other websites for 'news' purposes. This is especially so if it should conflict with a photographer's ability to exploit this image by selling copies or licensing the image to other businesses, such as magazines. If you are a blogger, gain permission before posting images taken by others, or better still take your own photographs or pay to use a similar image from a stock or image bank. The IPO Facebook page, by the way, can also be an exciting source of information and links. For more on IP tagging, licensing and orphan works, please turn to Chapters 5, 12 and 14.

Always a good The Essential Guide to Business for Artists and Designers idea & sometimes Pist compulsory 955e55ment P.S. Don't panic! professio Contents 7 indemnity Equipment K > writte Employer + Insurance Product K All risks K liability Public liability labelling safety signs Stock redulations K consequential 1055? Case Storage K. > Equipment 7 assessment Risk Reporting of Fire and building Injuries, Diseases Health & regulations and Dangerous safety Occurrences →Control of Substances pAT (electrical & British Chrone Standards Regulations CE Product V Hazardous to Health (RIDDOR) * Kire & Soeth testing) marking Indecency > Anti-terror obscuricy Packaging & recycling ecology 1 Late payment Fine Art Trade Guild (e.g. Giclée 7 regulations Standards) K Other Key > Business names laws & Ell directives + regulations > Company regulations Fibre content K Eco labelling > Data Protection Act labels Trading standards product liability Hallmarking Consumer Contract regulations 176

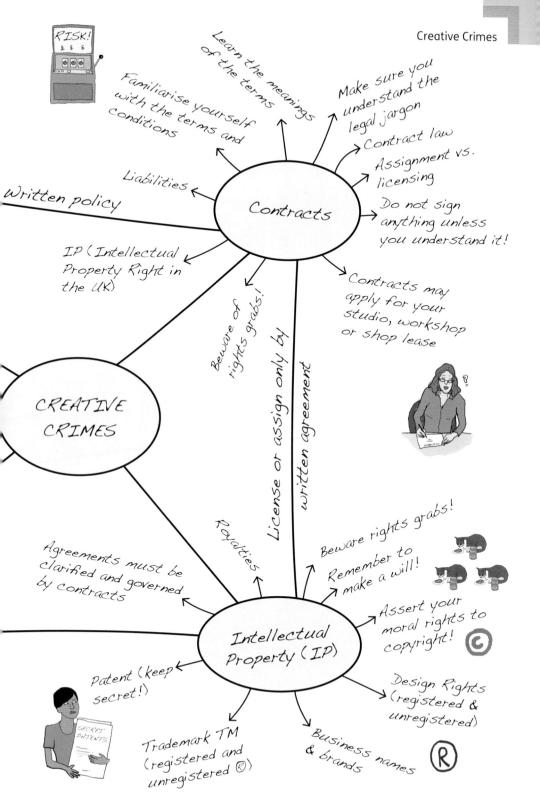

UK unregistered design right

This is like a lazy copyright, which offers limited protection for designers. UK unregistered design right lasts fifteen years from the object first being made, and ten years from first marketing. After the first five years since it was first made or marketed, others have the right to manufacture your products, after seeking your permission.

There has been a great deal of change to UK design right law. For instance, in a commissioning situation, it is now the case that the designer owns the 'unregistered rights' to their designs, not the client. However, the client may wish to obtain these rights, so it's vital to check the contract for assignment clauses. It is your responsibility to negotiate the contract and retain ownership of your rights.

UK industry know-how

You may have a brilliant trade secret, method of manufacture, recipe or process. When a patent is published, anyone can read the formula or method involved in making a material or product. Sometimes it can be wise to keep inventive processes a 'trade secret' and not to seek patent protection, thus keeping information private far beyond the lifespan of a patent. (You can read more about patents on the opposite page.)

UK unregistered trademarks ™

This right protects business names, logos and brands. Business owners use ™ to inform customers, clients and competitors that this is their 'trademark'. ™ is used when a business hasn't officially registered a business name/logo, is in the process of gaining registration with the Intellectual Property Office, or has failed to achieve such registration but are allowed to continue trading using the same name/brand/image.

Everything before this line is an automatic right in UK intellectual property rights law. There's no need to register it anywhere; you simply have to keep records, such as sketchbooks, photographs, tapes, recordings, emails, letters and contracts.

Everything after this line is 'registered intellectual property', where through registration, an artist, designer, inventor or business owner is enabled to gain further protection in the marketplace. Registration is optional, though strongly advisable. To register designs, patents and trademarks, contact a specialist IP solicitor or the Intellectual Property Office (IPO) directly.

UK registered design right

To be eligible for UK design right you must register a design within twelve months of it first being made or its first public display. Protection is only gained after the date when the claim is filed. If this application is successful, a photo or drawing of the product is published on the UK IPO website, with the registrant's details. Design right lasts for twenty-five years, but has to be renewed every five years in order to keep a commercial product protected in the marketplace. Readers might be interested to know that UK design right has now been strengthened, and intentional copying of a registered design is now a criminal offence.

If you have commercially viable products then it's essential to try and obtain UK or EU community design right. If you don't have enough spare cash to spend on filing a design, then you are simply not being realistic about the amount of investment required to start a creative business.

UK patent

Innovative product ideas, innovative materials or other inventions that have an industrial application can be protected by filing and publishing a patent. Diagrams, formulas and prototypes should only be shown to an IP solicitor or patent agent. Do not show innovative materials or products at exhibitions or fairs, nor make any public disclosure, before seeking professional advice.

Once a patent is filed as an 'initial application' for one year (no fee), then you can discuss the invention openly, appear on *Dragons' Den*, Kickstarter, etc. The filing remains confidential at the Intellectual Property Office (IPO). It's essential prior to filing that you make use of non-disclosure agreements (NDAs) when speaking with potential investors or manufacturers.

Gaining full registration takes up to three years. Once granted, a UK patent can last up to twenty years. There is also the option to register an EU patent, which covers the whole of the European Union, and to register patents, if the market determines, in other countries such as the United States, Canada, Brazil, Australia, etc. Patent law is one of the most specialised areas of law and can't be picked up simply by attending a few talks. It is essential with any innovative business idea to execute it quickly and not delay in seeking professional advice.

UK registered trademark®

Notice the word 'trade'. This area of IP law, as mentioned in Chapter 5, covers business names, visual images like illustrations or photographs, logos, shapes, brands, 3D objects (some limitations apply), sounds (jingles), even an artist or designer's name or signature, as with the likes of Picasso, Zandra Rhodes and Damien Hirst. You can seek registration and protection in your own country, e.g. in the UK, as well as other territories, such as the whole of Europe, for other countries or even on a worldwide basis.

It's vital to check www.uktrademarkregistration.com. Please note, the trademark search facility on the www.gov.uk/IPO website is more advanced though very complicated to use, so I would advise contacting an IP lawyer or specialist business adviser.

Intellectual property is an extremely complicated series of rights which can overlap each other. For instance, the introduction of Generic Top-Level Domains (GTLDs), e.g. .gallery .design .london, etc. is likely to lead to even more brand name disputes. The diagram on page 185 demonstrates some of these quirky crossover areas. Please note IP law in Europe and around the world is always evolving, so keep up to date through your industry body, an IP newsletter or specialist organisation.

No guarantee of success

When you start the application process to gain protection for a design, patent or trademark there is no guarantee that you'll be granted these rights. It's a tricky process, and this is why it's usually better to employ an IP solicitor to overcome any objections from the IPO and to guide you throughout the process with regards to the options available to you.

Avoid selling your rights

In 1971, Carolyn Davidson was paid a flat fee of just US\$35 for the Nike Swoosh logo by Nike founder Phil Knight. If only this young designer had been advised to license her logo design to Mr Knight instead of assigning it (i.e. selling it outright) for a one-off fee. Had she negotiated a licence, she might have limited how the logo could be used, for a specific purpose, time and territory – e.g. for use solely on certain kinds of footwear produced by the company, for a period of five years, and only on those products sold within specified jurisdictions. It's a classic example of where a well-drafted contract could have resulted in more successful exploitation for the designer.

Quoting fees

When an artist or designer ventures into the commercial world of company branding, advertising, merchandising or manufacturing, creatives should be aware of 'above the line' and 'below the line' usage (see page 81). Always remember to quote your fees on the basis of what, where and for how long the client wishes to use your artwork or designs. (Please consult page 313 in the glossary for more detail.)

A licence

The following checklist sets out typical priorities in a licensing agreement:

- The licence will be a written contract.
- Its payment terms may be either a fixed fee or royalties, or a combination of a set fee and royalties that can be negotiated.

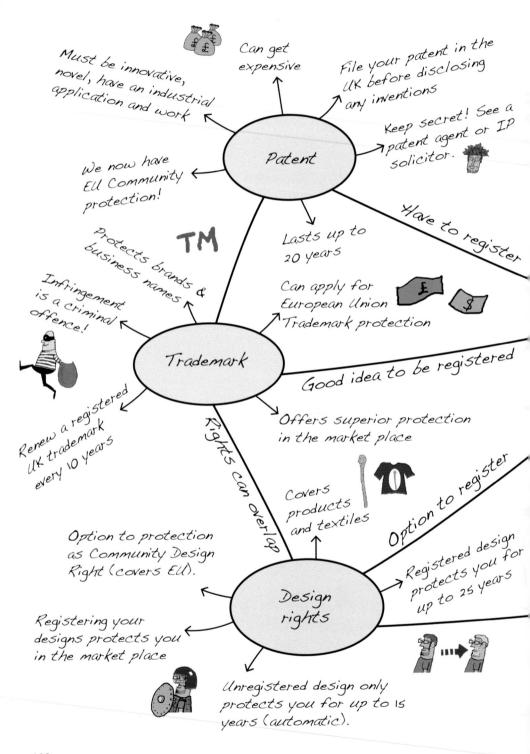

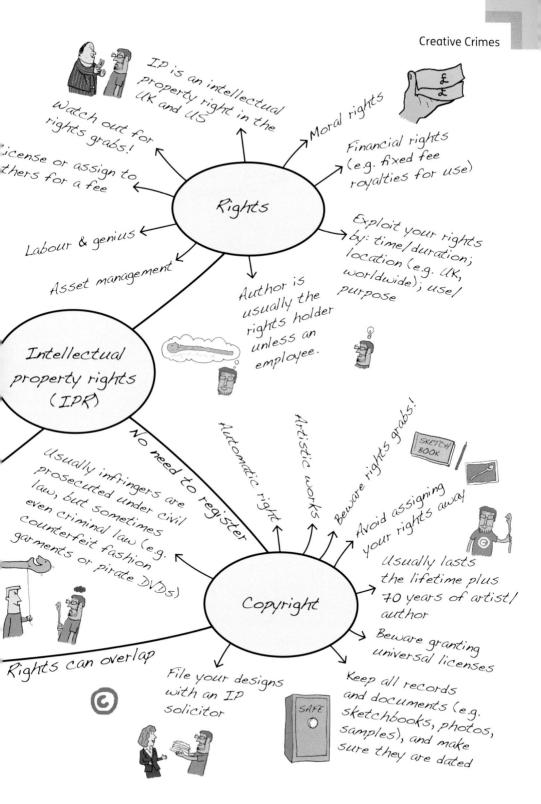

- The duration of the licence will be specified, e.g. a day, a week, a month, one year, four years, etc.
- The permitted uses of the design being licensed will be specified, e.g. magazines only, front covers only, T-shirts only, etc.
- The territory in which the licence applies will be specified, e.g.
 UK only, EU only, Japan only, worldwide, etc.

Stealing ideas

ou simply must not take images, lyrics or designs from the web or from books – even with a number of alterations such as colour changes, removing parts, distortion, etc. – and then claim them as your own creative product. It's important to gain permission from the creator or to pay a licensing fee, otherwise you could risk litigation. Unfortunately, artists and designers often only realise how damaging this activity is when it happens to them.

What to do if you have been ripped off

Do not communicate with the individual or business who you think may have copied your artwork, designs or products and passed them off as their own. Instead, quickly gather all your evidence of research and creation, sketchbooks, photographs of work in progress, catalogues, digital files and samples, together with a copy of the offending image (screenshot or print) or object (an actual purchase), and go straight to an IP lawyer to seek advice. Any delay can be fatal to your claim.

It can get messy if you try to be your own lawyer; I really wouldn't recommend taking on businesses who are 'passing off' your products or artworks as their own unless you are fully conversant with the law. However, it is possible to represent yourself and have your case heard in an Intellectual Property Enterprise Court. Equally, a local IP lawyer and the IPO itself via the gov.uk website can offer guidance.

However, if a business or individual is just using your images on their website without your permission, as mentioned earlier photographers can now take legal action. A Google image search is a good way to start tracking down websites that are using your images. You can upload an image that you are trying to check, or

Registered design covers the external form and appearance of a design object/product.

Unregistered design covers the external form and internal function of a design object/product.

Registered patent or secret industry knowledge covers inventions or innovations with industrial applications in core materials, like flooring.

Engineers, inventors or architects drawings/diagrams are covered under UK copyright.

PATENT

APPLICATION SOLAR POWER TOY TRACTOR MOTOR

Design right, registered or unregistered, covers jewellery, silversmithing, glass, ceramics, furniture, lighting, fashion garments, accessories,

etc.

patterns, toys,

A trademark, registered ® or unregistered TM, covers brands, logos, shapes, names, colours, images, signatures...

A drawing can be a logo, the logo could turn into a design and then a functioning product, like a toy, or be repeated as a fabric pattern. This product could be protected under registered design right and as a trademark.

O Copyright covers all artistic works such as drawings, paintings, sculpture, films, plays, written work, etc.

> A drawing can be an artistic work = copyright. A drawing could also turn into a logo or 3D trademark, registered or unregistered.

locate the use of the same image elsewhere if already on Google images.

If you are a photographer, illustrator, artist or designer and you see your images being used by a blogger, for instance, just to make their page look more appealing, then you could phone or email the owner of the blog or website and politely remind them in a friendly way that they may have 'forgotten' or 'overlooked' securing a licence from you to use the image concerned, and what a fair usage fee would be.

Equally, in another scenario the blogger might actually be using the image to endorse you and encourage people to commission or purchase your artwork or designs. Nowadays most creatives welcome this and may overlook any illegitimate use of an image in this circumstance. It is really about how they have used the images, how influential they are and whether they have a significant following.

Some artists and designers have taken to news and social media to vent their fury and expose infringers or copyists. This is a high-risk strategy, but if you search on Google for 'Tatty Devine vs Claire's Accessories' or 'You Thought We Wouldn't Notice' you will find some examples of victorious campaigns. It's best to seek advice from an IP lawyer when venturing down this route, especially when emotions are running high.

How to draw up a will

If you are starting to sell artwork and design pieces or if you have a number of public and commercial commissions then it is wise to have a will drawn up. Copyright, resale rights and other rights such as trademarks will still be commercially exploitable after your death.

You can leave your rights and the original artworks or designs to your company, family, friends or a charity. As owners of the rights they will be able to benefit from income generated by the licensing and resale of your artworks.

Often only the artist or their representatives and accountant will have inventories of the artist's commissions and sales and the places where original works are stored. When creators die without a valid will having been drawn up by a specialist solicitor, there can be a great deal of unnecessary confusion in the settling

of their estate. (For more information consult the books and websites recommended at the end of this chapter.)

The basics of terms and conditions

'The only way to be sure that your terms of trade form the contract is to send them at the earliest opportunity, as a written acceptance of the client's offer.'

Simon Stern (1943–2009), illustrator, author and former board member of DACS

If you are working regularly for a number of different clients, supplying numerous shops, taking on commissions or selling products from a website, then it's strongly advisable to invest in your own properly drafted set of terms and conditions. All sorts of calamities can occur when completing an order, so it's vital to limit your personal liabilities.

Most established artists and designers now have terms and conditions on their website. However, as regards trading online, many creatives have one set of terms and conditions governing creative products and services sold through their website, and another set of terms for retailers, other businesses or private commissions. It is not a case of 'one size fits all', so be careful of simply adopting someone else's terms and conditions to save money.

How to make use of terms and conditions

In Simon Stern's excellent *The Illustrator's Guide to Law and Business Practice*, the use of terms and conditions is described in detail. Though the context is that of an image maker or illustrator, the general premise is the same for all visual artists.

Sending your terms and conditions

Quite simply, if you send terms and conditions to a client, their acceptance can be indicated by silence, i.e. implied consent. They don't even need to respond in order for those terms and conditions to take effect. To avoid any confusion, it's wise to double-check confirmation of terms by phoning the client or sending them an email.

A few rules to avoid running into trouble

- Always have professional terms drawn up by an experienced solicitor who understands your sector.
- Alternatively, professional bodies often supply members with model terms, but look at them carefully to ensure they meet your requirements.
- Include a 'rejection' or 'cancellation fees' clause.
- Reduce personal liabilities by adding a force majeure clause for any situation in which a delay to delivery occurs that is beyond your control, e.g. due to postal strikes, accidents, fires, floods, volcanoes. Such a clause may oblige you to give written/email notice within seven days of the specified deadline, in order to agree an extension of time.
- Read any terms sent to you by a client.
- If something is unclear, consult with your professional body or an IP solicitor.
- Avoid signing if the other party wishes to 'own' your rights, e.g. by having you assign the copyright outright.
- A regular trick played by more mercenary clients is to acknowledge in a friendly way that you 'own' your rights, but then state that you agree to grant them a 'worldwide licence, for all time, for all uses, etc.' Beware of such sharp practice and don't let people take advantage of you.
- Also, search for other nasty clauses, e.g. those claiming ownership of original artwork or portfolios, and other unreasonable restrictions of trade.

- Check for any liabilities, e.g. insurance matters, repairs, data protection issues, image rights of celebrities, etc.
- If there are only a few concerns, raise them directly with the client and request an amended version of the terms. If they refuse, either accept the offer or politely decline it.
- If rejecting a clause, strike through with a black pen and write your initials at both ends of the line. Keep a printed copy for yourself and send the original back to the client. Again, if they refuse to send revised terms or don't mark their initials next to yours, just take the work if you're desperate for cash. But bear in mind that if clients treat you shabbily at the outset, relations are unlikely to improve.
- Never start work on a commission or under a contract until you have received and read both the terms and conditions and the contract, as they are interrelated agreements.
- If you commence work on a project before reading the client's terms and/ or conditions, and you have also signed a contract, it may mean that you consent to their terms/contract, whatever they may be.
- You can't impose your terms after the contract has started.
- Never, ever sign documents without fully understanding them.

Receiving terms and conditions

The general rule to remember is if a client sends you a set of their terms and conditions, your silence will be interpreted as acceptance. Moreover, if you receive a set of terms after the client has received yours, then unless it has been agreed to the contrary, the last set of terms governs the relationship or 'informs the contract'. This situation is known as the 'battle of the forms'.

Problems occur when artists and designers don't read clients' terms and conditions properly and fail to raise any concerns.

Insurances and other important regulations

'Bonheur also drew attention for sketching at the city's slaughterhouses, dressed in male clothing – a practice that was not only unconventional but technically illegal at that time.'

Rosa Bonheur (1822–1899), artist, from Dana Micucci's Artists in Residence, 2001

As I have mentioned, it's impossible to describe all pertinent insurance and legal matters in one chapter. Therefore I strongly urge readers to check the legal situation regarding insurance and any regulations that are relevant to your discipline and country.

If you want to trade or sell products in Britain, Europe and the wider world, it's important to comply with British Standards, European laws (in some cases international standards), and those of your own country, if applicable. Readers can undertake further research by visiting the websites and reading the books listed at the end of this chapter.

Health and safety

Health and safety, risk assessments and insurance are three interrelated areas. In recent years we have seen the partial destruction of the original Charles Rennie Mackintosh Glasgow School of Art by fire, and over a thousand workers killed in the Rana Plaza textiles factory collapse in Bangladesh.

Many artists and designers have also suffered terrible illnesses through failing to consider their own well-being. Since Michelangelo fell from scaffolding and nearly killed himself, many others have also faced personal tragedies. Sculptor Rebecca Horn ended up in a sanatorium after exposing her lungs and skin to toxic resin, and although she never smoked, Patricia Finch died from lung cancer caused by exposure to carcinogenic dust generated from sculptors' materials.

The Health and Safety at Work Act 1974, and subsequent amendments, enforces common sense. It's important to realise the dangers to yourself and others if basic risk assessments are not carried out properly. Once creative products are on sale in shops, mounted for exhibitions or installed on another's property, you can be liable if things go wrong. If a product causes a customer, visitor or participant harm in some way, they can sue you.

Insurance

In the UK at the time of writing, The Artists Information Company (www.a-n.co.uk) promotes inexpensive public and product liability insurance. The policy covers artists and designers in a range of activities including exhibitions, residencies and teaching workshops. Many professional bodies offer low-price insurance deals as a benefit of membership.

It's important to read any insurance policy very carefully, to ensure that it covers your full range of activities. If you're not fully covered then problems may arise in the future.

Public liability (personal)

This is simply a wise precaution, but it can be a contractual obligation for freelancers to take out public liability insurance.

You should seek cover if you are:

- carrying out work on other people's commercial or private property, e.g. mural work, installing sculptures, basic contract work, etc.
- running art workshops or private tuition for children or adults, either at home, on business premises or in other venues such as community centres.

 undertaking a residency, exhibiting artwork or products at galleries or fairs, performing, filming, out on a photo shoot or trading on a market stall.

Public liability (market traders)

Many councils prefer market traders to sign up to their own public liability insurance schemes. If you're thinking about setting up a stall at a local market, information about the application procedure is usually found on the local or town council's website.

If you're trading at festivals or other events, it's still advisable to take out appropriate cover, as organisers may request a copy of your public liability insurance. Contact the National Market Traders' Federation, which also offers low-price insurance deals for traders.

Winging it

Certain insurances are a legal requirement, while others are simply sensible for any professional creative to have. You may go for years and never have an accident or cause any injury to others. Then one day, through a gust of wind, forgetting to check something or becoming distracted, an accident will happen. They do.

If you don't have appropriate insurance, you could be liable for paying damages, hospital bills and replacing expensive objects or equipment. It's possible to be sued for hundreds of thousands of pounds if your product is faulty or if you have caused an accident.

In October 2009, a school in the UK was fined £16,500 and a substantial settlement was agreed after a sixteen-year-old girl attending an art class lost most of her fingers after putting her hands in a bucket of wet plaster until it set solid. Most of her fingers had to be amputated due to the severity of the burns.

This case highlights why you must have your own public liability insurance when facilitating art workshops in schools or community centres on a freelance basis. If you're not an employee of the school or local council concerned, then unless their insurance cover has been specially extended for the project you are engaged in, you will need your own. They may try and reassure you that you're covered, but that may not be the case if your specific activities and materials aren't included in the policy.

Read the insurance policy

Another type of 'winging it' is not properly reading the entire insurance policy, including all the schedules – if, say, a public liability insurance policy doesn't cover working at heights over ten metres and your job requires work to be done at fifteen metres. Avoid apathy, and thinking 'It'll be all right'. It might not be. It's far more sensible to contact a reputable independent insurance broker and add extra cover for activities or other risks outside of the current policy. Why lose sleep? Just pay for the extra cover if you need it.

Public liability (buildings)

All buildings open to the public are required by law to have public liability insurance. If you're paying any kind of rent for a studio or workshop to an arts or business organisation, then you might find that public liability insurance for the building is included; this is not always the case, however, so you might have to take out your own cover. If the landlord says the public liability insurance for the building is included in the rent, ask to see the policy and take a photocopy or scan for your records. If you're a tenant, ask for your interest as a tenant to be noted on the policy.

This type of insurance doesn't cover your personal equipment, tools, materials, stock or artwork. It's up to you to gain extra insurance against theft, fire and flood for your own contents.

If taking on a pop-up shop for a couple of weeks you may have to take out your own retail and 'pop-up shop' public liability insurance, there are a number of insurance firms which provide this, and some official pop-up shop projects may already include insurance as part of the deal.

Always seek advice from a solicitor and a chartered surveyor before taking on a longer-term lease for a shop or other commercial building, especially if you are entering into the lease in your own name.

Car insurance

Recently I have had a number of reports from artists and designers about the difficulty of obtaining commercial or even straightforward domestic car insurance cover. Why this is so heaven knows.

Trading from home

If you're trading from home then you may require public liability insurance for areas of the property that are used for business. Always seek advice from a solicitor and your insurance broker when planning to trade from home. Activities could include sitting at a computer, private tuition or manufacturing. If you are planning to trade from home, contact your insurance company about the policy that covers your house and contents, and notify them.

If you're living in rented accommodation and wish to trade from the property then check your tenancy agreement. You might have to talk to your landlord about amending his domestic policy.

When public liability insurance (on a property) is a legal requirement

If you're converting a garage or part of your home into a gallery or studio purely for business use, and this is open to the public, you are required by law to take out public liability insurance on these areas of the property. Planning permission must first be granted by the local council, and business rates have to be paid on the converted part of the property. (Please refer to page 233 in chapter 11.)

Product liability

This type of insurance covers you against claims made by customers for injury or damage caused by your products.

As a separate issue you should always check, before goods go on sale, whether they should be tested to comply with the BSI's British Standards, European, International or those of your own country. (Please refer to pages 197–198).

Equipment

As a general rule, businesses should insure key pieces of equipment for their current or replacement value. You need to think carefully about what to insure. I recall a stonemason who had not insured her tools. Individually they were not worth a great deal, but to have a whole bag stolen added up to such a sum that she had to cease trading for a period of time as she couldn't afford to replace them.

Data loss

Regarding digital files and databases, you can insure against data loss. With all matters concerning data storage, make sure you have good backup systems in place by backing up files on external drives, storing copies away from your main business premises or in cloud solutions.

Other important insurances

- Goods in transit
- Plate-glass window
- General theft, fire and flood
- Theft and consequential loss
- All risks (usually for photographers and film-makers)
- Home workers' package
- Accident and sickness
- Health insurance such as Bupa
- Pension, e.g. stakeholder pensions
- Employers' liability (legal requirement for employers)
- Professional indemnity (architects, engineers, and sometimes graphic designers and artists will require this; it covers any professional advice you may give in the course of your work)
- Infringement insurance (against others who copy your artwork or products) and legal expenses insurance.

Other important regulations

It's incredibly easy to find you have failed to comply with one of the following pieces of legislation. (If you have a knowledge gap, or other concerns, contact the recommended organisations; most of these regulations are revised periodically.)

- Health and Safety at Work Act (HASAWA) 1974 (and its many revisions and additions)
- Control of Substances Hazardous to Health regulations (COSHH) 1988
- Reporting of Injuries, Diseases and Dangerous Occurrences Regulations (RIDDOR) 2013
- Packaging (Essential Requirements) Regulations 2003 (and amendments)
- Electricity at Work Regulations 1989

- The Personal Protective Equipment at Work Regulations 1992
- The Manual Handling Operations Regulations 1992
- The Provision and Use of Work Equipment Regulations (PUWER) 1998
- The General Product Safety Regulations 2005.

It is advisable to go on a short course in health and safety, especially if you want to work in studio administration, art colleges, theatres or other hazardous environments. Contact the Health and Safety Executive (HSE) or your local AE/FE college about courses.

Important selling regulations

- The Sale and Supply of Goods to Consumers Regulations 2002
- The Consumer Rights Act 2015
- The Consumer Contracts (Information, Cancellation and Additional Charges) Regulations 2013
- The Sale of Goods Act 1979
- The Sale and Supply of Goods Act 1994
- The Supply of Services and Goods Act 1982
- Trade Descriptions Act 1968
- Unfair Trading Regulations 2008
- Misleading Marketing Regulations 2008
- Unfair Contract Terms Act 1977 (and amendments).

Under the legislation listed above, you have to be careful about how artworks, products and services are described.

If for example you sell a painting as a 'unique' piece but fail to tell the purchaser that you plan to make, or have made, a hundred limited-edition prints, the purchaser may have every right to ask for his money back. The same scenario applies to all 'one-off' products.

Remember, you have only sold the original artwork, and thus you retain the copyright. If at a later date you decide to make limited editions of any artwork, then it's good practice to let the original purchaser know in a friendly way that this is what you would like to do. It's likely they won't have a problem with your plan if they have been consulted.

The Consumer Contracts (Information, Cancellation and Additional Charges) Regulations 2013

These regulations partially replace, among others, the old Distance Selling Regulations, and these new regulations cover your responsibilities to the customer in a number of situations including face-to-face sales, sales by telephone or from your website. Customised products 'made to measure' or commissioned, i.e. 'made to order' are exempt from these regulations. For more information, contact your local Trading Standards Office or search on the www.gov.uk website. Within the European Union and most countries around the world there are some form of regulations covering sales via the internet; these are becoming increasingly similar as we move towards globalisation.

The Late Payment of Commercial Debts Regulations 2013

This act introduces a statutory right to claim interest on the late payment of debts. If you give a client a credit limit of thirty days to pay, and have sent enquiry letters and reminder emails, their failure to pay allows you to charge interest on the sum outstanding in addition to an administration fee or penalty charge of £40, £70 or £100, depending on the amount owed. In 2013 European Directive 2011/7/EU on combating late payment in commercial transactions came into force. Under this and the more recent UK regulations, businesses must pay within sixty days of invoice and thirty days if money is owned to the creative from a public sector organisation. (See www.payontime.co.uk for further details on these regulations and to access an online interest calculator.) At the time of writing the government is encouraging all businesses within the UK to pay one another within thirty days as a recommended default period unless special circumstances apply.

The Disclosure and Barring Service (DBS)

The Disclosure and Barring Service (DBS) is a new organisation formed after the closure of the Criminal Records Bureau (CRB) and the Independent Safeguarding Authority (ISA). If you're self-employed or an employee it would be the organisation, local authority or business who would undertake a DBS check and a small charge may be passed on to you, unless you are an unpaid

volunteer. A self-employed person cannot DBS check themselves; this needs to be done by whoever hires you, or via an umbrella agency. (For more information phone the DBS helpline. See page 203.)

Scotland also has a similar system in place called 'Disclosure Scotland' and a service for volunteers, The Protecting Vulnerable Groups (PVG) Scheme.

BSI British Standards (European/international standards)

If you're looking to sell furniture, soft furnishings, toys or other products, it's worth checking whether they need to comply with British or European standards, or those of your own country. Particular products have to be checked to confirm that they are safe for public use, though in certain cases manufacturers might be able to self-certify. Read the regulations concerning your product – it may have to be checked by an independent testing house.

The tests carried out are for durability, strength, stability and fire resistance. For more information, contact one or more of the following: BSI education (British Standards), Furniture International Ltd, the Association of Master Upholsterers, or, for toy makers, the British Toy and Hobby Association.

It's important that wherever you live or trade from that you comply with the standards not only of your own country but also where you plan to sell your products, e.g. if you are based in Brazil but make sales via the internet to Spain, you will need to comply with European standards.

CE marking

The CE mark on a product indicates its compliance with health and safety and environmental regulations. The main product areas where a CE mark applies are:

- low-voltage electrical products (e.g. lamps, kettles, vacuum cleaners, etc.)
- toys (e.g. characters or ideas fabricated in wood, metal, plastic, rubber, fabric – i.e. soft toys or dolls etc.)
- recreational craft products (e.g. mini stained glass, tapestry, handicraft or stencil kits for adults or children).

If you're planning to sell particular products, including lights, toys or recreational craft packs, within the UK or European Economic Area (EEA), makers or manufacturers must apply for a CE mark. If you're found to be selling these and other types of products without CE marking you are running the risk of prosecution by your local trading standards authority, although they may give you time to register (unless the product is unsafe). However, not complying with British Standards and CE marking is really not worth the risk.

Failure to comply fully with these regulations – for instance, by buying a light fitting with a CE sticker on it to fit into a lamp you have already designed to give the impression that an electrical product has CE marking – can result in a hefty fine or even imprisonment. Whatever the product is, the whole completed unit – in this case the shade, the lamp-holder and the light fitting – has to be tested. For more details, contact the British Standards Institution (BSI), the United Kingdom Accreditation Service (UKAS), the Lighting Industry Association or New Approach.

Textile products

- Indications of Fibre Content 1986 (various amendments 1988, 1994, 1998, 2005).
- Labelling and Fibre Composition Regulations 2012

If you are a fashion designer, dressmaker, costume maker, corset maker, milliner, textile designer, or if you make floor coverings, rugs or soft furnishings, then failure to advertise or label products with an indication of their fibre content is a criminal offence. Please refer to www.gov.uk (Textile Product Labelling) the UK Fashion and Textile Association or the Stationery Office for further details.

Vintage clothing

First off, if you plan to sell second-hand, aka 'pre-loved' clothes you need to check they are genuine. For more information on dating, labelling and grading of stock please visit the Vintage Fashion Guild website. You also need to check with your local council whether you require a licence or are required to register as a second-hand dealer.

Ecology

In this area the following legislation applies:

- Packaging (Essential Requirements) Regulations 2003 (amended 2004 and 2006)
- Hazardous Waste (England and Wales) Regulations 2005
- Environmental Protection Act 1990.

The key legislation here for most creative businesses is the packaging regulations. It's now a legal requirement for businesses trading within the European Community to make sure that all packaging can be recycled or that it is made from recycled materials.

Design of packaging should eliminate waste, and minimise weight and volume. Useful organisations to contact in this context are Friends of the Earth and Recycle Now.

(Please note there are some exemptions to the Packaging (Essential Requirements) Regulations 2003. To find out more visit the British Standards Institution (BSI), INCPEN, WRAP or www. gov.uk.)

Products or services that reduce the impact on the environment (for instance those using materials from sustainable or recycled sources) may be eligible to carry an EU Eco-Label, or a Forestry Stewardship Council mark; please see the resources at the end of this chapter for more information.

Barcoding products

You need to apply barcodes to your packaging when you are dealing with retailers so that you can identify and sell your products. Global Standards (GS1) is one of the main organisations that provide barcodes and EPC-enabled Radio Frequency Identification (RFID) tags. For more information on how to gain a barcode or identification keys please visit GS1 directly at www.gs1.org.

Industry regulations concerning limited editions

There are many different types of printing techniques employed in the reproduction of limited edition prints. There are British Standards, rules and general guidelines which auction houses, dealers and galleries observe. These are complicated. I would recommend looking at the Fine Art Trade Guild website, and books written by Annabel Ruston on the subject of the sale and reproduction of artworks.

There is a difference, for instance, between reproductions, on the one hand, and a series of themed works. British Standards categorise the degree of an artist's involvement in creating prints. Printmakers create prints as individual artworks using various means, e.g. linocut, etching, screenprinting, woodblock. These are distinct from purely 'reproduction' copies of an original artwork.

Artists now commonly reproduce paintings as modern giclée prints, rather than by the more traditional fine art printing methods. It's important to know the various rules and standards attached to them. For example, under the Fine Art Trade Guild's standards, the maximum edition of a limited edition print should not exceed 1,950, but the guild recommends that editions are kept below 850 worldwide. It's also best practice that once an artwork has been reproduced as a limited edition print, the image should not be relicensed for other uses such as greetings cards.

The Art Loss Register

The Art Loss Register is where you can report the theft or loss of artworks. If you register missing work and it comes up for auction or is found by the police, you can be reunited with the work. I recommend registration, as many artists, photographers and illustrators have experienced their original work simply 'disappearing' – at the printers, for instance – with the excuse that it's been 'lost'.

Be sure to let the person who has lost your artwork know that you will register it as missing on the Art Loss Register. That way, unscrupulous people won't be able to profit from its sale in the future. The Art Loss Register operates across many countries – please refer to their website for more details.

Busking and street entertainment

In 2014 the Anti-social Behaviour, Crime and Policing Act became law, which includes something called Public Spaces Protection Orders (PSPOs). If some form of activity takes place which is

viewed as a nuisance, councils can now take out a PSPO and stop noisy buskers, for instance, from performing in a particular place completely or on set days or times.

Street trading licences

There are all kinds of street licences available, and it's highly likely that one will be required if you're selling goods from a market stall. Even street entertainers such as pavement artists, buskers or human statues are often obliged to purchase a licence from the council or local trading standards office. If you're interested in trading at local fairs, or in town or shopping centres, contact your local council for more information.

Ethics

There are strange sets of double standards operating across the visual arts and creative industries. If we take fashion as an example, we find allegations of exploitation of child labour, of racism (prompted by the dearth of black or ethnic minority models), and of the industry's insistence on zero-sized models, to name but a few. The only recent positive developments in the fashion industry are its embracing of ecology, zero-waste initiatives and the creation of clothing made from recycled plastics and fibres. The fashion industry, like the music industry, gets away with a lot.

To avoid the reputation of your industry becoming tarnished, it's vital for all artists and designers to retain a sense of honesty and integrity. Avoid getting involved with untrustworthy characters. It's worth bearing in mind that if clients, agents or dealers discover any dishonesty in their business dealings with suppliers, it's likely they'll end the relationship.

Crime

You must not get drawn into any form of criminality including, but not limited to, tax evasion, fraud, piracy, drugs, or manufacturing fake or counterfeit goods. These activities are illegal. Criminal convictions can damage your reputation and your business. Even having minor convictions will prevent you from entering the USA and other countries for many years after the event.

RESOURCES

Legal services

Silverman Sherliker LLP, www.silvermansherliker.co.uk (free initial consultation session, affordable UK legal document solutions)

UK copyright, design right, trademark and patentIntellectual Property Office, www.gov.uk/ipo

(download various guides to trademarks, copyright, design right and patent) www.britishcopyright.org www.copyrighthub.co.uk www.start.biz (business name search) www.gov.uk/companieshouse www.uktrademarkregistration.com (free trademark search and legal advice) www.own-it.org (talks, advice, fact sheets, copyright) www.artguest.org.uk/artlaw.htm (art law section and new IP service) www.a-n.co.uk (most legal guides are only available to subscribers) www.tineye.com/ (find your photographers online) Google image search, https://images.google.com/ (use the camera icon to upload images and find Intellectual Property Enterprise Courts, www.justice.gov.uk/courts/rcj-rolls-building/ intellectual-property-enterprise-court www.gov.uk/defend-your-intellectual-property/ overview Design and Artists Copyright Society, www.dacs.org.uk Public Lending Right, www.plr.uk.com www.lac.gmul.ac.uk/ (artists' legal service) The Fashion and Design Protection Association,

Anti Copying in Design, www.acid.uk.com

(see the regular art market and legal news)

Patent Agents, www.cipa.org.uk/pages/home

Intellectual Property (IP)

World

www.wipo.int (global, links to all IPO websites in the world)

Europe

https://oami.europa.eu/ohimportal/en/ (European Union) (Note: OHIM will become EUIPO, The European Union Intellectual property Office)

115

www.copyright.gov www.loc.gov www.uspto.gov

Canada

www.cipo.ic.gc.ca/

Australia

www.ipaustralia.gov.au/

Brazil

www.cultura.gov.br/ www.inpi.gov.br/

Digital IP identifier system and app

www.creativebarcode.com (Creative Barcode is a digital IP identifier system that enables any creator anywhere in the world to attribute and protect their intellectual property, concepts and completed creative work)
Telephone: 01273 906067

Copyright infringement

www.youthoughtwewouldntnotice.com www.counterfeitchic.com www.spotcounterfeits.co.uk

Wills and trusts

The Society of Trust and Estate Practitioners, www.step.org Telephone: 020 7340 0506

www.fdpa.co.uk

www.thebis.org

www.artmonthly.co.uk

www.britishinventionshow.com

RESOURCES

Sources of information about UK trading regulations

The Department for Business, Energy and Industrial Strategy (BEIS) https://www.gov.uk/government/organisations/department-for-business-energy-and-industrial-strategy

Textile Product Labelling,
www.gov.uk and www.ukft.org
Late Payment Regulations,
www.payontime.co.uk
Trading Standards, www.tradingstandards.gov.uk

The Stationery Office, www.tsoshop.co.uk
The Financial Conduct Authority, www.fca.org.uk
Health and Safety Executive, www.hse.gov.uk
Disclosure Scotland,

Protecting Vulnerable Groups Scheme, www.pvgschemescotland.org Access Northern Ireland, www.nidirect.gov.uk/accessni

Disclosure and Barring Service, Telphone: 0300 0200 190

www.disclosurescotland.co.uk

https://www.gov.uk/government/organisations/disclosure-and-barring-service/about

Insurance

See the Artquest website for more information and a list of art/design insurance brokers. Also check with your professional body. www.a-n.co.uk www.saa.co.uk National Market Traders' Association, www.nmtf.co.uk British Insurance Brokers' Association,

Data storage and cloud computing

www.google.com/apps www.dropbox.com

www.biba.org.uk

British Standards and EU directives

www.gov.uk/european-commission-productdirectives www.bsieducation.org/education/default.php British Furniture Manufacturers' Association, www.bfm.org.uk FIRA International Ltd, www.fira.co.uk

Association of Master Upholsterers and Soft Furnishers, www.upholsterers.co.uk

Information about CE marking and other standards

www.ukas.com
www.gov.uk/guidance/ce-marking
www.newapproach.org
www.bsigroup.com
www.cen.eu/pages/default.aspx
www.iso.org/iso/home.html (international
standards)
www.thelia.org.uk/
www.btha.co.uk (toys)

Green regulations

Friends of the Earth, www.foe.co.uk
Waste and Resources Action Programme
(WRAP), www.wrap.org.uk
Netregs, www.netregs.org.uk (Northern Ireland
and Scotland)
The Industry Council for Packaging and the
Environment, www.incpen.org
Environmental Management Standards,
www.iso-14001.org.uk

Ecology

www.recyclenow.com www.fsc-uk.org/ www.gov.uk/apply-for-an-eu-ecolabel www.designcouncil.org.uk www.seedfoundation.org.uk

How to obtain a UK/EU product barcode for your products

www.gs1.org/barcodes (global) www.madeingb.org (new Made in Britain mark, optional)

Vintage and second-hand goods

http://vintagefashionguild.org/ www.which.co.uk/

Art

Art Loss Register, www.artloss.com/en Fine Art Trade Guild, www.fineart.co.uk (for access, quality, standards and logo use)

RESOURCES

Books

'BIID Concise Agreement for Interior Design Services (CID/11)' (London: RIBA Publishing) 'BIID Concise Agreement for Interior Design Services 2010 (ID/101)' (London: RIBA Publishing) Architect's Legal Pocket Book, Matthew Cousins (Oxford: Routledge)

Intellectual Property Law, Tina Hart, Simon Clark and Linda Fazzani (6th ed.) (London:Palgrave Macmillan)

The Architect's Pocket Book, Jonathon Hetreed and Ann Ross (4th ed.) (Oxford: Oxford Architectural Press)

The Pirate's Dilemma, Matt Mason (London: Allen Lane)

Dear Images: Art, Copyright and Culture, Daniel McClean and Karsten Schubert (eds) (London: UCA and Ridinghouse)

The Artist's Guide to Selling Work (2nd ed.), Annabelle Ruston (London: Bloomsbury) Starting up a Gallery and Frame Shop, Annabelle Ruston (London: A&C Black)

Confidence and negotiation tactics

'Belief in believing in believing...'

Tony Kaye (1952–), film director

On 9 June 2009, I attended a seminar in London, held as a tribute to the maverick art director Paul Arden. A clip of Tony Kaye singing a tribute song to Arden, called *Belief*, was shown to the audience, a lyric from which is quoted above. Paul Arden was sacked from six different advertising agencies during his career. Curiously, he never viewed his dismissal from any of these positions as a disaster. He eventually set up his own film production company and wrote two very entertaining pocketbooks based around the theme of self-confidence.

Self-confidence is essential for making sales and winning opportunities. Gaining the best outcome requires the ability to think through situations, an understanding of legal issues and a good grasp of the principles of negotiation.

Summary rejection, or receiving the brush-off, can lead to self-doubt. One solution might be mere dogged persistence. However, there might also be problems with your approach – for example, inadequate presentation in the form of amateur photographs, poor English, unimaginative or outmoded materials, and so on. A rebuff could be due to having no endorsement, no top art school, no reviews by critics, no references or no stockists. It could simply be the case, as any actor, dancer or musician will tell you, that supply is outstripping demand.

It's essential to realise that the business side of any creative profession is built on the invisible foundations of trust and reputation. This is why engineering introductions or gaining endorsements from other more established creatives, grandees of the art and design worlds, or other famous achievers is vital. You may not like this proposition, but unfortunately it's a reality.

How do I minimise the likelihood of rejection?

As with legal matters, a bit of 'wising up' is required. Always try to gain an introduction to established figures such as art entrepreneurs. If this isn't possible, then be bold and make an approach yourself.

If you're trying to gain representation or a show at a particular gallery and you're unknown to the dealer, search through back catalogues and find anyone you know who's exhibited at the gallery before. Make contact with them, turn on the charm a bit and hopefully they will introduce you formally or informally at some future event. If not, at least they may be willing to put your name on the gallery's mailing list.

If you're seeking to place products in large stores, visit the buyers, if they're willing to see you. Invite them to your degree show or trade fair and send them sample products. If necessary, pick up the phone and call them. However, be careful to avoid overpursuing buyers, as they don't like to be stalked.

It is a good idea to follow your favourite galleries, boutiques or brands on social media, so that you are visible on their radar.

If you're lucky enough to be invited to attend prestigious events with a guest, don't automatically issue the spare invitation to a friend. Consider whether there are potentially useful contacts who may not have an invitation and would like to go. Build relationships with people who might assist you in getting a lucky break.

Call in favours. Ask your friends, or friends of friends, if they would put in a word for you or recommend a contact. Many artists and designers feel nervous about asking for assistance from friends as they think it's unethical, but this is nonsense. If friends don't wish to help, are they really your friends anyway? Gradually bring your creative, business and future hopes into everyday conversations with friends. Then, eventually, real friends will always help out.

The art of persuasion

'Any fool can paint a picture, but it takes a wise man to be able to sell it.'

Samuel Butler (1835–1902), author and painter

As you can see from the mind map on pages 216–217, many aspects to do with improving confidence and related skills are interwoven with one another. Behavioural scientists and psychologists have explored the subject of persuasion in a number of published theories, research papers and books. Long before such research began, writers such as Napoleon Hill and Dale Carnegie in the 1930s had already hit upon many of these now widely accepted theories solely on the basis of their own observation, practice and experimentation.

Good interpersonal abilities and being able to engage people in conversation are central to securing opportunities. Please refer back to Chapter 6 for more on this subject.

Collectors

Individuals who buy art for their homes are not to be confused with professional collector-speculators, as some collectors are now called. Seasoned collectors very rarely buy work to hang in homes. It's more likely they will buy paintings, prints, sculptures or unique design pieces as investments. They will be concerned to know whether you have attended a prestigious college or studied under a well-known artist, and whether you have exhibited at established galleries, won awards or sold work previously at similar prices.

Making any comments along these lines will help convince a collector that the artwork is really worth the asking price. Collectors require an invoice, as well as your CV, as part of their archival documentation and also for insurance purposes.

Swap roles

Many artists and designers find that they feel more at ease selling or recommending their friend's artwork or creative products rather than their own. If this is the case with you, then team up with others whose work complements your own and share the task of selling each other's work.

How to improve the likelihood of gaining sales or commissions

- Undertake as much research as possible into your potential clients or customers. Understand what they want or desire.
- Why will/do your customers/clients buy your creative products and services? It's crucial to know this.
- Develop an enquiring mind.
- After an approach to an agency, or when a potential client responds to a mail-out, if they say, 'You must come in sometime', reach for your diary and make an appointment.
- If you're selling at fairs, stand up as much as possible and maintain a presence on your stand.
- Invest in a high stool with a small back, to sit on during short breaks.
 This helps to maintain eye contact with passing visitors.
- Have press packs, branded USB sticks, CVs, pricelists, business cards, postcards, brochures, etc. all to hand.
- If there's space on the stand, make a quiet area, perhaps in a corner, furnished with a laptop, tablet, calculator, and order forms, for conducting private discussions with customers. Sometimes access to Wi-Fi is available at shows as an extortionate extra, so connectivity via smartphone or dongle might be preferable. Often the signal is

- patchy so be organised, have PDFs and images stored on your tablet in case you can't access your online portfolio or gallery.
- Avoid eating in exhibition spaces, and don't become distracted by your smartphone or appear bored.
 You don't know who will pop round the edge of your stand.
- Engage with visitors all the time.
- However, try not to jump on floating browsers and attack them with an over-rehearsed sales pitch.
- Learn to be relaxed about talking to people by asking open questions such as:
 - Is this the first time you have visited this fair? How did you hear about the show?
 - Are you looking for a gift for a friend or for yourself?

These types of opening questions will help you to discover more about customers, by engaging them in light conversation. This can be initiated by asking the first question, which will help you to open a short, friendly discussion about the person's interests. Casual conversation gives your visitor the chance to steer discussion in a congenial direction.

In commercial sales, there is usually one person who is informative, who talks to customers about the artwork or products, technically, intellectually or practically. A second person manages the sales process and admin. If you're on your own at trade or retail fairs, it's essential to learn both of these skills.

Finally, if you're really hopeless at making sales, then hire people to sell or pay them on commission. Many artists and designers have successfully adopted this strategy, and it's common for creatives working in the fashion industry to work with a partner who looks after the business side.

Understanding contracts

'A contract is only as good as the people who sign it.'

Ivan C. Karp (1926–2012), art dealer

It's essential that artists and designers grasp the basics of contract law. The Illustrator's Guide to Law and Business Practice, by Simon Stern, is suitable for any creatives who have gained commercial commissions such as MP3 cover designs or images reproduced as patterns or artwork transferred to other merchandise such as clothing, fashion accessories or products, etc. This book demystifies legal terms and explains how to license rights.

Most professional bodies offer some form of advice service, and I highly recommend all the books and resources listed at the end of this and the previous chapter. If you really want to avoid being ripped off, then investing in textbooks and memberships is paramount.

When you first receive a contract

Think through what you want from the deal and make a list.

In Chapter 9 we discussed the subject of terms and conditions, and explained the phrase 'battle of the forms'. (Please read Chapter 9, if you haven't done so yet.)

After you have checked that there are no conflicting clauses between the two sets of terms, or after any amendments have been agreed, further commissions are usually agreed by

separate contracts. It's worth knowing that intellectual property rights can only be legally assigned (sold) or leased by a written contract.

What is a contract?

A contract is defined as an 'offer' and 'an acceptance' with something 'in consideration', which is usually money, i.e. a fee.

If a contract is emailed to you, print it out and read it carefully. If there are clauses you don't agree with or understand, seek advice from your solicitor or professional body. Then contact the prospective client directly and talk through your concerns in an objective way.

Once again, as with terms, the prospective client may issue an amended and more acceptable contract, without your having to go through the rigmarole of posting documents back with clauses struck out or amended. If the contract is acceptable, make sure that both parties sign it, to avoid any risk of ambiguity. It's far better to have a retyped agreement than one with crossing-out all over it.

If there are outstanding issues you may be asked to return the original hard-copy version with your amendments. If so, sign it and then write clearly next to your signature, 'Agreed subject to the striking out of clause x, y & z and amendments to a, b & c, etc.' Double-check that you have struck out or amended the clauses concerned, and initialled them at both ends of the line. Then return the document with a friendly covering letter, making it clear that you would like to proceed subject to the amendments suggested. They will either accept your suggestions or start negotiating with you. With any luck, an agreement will be reached and they will either send you a revised contract or post you back your original with their signature and initials added to your own next to the struck out or amended clauses.

Be alert to 'rights grabs'

Many firms practise what is known in the trade as 'a try-on'; they will literally 'try it on'. Sometimes these contracts are called 'standard' contracts. If you see the word 'standard' then it's likely that the contract states the creative firm wishes to own your

copyright, i.e. they want you to assign or transfer, or they want to buy, your rights or copyright. These are known as 'rights grabs'.

Once copyright is assigned, that's it. You can't even use the commissioned work for your own purposes, apart from being able to sell the original artwork (if the contract doesn't demand ownership of that, too). You won't be able to negotiate on future uses or further fees, as the commissioning party will own the copyright outright.

As mentioned in the previous chapter (and later on, in Chapters 12 and 14), be aware of granting an all-encompassing worldwide or universal 'licence' for all time (as most social media platforms state in the terms and conditions). This is more or less effectively the same as 'assignment'.

If you don't understand the contract, or you just sign it without reading it, you are storing up problems for later on. I have met many artists and designers who have agreed to contracts that restricted their ability to trade and caused them to relinquish copyright of their own portfolio. While there is a law against putting unfair terms into contracts, unfortunately, this doesn't stop companies from being ruthless and greedy. If a contract isn't a good one, then don't sign it.

Oral agreements

Across the visual arts sector, it's usual that established agents and dealers represent artists and designers upon trust and a 'gentlemen's agreement'. This is often how misunderstandings can occur over time between artists and their representatives as the artist becomes more established. It's always best to confirm any trading agreement in writing with the agent or dealer.

Beware of the sharks

Always be aware of claims from individual agents that they can represent your interests worldwide. Only large agencies can cover a wide number of areas of trade and territory, and there are very few agencies or dealerships in the world large enough to be able to justify such a claim.

A further warning

If you do receive a contract from an agent or dealer and find that it's a long, complicated affair, it may mean trouble. They might be trying unjustifiably to restrict your ability to trade. This can take various forms, such as, for example, clauses that disallow studio sales or the supplying of other businesses. Only very big fish indeed can demand exclusivity, so bear this in mind.

Remember, agents and dealers work for you. They're intermediaries between yourself and clients or collectors. Professional agents and dealers do not claim any rights over your copyright or original artworks.

The perils of not reading the contract

Recently, an illustrator showed me a contract with an 'agency' that was the worst contract I had ever seen. He had met the directors of a so-called agency. He told me the directors had been really fun and he had signed the contract without reading it. The contract had locked him into an exclusive relationship with the agency for three years, for all advertising and editorial work, and claimed all worldwide rights. The contract also stated that they, the agency, would own the originals of any work produced, along with his entire portfolio, including all work produced before the contract period.

The money he had been paid for work he had done up to the point when I met him was about twenty per cent of the going rate. Yes, he had been well and truly stitched up. I suggested that he consult with a solicitor and extricate himself from this deal. Beware charmers bearing contracts.

Public and private commissions

Public art commissions, community projects, private commissions and residencies are usually very different areas of trade from the commercial sector. I would urge artists to take these matters very seriously, in the first instance by subscribing to and exploring the a-n web guides.

In public art commissions large sums of money can be offered: £20,000, £40,000, £100,000, even £1,000,000. I've met many artists who have been trundling along for years earning profits of

anywhere between £16,000 to £25,000 per annum. Then after many attempts at being selected for larger projects they suddenly get a big break. If this happens to you, the size of your game will begin to change dramatically. (Please also refer to page 168 in Chapter 8 about DACs and resale rights, and also to Chapters 11 and 14.)

Some thoughts on how to deal with a large contract

- Understand all financial and health and safety liabilities.
- It's likely the scope of your insurance cover will have to be increased and expanded.
- What are the provisions stated within the proposed contract? Are they reasonable?
- Who is responsible for any maintenance? For how long?
- Are you personally liable if injury is caused to a member of the public?
- If you're accepting a large commission, consider whether to form a private limited company and get VAT-registered, even for a one-off project.
- Negotiate for your own terms and conditions to be those that govern the contract.
- Ensure that a proportion of the fee is paid up front as well as having interim payments scheduled for different stages of the project. If they are not met on the due date, stop work!

In the beginning

When you start out as an artist or designer you may find that getting your own contracts drawn up isn't necessary. Professional bodies should be able to furnish you with the basics. However, I do think it's extremely wise, if you don't manage to gain representation from agents or dealers, at least to have terms and conditions drawn up. As commissions or sales pick up, you can purchase other appropriate contracts or legal documents, such as the following, from a reputable firm of solicitors:

- model release form
- order forms
- sale and return
- terms of hire

The Essential Guide to Business for Artists and Designers

- licensing agreement/contract
- acceptance of a commercial commission
- private commission contract
- non-disclosure agreement (NDA) or secure file transfer system
- other agreements particular to your area of trade.

Always use an IP solicitor to draft contracts if you are unable to obtain up-to-date template versions from your professional body that meet with your specific requirements.

Here are a few useful tips

- Avoid making up your own terms or contracts; use the services of an IP lawyer.
- If there is a problem with a client's terms or contract, speak up, as silence will be viewed as acceptance.
- Don't be frightened about negotiating for better terms in agreements.
- Avoid relying solely on verbal agreements even if these are with well-established and reputable agents or dealers.
- After you have signed an agreement, you should always post two hard copies back to the other party. These they should sign and return to you (if the copies are not already pre-signed by them, in which case only return one of the original signed copies).
- Always keep a hard copy of all contracts with your other business records.
- Don't start work until a contract has been signed by both parties, and any deposits due have been paid.

- Beware of free or budget-priced model contracts downloaded from the internet. Always pay for such contracts to be checked by an IP solicitor.
- If a big opportunity comes along and you're without representation, then approach an established agent or dealer. Many agents will be very pleased to negotiate a one-off deal, and may want to represent you on an ongoing basis, if substantial contracts are forthcoming. Most agents charge between 20% and 30%. However, commissions vary for different markets for instance, 30% for advertising and 40% for work outside the UK.
- When you're undertaking regular commissions for a particular business, try to agree a standard-term contract so that follow-up commissions can be quickly arranged by phone and email. Agree that all future business will be conducted according to previous working arrangements, unless an unusual request is made – it's still good practice to have the arrangements in writing, even in an informal email.

The rules of negotiation

'After fourteen trades with people from all over North America, one red paperclip had just become a house.' Kyle MacDonald (1979–), maverick negotiator

The quotation above is from *One Red Paperclip* by the brilliant Kyle MacDonald, who, using Craigslist, traded up from one red paperclip, going from one deal to the next, until he owned a house. I highly recommend sparing an afternoon to be thoroughly entertained by his book which chronicles his famous barter story.

Business culture

A businessman with worldwide experience of conducting meetings once said, 'For the Americans it was best to arrive early, for the Chinese it was customary to be prompt, and for the Italians, be prepared to wait...'

Over the years I have heard many strange stories about conducting business in Italy. I recall one artist who arrived on time for a meeting in Milan. She walked into the curator's office to find the gallery owner naked, laid out on her desk having a massage!

Business culture differs in every country. However, securing the best deal for all parties is still the aim of every business meeting around the globe. Many artists and designers are not prepared for the rigours of negotiation; they are often so pleased to have work that they say yes to everything and consequently lose out.

Don't just say yes

I recall a story a businesswoman told me about visiting a degree show. She saw a painting and asked the art student the price. He said £1,000. The woman offered £400, expecting him to haggle the fee up to £850. Instead the young artist scratched his head and said, 'All right then', and accepted the first and lowest offer.

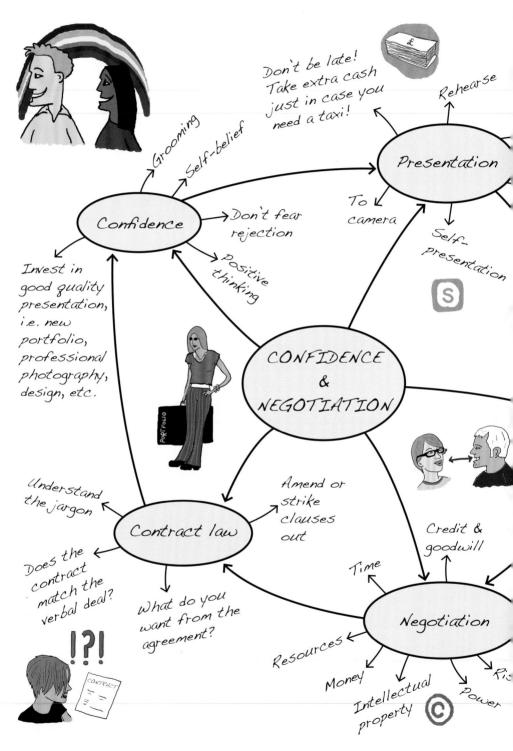

Understand Your Client

How to sell

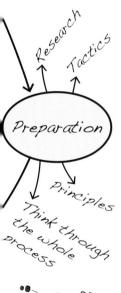

Overview of the negotiation process

We now have to turn our attention to some of the principles and tactics of negotiation.

Firstly, negotiation is a creative intellectual skill. Secondly, negotiation skills only improve with practice. After gaining a bit of experience you'll become more comfortable about the process.

Presentation

- Make sure to look the part. Pay a visit to the hairdressers, for example.
- Arrive early for meetings.
- Have extra cash to pay for a taxi, in case your car unexpectedly breaks down or you have problems with public transport.
- It's vital not to be late or to become stressed from panic.

Think about the client's needs

- Have a list of useful questions to ask, to clearly establish what the client wants, and to avoid misunderstandings.
- Think about your strengths and qualities, and interesting aspects that are particular to your work.
- Ask open questions, those that don't invite a simple yes or no answer, so you can draw out exactly what the client is looking for.

Confidence

- Make sure your portfolio looks contemporary no heavy clips or dusty wallets.
- A refreshed portfolio often boosts self-confidence.
- Think positively about the meeting.
- Eat properly beforehand.
- Believe in yourself, even if you feel unconfident. You are probably much better than you think you are. Don't confuse not having any money with a lack of talent.
- Be ready to talk confidently, and make sure your body posture is open, though not overly relaxed.

Preparation

 Do some research into the business, organisation or person you will be meeting.

- Think through the whole process and make a mind map or notes on index cards.
- Use coloured cards and theme them accordingly, e.g. by relevance, topic, 7 key negotiation rules. Put them in your pocket, so you can refer to them before the meeting starts.

Familiarise yourself with the principles of negotiation

- Think through what the other party will want to achieve in the negotiation.
- What's important to you? What's unimportant?
- What could be important to the other party and what is not?
- Think about the best and worst offer you will accept, e.g. the best fee, the most time and resources, versus your bottom line, below which you won't go.

Think about tactics

- Hopefully the other party will be up front about fees or budgets. If they're vague about these issues, don't quote a price until you have had time to discuss and consider the brief.
- When quoting fees, go in reasonably high. Remember, it's likely that you will be haggled down.
- Show a willingness to negotiate, and agree to compromises with clients. Stubbornness may get you a fat fee, but if it's at the expense of goodwill, then the working relationship may be a short one.
- Never reveal what is important or unimportant for you to the client. Use unimportant matters as bargaining chips.
 Unimportant matters could be time (if you're at a loose end), transport (if you own a van), or space (if you're already renting a studio), etc.
- Avoid negotiating by text, email or social media. Negotiation needs to be in real-time, and face-to-face where possible.
 Skype is acceptable as long as there is not too much of a delay and you can hear and see each other clearly.
- In Skype meetings, it may be worth making a light enquiry to
 check if anyone else is in on the call who might be out of sight
 of the camera.

The seven rules of negotiation

1. Time

To make life easier, always negotiate as much time as possible. Extra time means less pressure and the chance to take on other work. Remember, things can go wrong, so getting the maximum time will prove useful to allow for mistakes, corrections, illness or being let down by suppliers.

Time is of the essence, usually to the commissioning party. They will desire creative products and services completed by a deadline. If it's a short deadline, like 'tomorrow', you're within your rights to charge an extra 'rush fee', if it means working unsociable hours or turning down other opportunities.

2. Resources

Resources can easily be overlooked or undervalued. The commissioning party may have access to all sorts of resources which they would be happy to offer you. The key aspect here is to think creatively about what could be useful to you. Gaining extra resources could save money elsewhere in the budget. These resources could include:

 help with marketing or raising your profile

- postage or photocopying
- use of an empty space, e.g. a shop or studio
- venues
- accommodation
- temporary storage
- software or cloud subscriptions
- access to equipment or machinery
- delivery or transport
- materials
- models
- costumes
- props
- archive materials
- support with product development
- the assistance of skilled technicians.

3. Money

It's easy to make the error of focusing only on obtaining the largest fee. Try to think about the bigger picture. In the longer term there can be alternative approaches to gaining money, valuable endorsements or raising your profile.

I agree that one of the main points of negotiation is to get a decent fee, but fledgling negotiators must look at all seven parts of the negotiation mind map before rejecting any deal.

4. Intellectual property (IP)

This refers to licensing or assigning rights, copyright, design right, patents or trademarks. If clients wish to own the copyright or registered rights to your creative products, then charge them a substantial fee for assignment. If they don't wish to pay a large amount, offer them a licence to use it on agreed terms.

'Selling physical artworks or products' and 'licensing rights' are two separate arrangements. If a visitor to your show says, 'I would like to buy that picture and put it on T-shirts', purchasing an artwork doesn't mean they can reproduce it. You could sell, or more wisely license, the visitor with 'limited merchandising rights'. They could purchase a licence and buy the original artwork to hang in their office, if they wish.

More money can sometimes be made in the long run by licensing, while at other times it can't. This is why it's best to talk to other industry professionals to help you decide what to do.

If clients wish to own the copyright, and aren't willing to pay a commercial fee, then the stock phrase you utter is 'I only undertake commissioned work on a one-use basis.' This means you only license rights and never assign them.

5. Risk

A cunning negotiator will put the burden of risk on you. An example of this is offering you a deal with no fee, with only the promise of royalties. This is fine if products sell like hot cakes, but what if they don't? It would be better to negotiate a part-fee part-royalty deal, for instance.

Another example is a college or arts organisation offering you art courses to teach. They advertise the course with no guarantee of enrolment, nor a cancellation fee. Yet you can't book work on the dates advertised. This is common practice in the arts, I'm afraid. If you're unsure whether the marketing will be done properly, in the first year only commit to teaching the odd course.

6. Power

When you're on your own, and not part of a partnership, professional body or collective, it's easy to feel powerless. This is especially the case when you're without an agent or dealer, as representation by respected figures empowers your own reputation.

Open body language, formal posture and a clear speaking voice will make a good impression. If you exude confidence, then others will treat you with respect.

Knowing your rights, and being prepared to negotiate over rates, editorial decision making, retaining artistic control, etc. will gradually improve your position.

Saying no to a bad deal demonstrates that you won't be taken advantage of. If you're worth it, they'll come back to you with something more reasonable.

7. Credit and goodwill

Always gain acknowledgement as the author/originator on any reproduction of your artworks or creative products.

Make sure any individuals, organisations or sponsors are properly credited. Taking all the glory, when it's not yours to have, can become a sore point if the input of others is ignored. It's unlikely they'll support you again.

Goodwill is the principal factor in all business relationships. Once rapport or trust evaporates then relations can deteriorate. Always do your best to maintain goodwill in any business dealings.

However, this isn't a green light to give in to unreasonable additional demands from clients, which are often preceded by the phrase 'could you just'. If 'could you just' is a great deal of extra work, then the commissioner should pay more money or agree a further contract. Reputation is important. Be helpful, but not subservient.

RESOURCES

For other useful websites regarding legal matters and negotiation please refer to the resources at the end of Chapters 1, 2, 3, 4, 5, 8, 9, 12 and 14. See also

http://clientsfromhell.net www.redpaperclip.com

Books

Please also refer to the book list at the end of Chapter 13, for publications written by Vince Frost, Chris Barez-Brown and Jocelyn K Glei

How to Develop Self-Confidence and Influence People by Public Speaking, Dale Carnegie (London: Vermilion)

Words That Change Minds: Mastering the Language of Influence, Shelle Rose Charvet (Iowa: Kendall/Hunt Publishing) Against the Odds: An Autobiography, James Dyson (New York: Texere)

Getting to Yes: Negotiating Agreement Without Giving In, Roger Fisher and William L. Ury (London: Penguin)

One Red Paperclip: The Story of How One Man Changed his Life One Swap at a Time, Kyle MacDonald (London: Ebury Press)

Contract Law, Ewan McKendrick (Hampshire: Palgrave Macmillan)

The Mindgym: Give Me Time (London: Time Warner Books)

The Definitive Book of Body Language, Allan and Barbara Pease (London: Orion)

Graphic Design: A User's Manual, Adrian Shaughnessy (London: Laurence King)

Records, tax and basic bookkeeping

In specialist accountant Sydney Levinson's lectures to artists and designers he suggests that they try to see their accounts in '3D', so that the numbers are animated and meaningful.

It's vital, if you are new to business, to seek the advice of an accountant and learn how to maintain records properly. I've seen, for instance, notes of sales jotted down on the backs of diaries, or scribbled on scraps of paper. Others have greeted me with a jumble of documents and receipts in plastic bags.

The disorganised can become quite huffy when informed that this isn't a professional way to maintain records. You should be aware that failure to keep proper records is a fineable offence. If you've a heap of receipts under the bed, it's now time to buckle down and get organised.

This is a long chapter. For anyone new to the subject of invoicing, tax and bookkeeping, it might be advisable not to read this chapter in one sitting. HM Revenue and Customs will be abbreviated to HMRC. Please remember to consult the glossary for any terms you don't understand.

Invoicing and getting paid

'Bill-making times of course were busy; yet it was only at Christmas that the bills were sent out ... The idea was that farmers might have some money at that season.'

> From The Wheelwright's Shop (1923), by George Sturt (1863–1927), wheelwright Also known as George Bourne

As mentioned in Chapters 9 and 10, it can be helpful to adopt your own terms and conditions of trade. Issuing them to clients is the first step in ensuring you'll be paid for the provision of creative products and services.

An invoice is a bill. This can be a 'pro forma' invoice, which is what you send to clients if you need money up front to start work, e.g. for a substantial commission. The client may agree to stagger payments, e.g. part payment on presentation of roughs, with subsequent payments as later stages of the work are completed.

It's vital for any major undertaking that you minimise any financial liability to yourself by agreeing regular payments. Avoid heavily weighting an invoice (especially with clients you don't know very well) towards substantial payments on completion of a project. This could cause you cash flow problems or, worse, lead to bankruptcy.

How to send an invoice

An invoice can be sent by email as an email attachment, e.g. a PDF, in the body of an email or by post. It can also be generated and emailed to your client by online payment and invoicing systems such as PayPal, which is exceptionally useful when requiring payment from overseas clients.

I tend where possible to hand the invoice to the client when delivering work in person. Some artists and designers may require payment up front or on delivery of a painting, while others may request payment on presentation of an invoice. Every creative business is different. The example on page 226 is a template for what should be on a basic invoice if issuing them yourself. The design of invoices can vary. Suppliers of design products may

choose an elongated table format, so there's room for a list of products; other creatives may prefer no table at all. What's important is the content.

Dealing with late payment

I would strongly urge all UK readers to download and read the guidelines on late payment of commercial debt and the 2013 European Directive 2011/7/EU, both available at www.payontime. co.uk, as mentioned in Chapter 9. They explain what to charge as an administration or penalty fee for late payment of invoices.

It's generally advisable to make payment terms thirty days, unless the custom is payment on delivery of goods. You can add the following phrase to your invoice or terms and conditions: 'Payment to be received within 30 days of date of invoice. We understand and will exercise our right to interest and compensation for debt recovery under the late payment legislation if we are not paid according to agreed credit terms.' However, please note that including any terms on your invoice will only act as a reminder to the client, as terms and conditions have to be agreed before any trading commences. Please refer to Chapter 9 for more on this issue.

To avoid running into problems with clients regarding late payments, always clarify the agreed credit period before accepting the work. The default period should be thirty days, unless both sides desire more time. If you're allowing thirty days, and no cheque arrives by post or no deposit appears in your PayPal or business bank account, then phone and email clients around the 25-day stage and enquire as to whether the client received your invoice, and if so how the payment is progressing. With telephone, internet banking and PayPal systems, clients can pay any bill in a few seconds. So the cheque is in the post routine doesn't wash any longer, and is thus unlikely.

Important tips to keep you out of trouble

- Make sure that both digital and hard-copy invoices are produced/ printed on letter-headed paper.
- Make sure every invoice sent is numbered and dated.
- Include the name and address of the client, and any delivery address if necessary, to avoid any confusion.
- You can only charge VAT if registered for VAT with HMRC. Note that this is a common error. If you have been charging VAT without being registered, seek advice from an accountant.
- Terms and conditions on an invoice only serve as a reminder and can't be legally enforced.
- Always print out two copies of invoices – one copy for your records and the other for the client.

- If using purely digital or online invoicing systems, I still think it is advisable to print off paper copies in case of an unfortunate data storage deletion disaster.
- Many creative businesses record payments at retail or local craft fairs by issuing receipts. In the case of payment apps, a digital receipt can be issued by email or text message.
- Avoid using carbon books unless at trade fairs. It is better to have your own books made up by a printer with your own branding and contact details on. If you do use carbon receipt books, remember to retain your copy. It might be worth exploring payment apps such as Sumup, PayPal or iZettle, as most people these days don't carry cash.

If the enquiry yields no results, send reminders by email (or via PayPal if using this system) and by post on day 27. Only after the thirty-day period should you start issuing invoices with penalty fines. I have done this a few times over the years and it hasn't gone down well. Corporate firms can bully small suppliers, as they know smaller suppliers are dependent on them for business. However, the government is exploring the idea of making late payment to small businesses a criminal offence. If they do pass this law, life for the self-employed will be a lot easier.

I would advise joining the Federation of Small Businesses (FSB), as they have extremely good deals on debt collection if things get to this point. The FSB also runs a legal helpline, which can be a lifeline when things go wrong. However, if the amount owed is under £100 it may not be worth the effort in chasing or taking it to the small claims court.

What to put on an invoice (sample layout)

Letter-headed paper

Your name, address or letterhead/logo Include your telephone and a fax number (optional) E-mail and website address (especially when sending electronically)

All these things need to appear, though not necessarily in this order:

INVOICE NUMBER/REF: E.g. first invoice would be 0001

INVOICE TO: Name and address of client

DATE: Today's date

If a limited company, include registered place and number (these details should be included in your letterhead)

If VAT-registered, VAT registration number

PAYMENT TERMS: Usually 30 days from the date of the invoice, but it may be 10 days, if you wish, or even cash on delivery, for example

TERMS & CONDITIONS: You may want to state that you will:

 retain the right to copyright and the right to be credited on your design/artwork/film/ script/learning material, etc.

• charge fees for cancellation/rejection/liability/storage of late pick-ups

 charge interest on late payments at 8% over current base rate plus administration fees

Remember, printing terms on invoices only acts as a reminder.

		INVOICE	Ē	
Date	Quantity	Order Ref	Description	Amount
State date of sale or service	Number	Special code or reference number (Purchase Order no.)	Description of sale or provision of a service	£s, €s or \$
		Subtotal		£s, €s or \$s
		Handling/Transport Packaging/Delivery	1	Your own charge
		VAT 20%		N/A If not registered
		Total Due		£s, €s or \$s

- Insert logos of business/legal and professional bodies to demonstrate membership, e.g. FSB, ACID, The AOI, etc.
- Think about how your invoice is designed in terms of style and practical use. For example, you may not need a purchase order reference.
- You can include your business bank account details (bank name, account number and sort code) on your first invoice to a client or include it every time.
- Always keep a copy of any invoices sent to clients or customers for future reference.

Taxation demystified

'In particular, I enjoy nothing so much as the moment, in help sheet IR35 when, after a drill on the intricacies of National Insurance contributions, one is suddenly asked the question. apropos nothing: "Are you a deep sea diver?" I am not.' Ross Clark (1966-), author and journalist

Many readers may regard the subject of taxation as boring. Well, it can be, but you need to try and understand it. Running a business requires a reasonably good grasp of maths, and many artists and designers are not very good at this subject. I wasn't very good at maths when I was younger. However, I have learned, like many business owners, that you can only acquire wealth when maths and common sense are applied to fiscal matters.

In this section I hope you will grasp the basics of what profit is and what kind of costs can be claimed as business expenses. Please note that from 2020 onwards the way tax is collected from small businesses may change.

The UK tax year

The tax year runs from 6 April (e.g. 2017) to 5 April (e.g. 2018) every year.

Timeline of deadlines for tax year 2017-2018

6 April 2017 Start of the tax year

5 April 2018 End of the tax Deadline for vear

31 October 2018 paper tax return

to be submitted for HMRC to calculate any tax tax owed to be owed.

31 January 2019 Final deadline for tax return to be submitted electronically and paid.

When to register

As mentioned in Chapter 3, step seven, you do have to register with HMRC. Remember, the tax year runs from 6 April one year to 5 April the next. So if you start your business anywhere within these two dates, you have to register with HMRC by the following 5 October at the latest. But it is advisable to register as soon as you start spending money on a business or making sales. Otherwise you might generate a great deal of unnecessary work for yourself in terms of organising your records.

To register a business if you are based in the US, Canada, Australia or elsewhere you need to visit your government website, country or state tax office. For more information, please see some useful links in the resources section. Equally if you are living away from the country of your birth or residence you still may be legally obliged to pay tax in your own country as well as where you are living now. These matters can be complicated if living overseas, so it is best to speak to a specialist adviser as well as reading advice on government or other reputable websites.

UK tax returns

Tax returns or self-assessment forms can be posted to you, downloaded from www.gov.uk and printed out (main sections SA100, SA102 and SA103) or filed online. Paper returns must be completed and returned to HMRC, or filed online, before 31 October following the end of each tax year (e.g. 31 October 2018 if the tax year ended on 5 April 2018), and a cheque, or online payment, for any tax owed must be paid by the following 31 January (i.e. in the year 2019).

It's advisable if you're filling in the paper tax return yourself to send it to HMRC well before the first deadline of 31 October.

If you fail to submit your online digital tax return by 31 January 2019, HMRC will charge a series of penalties depending on how late you are when you finally submit. One day late equals a £100 penalty, three months late adds a further £10 penalty per day, six months late adds a further £300 penalty (or 5% of the tax liability if greater) and twelve months late means a further £300 penalty (or 5% of the tax liability if greater). Note that these penalties apply even if you have no tax liability for the year!

If your income is under £20,000, free advice is available from Tax Aid, who have offices in London, Birmingham and Manchester.

How UK income tax is charged

Income tax on net profits equals income, minus all business expenses and personal tax allowance. (See the business expenses chart, page 232.)

Your personal tax-free allowance (PTA) for the tax year ending 5 April 2018 is £11,500. (Please note this allowance is applicable for 2017–2018, but changes annually, and will have it tapered to zero if your income exceeds £123,000 in any one year.)

How is Profit Taxed?

P.T.A. LIL500 (2017-2018)

EXPENSES

Werheads

Variable

costs

Dual use

TOTAL INCOME

Meanings of basic bookkeeping terms

- Overheads regular or fixed business costs.
- Variable costs irregular and less predictable costs.
- Petty cash expenses in cash, e.g. stamps, taxi fare, art sundries.
- Dual-use tax relief claimed on a percentage of costs that are part-business/part-domestic, such as a car or a flat.

The term 'offsetting' means reducing your net profits by subtracting all your overheads, variable and dual-use expenses from all business income. You offset expenses to reduce the tax liability on your profits. See the following example and the chart on page 232. These summarise what can be counted as business expenses.

The more evidence of business expenses you have, such as paper or digital scans of invoices and receipts, the less tax you will be liable for. However, it's not wise to spend money on a business simply for the sake of paying less tax. On the other hand, if you understand how taxation works and are making a lot of money, it can be beneficial to spend money on equipment or vehicles before the end of the tax year.

UK tax bands

Tax bands are the same for the self-employed and employees alike.

Income tax is paid on any earnings over and above the personal tax allowance. The annual PTA can be set against your business earnings or employment if you also have a job. Remember, you cannot claim your personal tax allowance of £11,500 (2017–2018) twice in one year. It's worth noting that the PTA, like income tax bands and National Insurance contributions, increases slightly every year. Afer 2017 there are plans to abolish Class 2 National Insurance and how much Class 4 we pay will change. Please note we only have partial 2017–2018 rates at the time of printing, so please check for more recent information about Class 2 and 4 National Insurance on www.gov.uk/self-employed-national-insurance-rates. Due to the UK leaving the EU in 2016 please check for revised personal allowances and income tax rates on www.gov.uk/income-tax-rates/current-rates-and-allowances

Tax bands for the tax year 2017–2018

- The first £11,500 of profit (your PTA) is income tax-free.
- On the next £33,500 earned above that, income tax is paid at 20% (20p in the pound), and is known as basic rate.
- For earnings of over £45,000, income tax is paid at 40% (40p in the pound), and is known as higher rate.

Some pre-trading expenses can be offset against any profits made in the first year of trading. Usually, the pre-trading period is

eighteen months before registration. The pre-trading and start-up costs that can be counted are items such as business cards, equipment, computers and vehicles. See the business expenses chart overleaf.

National Insurance and personal allowance thresholds for 2016–2017

Class 2 National Insurance (NI) is set at £145.60 and is collected at the end of the tax year via self-assessment (i.e., your tax return) only if your profits are more than £5,965 (2016–2017 rates). If your profits are less than this, paying Class 2 National Insurance is optional.

Class 4 NI is payable at 9% if profits are between £8,060 and £43,000, and at 2% above £43,000 per year (2016–2017). This is paid with any income tax payments due, when a tax return/self-assessment form is submitted to HMRC.

Please note that after 2017 there are plans to abolish Class 2 National Insurance and the amount we pay for Class 4 will change.

A simple example (Using partial 2017–2018 rates)

Assuming you only have income from self-employment, you have earned £25,000 income from your business.

£8,000 of this is spent on business expenses: travel, insurance, postage, materials, studio rent, marketing, etc.

This leaves £17,000 net profit.

Take away your personal tax allowance of £11,500 and you are left with £5,500. (2017–2018 rates).

The first £33,500 of income is taxed at 20p in the pound (20%): 20% of £5,500 = £1,100.

Thus the total income tax you will have to pay on your net profits of £17,000 is £1,100.

Class 2 National Insurance at £145.60 per year applies to net profits over £5,965 (2016–2017 rates).

Class 4 National Insurance is 9% of any net profits of between £8,060 and £43,000 (2016–2017 rates).

So £17,000 - £8,060 = £8,940.

9% of £8,940 = £804.60

Thus there is £804.60 to pay in Class 4 National Insurance contributions (2016–2017 rates). So the total National Insurance you will have to pay is £145.60 (Class 2 NI) + £804.60 (Class

4 NI) = £950.20 (Combination of 2016-2017 and 2017 -2018 rates and thresholds).

Total income tax and total NI = £1,100 + £950.20 = £2,050.20

Business expenses chart for offsetting against profits and tax

Materials	Services	Fees/other	Equipment/trends	Premises	Advertising	Admin
Costs of goods bought for resale	All services: photocopying, film	Fees for professional organisations,	Hand tools, paintbrushes, power tools,	If your business is registered at a studio/ office/workshop/shop,	All marketing cards, postcards,	Stationery, envelopes, postage
Costs of	developing, framing,	conference fees, periodicals/	benches, any piece of equipment you	100% of your rent, electric and gas bills	postage, adverts, and	Cleaning
manufacture	casting fees, printing costs,	newspapers, gallery/other visits	need to make your work with	% of council tax bill	exhibition costs	expenses
Raw materials	renting	Travel (husiness)	100% tax valiation	bas little sackaslet to 70	Setting up	Office
חשפת	adaibilieile	motor expenses,	larger purchases.	rental (depending on	fees	sallalles
All materials:	Expenses for	insurance, servicing	Annual Investment	location)		Notebooks,
e.g.	hiring	repairs, petrol,	Allowance (AIA) is	As a rough anide if	Printing,	folders
fabrics,	Accountant's	travel fares, hotel	200,000	premises are also your	compliments	Storage
card,	fees, solicitor's	accommodation	Presses, easels,	home, % of use - so if	slips, rubber	units,
chemicals,	fees,		cupboards, storage	you have 4 rooms and	stamps	binders,
iz	photographer's	Licenses,	boxes,	use 1 for work, you can	Promotional	pens, ink
cartridges,	fees, web-	insurances, private	maintenance,	claim back 25% of your	gifts (low-cost	Year-
printing,	design fees	pension, bad debts,	repair, books/	rent or mortgage,	items)	planners,
plinths,		bank charges	portfolios, bags	council tax, gas and		calendars,
display cases,	Repair fees,	Registration fees	Food business trins	electricity	Gifts up to £50	diaries
USB sticks,	training fees	Special clothing	or undertaking	Cost of repairs to	branding on	Petty cash
fees	Wages for employees	Certain research grants	your usual workplace (e.g. in a client's studio or home) subsistence only (also depends on where business is registered)			book

Services, materials, equipment, premises, sundries, and other costs, that you can claim as business expenses to reduce your tax liability

Other information

- Tax rates and administrative requirements for registered companies are different from those for individuals.
 Companies pay corporation tax on their profits and income tax, and National Insurance on directors' salaries.
- At the current time in the UK the self-employed can claim tax relief on mileage for cars at 45p per business mile for the first 10,000 miles, and 25p thereafter; for motorbikes it's 24p per business mile, while bicycles can claim 20p per business mile (a green initiative!). Please note these are the 2016–2017 rates.
- There are special rules for the claiming of expenditure on premises, large plants, equipment and cars called capital allowances. They are designed to spread the cost of the asset to the business over its useful economic life. There are a number of different rates of capital allowances, the most common being the Annual Investment Allowance or AIA.
- It's impossible to cover all the important details in the space available. So if you plan to use your home for business and offset a proportion of rent or mortgage against tax, it is essential to seek the advice of a qualified accountant.

Annual Investment Allowance (AIA)

This is a scheme whereby it is possible to obtain 100% relief on equipment, plant and machinery costs (except cars, though vans are included); from 1 January 2016, the upper limit is £200,000. Please note this limit changes periodically, so check the most recent limit at https://www.gov.uk/capital-allowances/annual-investment-allowance.

Cars

If you buy a car and wish to offset its cost against your tax bill, the calculations can be complicated. Cars emitting no more than 75g CO₂/km, and registered between April 2015 and March 2018, will have 100% tax relief, meaning that you can deduct the whole cost as a business expense (2016–2017 rates). Please check with your accountant or HMRC before purchasing a new vehicle to be sure it is eligible.

Capital allowances

Most non-eco cars and vehicles are subject to a special capital allowance, where 18% of the balance of costs (reduced to 8% for cars with higher emissions) are claimed annually over the lifetime of the asset or until the vehicle is sold on.

A note to artists and designers who are currently not registered as self-employed

What if I'm making a loss?

If you are employed either part- or full-time, it can be worth registering as self-employed even if your hopes for profit from your arts or craft practice haven't materialised, and you have made a loss.

How so?

If over the course of a year, you spend more money on materials/ equipment than you receive from ad-hoc sales, you could offset any losses from being self-employed against the income tax paid in the course of your PAYE employment. Alternatively, you could move your losses forward to reduce your tax liability in future years.

How is it worked out?

Suppose that you have a part- or full-time job paying £13,000 gross (i.e., before tax), and your PTA (the first £11,500 earned; 2017-2018 rates) is allotted to your employment. The income tax on the remaining £1,500 will be charged at 20% (up to £33,500; 2017-2018 rates).

If you make a loss in your registered business of, say, £1,000, you can offset this loss against any tax paid through PAYE. Thus 20% of £1,000 is £200, meaning that if you are registered as self-employed and fill in a tax return, you will receive a cheque from the HMRC for £200.

The vagaries of VAT

VAT-registered business to VAT-registered business

Value Added Tax, or VAT, is a transaction tax charged on most products and services. The standard rate of VAT is currently 20% (2016–2017 rates). There are also reduced rates and zero rates, but these only apply to a limited number of goods and services. Businesses can only charge VAT if they are VAT-registered. Then they will usually be required to complete a VAT return every three months. (More on this in Chapter 14.)

Output tax

When a VAT-registered business supplies products or services and charges VAT on their invoices, this is termed 'output tax'.

Input tax

When a VAT-registered business receives an invoice or bill from a VAT-registered business and pays the supplier, this is termed 'input tax'.

VAT returns

VAT-registered businesses complete four VAT returns annually, when they are expected to pay the output tax, minus any input tax, to HMRC. This can become complicated. It requires you to complete forms and keep your accounts up to date.

Should your business have a good quarter, you'll have to pay HMRC all the VAT charged to other businesses (output tax). Against that, you'll deduct VAT paid on bills received (input tax). If you are charging more VAT (output tax) than you receive in relief on VAT paid on supplies or incoming bills (input tax), you will owe more VAT to HMRC overall.

The reverse is also true. Should a business have a poor quarter, i.e. your VAT-registered business has paid a large quantity of bills to other VAT-registered businesses (input tax) and has not generated many orders or sales, then your business will be paying more VAT on bills (input tax) than it's issuing to other businesses (output tax). In consequence you'll receive a welcome VAT refund from HMRC, of the difference between lower 'output tax' and higher 'input tax'.

When should you register for VAT?

- Only businesses whose turnover is greater than £83,000 (please note this is the registration threshold for 2016–2017) in any twelve-month period are required to add VAT to their prices.
- Any business whose turnover is below £83,000 (threshold for 2016–2017) can choose to register for VAT voluntarily or not deal with VAT at all.
- The general rule is that if all your customers are VATregistered businesses themselves (e.g. if you are a freelance designer working for a range of companies), then you will be better off financially if you register for VAT voluntarily.
- However, if your income is low, even if you deal only with VAT-registered businesses, you may be better off not registering for VAT in order to keep your financial affairs simple.
- If you supply digital products and services, there are now new VAT regulations known as VAT MOSS. It's best to seek advice from your accountant on these, or visit https://www.gov.uk/ register-and-use-the-vat-mini-one-stop-shop if based in the UK.

Selling to the general public

If all your customers are members of the public (e.g. if you are selling your own products on market stalls) then you might be better off financially if you avoid registering for VAT until your turnover exceeds £83,000 (threshold for 2016–2017) in any twelve-month period.

Payments

A variety of schemes are aimed at helping smaller businesses, such as the Flat Rate Scheme, the Cash Accounting Scheme and the Annual Accounting Scheme. It's worth discussing these options with an accountant to see if they would be beneficial to you.

Introduction to bookkeeping

'Bloom, do me a favour. Move a few decimal points around. You can do it. You're an accountant. You're in a noble profession.'

> From the film The Producers (1967), Mel Brooks (1926–), screenwriter

Bookkeeping, cash flow (money management) and working out tax liability are three separate sets of calculations. You may not fully grasp how to undertake these mathematical feats immediately after reading this book. These are activities that warrant demonstration by a trainer or one-to-one guidance from a sympathetic accountant.

I have done my best to try to provide as much explanation as I can in this section. If you have a grasp on the basics of tax and how to use a business bank account, then begin writing up your sales/commissions and noting expenses, that will be a good start.

How to use a business bank account

At the current time in the UK it's not a legal requirement to have a business bank account if you're self-employed. However, it is a legal requirement for a registered company.

Opening a business account is what any professional artist or designer should do if they're serious about managing a business properly. In some other countries, not having a business bank account is illegal, even for sole traders.

A business account will help you keep your accounts accurately, build trust with clients and suppliers, and help in the management of finances. Having a business account also acts as a buffer if you should find yourself investigated by HMRC. If you're self-employed with no business account, HMRC can delve straight into your personal current account and examine transactions going back over many years.

'How to manage a business bank account' demonstrates how business accounts work. Once you have worked out your Personal Survival Budget (PSB), the annual amount is divided into twelve monthly amounts. Remember, these are known as your 'drawings' – what you are taking out of your business to live on.

If your business account can stand the strain of regular payments to your personal bank account, set up a monthly standing order from your business account to your personal account. In the beginning, when earnings are unpredictable, this could well cause difficulties. Don't set up such an arrangement until you have a couple of thousand pounds in your business account.

Drawing money randomly from your business account, or worse still trying to trade from your personal current account, will lead to cash flow problems and confusion in your financial affairs.

If you have a part-time job and are claiming Universal Credit or on the former system of working tax credit, child tax credit and/or housing benefit, you may wish to pay these monies into your personal current account. You might find you only need to draw a fraction of your monthly budget from your business account, especially if there's other income coming in from a job, a lodger or benefits. Remember, should you have a lodger or be renting a room in your house, you must include this income in your tax return.

With all business matters, you must be honest and straight. Tax evasion is a criminal offence. Being dishonest can leave you open to blackmail, being reported to HMRC and possible criminal charges. Ask yourself if it's really worth the risk. If you're currently stretching the elastic of truth, there could be consequences, such as professional suppliers and clients deciding not to trade with you.

Bookkeeping

There are two main reasons for keeping an accurate record of your business income and expenditure. Firstly, you are legally obliged to comply with HMRC's minimal record-keeping requirements, complete a tax return and disclose business profits or losses to HMRC each year. Secondly, monitoring your incomings and outgoings is essential for making informed financial decisions.

HOW TO MANAGE A BUSINESS BANK ACCOUNT

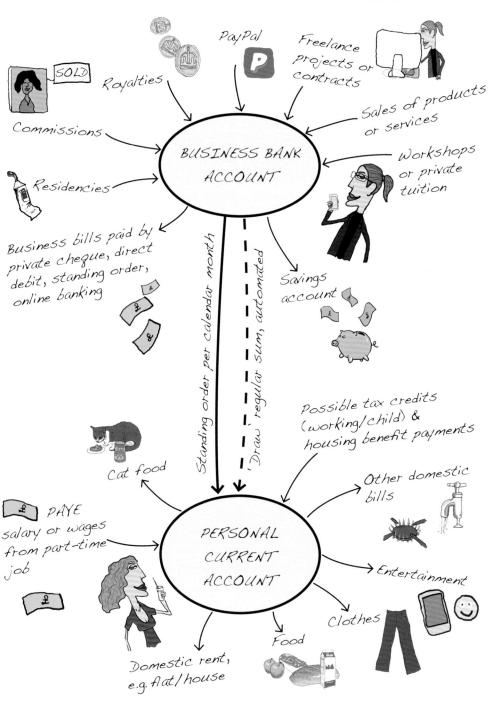

There are a variety of methods for recording business income and expenditure. The four most popular methods are as follows:

1. Manual bookkeeping in a paper cashbook

These types of books can be found at stationers' shops. You record every item of income and expenditure that you earn or incur. At the end of each month, add up the rows and columns to calculate your total net income for that month. Then repeat the process until the end of the financial year. Be careful to avoid errors by double-checking entries.

2. Computer-based spreadsheets (Excel)

These offer a significant advantage over their manual counterparts, as the software calculates everything for you. Many accountants like spreadsheets because they are flexible. They can easily manipulate and collate data, and, if necessary, correct mistakes.

To avoid data-entry problems, have spreadsheets set up by an accountant, tailored to your own requirements. Basic spreadsheets are all that the vast majority of artists and designers require. Please see the resources section for free template options.

3. Accountancy software packages (Sage/Tas/Quickbooks)

A good software package can tell you how much money is in the bank, which customers still owe you money, and which bills need paying.

One could be forgiven for thinking that this would be the best option. Many software companies market their programs as really simple to operate. However, I have yet to use one that I can wholeheartedly recommend as the perfect solution for the smaller business.

4. Online systems

There are various online bookkeeping solutions such as FreeAgent, Xero, Get Albert, Accounts Portal and Wave Accounting, which you pay to use via a monthly subscription (except for Wave, which is free). These services can manage invoicing and accounts online and across various digital devices including smartphones, iPads

and tablets. These systems can also import and integrate transactions directly from your online business bank account. For more on this please turn to pages 292–293.

Bookkeeping explained

You may find that Excel spreadsheets are the best place to start. A good spreadsheet designed by an accountant will make bookkeeping much easier, and is a good first step.

Let's use the example of 'A Beginner' to explain how a good bookkeeping spreadsheet should work.

Explanations follow about the three separate spreadsheets that should be completed every month. The three separate spreadsheets record:

- sales invoices raised
- income as it arrives into your bank account
- business expenses.

Record of sales invoices

Once it has been set up, you can use a spreadsheet like the record of sales (see page 243) to add up amounts automatically. If you have different income streams for your business, such as product sales, commissions and workshops, then you may find it useful to separate them out in columns, as shown in the first spreadsheet.

If your business is much more straightforward and has only one source of income, such as design fees, then simply use a single column.

An important feature of this record of sales is the 'date paid' column on the right. If you complete this date each time you're paid for an invoice, then it's very easy to see who still owes you money and how long customers take to pay.

Record of income

The income spreadsheet (page 244) is very similar to the sales spreadsheet. However, this time, instead of recording invoices as you issue them to customers, you record only income received.

As you will see in the example, any payments received from customers can go in the sales column. (This information is gained from looking at your invoice records and business bank account statements.) This should hopefully match any invoices raised. If not, then somebody owes you money!

You can check who has not paid by looking at the 'date paid' column of your sales spreadsheet as mentioned earlier.

Sales receipts are unlikely to be the only source of business income. You may have interest paid to you by the bank, or you may have taken out a loan or put some savings into the business account. All these different sources of income must be correctly recorded in the income spreadsheet, but listed in separate columns to your sales.

Record of expenses

The final spreadsheet (page 245) is the expenses spreadsheet, and this is slightly more complex. The layout should look familiar in that there is a date column and a space for your supplier's name and the receipt number. You can number receipts sequentially – 1, 2, 3, 4, etc. – when you produce them digitally, or by writing on each one with a pen if at a trade show. This will make it easy to locate specific receipts in future, in case you or your accountant need to look at them again.

One notable difference when entering data into this sheet is that you need to enter the same figure twice.

First of all, enter the amount paid in one of the two bold orange columns, which denote how the payment was made – either from the 'business bank account' or from 'other' sources such as cash or credit card. Then the same figure has to be entered again under one of the appropriate expense headings, so that we can analyse where money is being spent over the course of the year.

Note, for example, that on 2 November at Mr Fab's Art Shop, materials costing £95 and tools to the tune of £5 were purchased. These two amounts are shown under the appropriate columns, as a 'debit' in the reference column, and entered as a total of £100 in the bold coloured orange 'business bank' column.

The 'reference' column (or Ref.) is where you enter a description of the payment method – credit card, debit card, cash or cheque. The 'description' column to the far right details what it is you have bought, such as the 'materials and tools' on 2 November.

A beginner 2017–2018 – year end 5 April 2018

Invoice date	Customer/event	Invoice no.	Total	Sales	Commission	Workshops	Other	Date paid
1 Oct 17	Red Door Arts Centre/ drawing workshop	0014	200			200		1 Nov 17
10 Oct 17	Mr Saatchi Large canvas 33 'Eggs'	0015	1,400	1,400				5 Nov 17
15 Oct 17	Red Door Arts Centre/ drawing workshop	0016	200			200		14 Nov 17
TOTAL			1,800	1,400		005		

A beginner 2017–2018 – year end 5 April 2018

COLLE	NOVEMBER 2017					
Date	Detail	Total	Sales receipts	Bank interest	Sales receipts Bank interest Owner's funds	Other income
1 Nov 17	Invoice 0014	200	200			
5 Nov 17	Invoice 0015	1,400	1,400			
14 Nov 17	Invoice 0016	200	200			
28 Nov 17	Interest received	5		2		
29 Nov 17	Savings from Halifax Building Society 500	200			200	
TOTAL		2,305	1,800	2	200	-

Record of income

A beginner 2017–2018 – year end 5 April 2018

EXPENSES NOVEMBER 2017

					PAYMENT METHOD	METHOD													
Date	Payee	Receipt no.	Ref.	Total	Business	Other	Business Other Materials	Studio	Studio Travel and Advertising costs subsistence marketing	Advertising and Research and Postage marketing subscriptions and stationer	Research and Posta subscriptions and static	Postage Telephor and fax and stationery internet	Telephone, fax and internet	Bank charges and interest	Bank Loan charges repayments and interest	Equipment and tools	Drawings	Other	Description
2 Nov 17	Mr Fab's Art Shop	001	Debit	100	100		95									2			Materials and tools
5 Nov 17	Tracy's Stationers	002	Cash	2		2	2												Paper
10 Nov 17 Local transp	Local transport pass	003	Credit	08		8			80										Bus pass
17 Nov 17	Т8	900	Credit	20		20							20						Landline
20 Nov 17	Example Art 005 Publishers	900	Charge	38	38						38								Periodical subs.
22 Nov 17	Mr Fab's Art Shop	900	Cash	07		07	04												Paints
24 Nov 17	24 Nov 17 Colour Arts E-Shop	007	Debit	09	09		09												Canvasses
24 Nov 17	Reds Repo Graphic	800	Debit	65	92					65									Flyers
28 Nov 17	Miss A. Beginner	600	¥	1,700	1,700												1,700		Drawings
9 Nov 17	29 Nov 17 Post office	010	Cash	2		2						2							Stamps
30 Nov 17	Bank	011	Debit	200	200										200				Start-up loan
TOTAL				2,340	2,163	177	200		80	65	38	2	50		200	2	1.700		

In summary

If you use these three spreadsheets then you shouldn't go too far wrong. Any mistakes you make along the way should be easily rectified by your accountant.

What about PayPal?

As more and more people are buying products and services via the internet, it's advantageous to have a facility for accepting payments online. Accepting online payments can improve your cash flow significantly.

If you're unsure of the level of online sales you are going to make, then PayPal is a quick and easy method for collecting payments from customers. As PayPal is a recognisable brand, many of your customers will already have confidence in using it as a payment method.

Key points

- Your customer doesn't have to be registered with PayPal themselves and can pay using a range of credit and debit cards, bank transfers or even their own PayPal account balance. Though it is advisable for most consumers who pay for goods or services online to set up a PayPal Account.
- There are a range of business account options available, depending on whether you want to accept multiple currencies, use integrated PayPal buttons on your website or even accept payments over the phone.
- The fees per transaction can be higher than having your own merchant banking account, but PayPal is efficient, works on a global basis and is quick and easy to set up.

Bookkeeping and PayPal

- It's vital to retrieve your total income, fees, charges paid and balance transfers every month. These can be easily downloaded from PayPal in the form of a bank statement.
- To keep things simple, open one PayPal account for any purchasing transactions you make for your business, and have a separate account to accept payments from customers.

 You must keep all personal expenditure separate from your business PayPal account, just as you would from your business bank account.

Read more about trading online in the next chapter.

Records to be kept

Records must be kept for six years. So if you start trading in 2017–2018 you would have to retain your records until January 2024. This means storing all your physical records in boxes, and keeping any digital documents or scans of important papers securely stored and backed up.

- Keep all receipts/invoices of sales and expenditure in good order, filed by month, clearly labelled and organised, i.e. not in a jumble of unnamed digital files, or in a massive heap on the floor.
- Keep evidence of all expenditure and sales, such as all supporting documents relating to business transactions, including business and personal current account bank statements, as well as deeds, contracts, insurance records, important email correspondence, vouchers and receipts.
- All creative businesses should keep stock and work-inprogress records, and details of money introduced into the business from savings, grants and loans from relatives or banks. Also make a record of money taken from the business for personal use, usually referred to as 'drawings' for artists and designers who are sole traders.
- Keep a full set of accounts, using Excel spreadsheets, an accountancy software package or cloud-based system such as Xero, of all payments coming in and going out. You may need to keep two to four spreadsheets for each month.
- Keep summaries and documents relating to any indirect or dual-use expenses, including fuel/petrol, domestic rent, domestic mortgage, council tax and utility bills such as electric and gas.

Interior designer

Audrey Whelan

Audrey Whelan is an Irish interior designer who studied interior and furniture design at the Dublin Institute of Technology. After graduating, she moved to London and worked in a number of different design roles, before setting up her own business in 2009. She began by working in partnership with the paint brand Dulux – running the Dulux Design Service franchise in North London – and then progressed on to develop her own brand Audrey Whelan Interior Design in 2015.

Audrey works on both residential and commercial properties, designing interiors and bespoke furniture. Projects range from one room or office to an entire building. She starts by developing design concepts, then sources and supplies all of the elements involved including wallpaper, textiles, furnishings, as well as fixtures and fittings. Projects can also require a number of other services, including commissioning makers, onsite management of tradespeople and overseeing workmanship.

You can find out more about Audrey and her work at www.audreywhelan.com. Her five essential tips are:

1. Establish a business mindset

One of the benefits of being a franchisee is that you have a powerful and well established brand behind you. This gave me, as the franchisee, the confidence to start trading at a far more ambitious level than I would have been able to if I had been on my own.

2. Pressure can be liberating

One of the key requirements to buying my initial franchise license was to be registered

as a limited company with Companies House. So from day one I felt I had made a serious commitment to this business model and I was going to stick with it.

3. Credibility

One of the difficulties of starting out on your own is that it takes time to establish a trustworthy reputation. Being a member of an association, or collaboration or partnering with an existing brand or organisation can boost your credibility.

4. Get an accountant

Unless numbers are really your passion, you will find that hiring a professional eye to compile accounts and returns means that you can focus your energies on what you are best at! Accountants can also guide you through the complexities of setting up a limited company and all that this entails.

5. Join a network

When you start a business you can sometimes feel a bit isolated. My advice is to get out there; it can be good to be part of a business community.

RESOURCES

Please also view websites listed at the end of Chapters 1, 2, 3, 4, 5 and 14

Tax, self-employment and company registration

UK

HMRC, www.gov.uk/hmrc www.gov.uk/student-jobs-paying-tax Companies House, www.gov.uk/companieshouse

Europe

List of tax and business registration across the EU, http://ec.europa.eu/taxation_customs/common/links/tax/index_en.htm www.ebr.org/

US

www.irs.gov/Businesses/Small-Businesses-&-Self-Employed/Checklist-for-Starting-a-Business https://americansabroad.org/

Canada

www.cra-arc.gc.ca/bsnsss/menu-eng.html http://travel.gc.ca/travelling/living-abroad/ taxation

Australia

https://www.ato.gov.au/business/starting-your-own-business/registering-your-business/www.business.gov.au/business-topics/starting-a-business/Pages/default.aspx

Bookkeeping/online solutions

Easy Accountancy, www.easyaccountancy.co.uk/ resources/free-bookkeeping-template-software. html (free bookkeeping spreadsheets) Xero, www.xero.com/uk/ (not free) FreeAgent, www.freeagent.com/ (not free)

Tax and accounting services

Please note that details of tax rates and allowances given in this chapter are subject to change. In future, devolved governments such as Northern Ireland, Scotland and Wales may vary their taxation policies from those of England.

Please check www.gov.scot/, http://gov.wales/ and www.northernireland.gov.uk for more information.

For current updates about taxation matters, visit www.gov.uk/income-tax-rates

www.gov.uk/expenses-if-youre-self-employed www.gov.uk/simpler-income-tax-simplified-expenses/working-from-home Association of Chartered Certified Accountants, www.accaglobal.com
Institute of Chartered Accountants in England and Wales, www.icaew.com
Tax Aid, www.taxaid.org.uk
Federation of Small Businesses, www.fsb.org.uk
Pay on Time, www.payontime.co.uk (see 'Late Payment Guidelines': templates, late payment guides and interest calculator)
www.promptpaymentcode.org.uk/

Payment-taking apps

https://sumup.co.uk/ www.izettle.com/gb www.paypal.com/uk/home www.getalbert.com www.apple.com/uk ('Credit Card Terminal' and 'Timeworks' invoicing applications)

Books

The Designer's Guide to Trimming Your Tax Bill, Dean Shepherd (www.TrimYourTaxBill.co.uk)
Tax Answers at a Glance, H.M. Williams (London: Lawpack Publishing)
101 Ways to Pay Less Tax, H.M. Williams (London: Lawpack Publishing)
Bookkeeping Made Easy, Roy Hedges and Roger Walkley (London: Lawpack Publishing)

Websites, blogs and social media

'A new world organ for the collection, indexing, summarising and release of knowledge ... The phrase "Permanent World Encyclopaedia" conveys the gist of these ideas ... a world synthesis of bibliography and documentation with the indexed archives of the world.'

From 'World Brain', a collection of essays by H.G. Wells (1866–1946), author and visionary

It's difficult to know what H.G. Wells envisaged when he wrote this; was it some form of democratised encyclopaedia such as Wikipedia, or a wider concept like the World Wide Web and the Google search engine? What is certain, though, is that by the time this book is published the technicalities of websites and the forms of social media may well have changed. So readers will have to forgive the lack of some precise technical detail and refer to the internet for the latest specifics of digital systems and widgets.

Websites and trading online

'The faster, more automated, globalised and virtual things get, the more people will be interested in slowing things down, physical tasks, craft and provenance. It's about balance, scale, satisfaction and trust.'

Richard Watson (1964–), visionary thinker and author

There are so many ways of promoting, showcasing and trading online – such as Etsy, Bouf, Ispot and Behance, to name a few – that many artists and designers are starting to wonder whether they actually need a website. I am sure that things won't have changed that dramatically by the time the ink dries on this page,

and it will still be vital that you have a modern, responsive website and blog which are fully integrated with social media and from which you can securely sell your artwork, products and services.

Basics of setting up a website

There are several types of software for setting up a website on which blogs, galleries, and online shops can be created. At the time of writing, HTML5 and WordPress are far and away the most user-friendly and fashionable. I would stay away from any template systems or online web builders which you can't fully control, and which might require endless subscription payments. Some of these 'free' website creator solutions actually own your domain name and have strange email forwarding arrangements. It's far better to buy your own domain name, rent your own space from a reputable web hosting company and commission a web designer to create you a site based on a selected 'theme' and tailored to suit your needs. WordPress is child's play to update yourself once a website has been designed.

Design format, navigation and styling

It's vital that visitors or shoppers can search and navigate your website quickly. Design your site to guide visitors to where you want them to be, e.g. to make contact with you, make a purchase, place an order, pay to attend a workshop or confirm attendance at an event (e.g. via Eventbrite). Often artists and designers only show their work as basic images or placed in isolation in a white space. Things have moved on, and visitors now expect lifestyle shots of your artwork or products in domestic, gallery or business settings, including different views, such as close-ups, or items worn by a model. The styling of your site is also essential; banner, tiling and button websites can start to look a bit samey, so it's vital that you think through the format and use original design and images to make your website stand out.

Checklist for trading online

The key thing is to make sure when you buy your hosting space that you purchase a security certificate for your website, often referred to as an SSL (Secure Socket Layer) certificate. It's now essential to purchase a certificate from your hosting company even if you are not selling online. Google has de-ranked all 'unresponsive' websites and also those without a security certificate. This is what leads to the 'Oops!' 'Website not found' or 'security certificate' messages on Google for unsecured sites.

Make sure you also have security plugins for your website, such as Wordfence, to prevent hacking or other security attacks.

With the rise of credit card fraud, card companies have issued the Payment Card Industry Data Security Standard (PCI DSS), which requires all organisations that take card payment information directly to audit their IT systems and procedures and secure their servers. This can be prohibitively expensive, so most businesses use a third-party PSP such as PayPal, World Pay or other mobile payment systems.

It's sensible to find a payment solutions provider that suits your needs. I personally believe PayPal is the best solution at the present time, as it can also receive payment via email invoicing and works across all devices, e.g. via smartphone app or desktop website.

Arts Thread's homepage, the portfolio platform for emerging creatives

Search engine optimisation and registration

The first thing to do once you have purchased your domain name and hosting space is to understand that in order for clients, customers or collectors to find you, your website needs to be optimised in a number of ways. My advice to you is if you are not IT savvy then find a freelance web designer to undertake these tasks for you; or alternatively you can teach yourself in a number of ways from reading books or articles on the internet, watching YouTube videos, or attending a short course.

Meta tags and meta description

Meta tags can be an aid to search engine optimisation. They consist of a title, a description and key words/phrases. When a user searches for a website, the search results will feature this title as a link and the description below. When visiting a website, the title also appears within the top bar of the browser. Note that key words/phrases are not visible to visitors. Meta tags are placed within the code on each page so that the pages are accessible to search engines.

Key words/phrases are terms such as 'WordPress website designer' that are entered into a search engine such as Google in order to find websites that you're looking for.

The 'meta description' field is becoming the preferred system used by search engines. A meta description, which can be embedded into every page of your website, should contain one to two short sentences rich in keywords that best explain what that particular webpage is about. Search engines such as Google use this description in their public search results to describe the webpage.

Google AdWords and adverts

However, meta tags and descriptions are no longer sufficient on their own to bring you up on the first page of Google search results. Many businesses find 'pay-per-click', AdWords advertising or paying for other types of adverts useful, though expensive, particularly for popular words like 'design' or 'handmade'. It can be fruitful, especially in the first year or so of trading. Paying for this type of advertising will ensure priority positioning at the top or the right-hand side of Google's first page. It's also worth

considering niche keywords relating to your business that are a little cheaper.

Equally, some Google users put more trust in the more traditional ranking system than in sponsored adverts. I would say, if it's right for your business model and within your means, it may be worth giving AdWords a go.

SEO

In many modern WordPress packages, whether for blogs, websites or integrated platforms, search engine optimisation (SEO) tools are often installed on your dashboard. (The dashboard is a screen in the administration area of your website; it's a kind of editing suite, which only you or your web designer can access.) SEO is also the means whereby experts can improve your rankings by concentrating on the use of key words and fostering inbound or reciprocal links. Most search engines provide various free guides about SEO, but they are usually more keen on you purchasing one of their advertising packages.

Google Analytics

Google Analytics is a free demographic tracking tool, which tracks and reports how users are interacting with your website. Google Analytics can be accessed directly once you or your website designer has set it up by embedding a small amount of code into every page of your website. It's also helpful to have a mini view of Google Analytics maps and visitor stats embedded into your website dashboard.

Selling online and e-commerce payment gateways

There are numerous ways you can sell online; one of which is by having your own shopping cart on your website, where you can either set up your own secure merchant account with your bank, or use a third-party service such as PayPal, Apple Pay or Android Pay.

It is preferable to use a third-party service, unless you are taking hundreds of orders a day, in which case, setting up a merchant account with your own bank would be the way to go.

I think it's best when artists and designers have their own shopping carts as a 'shop' or 'gallery' integrated into their website,

as this looks more professional. It's also worth experimenting with selling your products on other platforms, such as Not on The High Street, Bouf, Etsy, Amazon Marketplace, Art Rookie, etc.

Most third-party payment service providers (PSPs) now have step-by-step instructions, free trials and tutorial videos on their websites for basic shopping cart systems. Popular shopping cart systems include Paypal, Shopify, Volusion, Big Commerce, Open Cart (OS), WooCommerce (OS) and Magento (OS). (OS stands for open source.) However, if the cart system is to be custom-built it can become beyond the means of small creative businesses. It's best to hire a web designer and use recommended shopping cart software that best suits your commercial needs.

A couple of legal issues and key regulations

There are a large number of regulations in regard to trading online; here are a handful of important ones.

Data protection

If you are gathering customer data (collecting and storing it digitally or even as paper records), you must also comply with the Data Protection Act 1998 and register if based in the UK with the ICO (Information Commissioner's Office) by visiting www.ico.org. uk. This costs £35, unless you are making over £25,900,000!

Consumer contracts

As mentioned in Chapter 9, most countries around the world have some form of 'distance selling' regulations; please refer back to Chapter 9 (page 196). It's important to comply with regulations not only in your own country but also with where your customers are based.

Contact details

Under the Electronic Commerce (EC Directive) Regulations of 2002, even if you are self-employed your website must display your business name (i.e. your own name if using that), trading address, email and phone number. If you are living in a studio flat and this idea makes you a bit nervous, just retitle it 'Studio no. 8' for example, to give a more bona fide appearance.

Under the Companies (Trading Disclosures) Regulations 2008 a limited company must, in addition to their telephone and email details, display their company name, place of registration, registration number and office address.

W3C validation

For best results your website should pass the W3C validation at http://validator.w3.org, which checks for HTML code errors and flaws.

Some final observations

Many artists and designers still don't understand about email forwarding. Forwarding can be set up from your domain/hosting company's online control panel, which you should have login details for. So if your website is www.abeginner.co.uk, you might like to have hello@ or info@abeginner.co.uk as your business email address, and mail received at this address could be forwarded to your ISP email e.g. AOL, TalkTalk, Virgin, etc. or to a web-based email account such as Hotmail, Yahoo or Gmail.

Anyone who has attended one of my lectures on this subject will know, and as mentioned in Chapter 6, I don't think it's wise to run a business from a transient, web-based account; you are much better off using your ISP's email service in your own email system.

A Beginner Artist abeginner.co.uk ainfo@abeginner.co.uk 209741 74* ***** 1 +44 (0) 20 836* **** 4 a.beginner1 studio, office or home address 2

A more professional-looking business card with email forwarding (remember to include an image or design on the front side and contact details as indicated above on the back)

Making new connections

'In Britain, for example, it meant a centralised "nickname" system could be introduced. Under this scheme, companies and individuals could reserve a special word as their "telegraphic address" to make life easier for anyone who wanted to send a telegram.'

From The Victorian Internet (1998), Tom Standage (1969–), journalist and author

If telegraph innovators William Fothergill Cooke, Charles Wheatstone, Samuel F.B. Morse and of course Thomas Edison were here today, I am sure there would be a collective raising of bushy eyebrows – expressing some surprise that, not only can the world communicate without copper wires, but in a real sense that very little has changed since the nineteenth century. The telegraph has strong practical similarities with social media and chat apps, such as brevity, frequency and the use of text codes or acronyms.

Recently, many people have moved away from speaking and composing emails to interacting via apps and social media. Whether the world will tire of this mode of communication and engagement is anyone's guess. I fear that though we are in contact with more people than ever before, it is at the expense of the development of important business relationships. Progress in business often comes through knowing people well, and I would still recommend phoning and having proper meetings with people in some cases to stand you in good stead for the future.

Social media: the basics

However, that said, social media is becoming an immensely powerful tool in attracting potential customers from around the world. But it is also the case, as mentioned in Chapter 6, that a social media strategy might not be the right approach for every business.

Your social media presence needs to be right for your particular arts practice or design business, and what works for one creative business may not work for others. It's vital that you don't just use your pages to spam followers about 'project me', and that you

engage with others, by posting, sharing, tweeting or retweeting stories that will be of interest to them.

Make sure you familiarise yourself with image sizes, formats and the styling of your photographs or images, so that your images are adaptable for different formats and applications.

Exploring networks and viral marketing

You need to think through your social media presences carefully; remember you are trying to find clients and customers, not just attract your contemporaries and potential collaborators. Each type of social media platform carries with it a particular demographic; for instance, the majority of Pinterest users are women, whereas on Twitter the majority are men. People are on social media for different reasons: some use it for fun, but others will use it for business purposes.

Unusual projects, publicity stunts, hashtags such as #AprilFool, hot news and intrigue are the ingredients of viral marketing. If your #hashtag or name is trending and there are thousands of hits on your link, website or YouTube film, these are all successful indications of an engaging and well-timed online marketing campaign.

It's also worth including a 'Call To Action' (CTA) on your chosen social media outlet, where you encourage your followers to click through to access a generous discount code, free gift, a chance to win, book a place, place an order or buy now!

Keep your eye on what your contemporaries or competitors are up to; learn equally from their PR hits and misses.

How to build a social media presence

A slow but steady way to build up followers is to follow, chat and share or retweet other people's posts that would be of interest to the audience that you would like to attract. A quicker way is to just follow a large number of people, organisations and anyone using a key # hashtag relevant to your business, such as #fashion or 'hour', e.g. #jewelleryhour, #artistshour, #handmadehour. Refer to page 266 for a useful list of hashtags. Hashtags work in slightly different ways on different social media sites, so check how others make use of them if new to this subject.

Social media can be a powerful tool to engage customers from around the world

Equally there are also free systems such as Crowdfire where you can follow large numbers of people in your target audience quickly. But avoid doing a mass follow all at once, as people can tell if they visit your page. Also don't follow people, then immediately dump them as soon as they follow you. Many large corporate businesses do this and I believe it to be abusive. Remember the 'social' in social media: it's not all about you.

Alternative promotion

Take advantage of the various #hours out there (see page 266 for a list), use key terms, post invitations to free events or post unusual photographs, interesting news, links to films, vlogs or blogs. Run giveaways, competitions, prizes and offers, give out media codes and share where you are showcasing with 'Come and see us', #savethedate, etc. Make sure you visit AddThis, and embed social media 'share' buttons on your website. Include 'follow us' buttons, and perhaps a live Twitter feed on your homepage. Encourage people to follow you or your business by adding social media links or addresses on your business cards, blog, email signature or eNewsfeeds.

IP tagging and protecting your images online

As mentioned in Chapters 5 and 9, an IP tag is an embedded QR code and tiny URL, and can also include a logo, symbol or

monogram associated with your creative business or arts practice. Creative Barcode is a popular provider of this service. It is possible to generate QR codes for free using websites or apps, but I believe it is more professional to use a reputable paid-for service, such as Creative Barcode. This enables you to control where the tag is positioned, and what metadata or information is embedded, such as who owns the copyright or how the static or moving images can be used, etc.

A couple of good things to remember

Remember that in many parts of the world 'collective licensing' is permitted under license of 'orphaned works'. The UK government is now licensing orphan works via a register at www.gov.uk. To avoid ending up in this licensing system it is essential to make sure your images are easily identifiable. Even simply watermarking your images with your website, logo or name with the date and © symbol is better than nothing.

It's against many international agreements, also UK copyright law and WIPO to remove 'identifiers' with the intention of passing off, committing fraud or infringing a creator's rights by reproducing without permission, or of denying the right to be identified as the creator or copyright holder, e.g. by cropping off or removing a credit, signature, watermark, system code, IP tag or ISBN. If you do notice this, online or elsewhere, seek advice from your professional body or an IP lawyer. For more information on this please refer to pages 94–95 and Chapter 9.

Blog your art out

'What came to be known as the "New Journalism" reflected these technological changes by developing a characteristic style and page-layout of striking headlines, short paragraphs and abundant illustration.'

> Matthew Arnold (1822–1888), poet and cultural critic, article in Nineteenth Century (May 1887)

The phrase 'New Journalism' at the time when the quotation above was written was a slightly ironic term, reflecting the concern towards the end of the nineteenth century that 'light reading' might lead to the demise of serious journalism. Blogging, a modern development of this style of journalism, can take many forms, and even senior mainstream media correspondents blog on a regular basis.

In the contemporary art, design and business worlds, bloggers and vloggers can have huge influence if they give a five-star rating to a movie, write a favourable book review, or rave about a product. However, blogging is not for everyone, and it can be difficult to maintain original, interesting content. Equally, there are many poor-quality blogs and plenty that are little more than a thinly disguised sales pitch.

Setting up a blog

The best way to start is to set up a free blog on Tumblr, Blogger or WordPress, either as a standalone web presence or linked to your website. This is a very straightforward process – no more complicated than creating a document in Word or composing an email. These free systems are also integrated with social media, so it's easy to post to your timeline, page or feed.

An engaging blog can connect and draw in new clients However, I think it's more professional, perhaps after an initial period of experimentation, to have your blog within your own website, rather than one hosted on a separate free blog site. Most systems, such as WordPress, offer a blog widget or 'plugin' that will integrate your blog seamlessly with your template theme or design format.

Key benefits and raking in the cash

There are bloggers who make money from their blog through product endorsement, or monetarise it by displaying banner, payper-click adverts or other affiliated marketing schemes. This type of activity is not wise when blogging about your own arts practice, design business or micro-enterprise, unless your business model is some form of creative eNewsfeed, industry support or portfolio site, which needs to raise revenue from advertising or other brand associations to keep its services free.

The key benefit of a blog is to connect and draw in new clients, collectors or customers to your website. It is mainly to inform and excite people about new products or offers, but it should not always be about product or service promotion. Have a look at blogs by artists and designers you admire, or successful competitors' blogs, and see what sort of features, articles, interviews or reviews draw people in. It depends on your energy levels, the size of your business and the level of engagement from your customers, whether you make a blog post every season, month, week or day.

Think very carefully about your use of photographs: make sure they are the right pixel width, for instance, and set your own design format rules about how you compose your pages. Don't be inconsistent or use poor-quality images. Make sure, if using images of your products, that they are not always the same, e.g. always on a white background or always with yourself as the model.

Should I dump my press page?

For many years now artists and designers have had a press page, where they either displayed previous media coverage or had materials that would help journalists or fellow bloggers circulate news of an exhibition, achievement or the launch of new products, etc.

Often you find that blogs are now used to draw attention to a recent feature on a design trend portal or in an arts periodical, forthcoming news about an event, or winning a competition. I think it is still useful to have a press and features or publications section of your website, but don't neglect it. Use it; include your forthcoming events, and key features in lifestyle portals or magazines, make rights-cleared images available, and include a downloadable media release, profile statement and other useful background information such as key achievements and useful links. 'Press' can also be a category within your blog, so when visitors click the 'press' tag, all related posts come up, which can be very useful.

Guest blogging: should I be paid?

This is becoming an increasingly thorny issue; so many larger businesses or media outlets expect contributors to blog or create content for free, in return for providing links to your own website or store. I personally think that doing the odd unpaid post for a well-known organisation, professional body, brand or news portal can help with building credibility through association. However, it's pretty annoying that there is the expectation that you will work for free, and I think if asked to contribute blog posts or short articles on a regular basis then you should be paid a proper fee. Have a look on the National Union of Journalists' website for suggested rates.

A couple of good things to remember

As mentioned previously on page 254, make sure you have Google Analytics embedded in your website and blog. Take note of the numbers of people who are clicking through via social media links and reading your blog or attracting attention to it through sharing or retweeting links. Make use of LinkedIn or other online portals to post a small amount of content, to encourage even more potential clients or customers to click through to read or view more images. Blogging isn't right for every creative business, but it might well be for you; it could be worth attending a workshop presented by successful bloggers, or consulting an experienced web designer or social media experts in your field.

The online portfolio website

Alex Brownless and Katie Dominy

Alex Brownless and Katie Dominy are co-founders of ARTS THREAD ®, which they set up jointly in 2009. Grown up from humble beginnings, the business now operates globally on a transatlantic basis with offices in London and New York.

Alex originally studied to be an engineer before graduating with a textile degree at the University of Derby in 1993. He then went on to build popular rave fashion label NASA. Alex and Katie met at global fashion trend forecasting company WGSN, while Alex was the eBusiness manager and Katie was one of WGSN's first trend analysts. She is now a Laurence King author and consults for leading design publications.

ARTS THREAD ® is a digital online platform designed to connect students, graduates, art and design schools and industry exclusively in the field of creative art. They have established relationships with over five hundred educational establishments worldwide, such as the Royal College of Art, Pratt Institute New York, Istituto Marangoni, Domus Academy, and Central Saint Martins UAL.

For more information and to view or upload a portfolio visit www.artsthread.com.

Their five essential tips are:

1. Collaborate

Never think of other creatives as your enemy - you need to work with others. With regard to selling opportunities, build up a group of like-minded people with whom you can then pool resources, share stand space, promote each other, etc.

Have a consistent online presence

Keep the key messages you wish to send out about your brand consistent across all marketing channels. For example, use the same profile image on your website and across all social media and showcasing platforms.

3. Conquer social media

Many artists and designers feel daunted by the prospect of keeping all social media channels alight 24/7/365. It's best to choose the platform/s that work for you - don't feel you have to be on all of them.

4. Impeccable presentation

Work on the way you present your work to a store or gallery. Any paper portfolios need to be ruthlessly combed to show only your best work, and should be presented in a professional manner. Less is more. Do your research on the store or gallery - why are you right for them?

5. Image, image, image

The one thing that lets down the work of a new creative most is poor photography. Invest in some professional images, which will work across print, web, blog and social media formats.

RESOURCES

Hosting and name info/search engines

www.ukrea.com www.whois.net Nominet, www.nic.uk www.thename.co.uk www.myhosting.com www.3dpixelnet.com www.sitepoint.com

E-commerce and payment solution providers

Contact your bank about merchant payment options.

Google search 'credit card terminal apps' for Apple or Android smartphones. Please note a 'PDQ' (Process Data Quickly) hand-held device is something different. If you plan to do lots of fairs and you don't wish to use payment apps, then it might be worth looking into - refer back to Chapter 11. Your bank might be able to help, and if a member, these can be hired from the Federation of Small Businesses.

www.shopify.com or .co.uk www.paypal.com (most popular and easy to install) www.android.com

www.apple.com/uk/apple-pay/

www.worldpay.com www.protx.com

www.lynxinternet.com www.streamline.com

www.pavm.co.uk/

The law online

Orphan works,

www.gov.uk/guidance/copyright-orphan-works (how to apply for a licence and access to the register)

Consumer Contracts, www.gov.uk/online-anddistance-selling-for-businesses (distance-selling regulations)

Financial Conduct Authority, www.fca.org.uk Trading standards, www.tradingstandards.org.uk Information Commissioner's Office.

www.ico.org.uk

Technical

www.w3.ora http://oss-watch.ac.uk/ (Open Source Software Advisory Service) www.dropbox.com (free online storage)

Social media

www.facebook.com/business/overview www.twitter.com www.linkedin.com www.flickr.com www.gb.pinterest.com www.pinterest.com www.reddit.com www.voutube.com

Blogs

www.vimeo.com

https://feedburner.google.com (RSS (Really Simple Syndication) feed system) www.wordpress.com www.typepad.com www.tumblr.com www.blogger.com www.blogspot.co.uk www.mashable.com

Apps (find on Google Play Store or Apple iTunes)

Instagram Vine

Social media analytics

www.twitter.com/search-advanced www.twittercounter https://analytics.twitter.com www.facebook.com/help (help centre) www.klear.com (join up for stats and more) www.klout.com https://web.crowdfireapp.com www.tweetdeck.com www.hootsuite.com

RESOURCES

Other tools

www.addthis.com (find the code for social media share buttons)

www.google.com/alerts (track mentions of your name or products online)

www.google.com/analytics (free but needs to be embedded into your website)

www.google.com/business (links up your business to Google Maps for free)

Internet

www.bitly.com (shortening a link for redirection) www.eventbrite.com (online system, to promote events, take bookings and payments) www.mailchimp.com (online system to distribute eNewsletters)

www.wordpress.org (WordPress mobile pack, customise websites and blogs for phones)

Useful hashtags (Twitter, Pinterest, Facebook and Instagram)

#HandmadeHour #MadebyHand #CraftHour #JewelleryHour #FashionHour #VintageFindHour

#ArtistsHour

#CreativeBizHour #EnterpriseHour #FreelanceHour #B2BHour #Vloggerschat #CreativeCoding #NoFreeWork #BuyingArt #FBloggers #IdealGift #cbuk #Upcycle

Books

HTML5 and CSS3 All-in-One for Dummies, Andy Harris (New Jersey: John Wiley & Sons) Blogging for Creatives: How Designers, Artists, Crafters and Writers Can Blog to Make Contacts, Win Business and Build Success, Robin Houghton (Lewes: Ilex)

Online Marketing for Your Craft Business: How to Get your Handmade Products Discovered, Shared and Sold on the Internet, Hilary Pullen (Newton Abbot: David & Charles Publishers)

WordPress for Dummies, Lisa Sabin-Wilson (New Jersey: John Wiley & Sons)

Social Media Marketing All-in-One for Dummies, Jan Zimmerman (New Jersey: Wiley & Sons)

Innovation and future trends

'Designers always need to have a foot in the future while also having the other foot in the present ... so they can make the future happen by pushing innovation.'

> Paola Antonelli (1963–), senior curator of the Department of Architecture and Design, and director of R&D at the Museum of Modern Art, New York

Since the first edition of this book was completed, we have moved at breakneck speed into a whizzy world of instant and constant communication. In this first quarter of the twenty-first century. there is free global connectivity and numerous superbly efficient online galleries, shops and portfolio portals to sell artwork and products and to attract commissions. Smartphones are simply no longer just handsets; they are now complete interactive business solutions which fit neatly inside an average-sized pyjama pocket. The world has been transformed with new digital movements and emerging technologies. As you can see from the mind map on pages 272-273, there is a great deal going on.

The entrepreneurial environment

'Being enterprising is about "going into the unknown", experimenting and trying out new ideas.'

David Rae (1958–), expert in entrepreneurial learning

To move forward from Chapter 1, if an artist or designer is not only to survive but prosper in this post-financial-crash world it is essential not only to learn, but to master entrepreneurial skills, to adapt and discover new ways of creating and working.

Cultivating collaborations

Artists, designers, businesses and organisations have found strength through formal partnerships and more informal collaboration, rather than being in outright competition. There are more ways to work together than ever before, such as contributing to open source software projects, attracting manufacturing support via crowdfunding or setting up pop-up galleries with artist-led collectives.

Experimentation and taking risks

Making time to experiment is crucial. This reflective space is becoming more precious. Austerity is an increasing financial burden on our ability to generate income and has consequently put personal relationships under pressure. It's difficult to try out new things if you have no cash reserves or can't gain the support of friends or family in your endeavours. But to make new things happen, something has to give.

Creative regulation

Within the next twenty years I imagine that we will be moving to a global model of trading with globally integrated trading regulations, IP laws and registration systems. The internet, online stores and digital innovation are a driving force that will eventually bring this about. The European Union now has EU design right, trademark and patent registration systems; it also has new worldwide registrations for trademarks and designs.

It can be an overwhelming experience for a product designer when they realise the number of ecological and health and safety issues they need to comply with in relation to production and sales. But in order to grow and expand your business you will require a good working knowledge of a wide number of standards. For more on this, refer back to Chapter 9.

Crowdfunding and pop-up shops

There are numerous platforms for crowdfunding, where individuals, collectives and micro-enterprises can raise investment through donations and honouring pledges. Many such platforms operate on a global basis, such as Kickstarter and Indiegogo. The

first thing you need to do if you are interested in launching a crowdfunding campaign is to go and watch some successful previous bids for degree shows, pop-up shops or product development. It's important not to leave making the film and starting a campaign too close to your degree show or key launch date. Crowdfunding may seem like an exciting and easier alternative to getting a loan, and in a sense it can be, but it will still require a lot of effort.

Make sure you carefully read the terms and conditions of any crowdfunding portal, and find out what percentage they take; this is usually between 3% and 5%. Some portals, like Kickstarter, insist that you only have a set number of weeks in which to raise your money, and if you don't hit your target the funds are not awarded. Whereas Indiegogo (at the time of writing) will let you keep most of the money even if you don't quite make it, and they also let you continue to raise funds after the official deadline.

One key thing to know is that once you have made your film and organised your social media pages, it could still take a week or so for the film to actually go live, as each film has to be viewed before it makes the final leap onto the website and the campaign goes live.

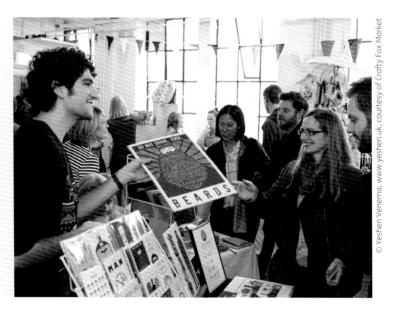

A recent pop-up Crafty Fox Market in London

It can be helpful to already have a reasonable social media following before you start, especially if you are up against the clock.

There are also crowdfunding portals for social or community projects such as Space Hive, and for personal aspirations such as GoFundMe. For more information, please see the resources section and Damien Borowik's profile on page 278.

Acting on opportunity

One of the problems I often observe, which is crucial to entrepreneurial development, is the failure to be responsive to opportunities. It's vital, for instance, if you have been given an introduction to have the tenacity to follow it up; don't leave it for weeks and weeks. Any activity in relation to media campaigns, retail, seasons or trends requires quick and early reactions. For example, Not On The High Street's Christmas catalogue is printed and ready for distribution by August; thinking about wanting to be in a Christmas catalogue in November is far too late. Be prepared to drop what you are doing if an unexpected opening should materialise – lucky breaks don't happen every week.

Innovation and technology

'Let not the carpenter become merely the servant of the machine. The machine should be the tool and not the dictator.'

From The Village Carpenter (1937), by Walter Rose (1871–1960)

I have a fear that one day many craftspeople, especially those working in construction, will find themselves replaced by on-site 3D printing, cutting or fabrication machines. Even the European Space Agency has plans to fabricate a lunar base made by these types of machines, and NASA has been experimenting with printing acrylic tools on the International Space Station. All of this is now achieved without the intervention of the artisan's hand.

However, artists, designers and creative businesses should not fear these advances, but should exploit new technologies to their own advantage, generating new, brilliant opportunities and positioning themselves at the forefront of their sector or industry.

Recent innovations

One of the most fantastic recent developments for emerging artists and designers is 'product on demand'. Merchandising is not the same as product on demand: merchandising suppliers apply designs or artwork to key rings, mugs and tote bags on a minimum order. These types of branded products are usually inexpensive gifts for clients, customers or an audience at a gig or festival. Product on demand is quite different. It's an online service whereby images or designs can be rendered onto any quality product. Anyone can order selected goods and the company will produce the product and take care of packaging and postage.

All sorts of innovations are occurring in the digital realm, such as 'disruptive technologies', which is a term continual evolving in its definition. Arguably it's where new markets are created that shake up an industry to such an extent that it leads to a sudden collapse in demand for a particular product or service, e.g. from letter to telegram, through to Bell's telephone, evolving into email and texting, then personal communication shifting on again into social media chat apps.

'Immersion' Virtual Reality Experience, MA Computational Arts show at Goldsmiths © Damien Borowik, 2013, www.dborowik.com/immersior

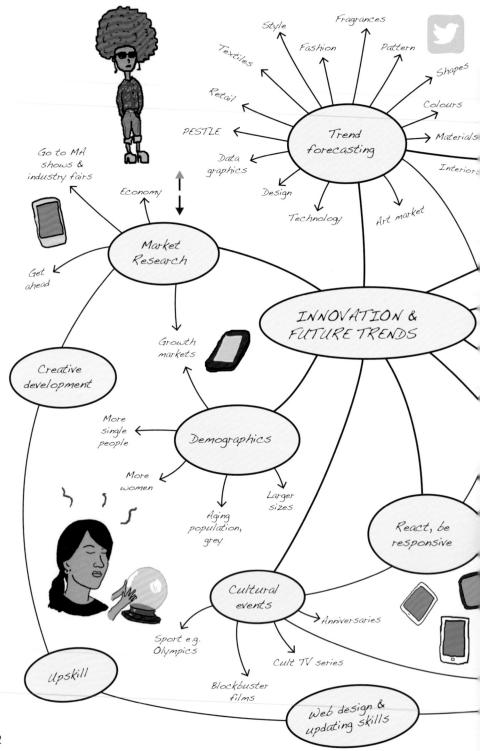

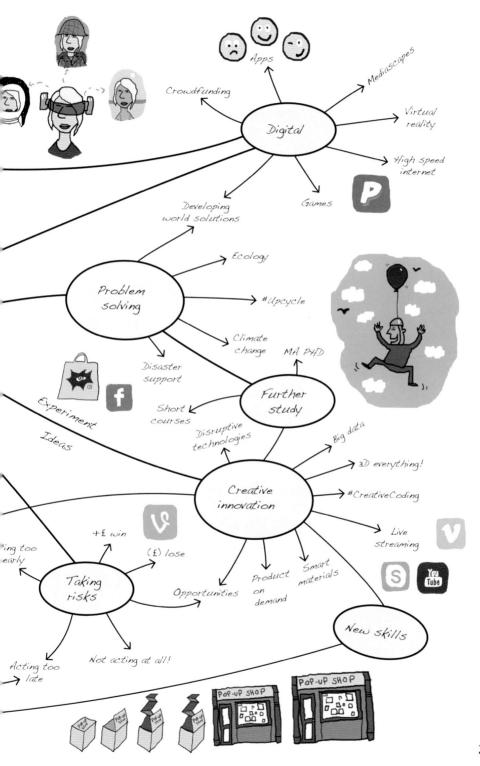

'Creative coding' is a new form of programming whereby a community of artists create images, objects, animations, sounds and installations through generating expressive content via software, shared coding libraries or algorithms.

3D printing, fusing and laser sintering are other amazing innovations which have revolutionised the way products are manufactured and distributed across all industry sectors and materials.

Exploring key legal issues

All innovations bring with them new challenging situations regarding issues such as ethics, data protection, safety and intellectual property. The Periscope app, for instance is a good example of this, as it has thrown up a number of issues such as broadcast rights, musical copyright, moral rights and privacy issues.

Are we witnessing the end of copyright?

Richard Watson, on his extinction timeline, predicts the end of copyright in 2020. I'm not sure I totally agree, but it's an endangered species for sure. Google, and popular social media sites that encourage public 'sharing' but firmly embed a mandatary universal copyright licence into their terms and conditions are certainly concerning in this respect.

Where will rights reside in the future?

We will have to wait and see. My own view is that very soon the value of copyright or design right could lie in the coding to make products on 3D printers or in other digital formats. It's possible that in the future images posted on numerous social media websites will acquire a 'junk' status, whereby creators will lose the value of their copyright due to multiple licence holders and the sheer numbers of copies, retweets or shares. In terms of exploiting rights for financial gain, the only winners will be global search engine and social media companies. Think carefully about how and why you are posting images of your work. (For more on rights please refer to Chapter 9, page 174 and Chapter 14, page 290.)

Creative development and future trends

'As soon as you become complacent in any creative industry, then there is somebody in the fast lane overtaking you.'

Paul Smith CBE (1946–), fashion designer

This relentless pace of change in styles, apps, software and technology is an additional challenge. Many designers find it a struggle to use the latest industry software due to the new 'cloud'-based subscription systems. Maintaining access to large machines, knowledgeable tutors and digital technicians can also be a huge problem once art and design students graduate.

Why do I need creative development?

There are always challenges facing creators at all stages of their careers, practice or business. As Rob Dakin mentions at the end of Chapter 14, it's vital to keep learning new creative, technical and digital skills. This can be achieved by attending conferences, short courses or pursuing advanced levels of study to MA or PhD level. The responsive format of the World Wide Web, internet communication, wearable tech, Oculus Rift and virtual reality

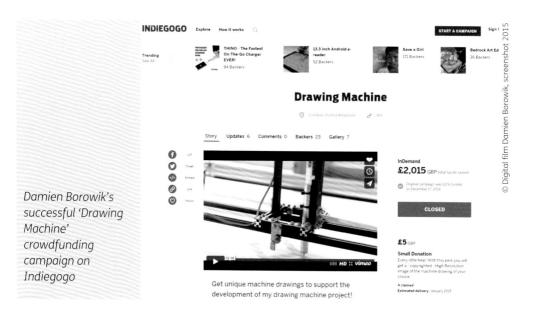

experiences have now changed how we like to see and engage with the world. It's essential that you invest time in exploring new concepts and directions; step up to the challenge.

The importance of market and demographic research

As you can see from the innovation and future trends mind map on pages 272–273 there are a number of topics you need to investigate before starting out, as well as on an ongoing basis. One point I must repeat here from Chapter 3, is that it's very important that you don't base your entire understanding of business from posts you see on social media.

Undertake thorough market research, understand demographics. Who are your clients, collectors, stockists or customers? Where are they, what do they earn, do they have children?

Failure to understand demographics, especially in relation to taking on retail units, can lead to financial disaster. For instance, I often see children's toy or clothes shops spring up in Islington, a borough north of the Thames in London, only for them to close down a short time later. Islington has the highest proportion of single adults of anywhere in the UK; 60% of the inhabitants have never married and a further 11% are widowed or divorced, so a total of 71%! (ONS, 2011 Census/Population Data.)

How to spot new trends

Learning how to spot business, cultural, social and economic trends is addressed in the thinking and making connections 'PESTLE' exercise in Chapter 14. But from a practical point of view you need to read your industry periodicals/portals, blogs or newsletters. Avoid snapping or screen-saving content on your phone, unless you regularly make use of stored data. Instead, take time to read good quality print or online broadsheet newspapers, develop a wider view of the world and what is going on. Attend conferences, fairs and expos, read books, watch TED talks and interviews with established artists and designers on YouTube, Vimeo or mainstream media. Investigate, listen, make notes, bookmark and absorb these influences and information sources fully.

What are trend forecasting organisations?

You might be surprised to learn that there are specialist trend forecasting organisations, and numerous trade publications on the subject. Many large-scale retail stores purchase official trend reports from professional forecasting companies such as Color Hive, The Future Laboratory, WGSN, Adorn Insight, Mode and others. These reports forecast consumer trends and themes for seasons up to four years in advance. However, individual makers can gain insight from more affordable subscriptions, or by attending forecasting events, where details of interior, product or fashion design trends are released eighteen months ahead.

How do I apply this knowledge to my own arts practice or design business?

Whether it's through subscriptions to industry periodicals such as *Drapers* or via a trend forecasting periodical or app, this information can help you understand where your own artwork or products will fit into future trends. Being aware of what stylists or buyers are looking for will give you an advantage in terms of editorial coverage and will allow you to widen the appeal of current or forthcoming products or collections.

Every product, soft furnishing, textile or interior designer should subscribe to *Mix* magazine if they wish to know what the lifestyle or decorating magazines, stylists or retail stockists will be procuring or stocking for the next season.

In summary

It's vital to be aware of trends and innovations and, as discussed in the next chapter, plan a business for growth. Sometimes trends can be predicted, often they can't, and frequently a particular activity is popular for a period of time and then suddenly fades away. A significant innovation could make productivity more sophisticated, or enable you to manufacture more cheaply and efficiently. Equally evolving technologies could disrupt or end the sale of a key product or service.

To achieve profitability in a sustainable way you must be alert to any kind of change in your industry, sector or market.

Digital craftsman

Damien Borowik

Damien is a French artist based in London, with an atypical background. After obtaining a scientific mathematics baccalaureate, he studied applied arts and visual communication in France. He then furthered his studies in graphic design at Central Saint Martins and also completed a master's degree in computational arts at Goldsmiths University.

His practice is a fusion of art with digital and analogue technologies. He is at the forefront of this emerging movement, taking part in projects and exhibitions such as Christian Dior Couture, Samsung Electronics, the Kinetica Art Fair and the Love festival at the Southbank Centre.

After initial prototyping, he gained support from a crowdfunding campaign on Indiegogo to develop his Drawing Machine.

Damien's projects and artworks can be viewed at www.dborowik.com and www.drawingmachine.com.

His five essential tips are:

1. Innovation and lifelong learning

Be the vanguard of your practice. The moment you stop breaking new ground is when innovation ends. Reworking old ideas can be a helpful process: new insights can be gained and then applied to future projects.

2. Be interdisciplinary

If you can't do it all yourself, get together with experts in other fields. Innovation is often found at the crossroads of disciplines. To create new ground, the trick is to be able to communicate well between practices, and there is nothing like a collaborative project to achieve this.

3. Promote a crowdfunding campaign

Have a budget and a plan of action to promote your crowdfunding campaign. Create a launch event to celebrate the start of your campaign, and participate in as many events as you can where you can talk about your project. Involve your local press and give regular updates to your followers on the crowdfunding website and on social media.

4. Make an enticing video

In today's visual world, a well-prepared video is a must. Time it well – no more than three minutes – and have the main speaker in the frame while talking. Make sure you can be heard clearly; tie-clip microphones are useful and inexpensive.

5. Offer attractive pledges

It's best to have a range of pledge offers ranging from a couple of pounds rewarded with thanks on social media, to more lavish tokens and services for higher-end donors. Encourage family and friends to make early pledges, as there is nothing worse than a campaign starting with no funds.

RESOURCES

For information on crowdfunding, please see the resources in Chapter 14

Trend forecasting

There are official organisations who forecast trends, businesses that observe trends and offer consultancy, and then there are a large number of portals and bloggers who disseminate and supply trend news.

www.professionaljeweller.com (jewellery trends) www.silkfred.com (fashion trends) www.shopcade.com (fashion and product trends)

www.snapfashion.co.uk (fashion styles/trends)
lookbook.nu (fashion trends)
www.fashiontrendsetter.com/
https://patternbank.com (fashion/textiles)
www.trendstop.com (fashion)
www.thetrendboutique.co.uk (fashion)
www.trendbible.co.uk (fashion)
www.vogue.com (fashion)
www.vogue.com (fashion)
www.bc.co.uk/news/blogs/trending/
@bbctrending #bbctrending
www.pantone.com/trend-forecasting (fashion
and design)
www.pantone.co.uk (search for trends, fashion
and design)

Research

The Fashion Council, www.britishfashioncouncil.co.uk (view 'business support') Crafts Council Resource Centre, www.craftscouncil.org.uk Telephone: 020 7806 2501

Trend organisations

www.artlyst.com www.wgsn.com (product and fashion) www.drapersonline.com/ (fashion industry/ shows/trade news; not free) www.colourhive.com (offers global trend forecasting for interiors, design and other sectors, various publications, Mix, etc.) www.thefuturelaboratory.com (trend forecasting for design, also perfume, food, retail) www.trendvisionforecasting.com (jewellery trends) www.adorninsight.com (jewellery trends) www.adorn-london.com (jewellery trends) www.psfk.com (trend forecasting for retail innovation, etc.) www.modeinfo.com (textiles, also publish a number of trend journals for clothing trends) www.artnet.com (art market news/research: not free for specific info) www.shutterstock.com/trends http://stories.gettyimages.com/category/visualinsights/visual-trends/ (series of free creative photography trend reports on 'visual trends')

Market research

www.mintel.com/trendsinnovation (reports cost £10–£25)
Market Research Society, www.mrs.org.uk www.cobra-express.net
www.scavenger.net
(factsheets cost £5.99 upwards)
British Library, www.bl.uk
(business resources and workshops)

Demographic statistics

Your government or local council will also have demographic data about your region, town, borough or city

www.ons.gov.uk
www.gov.uk/government/statistics/
announcements
Professor Danny Dorling, www.dannydorling.org
(demographics expert and publications)
www.guardian.co.uk/news/datablog (occasional
exciting demographic information graphics)
www.bbc.co.uk/news/blogs/trending (for global
cultural trends and social media stories)

RESOURCES

Design trends and innovation

www.designboom.com (design) www.productandplacement.com (interesting art/design project) www.design-milk.com www.desianTaxi.com www.itsnicethat.com www.ideo.com www.youngcreativecouncil.com www.creativereview.co.uk www.designweek.co.uk www.random-international.com www.bbc.co.uk/click www.barbican.org.uk/digital-revolution www.guardian.co.uk/technology www.nesta.org.uk www.newscientist.com www.sciencemuseum.org.uk www.hhc.rca.ac.uk www.innovation.rca.ac.uk. www.12foot6.com (illustration and animation) www.apple.com (art/design software and products) www.adobe.com (art/design software and products) www.wacom.com (art/design software and products) www.artcam.com (art/design software and products) www.thebis.org (inventors) www.ted.com (online videos, technology, entertainment and design) www.nowandnext.com (Richard Watson)

Books

It's Not How Good You Are, It's How Good You Want to Be. Paul Arden (London: Phaidon) Whatever You Think, Think the Opposite, Paul Arden (London: Penguin Books) Contemporary books inspired by Arden include: Shine: How to Survive and Thrive at Work, Chris Barez-Brown (London: Penguin) Free: Love Your Work Love Your Life, Chris Barez-Brown (London: Penguin)

Design Your Life, Vince Frost (Penguin import available from http://designyourlife.com.au/) Plus a number of books published by 99u.com

including:

Manage Your Day-to-Day: Build Your Routine, Find Your Focus & Sharpen Your Creative Mind. Jocelyn K. Glei (Amazon Publishing)

Maximise Your Potential and Make Your Mark: The Creative's Guide to Building a Business with Impact,

Jocelyn K. Glei (Amazon Publishing)

Further reading

Digital Revolution (exhibition catalogue) (London: Barbican)

Tomorrow's People, Susan Greenfield

(London: Penguin)

Textile Visionaries, Bradley Quinn (London: Laurence King)

Future Files - A Brief History of the Next 50 Years, Richard Watson (London: Nicholas Brealey)

The Future: 50 Ideas You Really Need to Know, Richard Watson (London: Quercus)

Cradle to Cradle.

Michael Braungart and William McDonough

(London: Vintage)

In The Bubble: Designing in a Complex World, John Thackara (Cambridge MA: MIT Press)

Opportunity-Centred Research, David Rae (London: Palgrave)

For specialist books related to your industry investigate the following publishers:

Bloomsbury/Fairchild, Laurence King, Thames and Hudson. Also explore titles from Adrian Shaughnessy's publishing company (www.uniteditions.com), and Amsterdam-based BIS Publishing (www.bispublishers.nl/) for various publications on design.

Ideas for growth

'Don't give your ideas away for free'

Steve Jobs (1922–2011),
first advice to fellow Apple co-founder, Steve Wozniak

Today's 'sharing' and 'crowdsourcing' cultures, whereby people are literally giving their work away for free or having freelance work commissioned on a bottom-dollar basis is not the way to grow a strong, vibrant creative community and economy. We don't want to end up, at the age of fifty, still being offered unpaid work that will be good 'experience' or 'valuable exposure' for us.

To achieve growth, artists, designers and micro-enterprises need to be able to trade with each other and with big business through the sale of creative services, artworks and products and the licensing of intellectual property. For the poetic or experimental creative who may feel uncomfortable about this notion, most grants, for instance, originate in tax receipts from companies and those employed by them; many cultural activities in public galleries can only be staged with assistance in the form of sponsorship from large corporations; and finally, those who buy art usually come from the business world.

It's worth reflecting on the period shortly before Steve Jobs' death when he was very upset, in his view, by the infringement of Apple's patent, which then led to Apple and Samsung suing one another. He understood the value of intellectual property, and, as mentioned in the previous chapter, there will be no winners if our rights are eroded.

Options for growth

'You'll never have a good art career unless your work fits into the elevator of a New York apartment block.'

Sarah Thornton (1965–), author and sociologist

This quote was included in the 2013 Reith Lectures by the artist Grayson Perry and it sums up a great deal about the commercial and practical realities of making money from creativity. When we graduate from art college or turn a passion into a business we often have a naïve or unrealistic view of how the arts sector or design industry works, and who our clients will be.

Unfortunately, the world we live in is far from ideal, and it can be extremely unfair. It is important not to think that adapting what you are doing is somehow 'compromising artistic integrity' or 'selling out'. If you wish to achieve growth and prosperity, then you need to find a way to make a life for yourself with the resources you already have or with what you can easily acquire.

Achieving the vision

If you have big ideas, it might be possible to achieve them in your lifetime but not on your own. You will need to learn to walk and then run with others, as the old African proverb goes: 'If you want to move quickly, go alone. If you wish to go far, go together.'

Exciting ideas can attract attention, and with crowdfunding portals such as Kickstarter, dreams can come true. It can be possible to progress from small amounts of cash to super sums if willing to take the risk and put the effort in.

Sometimes, if the idea is fantastic enough it will attract investment or support from people of influence either inside or outside your current community. Sometimes it can be worth trying out bigger ideas in smaller forms, so for instance if you would like to set up a wool shop, then perhaps try a pop-up shop or some form of stall first. You can learn a lot by just giving things a go.

Many things can go wrong in business, and to increase the chances of success you will need to think at a much deeper level.

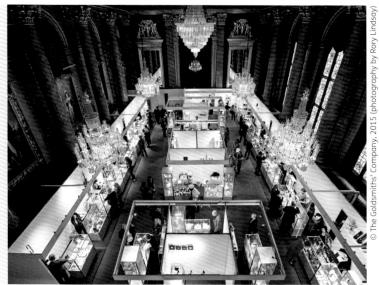

It's important to take part in key industry fairs such as Goldsmiths' Fair in London

Advanced business planning and PESTLE analysis

This is where PESTLE comes in. As you can see from the box diagram on page 284, PESTLE stands for political, economic, sociocultural (aka trends), techno-innovation and ecological or environmental issues, and how they interrelate with one another.

Some factors are within your control when you start and expand a business, and others are not. Though this doesn't mean you can't prepare for or react to such matters if you're aware of them. Younger artists and designers often struggle with drafting their first PESTLE due to knowledge gaps. It is vital that you absorb as much information about business as you can, or otherwise things will go wrong.

The example on page 284 shows a couple of points that a jewellery designer-maker may need to be aware of. The content of your PESTLE will be different, as this example only reflects the situation for jewellers in 2017. The dotted lines demonstrate how these separate sections can link up, cross over and overlap. No one element is unrelated to another. This is why creating a PESTLE is an essential tool for spotting trends and achieving growth, and what this will mean for your business, especially if feedback is gained from knowledgeable professionals or practitioners.

PESTLE Analysis Diagram

	LEGAL/LAW CHANGE	POLITICAL	ECONOMIC
0	Insurances, public, product liability	 Change of policies, laws or government 	 Coming out of a recession
0	Certificated diamonds and gold	New policies regarding tax for married	 Price of gold increasing
0	New design rights in commissions	couples and incentives for first time home	 Inflation, cost of materials and
0	Hallmarking new convention and	owners (link to marriage/engagement)	postage going up
	international stamping options	New programmes to support the	 More people buying houses
0	Displaying British Hallmarking	self-employed /	More businesses starting up,
	Dealer's Notice	 Change in import-export regulations 	increased competition
0	Ts & Cs, Consumer Contracts	Disruption through economic sanctions	Globalisation/International Trade
	ENVIRONMENT/ECOLOGY	SOCIAL /CULTURAL	TECHNOLOGY/INNOVATION
0	Increased regulations	More people using smart phones	 Skills being superseded, e.g. CAD
0	Safe disposal of hazardous	Key selling dates, Mother's Day, Father's	 Quicker prototyping, e.g. 3D printing
	materials	Day, Valentine's Day, Christmas, etc./	 Smart materials, wearable tech
0	Mining and conflict issues	 More people shopping online using Etsy, etc. 	Lighter use of metal or use of plating
0	Using recycled metals or materials	 Trends for larger stones, less gold 	 Affordable, easy to install online
0	Packaging, recyclable and	 Increase in demand for fair trade/ethically 	payment systems
	minimising waste	sourced materials	Styling apps
		 Fashion forecasting/trends 	

Creating your own PESTLE analysis is a vital part of advanced business planning. Understanding how various trends, regulations and innovations can directly affect your business can make your planning more robust to such influences in the future.

How can you grow? What are your options?

- Do you need to gain more substantial orders?
- Should you take a risk and host a stand at a contemporary trade or retail fair?
- If so, do you need to up your game in terms of manufacture and distribution on a much larger scale?
- Is it possible you require exposure to different or wider markets through representation from a dealer, agent or showcase via online portfolios, online stores or gallery websites?
- Is it that your business can only flourish through taking on premises or employees or hiring other freelancers or subcontracting work to others?
- Can additional income be generated through licensing images or designs either by written agreement or via stock image banks?

- Equally, could profits be increased by investing in technology, new machines, software, revamping your marketing strategy or investing in a well-designed website?
- Is creative merchandising worth exploring? Product on demand? Craft or art kits? Greetings cards?
- Is it possible that collaboration is another route to achieving more by pooling resources?
- Do you need to relocate? Export?
 Change direction? Learn new skills?
- Could you expand your brand by selling licenses as a franchiser or becoming a franchisee (see Audrey Whelan's profile on page 248)?

Is your arts practice or design business scalable?

The key thing to consider here is: is there some form of scalability to your arts, design or micro-enterprise?

Remember, there is only so much one person can achieve on their own without investing in some form of expansion, which will have some degree of risk attached. You need to think or gain advice about what would be your best plan for growth. It could be that your options for growth are limited, especially if you have a small or niche market.

Approaching new or expanding markets

Moving to a new, larger or emerging market is always risky, especially if you're under some degree of financial pressure. At some point you need to notice the writing on the wall (see, for example, The Mango Lab profile on page 109) and radically change your whole operation if you are to survive or prosper.

There are many different approaches to entering new markets, and they will require you to fall back on reserves or seek further expert advice, which could result in writing a new business plan at an advanced level. This may require a loan or other form of investment to help you create new products and services, visit conferences or trade fairs, or find new clients, factories, stockists or suppliers overseas.

How to obtain funding and finance for growth

To achieve business growth, specialist business advice is essential, as well as access to funds. As mentioned in Chapter 8, there are business loan schemes available which come with a degree of one-to-one support. Small loans may be available with mentoring support from local studio networks or cultural organisations. For more detail, please refer back to Chapter 8.

Optionally you could approach Business Angels for investment, who are usually other business owners who seek to invest in your business; they input their experience and money in return for a share in your company and profits. Growth accelerator schemes can also provide investment and support in the form of office space or mentoring, in return for a stake in your company.

All options will require you to write an extensive business plan (with some support), with special attention given to the cash flow forecast, which would usually need to be for at least two years ahead.

As mentioned in Chapter 13, crowdfunding is now a popular option for attracting funds – see, for instance, Damien Borowik's profile on page 278. There are also other types of crowdfunding that are more about 'peer to peer' lending, i.e. business to business, such as Zopa, Ratesetter or Crowd Cube.

Structures for growth

Lord Finchley tried to mend the electric light Himself. It struck him dead: And serve him right! It is the business of the wealthy man To give employment to the artisan.

> From 'More Peers' (1911), by Hilaire Belloc (1870–1953), poet

This section introduces a range of matters that you will need to explore further to help you underpin a growth strategy. As the engineer William Julian King said in his book, *The Unwritten Laws of Business*, 'Do not try to do it all.' It will often save you time to employ or hire people to do particular tasks. This will not only free up your time to focus on your business, but could equally save you from unnecessary electrocution!

Employing people

Taking on interns, assistants, employees or hiring other businesses or freelancers to undertake casual or more regular duties is something at some point all growing enterprises need to do. You don't have to be a limited company to be able to employ people on a payroll; you can also employ people when trading as a partnership or even as a sole trader.

This is a vast subject, and you will need to visit the 'Registering as an employer' section of the www.gov.uk website to understand it in full. I also recommend visiting other trustworthy websites and reading various employment publications listed in the resources section at the end of this chapter.

Firstly, you will need to register yourself as an employer via the www.gov.uk website and follow the checklist there. You will also require employer's liability insurance before taking on your first employee. It is vital that you check whether your new recruit has the right to work in the UK. As an employer you have to give your employee a 'Statement of employment particulars', and you might have to set up a pension scheme if you plan to pay your employee more than a set amount (currently over £10,000). In the UK, employment law and rights in regard to employing people

The Essential Guide to Business for Artists and Designers

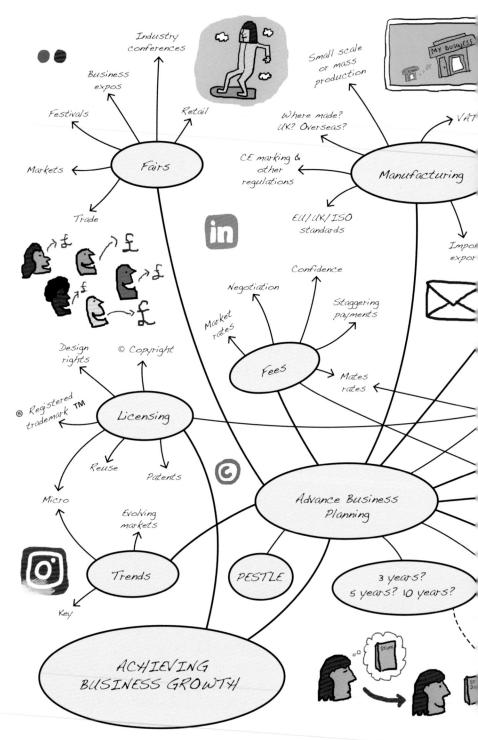

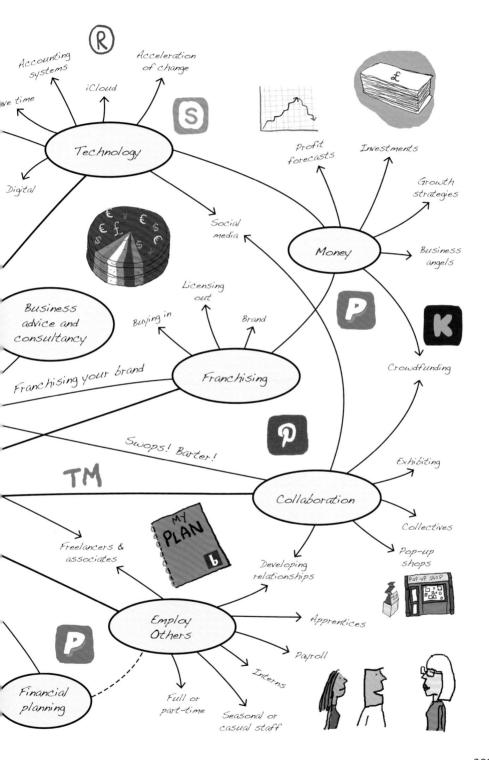

on a temporary, fixed, part- or full-time basis changes periodically, so seek advice even before placing an advert.

In the early days and months of setting up a business, it can be a far easier solution if you get busy to hire interns or other people who are registered as self-employed. To avoid any future confusion, it's advisable to have a contract for services (not employment), that you pay by invoice, according to agreed terms, and ideally the freelancer should have their own insurance cover.

Associate and freelance agreements

If you wish to become more of a team enterprise, many companies make use of 'associate agreements', which are contracts that allow businesses to make use of other freelancers' or businesses' services. The contract makes clear that this is a business relationship between your business and that of the web developer, stylist or designer. That their services are only required when your business needs their assistance, for example, for help with a larger project or commission. This allows you to have a section on your website showcasing your team of specialists, which can build credibility and attract more substantial clients.

When engaging freelancers, often they will have their own terms and conditions, contracts or letters of agreement. If they don't, it's up to you to agree terms with the freelancer concerned, and to have your own engagement contract for freelance or self-employed services – this can be drawn up by a reputable solicitor's firm based in the same country where your business is based, or a paid-for online template from a trusted source. Issues such as copyright are also important; it's likely that if the freelancer is creating any art, photography or design work for you they may wish to retain their rights. Suddenly, you may realise why businesses often require rights in commissioning situations, when you hire you own creative freelancer for the first time.

Licensing and royalties

As outlined in Chapters 9 and 10, a licence is a written contract, whether it is typed out on paper, written in digital form or agreed via a tick box on a stock image website. A licence sets out the fee or royalties owed, what purpose you can use an image or design

for, how long you can use it for and what territory it covers, e.g. UK only, America only, worldwide, etc.

If you decide to license a brand, this can take the form of a franchise, whereby you license rights from a company by time, purpose and territory, to use that name with regard to the provision of services. Equally you can buy in to franchises; see the example of Audrey Whelan on page 248. Some popular franchises are Dulux Interior Design Services, Clarks shoe shop, Printing.com, The Headshot Guy, and dozens of well-known fashion brands such as Burberry, French Connection, River Island, and other established brands such as Topshop, owned by the Arcadia Group.

Royalties are usually a percentage of net sales receipts, of books or products for example, but not always; royalties could also be generated from the licensing of an image, photograph, film, pattern or design. These are paid either monthly, quarterly or annually. Percentages can vary so it's best to seek advice from your professional body, IP lawyer or agent. Be careful when you receive any kind of agreement: a 'royalty' agreement means you are licensing your copyright to the client, whereas 'revenue' sharing is not the same thing – you should be wary as this means the client owns the rights, not you.

Setting up a payroll

Once you have registered as a first-time employer via www.gov. uk you must set up a payroll system, whereby you deduct National Insurance Contributions (NICs) and any income tax owed to HMRC. The 'PAYE and payroll' section of www.gov.uk explains everything you need to know, even listing the different types of payroll software that HMRC recognises. If your business is getting to the level where you need to take on an employee, then I would discuss this with your accountant, who would also be able to set up a payroll system and services for your business if you're not interested in doing this yourself or if you aren't very experienced with setting up IT systems.

Setting up a private company

As explained in Chapter 3, there is much to understand when setting up a limited company. Sometimes creative people will

choose to set up as a company from the off, and sometimes they have to, due to industry expectations or traditions e.g. a film production company. Many may reserve the option of incorporation until their annual net profits start to near £40,000. Corporation and dividend tax, if managed correctly, will be less burdensome than the higher rates of income tax and National Insurance if you are self-employed or a partnership.

The advantage of setting up a private company is that if you are seeking investment or taking on a loan, then if the limited company should fail, not through any fault or negligence on your own part, then your personal assets – such as your home – are protected. As a company 'director' or 'shareholder' you have 'limited' liability in regard to financial exposure.

The first thing to do is visit www.gov.uk/companieshouse and go to the section on starting a company. Here you will find model articles and 'Memorandum of Association' documents available to download, plus a step-by-step online registration service. I personally think it is worth paying your accountant to set up a limited company for you and have a professional explain all the regulations you will need to comply with.

Setting up a social enterprise

A social enterprise is a company that can be termed 'not-for profit', a company limited by guarantee, or a community interest company (CIC), which can be a private or public company. It's a legal status for a company that seeks to assist the community. A social enterprise is more interested in ecology, education, social issues or encouraging arts and culture than seeking commercial profit. It is possible in some cases to be paid a salary from earned or grant-generated income to run your own social enterprise, especially if a CIC, but in most instances it is not possible. It depends on how the 'Memorandum' and 'Articles of Association' (formation documents) are drawn up. (Please note, company law is revised periodically so please seek specialist advice if considering setting up a company.)

VAT and advanced accountancy systems

The basics of VAT are outlined in Chapter 11 on pages 235–236. But readers may also be interested to know about various VAT

retail and margin schemes. Basically these take several forms; the retail scheme allows you to pay VAT on total sales in a set period rather than on every individual item. The VAT margin scheme is for those involved in the arts, antiques, collectables, vintage or second-hand goods trade. It allows an art dealer, for instance, to account only for the VAT on the difference between the price paid for an item from an artist, gallery or private individual and the price received for it, i.e. the margin, rather than on the full selling price. For an example, please refer to Chapter 4.

As mentioned on pages 238–241, investing in decent accountancy software such as Sage, Quickbooks, Xero or FreeAgent is vital if handling multiple sales, jobs and orders. If selling stock, it is worth exploring wider accounting and electronic till integration. Equally, many design or creative studios integrate their cloud systems such as Xero with other client and project management solutions such as Streamtime.

Output 2030

'Your horizon always grows.'

Gareth Neal (1974–), furniture designer

At the 2009 Hidden Art Forum, Gareth Neal, now one of Britain's leading contemporary makers, spoke about how he nurtures relationships with collectors and had successfully raised his profile by showcasing his work at prestigious design fairs in London, New York and Milan.

He talked about how aspirations change as a practice or creative business develops. This is true: as a third-year student you're hopeful that sales or offers of work will arise from your degree show, whereas after graduation an ambition may be to have a solo exhibition, seek representation from an agent, host a stand at a trade fair, find a manufacturer and so on.

To make progress, it's essential to pursue new initiatives. Larger-scale ventures will always be riskier and more costly, and may not yield immediate benefits. However, to move a creative business forward, you have to seek fresh direction, and take some risks.

What history tells us

Some artists and designers may put their success down to many factors, or it can just be due to having a lucky break, but you should ask yourself what needs to happen in order to take your art practice or design business to the next level. How could you make this happen? What needs to change?

Advanced business planning, as illustrated on pages 288–289, might not sound like much fun now, but if you seek profitable growth then advanced business planning is essential. It will enable you to identify new trends, target investment, create detailed sales forecasts, accurately cost and price your work, etc.

Creative futures

The financial crash, as mentioned, has caused many problems within the visual arts and creative industries, and the breaks that many creatives should have had have never materialised. It's worth considering that there may be a second major financial crash in future years as the bubble may burst due to phoney liquidity and the yet unknown consequences of Brexit.

The iconic Dyson headquarters in Malmesbury, UK It is possible to survive and even grow a business in a recession, as all the profiled artists and designers in this book have demonstrated. A squeeze on our resources has forced us all to be more creative, and achieve more with less – lessons that will stand us in good stead for the future.

What could the world be like in the future?

I very much still hope to be around in 2030, when global communication and the integration of different nationalities will be a firm reality. Large continents will simply become the seven key regions of the earth and we will all see them as such, as we work and collaborate together from huge distances on a daily basis.

Virtual reality and continuous live internet experiences will become a regular occurrence, and we may end up shifting our lives around to be more in tune with our clients and customers, as international trade regulations are universally adopted.

However, there is a danger that we could all become more emotionally isolated unless we can shift from chat apps back to oral conversation once again, and build relationships of quality instead of ones of transience.

How will art and design be acquired or purchased in the future?

Micro licensing is a new way of generating royalties where tiny payments from multiple downloads or exposure to adverts go to the creator. This is establishing itself and, by the end of this decade, is likely to be how all creators will license their artwork or designs.

Businesses and consumers are increasingly accessing and displaying visual art in accessible digital formats, rather than visiting actual exhibitions or paying for original framed pictures for instance. In the future, art and design might be embedded through other innovative means into our everyday surroundings and experiences, which may mean viewing artwork virtually more often than in material form.

Large corporations, search engine software services and social media companies, who are universal rights holders, will have a major role in how art and design can be located, shaped and distributed.

No time to waste

Try not to fall into the trap of the distraction culture; we can only absorb so much. Just as too little information can hinder our ability to make decisions about the future, it's easy these days to simply become overwhelmed by too many facts, stats and data, some of which might not be accurate or even true.

Focus your time and energy on building your arts practice or design business; this is the most important tool you have. Without focus you will not achieve anything.

Reflection

Build time into your schedule when you can reflect over your recent progress and think about what your next move will be. In these fast-moving and often chaotic times we live in, your brain needs space to think. Avoid sitting and scrolling through social media in every spare moment you have. Turn the smartphone off, and instead think about whether you have forgotten to do something, or what you need to achieve by the end of the month and how you are going to do it.

Well, farewell for now, and good luck!

I hope very much that you have enjoyed reading this second edition of *The Essential Guide to Business for Artists and Designers*, and that you now feel more prepared not only to start, but to plan and grow a business. The chapters, diagrams and illustrated mind maps have been designed to take you on a journey.

It can be complicated to make it in this world, which is why researching, planning and developing a vision can help you make more informed decisions.

I and the Bloomsbury team wish you all the best of luck with your practice or creative business. Please feel free to get in touch at alison@alisonbranagan.com if you have any recommendations, such as new content, organisations or websites, to include in future revisions or editions. \odot

The toy designer

Rob Dakin

Rob Dakin is a British designer who studied branding and packaging design at Somerset College of Arts and Technology.

After graduating he started his career as a branding designer in London. He then worked in similar roles for a number of companies, but his career took a radical change when he worked for Marks and Spencer as a children's toy concept designer.

After a couple of years he decided to change from being an employee to freelancing for a number of companies, such as Twentieth Century Fox, Disney, the Early Learning Centre and the BBC.

In 2010 Rob started Clockwork Soldier which creates children's games, gifts and activity sets that are now sold in multiple countries around the world. His products can be found in London in Selfridges, the Royal Academy of Art, the Design Museum and the V&A Museum, among others.

You can view his product ranges at www.clockworksoldiershop.co.uk.

His five essential tips are:

1. Creative development

As a professional designer it's easy to get 'pigeonholed'. Give yourself time and space for new creative experiences. These could include different work roles and enrolling on short courses – the results will surprise you.

2. The business plan

Business plans can be a dull minefield of business terms and clichés. It's important to plan your business and make it creatively engaging for yourself. Shape a plan around your own business practice, but most

importantly, do your market research and pay attention to costing and pricing your products.

3. Trade fairs

Trade fairs can be an excellent source of information. Every industry has one and they are usually free to attend. If you are visiting fairs, it's an opportunity to check out trends and competitors, and gain fresh knowledge from free seminars.

4. Creative economics

This is not just a fancy name for being thrifty. Your two main commodities are your own time and money. By planning ahead, you can save on both of these at the same time. For example, negotiate a discount when placing larger orders on materials.

5. Kiss a few frogs to find a prince

When embarking upon any creative venture, there'll always be a few creative and financial risks involved, some of which just won't pay off. You're not alone – everyone makes mistakes. The trick is to have a thick skin, pick yourself up and keep going. Sooner or later you'll find the right path.

RESOURCES

Useful organisations

www.cobwebinfo.com/services/newsletters www.fsb.org.uk

Manufacture

www.letsmakeithere.org http://makeworks.co.uk/ www.alibaba.com Various LinkedIn Groups, e.g. Made in Britain – Manufacturing Network www.innovate-design.co.uk

Franchising

www.thebfa.org www.eff-franchise.com www.thefranchisemagazine.net www.theukfranchisedirectory.net

Pop-up shops and shelf rental

www.wearepopup.com www.appearhere.co.uk www.thingsbritish.co.uk www.londonpopups.com

Employing people

www.gov.uk/browse/employing-people www.gov.uk/paye-for-employers www.gov.uk/register-employer www.acas.org.uk

Crowdfunding and sponsorship

www.kickstarter.com www.indiegogo.com www.unbound.co.uk www.gofundme.com http://sponsorcraft.com www.spacehive.com www.crowdfunder.com or co.uk http://crowdingin.com/

Peer to peer lending

www.zopa.com www.crowdcube.com www.fundingcircle.com www.ratesetter.com Funding and finance
www.gov.uk/government/organisations/
uk-trade-investment
www.creativeindustriesfinance.org.uk
www.bbaa.org.uk
www.fashion-angel.co.uk/w.angelsden.com
www.idea-london.co.uk
http://collider.io
http://wayra.co/
http://wayra.co.uk

Collectives (and those that started as)

Search the internet for more art, design and craft collectives in your borough, town or city, as these can be transient in nature, often having a presence on blogs/social media and temporary websites

www.artquest.org.uk/articles/view/how-to-setup-an-organisation www.peepshow.org.uk www.punkcollective.co.uk http://nousvous.eu http://cargocollective.com www.unlimitedshop.co.uk www.breadcollective.co.uk www.gluesociety.com www.streetphotographylondon.co.uk/ www.cardiffartscollective.co.uk http://makerhood.com www.onecraftgallery.co.uk/ www.craftcoop.co.uk/

Setting up a company

www.gov.uk/companieshouse

VAT

https://www.gov.uk/browse/tax/vat https://www.gov.uk/vat-margin-schemes https://www.gov.uk/vat-retail-schemes

Social enterprise

www.socialenterprise.org.uk http://can-online.org.uk/ www.the-sse.org

RESOURCES

Technology

Please also refer to the resources at the end of Chapters 12 and 13 www.ted.com www.lynda.com

Books

Cradle to Cradle: Remaking The Way We Make Things, Michael Braungart and William McDonough (London: Vintage)

The Employer's Handbook (find the latest edition), Barry Cushway (London: Kogan Page)

Hooked: How to Build Habit-Forming Products, Nir Eyal (London: Penguin)

Mastering Fashion Marketing, Tim Jackson and David Shaw (London: Palgrave Macmillan) Value Proposition Design: How to Create Products and Services Customers Want, Alexander Osterwalder, Yves Pigneur, Greg Bernarda and Alan Smith (London: John Wiley & Sons)

Monetizing Innovation: How Smart Companies Design the Product Around the Price, Madhavan Ramanujam (London: John Wiley & Sons)

Pop-Up Business for Dummies, Dan Thompson (New Jersey: John Wiley & Sons)

Bloomsbury Publishing also publish extensively on art and design/specialist design practice; visit www.bloomsbury.com/uk to find out more.

Appendix 1: Business knowledge exercises

This section of the book is designed for lecturers or those who work in enterprise support, to help with setting exercises for students, and also for any readers who wish to give some of these suggestions a go.

Creative business assignments, exercises and challenges

Visiting fairs, expos and exhibitions

- If a first or second-year student it's not too early to go out and visit key exhibitions and fairs such as New Designers, New Blood, 100% Design, Art Festivals, etc. If a lecturer, send your students out in groups to some events and ask them to prepare a short report or make a presentation about what they have learned. For more guidance please refer to the list of fairs and events in Chapter 7.
- If a second-year student, go and visit as many BA shows as you can, and if a third-year BA student or recent graduate, visit a number of MA shows (which usually start after the BA shows are over); this can be helpful if you intend to go on to further study.

Promotional and marketing ideas

 If a second-year student, make sure you set up a blog or website and prepare draft materials for your third-year degree show, to help you secure an internship or commissions. Maintaining a blog can be especially useful if seeking opportunities in the fashion or media industries.

- Use free Moo business cards if in your second year, and only spend money when you are ready for your third-year show.
- If a lecturer, setting up mini-marketing material assignments in the second year or even early on in the third year will avoid last minute rushing and making avoidable mistakes in the final weeks before a degree show. For more information, refer to Chapters 7, 12 and 13.
- It's likely you will need to draw attention to your degree show, first exhibition, fair or crowdfunding campaign, so think through and create a publicity stunt. For lecturers this could be done as a group exercise or set as a challenge to secondor third-year students. For more detail refer to Chapters 1, 6, 7, 12, 13 and 14.
- Set up a very large piece of paper or blackboard along the whole of one wall, and encourage group work on a larger scale with chunky felt tip pens, markers or coloured chalk. Students could then draft out ideas as sketches, storyboards or mind maps.
- Set aside an area in the studio for Post-it notes where ideas can also be jotted down about the show.
- Set students a £10 challenge: what could they do to promote themselves or their show with £10? Encourage presentations on their ideas. Put into action if possible, just posting a snap on social media is not enough. Please refer to Chapters 6, 7, 12 and 14.

Product on demand or transfer experiment

• If a student or recent graduate, either on your own or working with others, take some of your artwork, designs or images and apply them to different surfaces, materials or objects. Try swapping a couple of images within a small group to see what another student would do with them. Fine artists may find this difficult, so I suggest you see this as a business experiment or fun commission outside your usual practice or serious body of work. Try creating a drawing or image as a separate exercise for this project and, if possible, work with students from other disciplines.

- Images or patterns could be digitally transferred, or transferred using Lazertran or other processes, onto different materials such as tote bags, ceramic ware, tiles, mobile phone covers, wallpaper, fabric, etc. Please note, any photographs of the results should not be released onto the internet unless everyone agrees. I suggest not doing so, and that it should be made clear that copyright, both moral and financial, remains with the original creators and this is just a creative, in-house experiment. For useful resources please refer to Chapters 7, 13 and 14.
- Equally, for fun or for market research purposes use a product on demand service such as Bags of Love, Art Rookie, Red Bubble, Zazzle or Society6, to make a more professional product or create a prototype sample. (Please double-check the terms and conditions of any websites used; the creator, for instance, should retain complete control over their copyright.)
- This exercise can go wrong, some students may not like the experience, but this is part of the process of widening the art or design student's perspective on the realities of the commercial world, and helping them to view their creative images or designs differently. Lecturers should prepare the ground a bit by making up some samples or learning materials around the idea. For more explanation, refer to Chapters 13 and 14.

Negotiation and selling practice

If you are a student or recent graduate here are some things you can try yourself; if you are a lecturer, set the following as challenges to students and ask them to present their experiences:

 Set yourself or students challenges, where they ask suppliers for a little bit more or try to seek small discounts, and see what happens. Some of them might not have very good experiences, but some of them will, and it is often interesting to see what they managed to achieve.

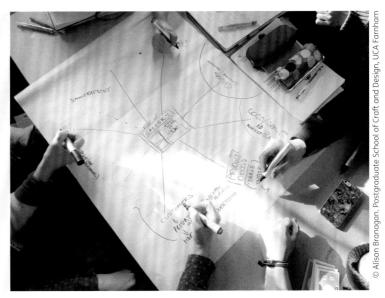

Students completing a creative business challenge

- When ordering supplies for instance, ask if there is any discount or offers available? Do they have old or damaged materials they could give you? Can the price be dropped in return for a longer turnaround? Could they throw anything in extra for free? Would they be willing to give you the supplies in return for promotion, through sponsoring your show? (See Chapter 8). Do they give discounts or rewards for recommendations, which turn into new clients or orders?
- When commissioning any kind of service or product, e.g. photography, design work, piece of jewellery, a painting, etc., ask whether they would be willing to swap a service, artworks or products in return for the services or products of those they wish to hire or buy from. Bartering is to be encouraged as long as it is clear what both parties are giving and receiving in return. Many creatives trade products for services such as photography, web design and bookkeeping.
- Equally, if you are a lecturer you can create scenarios, with a small brief for each party; for example, a web designer meets a fashion director who wishes to set up a website in a hurry, an interior designer dealing with a stingy client, or a product designer or artist faced with an unpaid commission. Is there any way students could learn a valuable lesson from this

- scenario? Could they build or make something more of the opportunity, for instance could they gain greater exposure, a chance to meet new clients or gain valuable contacts, secure an endorsement for their website, or understand the importance of being paid at set stages, etc.? Give students ten minutes to study their side of the situation before acting out a role-play situation.
- Bartering or selling games can be fun, such as making mini sales pitches with inexpensive novelty products like bubble blowers, rubber ducks or joke fried eggs. Pair up students to sell each other's artwork or products, or more serious experiments such as art car boot sales, etc. only if prepared beforehand by a lecture/presentation or other learning experience, e.g. reading Chapter 10.

Calculating product margin or commission on sales and mark-up

- Art and design students' ability to understand basic maths such as ratios, percentages and multiplication can be poor.
 Some may struggle with working out ratios for costing and pricing, but they need to grasp it if they are to make progress.
- Using the ratios for mark-up and profit margin, also referred to in a gallery context as commission on sales (as outlined in Chapter 4), a lecturer could set some basic questions with pictures of products or artworks on each of the different calculations. For instance, one question could be:

 If a child's colouring in book's trade price is £1 (no VAT added as it's a zero-rated/exempted product) what would the profit margin be if the retail price is £2.50?
 - The answer is a 60% profit margin (calculated either by the difference between £1.50 margin and the selling price of £2.50, or multiplying the trade price of £1 by 2.5 to make £2.50).
- You may also like to make some questions on how to work out VAT and add it to the final retail price. (Steer away from setting examples using any products designed for children, as they might be zero-rated.) Generally, products such as lamps, chairs, rugs and artworks sold in stores or galleries will

usually attract standard VAT rates of 20%. VAT calculations can vary due to different margin schemes, but setting the odd question with a straightforward percentage, just to convey the basics, shouldn't cause too many difficulties. For more on this subject refer to Chapters 4 and 11.

Manufacturing research

- Very little manufacturing goes on in the UK, compared to other countries. However, some new factories are starting up, and there are quite a number of small factories still going. For more information, refer to the resources in Chapter 14.
- Most designers and makers use factories overseas to make their products to keep down the cost of manufacture.
 However, as a basic exercise, students could explore different manufacturing processes and perhaps make contact with small factories in the UK, either to visit or gain quotes for services such as large-scale reproduction moulds, casting, stamping, digital printing, 3D printing, laser cutting, plating or other services, in order to get a realistic idea of how much this can cost.
- Also, it's incredibly useful to speak to tradesmen/women or technicians who provide services to a specific arts or industry sector by showing them a physical model, 3D CAD visualisation or draft designs before even making a prototype. An expert mould maker, for instance, would be able to tell you in an instant how a design could be modified to ease the reproduction process.
- Working out manufacturing ratios for a business plan will take some time and requires expert guidance. This should not be rushed or guessed. However, a very rough rule of thumb to get the learning process going is to find a rough trade and final selling price. Businesses sometimes work out a trade price by doubling the cost price of producing a product and then adding VAT (if the business is VAT-registered). To find a retail price, the trade price (without VAT) may need to be doubled or multiplied by 2.4, 2.5 or 3, and then VAT added into the final retail price if registered. Other background costs

such as postage and packaging will also need to be considered. Please note trade and retail prices can be set in different ways, but students need to find a simple ratio in order to write their first cash flow forecast.

Thoughts about pricing products

- There are several things students and graduates can do to find out more about pricing. At a basic level, they need to work out the cost of their materials, time and background expenses. Then, if relevant, proceed to talking to manufacturers, factories or advisers on how to get the unit price down if the product is to be mass-produced and viable.
- Students also need to undertake thorough market research to see what competitors are charging. This could be partially achieved by visiting trade fairs and collecting trade price slips from stand holders. (Stand holders may not wish to give these out to potential competitors, so tread carefully.)
- Equally, when you walk into retail fairs, or small or medium-sized stores, if you take the VAT off a product's retail price (i.e. take off 20% in most cases) and divide the remainder by 2, 2.4 or 2.5, then you will have a rough trade price for that product. The calculation may well be higher, by dividing the retail price (minus VAT) by 3 or even 3.5 for high-end products in large flagship stores or other prestigious outlets. Remember this will only give you a hazy idea of a trade price and should not be treated as a bone fide fact. For more on this please refer back to Chapter 4.
- If prices for services are not very clear on a competitor's website (which they should be, unless a bespoke service or commission), another approach is to ask friends to undertake some sleuthing work by contacting artists and designers to obtain quotes. This can help you gain an insight into what your competitors are charging for services/commissions. Equally, there is a lot of information at the end of Chapters 1 and 4 about professional fees and pricing surveys, some of which is freely available on the internet.

Exploring real-life stories

Whether a student, recent graduate or lecturer, it's important to explore real-life business stories. Often the truth of how creatives set up only comes out when artists or designers are interviewed or come in to art and design departments as guest speakers, and they tell it from the heart.

- All artists and designers will have stories to tell, and if a lecturer it can be a good idea before a speaker comes in to spend time preparing students through brainstorming sessions, for instance using felt-tip pens and large sheets of paper, or coming up with ideas for questions to put to the speaker. Equally other challenges can be set.
- If a recent graduate or student, contact your student union's magazine/blog, or another online web or print industry magazine and see if they would be interested in an interview with a particular artist or designer. If they agree, then you can approach your favourite creative or business to seek an interview for this publication or portal. This can be a way for you to make progress.
- Equally you could see if the artist or designer would be interested in doing an interview for your own blog. Often established artists and designers are so busy they don't have time to meet you in person, so ask if they would give you some time on Skype, on the phone or if they might answer a couple of questions by email. Face-to-face interviewing is best, but always gain permission if you wish to record or film the interview.
- This can be set as an individual or group project. If a group project, I would set the group a challenge to interview two or three different types or sizes of creative business, then write a report, make a mini documentary or give a presentation about their experience and findings. The success of this type of exercise depends on team dynamics and involves learning to work together. Students need to be given three to six months to do this kind of project, to fit it in around their practical work.
- Another good way for students to learn about how to start up is to ask them to go out and find three films on YouTube, online/print interviews or articles about artists and designers.

- Ask them to compare and contrast the stories and make a presentation and/or file an assignment.
- An alternative successful session you can try, which I ran many years ago, is to find ten to twenty stories yourself, about how artists and designers established themselves. Print them out in batches and get students into groups to review and feed back on a couple of their choice. In the exercise I also included some historical tales such as Madame Tussauds' story mixed in with more modern examples. Interestingly, the students appeared to find the historical articles far more interesting than those of their contemporaries. History can teach us a lot.

What has gone wrong with a business opportunity?

One of the most important exercises for graduates or students to do is have real case studies (with business names disguised, if necessary), about something going wrong in a business. These stories can be analysed in several ways as a focus of debate. Make sure you hold back some interesting details about the outcome until the end!

- What went wrong and why?
- What would students do if they were in this position?
- Is anyone at fault?
- Could the artist or designer have done anything beforehand to stop the mistake from being made?
- What could they do now?

The conclusion of the story can remain hidden until the end and it can be revealed post-debate what the artists, designers or microenterprise owners learned, i.e. what happened next; whether the problem was resolved or not, and if so, how.

Appendix 2: Answers to the costing and pricing quiz in Chapter 4

1. How much do artists get paid for exhibitions in public galleries and museums?

Exhibition figures quoted in a-n's 'Paying Artists' research are as follows:

70.9% of artists do not get paid for exhibiting at all

10.7% are paid between 0-£200

5% are paid between £201-£500

5.4% are paid between £501-£1,000

1.9% are paid between £1,001-£1,500

2.3% are paid between £1,501-£2,000

3.8% are paid £2,001+

Remember there is a difference between exhibiting in a commercial gallery and a public gallery, as there is little emphasis on sales in the latter, and artists have exhibitions there for cultural purposes.

2. For designer-makers, what is the most popular price range for their products?

In the Crafts Council 'Making it in the 21st Century' research report published in 2003, 63% of applied artists and craftspeople said the most popular price range for their products was between £51 and £100. An earlier report in 1994 found that the most popular price range was between £5 and £20. This demonstrates how bespoke and handmade items have become more valued by the public in the period of time between the two reports. However,

in the Crafts Council 'Consuming Craft' research report in 2012, 61% of sales were under £50; 9% of sales were between £50 and £100; and 25% of sales were between £100 and £500. I will leave you to draw your own conclusions on the continuing effects of the 2008 financial crash.

3. What is a freelance photographer's daily rate?

This varies between £200-£280-£380 per day for a regional/national newspaper, though it can be more or less than these amounts with some syndication deals, whereas other commissions will only pay a flat rate and require copyright. Newspapers can also pay as little as £100, as they can source photographs from stock image banks.

The day rate can be more for a large circulation magazine: £500-£800+ for a day, and advertising or specialist shoots can be extremely well-paid (in the £1000s). Commissions for design firms are around £1,000+ a day, and £400-£500+ plus expenses is an average day rate for businesses. Weddings can be from £300 to £3,000+ plus expenses. For more info on rates and fees visit www.theaop.org and www.londonfreelance.org. Information about circulation can be gleaned from www.abc.org.uk.

4. What is an acceptable daily rate for a ten-hour day as recommended by BECTU for a costume maker working on a TV advert?

For a costume maker an acceptable daily rate is £200-£280 per day, whereas a costume designer earns more, with fees usually agreed by negotiation, £450-£500+ per 10-11-hour day. For further information, take a look at the rates cards on www.bectu. org.uk.

5. What is the average daily rate for a junior freelance designer? Also, what would an annual salary be according to the Major Players Report?

For a junior designer (freelance) it's between £100–120 per day, for a mid-level designer it's between £130–£170 per day. However, if employed by a company then for a junior designer an average annual salary is £22,000–£26,000. For more information on

industry rates in design, IT, creative and studio visit www. majorplayers.co.uk.

6. What is the average annual salary for a junior fashion designer inside London and outside London?

According to the 'Drapers Salary Survey 2012' a junior designer earns on average £24,879 in London and in the region of £24,235 outside London, per year. A recent search on www.drapersjobs. com quotes junior fashion designers with salaries advertised at between £22,000 and £26,000+ for those with more experience. It appears that not much has changed in terms of salaries since the 2012 survey.

7. How much would an illustrator get paid for the front cover of a mass-market UK magazine?

According to the AOI 'Pricing Survey' figures, which are only available to members, rates are as follows:

Three-month small circulation – £1000 to £1,100 Three-month medium circulation – £1,200 to £1,300 Three-month large circulation – £1,450 to 1,550

To gain such fees for below the line work (see page 313) you need to understand the commissioning process and make sure that the illustration is licensed (i.e. rights are not transferred, assigned or sold to the magazine) and that your rights will be returned to you after ninety days from the date of publication. To gain access to a substantial database of guideline fees and rates you will need to join the Association of Illustrators.

8. How much do jewellery designers charge for a commission?

For private or commercial commissions, gauge this by meeting the client and the scale of the job. Regarding a set rate, it's a bit more mysterious; a junior rate might be £16 per hour, or £20–25 for a basic rate. For top-end work with wealthy clients it could be as much as £500–£1,000 per hour. Usually if it is a design and making commission the design fee will be incorporated into the job, or taken off when the design goes to commission. For commercial jobs you should charge a commercial fee and be awarded a

percentage of sales of the manufactured piece. The client keeps the paint-up as soon as payment is made. Rough sketches are not part of the deal, but if the client wants them then you need to charge for them. The designer owns the copyright and unregistered design right unless otherwise stated. Avoid emailing designs unless a good degree of trust and trade has been developed with the client or business, over a period of time.

9. What are the hourly PAYE rates for lecturers working in adult, further and higher education?

Rates vary around the UK but generally employed lecturers in AE and FE earn between £18-£38 per hour before tax; in HE it's between £32-£75 per hour, with most lecturers earning between £40-£50 per hour.

10. What is the UK national minimum hourly wage if you are twenty-one years of age or over?

From 1 October 2016 if you're aged 21 or over, the hourly rate is £6.95. Thus if you're aged 21 or over, for a 37.5-hour week at £6.95 per hour, you will earn £260.62 before tax. (Please note these rates are pre-October 2016; visit www.gov.uk for current rates.)

If you're aged 18–20 then the hourly rate is £5.55 per hour before tax, and for those aged 16–17 the hourly rate is £4.00. For apprentices who are aged 19 or under and in their first year, the rate is £3.40 per hour.

The new 'National Living Wage' is for those aged 25 or over from April 2016, and is set at £7.20 per hour. This is not to be confused with the current voluntary 'Living Wage' rate which is currently £9.40 inside London and £8.25 outside London. For information on the latest rates, visit https://www.gov.uk/national-minimum-wage-rates and www.livingwage.org.uk/what-living-wage.

Attention artists!

For information on artists' fees you can visit online advisory portals such as www.artquest.org.uk or www.a-n.co.uk and read their recent research or use their online calculators. Note that you may have to subscribe to a-n to gain access to the latest research and reports.

Glossary

Meanings of business, financial and legal jargon

AAT The Association of Accounting Technicians (www.aat.org.uk) is a professional body for bookkeepers and accountants.

Above the line/below the line 'Above the line' is a term used to describe the commissioning or buying of artwork, usually for advertising purposes, that appears within 'paid' or 'rented' space, e.g. adverts in magazines, on billboards or on TV. When agreeing fees for usage, this type of use is charged at a premium rate.

'Below the line' is a term used to describe the commissioning or buying of artwork for non-rented advertising space. This sort of publicity is in the form of mailshots, packaging, artwork for a client's website, business cards, flyers, posters or signage. When quoting fees for 'below the line' use, you should make it clear in your agreement that the artwork can only be used for the purposes agreed. If the client desires to reproduce the artwork for other purposes outside the agreement, then they will need to negotiate another licence.

For a half-page illustration in a large circulation UK print newspaper for a one-off edition, you are looking at £350 to £450 (below the line); whereas a commission from an advertising agency for a national or regional billboard campaign, depending on the size of the poster, territory and length of usage, would gain you a commissioning fee plus a fee of around £1,600–£7,500 or more for the usage (above the line).

Remember, there are two issues: a fee for originating the artwork, if a new commission,

and then other fees for 'usage', i.e. the right to reproduce artwork in a newspaper (on a national level) or on billboards (on a regional/national level). Quite a number of creatives and illustrators often quote fees including usage. However, it's better to keep commission and licensing rights separate.

This is a complicated area, so I suggest you read more about this subject. Please refer to the Association of Illustrators' 'Pricing Survey' and Simon Stern's book *The Illustrator's Guide to Law and Business Practice* (see www.theaoi.com).

ACCA The Association of Chartered Certified Accountants (www.accaglobal.com) is one of the six chartered accountancy bodies in the UK.

Accountant A professional who can assist with your tax and financial affairs. Most professionally qualified accountants fall into one of these categories:

Chartered accountant – www.icaew.com Certified accountant – www.accaglobal.com Management accountant – www.cimaglobal.com

There is little difference between a chartered and a certified accountant, and both qualifications entitle the practitioner to prepare the accounts of any business. However, there is no statutory requirement for an accountant to be professionally qualified, so do check their credentials.

Accounts/Accounting These are detailed financial records of your business, usually set out in spreadsheets on a computer, using an accounting package such as Sage, or on online systems such as Xero or FreeAgent. They show. usually on a daily, weekly or monthly basis, for each year, money flowing in and out of the business. These translate into summaries, showing end-of-year profit, or, in a bad year, loss. They form a major part of your business records and must be kept for six years.

Analytics This is a system of analysing data or statistics. If you have a website you can use 'Google Analytics' (a free tool), to track and report, when, how and from where people are visiting your website. Equally most social media systems have analytical tools you can use. This information can be essential to help you make informed decisions about your marketing.

Annually/Per annum This means 'each year', i.e. something that happens once a year.

Assets A word used to describe the physical property that a business owns, such as machines, furniture, vehicles and property. However, it can also refer to intangible assets such as debts owed to the company by customers, and intellectual property, e.g. brand rights in trademarked names or logos, patents or other IP rights.

Assignment/Assigning A legal term usually employed in the transference of rights in property and intellectual property. In the UK rights can only be 'assigned', i.e. given over, in writing. An assignment of rights means a total sale of all rights concerning a property or artwork. Artwork assignment means giving away all rights for all uses, territories and time, until the end of copyright. This could be more than a hundred years if the artist is still alive at the time of the buyout.

Bankruptcy When a court of law decides a person cannot pay their debts to suppliers or

other financial commitments, that person is said to be bankrupt.

Bank statements These are quarterly, monthly or weekly bulletins from the bank showing deposits, transfers and withdrawals to and from your account. You need to keep these, as they are part of your business records. If you have both business and personal bank accounts, you should retain records and bank statements for both, but separately.

Basic rate (BR) The lowest rate of income tax in the UK, which at present is 20%. There are higher rates for higher earners. Tax rates are reviewed each year and are subject to change.

BEIS The Department for Business, Energy and Industrial Strategy (formerly the BIS). This government department manages matters to do with business and regulations within the UK. It has useful resources and reports available on its website, www.gov.uk/government/organisations/department-for-business-energy-and-industrial-strategy.

Bookkeeping/Bookkeepers Bookkeepers ensure that businesses' financial records are accurate and kept up to date. They maintain records of basic business transactions, including receipts and payments, and may be involved in the preparation of sales invoices. You can find lists of registered bookkeepers on these sites: www.iab. org.uk and www.bookkeepers.org.

Branding This refers to the logos, avatars, icons, motifs, design formats or sounds that are part of the distinctive identity of a company, product or service. Branding helps to build a recognisable image, builds trust with the customer and 'ownership of mind'. You can apply for recognised brand protection under the trademark route via the Intellectual Property Office (UK).

British Standards If you plan to sell products within the UK then your products may have to be tested by you or be independently verified

to check that they are safe to sell, and that they comply with British Standards. For more information, refer to Chapters 9 and 14.

Business bank account This is a bank account for people who are in business, i.e. in self-employment. It demonstrates that you have a professional trading status, and allows you to trade with a business name.

Business library A business library is a resource through which you can access business information. The most famous one in the UK is the British Library in London. You may find a business library in your local town. If not, there will be a business section within the main public library where you can borrow or access reference books.

Business rates/Non-domestic rates (NDR) If you are planning to rent premises such as a retail unit, or convert part of your house into a gallery with public access, you need to be aware about Non-Domestic Rates, also known as business rates.

Although similar in principle to council tax, business rates are calculated in a different way. A separate rateable value is determined for each individual business property, and this value is multiplied by a rate per pound. Business rates are no longer set by national government as they are now set by local councils, please refer to www.gov.uk/introduction-to-business-rates

Arts organisations that lease studios to artists and designers should include any business rates within the rent. However, they may not do this, so check carefully before agreeing to take on a lease. If rates are not included, you'll pay rent to the landlord and business rates separately to the local council.

You will only be liable to pay business rates on your home if you have made structural alterations to your property for business purposes. If you are only using a room in your home as a studio or office, you will not be charged.

If you have turned part of your house into a gallery or shop, for instance, then valuations

are undertaken by your local Valuation Office Agency. You can gain relief on the rateable value of a property under certain amounts on the Small Business Rate Relief scheme. Contact your local authority for more information.

Capital This is a complex word with many meanings. In its simplest form it is money used or accumulated in a business by a person, partnership or company. For start-ups it usually applies to grants, loans or savings being put in to the business.

Cash book A cash book records the flow of cash in and out of your business, i.e. any transaction that involves the inflow (receipt) or outflow (payment) of money in cash from your business.

Cash flow forecast A cash flow forecast is a prediction of when cash will be received and paid out by a business. This allows the business to anticipate any potential cash problems and make arrangements to reduce spending, to speed up payment by those who owe money, to borrow money or to inject more working capital. Usually, a twelve-month forecast is enough when you start out, but many businesses plan up to between three and five years ahead.

CE marking (European conformity) Quite a number of products now have to display a CE mark so that they can legally be sold in the UK and across the European Union. For more information on the procedures you should follow to obtain a CE mark, please refer to Chapter 9.

Chambers of commerce Your local chamber of commerce is an official association for people in business; it supports and promotes trade within the local area.

Class 1 National Insurance This is for individuals in employment. (Employees are those under a contract of service, or those employed in an office with earnings subject to

tax at source.) There is no liability on employee or employer National Insurance Contributions (NICs) on wages at or below a set threshold which is currently £155 per week (2016–2017 rates). On all earnings above the threshold, both employee and employer have to pay contributions.

Class 2 National Insurance This is paid by selfemployed people whose profits exceed the small-earnings threshold, which are paid at the end of the tax year when you file your tax return (see Chapter 11). (Please note at the time of writing the PTA and small earnings threshold are set at different levels; they may be set at the same level in the future.)

Class 3 National Insurance These are voluntary payments made by people who for one reason or another have not paid other forms of National Insurance payments, or who have a shortfall.

Class 4 National Insurance This is paid by the self-employed as a percentage of their profits that exceed a set threshold. The amount is calculated at the end of each tax year. The threshold varies from year to year.

COSHH (Control of Substances Hazardous to Health) Part of health and safety legislation; employers have to comply with these regulations to control, minimise or eliminate employees' exposure to hazardous chemicals or materials.

Commercial As well as its connection with advertising, e.g. a TV commercial, if something is commercial, this means its main aim is to make a profit.

Commission (1) This kind of commission refers to a person being offered business or a work opportunity in the shape of a project or an order being placed, e.g. a sculptor commissioned by their local council to create a memorial for a civic park, or a writer being commissioned by a publisher to write a book. Commissions are

usually one-off events. Some creative businesses rely heavily on attracting commissions, while others don't need them at all.

Commission (2) This second kind of commission is when an intermediary or agent takes part of the income from a sale in exchange for their services. For example, if a shop takes an item made by a potter and agrees to sell it, the vendor will deduct a percentage from the final sale/retail price of the piece to cover the costs of their role in the deal. In an art gallery, it's common for the business owner to take between 33% and 50% of the retail sale price of a painting, known as 'commission on sales', with the artist receiving the rest. (If you are confused about the different terms used in selling, please refer to Chapter 4 for more detail.)

Company There are many different types of companies. These are outlined in Chapter 3 on page 68 and Chapter 14 on pages 291–292.

Consequential loss (insurance) Usually referred to when insuring stock, consequential loss means that goods or stock are covered for the full sale price of the products rather than the trade/wholesale price, so if your stock is stolen, badly damaged by flood or destroyed in a fire you can make a claim for the full amount. Bear in mind, though, this does mean you will pay a higher insurance premium.

Contract A contract is an agreement in which there is an offer and the acceptance of an offer, with something in exchange (known as consideration), usually money, and the desire of both sides to form legal relations – meaning to enter into this arrangement. A contract can be oral, but is best put in writing with both sides having a signed copy. Contracts can be difficult to understand, and I advise seeking professional advice before agreeing and signing any contract.

Copyright Copyright is part of what we refer to as intellectual property. In the UK it means

that any author (not an employee of a business) who creates an artistic work – a painting, sculpture, photograph, drawing, performance, film, story, song or musical score which exists as an object, drawing, as a digital recording/tape/video, two-dimensional design or craftwork, recorded on CD/film/video/as a digital file or stored in a computer – has automatic protection in the UK. If you're an employee, however, your employer will usually own the copyright to your creative work.

Council tax benefit Just about everyone has to pay council tax, but there is a certain amount of relief you can claim if you are not earning enough from your business. You need to make an application to your local council for housing and council tax relief (please refer to Chapter 8).

County Court Judgement (CCJ) This arises when an organisation that you owe money to takes you to court. If a county court judgement is made against you, as well as having to pay your creditor, you will have what is known as a bad credit rating. This means it could be difficult, sometimes for a number of years, to get a credit card, open a business bank account or take out a mortgage.

Credit check This is where a lender or sometimes an employer looks into your credit history to check you don't have any outstanding unpaid loans or recorded county court judgements against you. You can also check a new business/customer/client's credit worthiness by contacting your bank or a credit agency such as Experian.

Credit terms This phrase describes how much time you agree to give your clients/customers to pay. It's usually thirty days or longer. Alternatively, payment may be required on delivery of goods or services.

Creditor A business to whom money is owed by another business. For example, Jack is owed £30 from Jane, so Jack is a creditor of Jane.

Crowdfunding This is a way of gaining funding from gathering donations and pledges from a large number of people, usually via the internet, in order to e.g. start up a business, start a manufacturing run, make a book, develop an app or game, get a film into production, and so forth. More about this subject is covered in Chapter 13 on pages 268–270.

CWF1 The CWF1 is now an online form which you fill in if you already fill in a tax return (self-assessment) for other purposes, such as income from renting out a property or investments, and you wish to register as self-employed. See www.gov.uk/set-up-sole-trader/register (for more information refer to step 7 in Chapter 3).

Debit An entry on a financial statement that reflects payments or disbursements made on behalf of a party for which the party is responsible (the opposite of credit), i.e. money taken out of a bank account to pay bills for goods and services.

Debtor A debtor is a person (or business) who owes another business money. For example, Jack is owed £30 from Jane, so Jane is one of Jack's debtors.

Depreciation Decrease in the value of equipment from wear and tear and the passage of time. Depreciation on business equipment is calculated to provide a truer profit figure. This is a complex subject that is best discussed with an accountant or business adviser.

Design format This means applying a range of design rules to the presentation of your product, packaging, marketing material, website, stationery and business cards. It feeds into a recognised design style, using preferred fonts, sizes, colours, shapes, lines and their arrangement. This not only makes your documentation look distinctive, it can also assist with the development of your brand identity.

Design Within business culture it is well understood that design is not simply a matter of branding. Nowadays businesspeople are working with designers in every aspect of their enterprises. Design is being incorporated into office and factory spaces as colour schemes, furniture, administration systems, communication methods and working practices.

Design right This is part of what is known as intellectual property and is similar to copyright. UK design right applies to works of 3D and 2D design. Areas such as fashion, product design, furniture, textiles, glass, ceramics and jewellery are included. Unlike copyright, design right has two distinct areas of entitlement: registered design right and unregistered design right. If you can gain a registered right to your design you can secure a higher level of protection than if it's not registered.

Design right is meant to protect works of design that usually have some function – e.g. a lamp, table or dress – and that are intended to be reproduced as multiples for sale. To find out more and to see a full list of design classifications, visit the UK Intellectual Property Office website, www.gov.uk/ipo.

Direct debit This is a UK payment system designed to allow other businesses such as utilities – e.g. telephone, gas or electricity – to collect variable amounts due to them from your business, current or savings account by electronic funds transfer on a regular basis. A direct debit is different to a standing order (see **Standing order**).

Domestic Usually we use the term 'domestic' when we are referring to matters related to home, such as using part of our home for business activities. For example, if you work from a rented flat you can claim tax relief on the percentage of the flat you use for business expenses. Please refer to Chapter 11.

If you are planning to run a business from a rented flat or house, you need to check your tenancy agreement. If you're unsure, check with your landlord that s/he is OK with you

working from home as a self-employed person. The property will have 'domestic insurance', so if a business is based there, the landlord's insurance company will need to know. This is the same for homeowners: if you plan to register your home address as your business address, you should discuss these plans with your insurers.

Drawings (similar to your Personal Survival Budget). This is the word we use to describe the monthly payments that self-employed people draw from their business to cover personal living expenses. Drawings are based on the financial exercise of working out what your annual Personal Survival Budget is; your drawings are actually your profits, which you draw from your business to live on. You can't offset these against tax or claim them as a business expense. It can be difficult as the year proceeds to know how much tax you will need to pay on your profits, and therefore how much you need to put aside for your tax bill. The best tip is to store away between 15% and 25% of all your income in order to pay tax at the end of the tax year.

Dual use This phrase, often used by accountants, refers to things such as premises, clothing, equipment and vehicles that are used for both business and domestic purposes. Sometimes, for instance in the use of cars for business and personal use, a percentage of petrol and maintenance costs can be offset against profits, thus reducing your tax bill. It's always best to seek the advice of an accountant to clarify what you can and can't claim for.

Eco- Abbreviation for 'ecology' or 'ecological'. Ecology is about the delicate balances between life forms and the environment. There are many environmental regulations, which have become law. They affect all businesses and their relationship to waste disposal, emissions, packaging and recycling. For more information, please refer to Chapter 9.

Economics The study of the relationship between the production, distribution and consumption of goods by the population. It's a study of the rate of growth or recession in these activities, and their relationship with such factors as unemployment, government spending and inflation.

Enterprise agencies These are business support organisations that offer advice, training and sometimes access to loans. To find your local agency, visit the National Federation of Enterprise Agencies website, www.nationalenterprisenetwork.org.

Ergonomics is the relationship between people and their working environment in terms of efficiency, safety and ease of action. Ergonomics is often associated with the design of buildings or products, where the design minimises waste, and maximises efficiency through saving energy and using recycled materials.

Exporting is where a business sells products or services to foreign countries.

Factoring This is a form of short-term financing whereby the lender, also known as the factor, will purchase the value of an invoice debt from you at a discounted price. For example, if you raise an invoice for £1,000 that would normally take thirty days to be paid by your customer, a factor will pay you £900 immediately in exchange for collecting the £1,000 directly from your customer. It can be a very expensive form of financing but very useful for cash flow if you have a large number of debtors who take a long time to pay.

Federation of Small Businesses (FSB) This is a fee-paying membership service open to anyone who has started a business within the UK, whether self-employed, a partnership or a company. The FSB is really a lobbying organisation for businesspeople's rights. However, their support services are another reason to join, and these include a free legal helpline, a tax line, insurance and banking

deals, a web package and phone offers, plus much more.

Finance This is the commercial activity of providing funds and capital, usually in the form of obtaining a loan from the bank.

Finance raising In a very real sense, raising small amounts of money (less than £10,000) can be just as difficult as searching for larger sums. For small investments, approach family, friends and banks, join credit unions or contact local enterprise agencies first. (But be careful about borrowing from friends and family; you must formalise the arrangement with a repayment schedule.)

Larger business ventures may often require more than one source of finance. For example, say you need £100,000. One investor may agree to put £50,000 into your business on condition that you find another investor or source of finance for the balance. The essential tool in raising money is a detailed business plan. Seek professional help from a business adviser before approaching investors and applying for loans.

Forwarding A service that enables emails to be sent using a business email address and forwarded to your personal email account. So, for example, my personal email could be abeginner@talktalk.net but my business address is info@abeginner.co.uk. Forwarding means you can have a number of emails, e.g. info@, alison@, john@, etc., all at abeginner. co.uk, and all being diverted to a personal email account. So this means when you add your www.abeginner.co.uk. website. e.g. promotional materials such as a business card, you can have a professional email address 'info@abeginner.co.uk', rather than giving out your personal email address (at Yahoo, Windows Live, Gmail, TalkTalk or other provider).

Freehold/Freeholder When you buy a property freehold it means that you own both the building and the land it occupies. A freeholder is a person who owns the freehold of the property/land.

Freelance/Freelancer Preferred or customary term for someone who is self-employed and works for a number of different organisations on an occasional basis. The legal term is 'sole trader'.

Gross profit Gross profit is the total income from sales, less any variable or direct costs incurred. For example, 100 vases bought wholesale cost £1,000. The cost of packaging required before these are sold on to the customer is a further £300. This is a variable cost. If all the vases are sold at £30 each, the seller makes £3,000, leaving a gross profit of £1,700 (£3,000 - £1,300). This excludes overheads or indirect costs such as rent on premises, advertising, insurances, etc. (See **Net profit**.)

Hashtag # is a symbol added to key words in posts on social media, for instance Twitter and Instagram. This makes it easier for people to find posts/messages about a particular theme or content, e.g. #idealgift, #crafthour, #selfie, #fashion. For a more extensive list please visit the end of chapter 12.

Health and Safety Executive (HSE) The government organisation to turn to if you need information or leaflets about risk assessments or any health and safety matter. I would always advise seeking professional advice from your local council, the fire brigade and health and safety consultants before taking on a large building. Visit www.hse.gov.uk.

Housing benefit If you are on a low income, and either in self-employment or a mixture of paid employment and self-employment/ employment as a company director, you can apply to your local council for housing benefit and council tax relief. (Please note the situation regarding being self-employed and Universal Credit is unclear at the time of writing.)

HMRC Her Majesty's Revenue and Customs is the UK tax collection service. This is where you register as a sole trader when you are ready to start trading. HMRC also administers tax credits. Visit www.gov.uk/hmrc.

ICAEW The Institute of Chartered Accountants in England and Wales (ICAEW) is one of the six chartered accountancy bodies in the UK. Visit www.icaew.com.

Importing Importing is where a business brings into the country products and services from another country.

Income tax A tax levied on the earnings of employees, partnerships and the self-employed.

Inland Revenue The former name for the tax office, which in 2005 merged with the department of Customs and Excise, the new body being called Her Majesty's Revenue and Customs (HMRC).

Intellectual property rights (IPR) The term 'IP' or 'IPR' includes within it all intellectual property rights, whether moral or financial: that is, copyright, design right, trademarks and patents.

Invoice An invoice is a bill issued to a customer or client seeking payment for the supply of products or services which have been provided. Please refer to Chapter 11 for more details.

Large firm A large firm can be defined as a business that employs over 250 people and has a turnover of over €50 million per annum.

Lawyers For Your Business (LFYB) Under this scheme, sponsored by the Law Society, more than 1,800 solicitors across the UK will offer half an hour of their time to outline the legal needs of your business at no cost or obligation to you. If you do take advantage of a free thirty-minute consultation, make sure you can convey the essentials of your business query in just a few minutes so as to maximise the advice time. Bring with you a selection of images or samples of products or services.

Make sure you target an appropriate solicitor. Solicitors often specialise in different areas, such as contracts, employment or intellectual property; for more info visit www.lawsociety. org.uk.

Loan Before you approach a bank to borrow money you must first set up a business account and then seek a loan separately. Make sure you have a business plan with financial forecasts showing how you intend to pay back money to the bank with interest. The bank usually has business planning software to help you develop a plan. (See **Finance**.)

Market/Marketing The word 'market' has many meanings. Here we define 'market' as a particular section of the population who are likely to be the customers or audience for a particular work. They could be of a particular age, gender, occupation or location. Other factors that may be of interest are social class, income, distribution, lifestyle and aspirations. The analysis of such data is known as creating a demographic profile, whereby the population is divided up into distinctive consumer groups.

Before you start targeting your publicity at particular groups of people, organisations or businesses, you have to understand who and where your customers are, and why they might be interested in your creative products and services.

Microblogging Microblogging is about posting out short messages. Twitter is the best known social media provider whereby you can post a message of up to 140 characters with hashtags and an image or link to a film. With Instagram you can post up to 2,200 characters.

Micro-enterprise A micro-enterprise is a business made up of fewer than ten employees with an annual turnover of less than €2 million.

Net profit Net profit is what is left after all your variable costs and overheads have been deducted. For example, 100 vases bought wholesale cost £1,000. The cost of packaging

required before these are sold on to the customer is a further £300, which is a variable cost. Then there are overheads, such as a proportion of the marketing budget, insurance and the rent of a market stall, totalling £200. If all the vases are sold at £30 each, the seller makes £3,000, leaving a net profit of £1,500 (£3,000 – £1,500). (See **Gross profit**.)

Non-disclosure agreement (NDA) A non-disclosure or confidentiality agreement is a document you can present to investors, manufacturers, advisers or other businesses with whom you are discussing commercially sensitive proposals. If you download a model contract from the internet, make sure it's governed by the law pertaining to your country, e.g. England and Wales, or Scotland.

Always make sure NDAs are checked by a solicitor and signed by them as well as yourself. You will also require the signature of the person you plan to discuss matters with before revealing any designs, plans or prototypes. If the other parties refuse, then it's advisable to withdraw. For more detail and model templates please visit www.gov.uk and for secure file transfer systems www.creativebarcode.com.

Offsetting expenses When running a business, you only pay tax on your net profits. If you're self-employed you pay tax on your profits only after your personal tax allowance has been exhausted. The more receipts and evidence you can provide of business expenses, the less tax you will pay. So when business people say, 'I'm offsetting the expenses of this research expedition to China against my tax,' they mean they are counting the costs of the trip as a business expense, and in the process reducing their net profit by the same amount and thus a proportion of their tax liability. See Chapter 11 for more explanation, and always check with your accountant what can be legitimately claimed as a business expense.

Orphan works In many parts of the world, including in the UK, 'collective licensing' is in place. This is the means whereby people in the

UK can use 'found' materials, if they cannot identify the creator/rights holder. They can apply for a licence to use the creative work for commercial or non-commercial purposes. Across the EU and Canada there are also collective licensing systems in place. The situation in America, at the time of writing, is unresolved. I believe this new 'service' in the UK might lead to trouble in the future. Visit www. gov.uk/guidance/copyright-orphan-works.

Overheads are expenses to your business which are indirect but pretty much fixed and predictable. Each business will class their overheads differently, though as a general rule expenses such as studio rent, insurance and other regular payments are classed as overheads.

P45 A P45 is the document you receive after you resign or are made redundant from any PAYE employment. Keep documents relating to your employment with your business records.

P60 A P60 is a document sent annually by your employer that informs you about how much income tax and Class 1 National Insurance has been deducted from your wages. You need this form to help you fill in your self-assessment form/tax return at the end of the tax year, which always ends on 5 April. Employers are legally obliged to send this to you, or make it available from your staff/employee portal before the end of the following month, 31 May.

PAYE Pay As You Earn or PAYE refers to employed work, where income tax and National Insurance are deducted at source, i.e. before you receive your salary, by your employer.

Pay-per-click (PPC) This is when an advertiser pays a website owner a small fee every time someone clicks on their advert. 'AdWords', for instance is a well-known and popular service provided by Google to give businesses more visibility on its search engine. Some PPC systems can work very well for creative

businesses, whereas others can put potential web visitors off, as they can tell it's a sponsored link.

Patent Patents are part of the group of intellectual property rights that protect inventions. A patent is a legal instrument giving the holder the sole right to sell or license an invention. It also protects your rights in the country or countries where you have filed and published a patent. Refer to Chapter 9 and contact the IPO for more information, www. ipo.gov.uk.

Payment terms Your payment terms should be included in your terms and conditions. If you're operating without terms, you need to check the terms of your clients and suppliers and confirm that you are happy being paid, or making payments, within a specific number of days or months.

PEST (also known as STEP) PEST is an analytical tool to help you understand the growth or decline of markets by discovering the relationships between politics, economics, society/social trends and technological advancement. Other areas to consider in this mapping exercise are law, innovation, culture and ecology (LICE). The exercise helps you to think about how external factors such as changes in the law could help or hinder your business. For more on PESTLE, a merging of the two, please refer to Chapter 14.

Personal Survival Budget (PSB) A Personal Survival Budget is what all self-employed people should calculate before going into business. You need to include all your personal living expenses. See **Drawings**, and refer to Chapter 4.

Personal Tax Allowance (PTA) The government allows everyone in the UK to earn a certain amount of money per year free from income tax. This amount can vary each year. The PTA for 2017–2018 is £11,500 per year. Refer to Chapter 11 for more details.

Petty cash This is money spent on incidental business expenses such as taxis, buses or postage.

Profit Profit is what you are left with after all your business expenses have been taken away from your business income (see **Gross profit** and **Net profit**.)

Profit forecast A profit forecast is similar to a cash flow forecast. The key difference is that you do not show any data to do with drawings, grants or loans. It is purely an exercise in predicting business profit.

Receipts When trading at retail fairs or on market stalls, it is good practice to issue customers with receipts. This can be via a till, a PDQ machine, smartphone app, or a small receipt book.

Records of trading As well as recording all your financial dealings in your accounts, you are also required by law to keep all your receipts together with invoices, contracts, bank and HMRC documents, business and personal bank statements. Please refer to Chapter 11 for more details.

Royal Institute of Chartered Surveyors (RICS) RICS is an organisation with information and free guides about property, leasing and surveys. Visit www.rics.org.

Royalties Royalties are a share in profits from the sale of reproductions of designs, images, music, literary works or products. The amount of money paid to the rights holder is calculated as a percentage of the trade or retail price. As an artist, designer or photographer you need to retain ownership of your copyright or design right to be able to license other businesses to reproduce your artworks or creative products, and to receive royalties. Please refer to Chapters 9, 12 and 14.

Search Engine Optimisation (SEO) SEO is a process whereby you or an expert can improve your website rankings by concentrating on the use of key words and fostering inbound or reciprocal links. For more information, please refer to page 254 in Chapter 12.

Self-Assessment Self-assessment tax returns are completed annually by the self-employed, by partnerships and by those with mixed incomes or investments. Please refer to Chapter 11 for more details.

Self-employed Being self-employed is a preferential or customary term for people who wish to enter into business and trade independently of an employer. (See **Sole trader**.)

Small business A small business is a technical term for a partnership or company that employs fewer than fifty people and turns over less than €10 million per annum.

Small claims court This is where you need to go if you wish to take a creditor to court for non-payment of an invoice, and where you might also find yourself if you have outstanding debts. You can use the online small claims court service. Visit www.gov.uk/make-court-claim-for-money/overview.

Small Earnings Exception If your net profits are a below a certain threshold, which is £5,965 for 2016–2017, you do not need to pay Class 2 National Insurance but can do so if you wish, even if your profits are below the threshold. For more information, refer to Chapter 11.

SME 'Small and medium-sized enterprises' is a term for a business that is either small (10–50 employees and an annual turnover of less than €10 million per annum) or medium (50–250 people and turning over less than €50 million per annum).

Sole trader A sole trader is a legal status and term for being self-employed. (See **Self-employed**.)

Standing order This is where the purchaser sets up a regular payment from their bank account to pay their suppliers. Only the purchaser can alter the amount the supplier can be paid. You may choose to use a monthly standing order to pay, for example, rent to the landlord of your business—premises. Both purchaser and supplier need to agree to the arrangement, as the purchaser requires the supplier's bank details. A standing order is different from a direct debit. (See **Direct debit.**)

Tax Aid Tax Aid is an organisation based in England that gives free advice to businesses with an income of less than £20,000 per annum. Visit www.taxaid.org.uk.

Tax There are many different forms of taxation for businesses and private individuals. For most readers the basics are covered in Chapter 11. However, to ensure that you are aware of any other taxes you may be liable to pay, I would always recommend discussing business matters regularly with your accountant.

Tax bands The tax bands for employees, partnerships and the self-employed are the same. See Chapter 11 for more details. Please remember, thresholds and bands usually alter every year.

Tax credits Working tax credit and child tax credit are available to people who are on a low income, whether employed, running a business or a mixture of these activities. Please refer to Chapter 8 and https://www.gov.uk/topic/benefits-credits/tax-credits for more details.

Tax return See Self-assessment.

Turnover Turnover means the amount of money that a business brings in from sales of products and services over a particular period of time, usually a twelve-month period.

Unique selling point (USP) A unique selling point is a sentence that sums up the key features and benefits of a product or service.

USPs can turn into slogans or can be incorporated into marketing statements.

Unique Taxpayer Reference (UTR) The UTR is also known as your self-assessment number, tax reference or self-employment number, and can still be referred to as a Schedule D number. The ten-digit number appears on the front of your tax return and is printed at the top of any correspondence from HMRC.

Universal Credit This is a new system of benefit payment which is currently being trialled in various parts of the UK. The current ideas for Universal Credit and the self-employed have been suspended; it is likely there will be some support in the first year of trading and possibly afterwards if you are on a low income and continue with a job search, but I cannot say for sure as the policy is in flux. I recommend visiting www.gov.uk/universal-credit and reading Chapters 3 and 8.

Usage When quoting for any commercial projects, commercial artists and photographers need to divide their fee into two parts. One part, a fee for undertaking the work, is usually based on an hourly rate, while the other part is for licensing the copyright of the artwork or photographs for particular uses. Refer to **Above the line/Below the line** for more detail.

Variable costs Variable costs are business expenses relating directly to the creation, manufacture or sale of your product or service. These could be the costs of production, materials or delivery.

VAT Valued Added Tax is a tax that is added on to the sale of a wide variety of goods, products and services. The rate can vary depending on what you are selling. The obligation to register for VAT is dependent on your turnover, though in some areas of trade it's advisable to do so in any case. Please refer to Chapter 11 for more details, or contact HMRC. Visit www.gov.uk/topic/business-tax/vat.

Warranty This is a written statement that a business gives to a customer, undertaking to repair or replace faulty items. You also find the term 'warranty' in commissioning contracts, which could mean that you as a supplier or contractor are liable for repairs to, or even the replacement of, damaged parts of artworks or sculptures.

Useful organisations

Please note the author is not responsible for the reputable nature of these listings as the nature of organisations and ownership of domain names can change. Every effort has been made to create a comprehensive list of national bodies and membership organisations across a large geographic area. Apologies if we have missed anyone! There are hundreds we just couldn't include, so please conduct an online search to locate other support organisations and professional bodies in Europe, America, Canada, Australia, South America or countries around the globe.

UNITED KINGDOM

Key organisations

Artists Information Company www.a-n.co.uk/news The Artists Information Company publishes a-n magazine, a UK-wide digital artists' periodical. A small subscription provides access to their resource centre.

Artquest www.artquest.org.uk Though a London-based service, the Artquest website includes lists of professional UK-wide art and design bodies.

Crafts Council www.craftscouncil.org.uk
A support service covering England and Wales; their website includes a list of professional guilds, agencies, organisations and societies.

Craft Northern Ireland www.craftni.org

Rural Crafts Association www.ruralcraftsassociation.co.uk A UK-wide organisation providing advice and resources.

The Heritage Crafts Association www.heritagecrafts.org.uk

Arts Council England (ACE) www.artscouncil.org.uk A support organisation for artists based in England. Their website includes links to regional councils, as well as information about funding and resources.

Creative Scotland www.creativescotland.com

Arts Council of Wales (ACW) www.artswales.org.uk

Arts Council Northern Ireland www.artscouncil-ni.org

Design Council www.designcouncil.org.uk Promotes effective design to UK businesses, and has a useful website, with links to other sites.

British Fashion Council
www.britishfashioncouncil.co.uk

British Council www.britishcouncil.org/arts UK organisation for international cultural relations.

Department for Culture, Media and Sport www.gov.uk/government/organisations/ department-for-culture-media-sport

Professional bodies and associations Art and design

Federation of British Artists www.mallgalleries.org.uk

The Federation of British Artists is based at the Mall Galleries in London. It comprises the following

organisations:

Hesketh Hubbard Art Society

New English Art Club

Pastel Society

Royal Institute of Painters in Watercolours

Royal Society of British Artists Royal Society of Marine Artists Royal Institute of Oil Painters Royal Society of Portrait Painters

Society of Wildlife Artists

Hilliard Society of Miniature Artists

www.art-in-miniature.org

Royal Society of Miniature Painters, Sculptors and

Gravers

www.royal-miniature-society.org.uk

Medical Artists' Association of Great Britain

www.maa.org.uk

Society of Equestrian Artists www.equestrianartists.co.uk

Society of Botanical Artists www.soc-botanical-artists.org

Guild of Aviation Artists www.gava.org.uk

Guild of Motoring Artists www.motorart.co.uk

Guild of Railway Artists www.railart.co.uk

Society of Wood Engravers www.woodengravers.co.uk

Royal Watercolour Society

www.royalwatercoloursociety.co.uk Royal Society of Painter-Printmakers

www.re-printmakers.com

Royal Society of British Artists

www.royalsocietyofbritishartists.org.uk

Printmakers' Council www.printmaker.co.uk

UK Association of Print Specialists and

Manufacturers www.prismuk.org

British Art Medal Society www.bams.org.uk

Royal British Society of British Sculptors www.rbs.org.uk

www.rbs.org.uk

British Association of Modern Mosaic

www.bamm.org.uk

Association of Illustrators (AOI)

www.theaoi.com

Society of Architectural Illustration

www.sai.org.uk

Institute of Medical Illustrators (IMI)

www.imi.org.uk

Cartoonists' Club

http://ccgb.org.uk/wordpress

Federation of Cartoonists' Organisations

(worldwide) www.feco.info www.fecocartoon.com

Professional Cartoonists' Organisation (Feco UK)

www.procartoonists.org

Society of Authors

www.societyofauthors.org

Design and Art Direction

www.dandad.org

Institute of Practitioners in Advertising

www.ipa.co.uk

The Association of Lighting Designers

www.ald.org.uk

Chartered Society of Designers

www.csd.org.uk

Design Industries Association

www.dia.org.uk

British Industrial Design Association (BIDA)

www.britishindustrialdesign.org.uk

British Computer Society (Chartered Institute for IT)

www.bcs.org

Computer Arts Society

www.computer-arts-society.com

UK Web Design Association

www.ukwda.org

Design Business Association

www.dba.org.uk

British Sign and Graphics Association

www.bsga.co.uk

The Essential Guide to Business for Artists and Designers

Sign Design Society www.signdesignsociety.co.uk

British Institute of Interior Design www.biid.org.uk

British Interior Textiles Association www.interiortextiles.com

Finishes and Interiors Sector http://thefis.org/

Royal Institute of British Architects www.architecture.com/Explore/Home.aspx

Royal Incorporation of Architects in Scotland www.rias.org.uk

Institute of Engineering Designers www.ied.org.uk

Innovation Bank www.innovationbank.co.uk

Photography, moving image and film

Association of Photographers www.the-aop.org

British Institute of Professional Photography www.bipp.com Royal Photographic Society www.rps.org

Master Photographers Association www.masterphotographersassociation.co.uk

British Film Institute (BFI) www.bfi.org.uk

The Production Guild www.productionguild.com/

Film London http://filmlondon.org.uk

Royal Television Society www.rts.org.uk

Creative Skill Set www.creativeskillset.org

Broadcast Entertainment Cinematograph and Theatre Union www.bectu.org.uk

Producers' Alliance for Cinema and Television www.pact.co.uk/home

Production Guild www.productionguild.com

Institute of Videography www.iov.co.uk

The Guild of Professional Videography www.professional-videographers.co.uk/

Applied arts and crafts Contemporary Applied Arts www.caa.org.uk

Craft Scotland www.craftscotland.org

Guild of Master Craftsmen www.guildmc.com

Society of Designer Craftsmen www.societyofdesignercraftsmen.org.uk

Art Workers Guild www.artworkersguild.org

Carpet Foundation www.carpetfoundation.com

Textile Society www.textilesociety.org.uk

Textile Institute www.texi.org

Worshipful Company of Cordwainers www.cordwainers.org

Vintage Fashion Guild www.vintagefashionguild.org

British Costume Association www.incostume.co.uk

Worshipful Company of Pattenmakers www.pattenmakers.co.uk

Association of Guilds of Weavers, Spinners and Dyers www.wsd.org.uk

Worshipful Company of Weavers www.weavers.org.uk

UK Handknitting Association www.ukhandknitting.com

Braid Society www.braidsociety.com

Embroiderers' Guild www.embroiderersguild.org.uk

Worshipful Company of Broderers www.broderers.co.uk

Worshipful Company of Glovers www.thegloverscompany.org

Worshipful Company of Fan Makers

International Feltmakers Association www.feltmakers.com

Worshipful Company of Feltmakers of London www.feltmakers.co.uk

Worshipful Company of Woolmen www.woolmen.com

Lace Guild www.laceguild.org

Worshipful Company of Drapers www.thedrapers.co.uk

Worshipful Company of Haberdashers www.haberdashers.co.uk

British Clothing Industry Association *Includes the following associations:*

British Footwear Association www.britfoot.com

British Menswear Guild www.british-menswear-guild.co.uk

UK Fashion and Textile Association www.ukft.org

Silk Association of Great Britain www.silk.org.uk

Worshipful Company of Basketmakers www.basketmakersco.org

Association of British Wood Turners www.britishwoodturners.co.uk

Worshipful Company of Turners www.turnersco.com

British Woodworkers Federation www.bwf.org.uk

British Woodcarvers Association www.britishwoodcarversassociation.co.uk

British Furniture Manufacturers www.bfm.org.uk

British Contract Furnishing Association www.thebcfa.com

The Office Furniture Advisory Service www.ofas.org.uk

Association of Master Upholsterers and Soft Furnishings

www.upholsterers.co.uk

British Antique Furniture Restorers Association www.bafra.org.uk

Institute of Carpenters www.instituteofcarpenters.com

Worshipful Company of Carpenters www.thecarpenterscompany.co.uk

Marquetry Association www.marquetry.org

Guild of Rocking Horse Makers www.rockinghorse.co.uk

British Toymakers Guild www.toymakersguild.co.uk

British Toy and Hobby Association www.btha.co.uk

Worshipful Company of Glaziers and Painters of Glass

www.worshipfulglaziers.com

British Society of Master Glass Painters www.bsmgp.org.uk

British Society of Enamellers www.enamellers.org

British Glass Manufacturers Confederation www.britglass.org.uk

Contemporary Glass Society www.cgs.org.uk

Guild of Glass Engravers www.gge.org.uk

Goldsmiths' Crafts and Design Council www.craftanddesigncouncil.org.uk

Worshipful Company of Goldsmiths www.thegoldsmiths.co.uk

The Institute of Professional Goldsmiths www.ipgoldsmiths.com

Contemporary British Silversmiths www.contemporarybritishsilversmiths.org

Association for Contemporary Jewellery www.acj.org.uk

The National Association of Jewellers www.naj.co.uk

Designer Jewellers Association www.designerjewellersgroup.co.uk

British Allied Trades Federation www.batf.uk.com

The Jewellery Distributor's Association www.jda.org.uk

Worshipful Company of Cutlers www.cutlerslondon.co.uk

Worshipful Company of Pewterers www.pewterers.org.uk

The Ironmongers' Company www.ironmongers.org

Welding Institute www.theweldinginstitute.com

British Art Blacksmith Society www.baba.org.uk

Craft Potters Association of Great Britain www.cpaceramics.co.uk

International Association of Papermakers and Artists www.iapma.info

Society of Bookbinders www.societyofbookbinders.com

Designer Bookbinders www.designerbookbinders.org.uk

Calligraphy and Lettering Arts Society www.clas.co.uk

Society of Scribes and Illuminators www.calligraphyonline.org

Miscellaneous organisations

Institute for Conservation www.icon.org.uk

Archive and Records Association www.archives.org.uk

The Great Diary Project www.thegreatdiaryproject.co.uk

The National Archives www.nationalarchives.gov.uk

British Association of Paintings Conservator-Restorers www.bapcr.org.uk

Society of London Art Dealers www.slad.org.uk

Visual Arts and Galleries Association www.vaga.co.uk

Society of Artists' Agents www.saahub.com

Fine Art Trade Guild www.fineart.co.uk

Greeting Card Association www.greetingcardassociation.org.uk

Tattoo Club of Great Britain www.tattoo.co.uk

Tattoo and Piecing Industry Union www.tpiu.org.uk

British Travel Goods and Accessories Association www.btaa.org.uk

The Luxury Society www.luxurysociety.com

Association of Suppliers to the British Clothing Industry
www.ashci.co.uk

National Childrenswear Association www.ncwa.co.uk

Royal Society for the Encouragement of Arts, Manufactures and Commerce www.thersa.org

Institute of Materials, Minerals and Mining www.iom3.org

Manufacturing Technologies Association www.mta.org.uk

Federation of British Hand Tool Manufacturers www.mta.org.uk/fbhtm

Plastic Historical Society www.plastiquarian.com

Craft Central www.craftcentral.org.uk

Hidden Art www.hiddenart.co.uk The Visual Effects Society www.visualeffectssociety.com

The UK Screen Association http://ukscreenassociation.co.uk

AUSTRALIA

Key organisations

Australia Council (Arts) www.australiacouncil.gov.au

National Association for the Visual Arts www.visualarts.net.au

Screen Australia www.screenaustralia.gov.au/

Professional bodies and associations Art and design

Australian Artists Association
www.australianartistsassociation.org.au

Art Association of Australia and New Zealand

Guildhouse www.quildhouse.org.au

Portrait Artists Australia http://portraitartistsaustralia.com.au

The Association of Australian Decorative and Fine Arts Societies www.adfas.org.au

The Sculptors Society www.sculptorssociety.com

Illustrators Australia www.illustratorsaustralia.com

Australian Graphic Design Association www.agda.com.au

Design Institute of Australia www.dia.org.au

Australian Institute of Architects www.architecture.com.au

Photography and film

Australian Institute of Professional Photography www.aipp.com.au

Australian Commercial and Media Photographers http://acmp.com.au

Applied arts and crafts

The Folk and Decorative Artists' Association of Australia www.fdaa.org.au

NSW Guild of Craft Bookbinders www.nswbookbinders.org

Jewellers Association of Australia www.jaa.com.au

Contemporary Glass Society www.cgs.org.uk

The Australian Ceramics Association www.australianceramics.com

The Textile Institute www.textileinstitute.com.au

Council of Textile and Fashion Industries of Australia www.tfia.com.au

The Furnishing Industry Association of Australia www.fiaa.com

Commercial Leather Association of Australia and New Zealand www.leffler.com.au/cla.htm

Australian Sewing Guild Inc. www.aussew.org.au

Miscellaneous organisations

Australian Society of Authors www.asauthors.org

CANADA

Key organisations

Canada Council for the Arts www.canadacouncil.ca

Canadian Crafts Federation http://canadiancraftsfederation.typepad.com

National Film Board of Canada www.nfb.ca

Professional bodies and associations Art and design

Society of Canadian Artists www.societyofcanadianartists.com

Federation of Canadian Artists www.artists.ca

Canadian Society of Children's Authors, Illustrators, and Performers www.canscaip.org

Society of Graphic Designers of Canada www.gdc.net

Interior Designers of Canada www.idcanada.org

Association of Canadian Industrial Designers www.designcanada.org

Royal Architectural Institute of Canada www.raic.org

Photography and film

Canadian Association of Photographers and Illustrators in Communications www.capic.org

Canadian Association of Photographic Art www.capacanada.ca

Professional Photographers of Canada www.ppoc.ca

Applied arts and crafts

Canadian Jewellers Association https://canadianjewellers.com/

Canadian Glass Association www.canadianglassassociation.com

Potters Guild of British Columbia www.bcpotters.com

Metal Arts Guild of Canada www.metalartsguild.ca

Canadian Apparel Federation www.apparel.ca

Canadian Textile Association www.cdntexassoc.com

North American Home Furnishings Association www.nahfa.org

American Society of Furniture Designers www.asfd.com

Miscellaneous organisations

CARFAC Canadian Artists' Representation www.carfac.ca

Canadian Printing Industries Association www.cpia-aci.ca

USA

Key organisations

National Assembly of State Arts Agencies www.nasaa-arts.org

Americans for the Arts/Public Art Network www.americansforthearts.org/

American Crafts Council www.craftcouncil.org

New York Foundation for the Arts www.nyfa.org

National Endowment for the Arts www.arts.gov

Professional bodies and associations Art and design

National Association of Independent Artists https://naia-artists.org

American Watercolor Society www.americanwatercolorsociety.org

American Medallic Sculpture Association www.amsamedals.org

National Sculpture Society www.nationalsculpture.org

American Institute of Graphic Arts www.aiga.org

The Graphic Artists Guild https://graphicartistsguild.org

Society of Illustrators http://societyillustrators.org

Society of Children's Book Writers and Illustrators www.scbwi.org

National Cartoonist Society www.reuben.org

Surface Design Association www.surfacedesign.org

Council of Fashion Designers of America www.cfda.com

Society of Publication Designers www.spd.org

American Institute of Interior Designers www.asid.org

Industrial Designers Society of America www.idsa.org

American Institute of Architects www.aia.org

Photography, moving image and film

Professional Photographers of America www.ppa.com

American Society of Media Photographers http://asmp.org

Photographic Society of America www.psa-photo.org

The Visual Effects Society www.visualeffectssociety.com

American Film Institute www.afi.com

Association of Independent Video and Filmmakers www.aivf.ora

Art Directors Club www.adcglobal.org

Applied arts and crafts

Jewelers of America www.jewelers.org

American Gem Association www.americangemsociety.org

Society of American Silversmiths www.silversmithing.com

Society of North American Goldsmiths www.snagmetalsmith.org

Glass Art Society www.glassart.org

American Ceramic Society www.ceramics.org

Handweavers Guild of America www.weavespindye.org

The American Sewing Guild www.asq.org/

American Association of Woodturners www.woodturner.org

United Brotherhood of Carpenters www.carpenters.org

Miscellaneous organisations

Jewelers Board of Trade www.jewelersboard.com Hosts an extensive list of professional associations.

Textile Society of America www.textilesocietyofamerica.org

National Council of Textile Organizations www.ncto.org

SOUTH AMERICA

Professional bodies and associations Art and design

Argentina Association of Art Galleries www.galeriasargentinas.org.ar

Argentine Society of Visual Artists www.sava.org.ar

Argentina Society of Plastic Artists www.artesaap.com.ar

Brazilian Association of Contemporary Art http://abact.com.br/

Brazilian Association of Music and Arts www.abramus.org.br

Painters and Sculptors Association Chile www.apech.es.tl

Product Designers Association (Brazil) http://adp.org.br/

Graphic Design Association of Brazil www.adg.org.br

Association Object Brazil www.objetobrasil.com.br

Brazilian Association of Interior Design www.abd.org.br

Decorators Association of Chile www.add.cl

The Brazilian Association of Fashion Designers www.abest.com.br/abest/

Central Society of Architects (Argentina) www.socearq.org

Photography and film

Brazilian Association of Cinematography www.abcine.org.br

Applied arts and crafts

Jewelers Association of the State of Sao Paulo www.ajesp.com.br/

Brazilian Association of Textile and Apparel Industry www.abit.org.br/Home.aspx

Brazilian Association of Binding and Restoration www.aber.org.br

Miscellaneous organisations

ABIMAD Brazilian Association of High Decoration and Furniture Industries www.abimad.com.br

Quotation credits

Abbing, Hans, p.15: from p.122, Hans Abbing, Why are Artists Poor?

The Exceptional Economy of the Arts (Amsterdam: Amsterdam University Press, 2002).

Allen, Woody, p.112: from p.107, Nigel Rees, *Cassell's Humorous Quotations* (London: Cassell & Co, 2003); sourced from *The New York Magazine*, 13 August 1989.

Allen, Woody, p.72: from p.4, Elizabeth Knowles (ed.), Oxford Concise Dictionary of Quotations, 4th ed. (Oxford: Oxford University Press, 2001); sourced from 'Sayings of the Week', the Observer, 10 March 1996.

Antonelli, Paola, p.267: in an interview with Evan Davis on the *Today* programme, BBC Radio 4, 2009.

Baylis, Trevor, p.173: from p.60, 'Intellectual Property with Trevor Baylis', in *Start Your Business Magazine*, June 2007.

Beckwith, Harry, quoting Picasso, p.78: from p.137–138, Harry Beckwith, *Selling the Invisible: A Field Guide to Modern Marketing* (Texere, New York: 2001).

Belloc, Hilaire, p.287: from p.22 Hilaire Belloc, 'More Peers' (London: Duckworth & Co, 1911). (Referenced with the help of Nigel Rees.)

Beuys, Joseph, p.33: from p.121, Lucy Lippard, Six Years: The Dematerialisation of the Art Object from 1966 to 1972 (Berkeley and Los Angeles: University of California Press, 1997); sourced from an interview with Willoughby Sharp, Artforum, November 1969.

Bonheur, Rosa, p.189: from Dana Micucci, *Artists in Residence*, 1st ed. (New York: The Little Book Room, 2001).

Boone, Mary, p.93: from p.29, Don Thompson, The \$12 Million Stuffed Shark: The Curious Economics of Contemporary Art and Auction Houses, 1st ed. (London: Aurum Press, 2008). Brooks, Mel, p.237: from Nigel Rees, *Cassell's Humorous Quotations* (London: Cassell & Co, 2003); sourced from the film *The Producers*, dir. Mel Brooks (Crossbow Productions, 1968).

Brownless, Alex, p.149: from a talk at the Entrepreneurship Summer School taught by Alison Branagan, Central Saint Martins, London, 2015.

Butler, Samuel, p.207: from p.61, Nigel Rees, Cassell's Humorous Quotations (London: Cassell & Co, 2003); sourced from A.T. Bartholomew (ed.), Further Extracts from the Note-Books of Samuel Butler (London: Jonathan Cape, 1934).

Childish, Billy, p.114: from Sally Williams, 'Divided They Stand' in *The Guardian*, 6 June 2009.

Clark, Ross, p.227: from p.31, Ross Clark, *How to Label a Goat*, 1st ed. (Petersfield, Hampshire: Harriman House, 2006).

Covey, Stephen, p.24: a popular version of Covey's quotation: 'Live out of your imagination and conscience instead of only your memory', from p.304, Stephen Covey, The 7 Habits of Highly Effective People (London: Simon and Schuster, 1999).

Degas, Edgar, p.66: from M. Guerin, *Degas' Letters* (Oxford: Cassirer, 1947).

Emin, Tracey, p.172: in an interview with John Humphrys on the *Today* programme, BBC Radio 4, 2004.

Galliano, John, p.65: from a report by Imogen Fox in *The Guardian*, 6 April 2009.

Genn, Sara, p.45: from p.186, Alain Briot, Mastering Landscape Photography: The Luminous-Landscape Essays (Santa Barbara: Rocky Nook, 2007).

Griffin, Susan, p.124: from Susan Griffin, The Eros and Everyday Life: Essays on Ecology, Gender and Society (New York: Knopf Doubleday Publishing, 1996).

Jackson, Alexander Young, p.56: from p.196, Alain Briot, Mastering Landscape Photography: The Luminous-Landscape Essays (Santa Barbara: Rocky Nook, 2007).

Jobs, Steve, p.281: from p.28, John Boulton, Digital Revolution (London: Barbican International Enterprises, 2014).

Karp, Ivan C., p.209: from p.138, Curtis W. Casewit, *Making A Living in the Fine Arts: Advice from the Pros*, 1st ed. (New York: Collier Books, 1984).

Kaye, Tony, p.205: quoted during a seminar to celebrate the life of Paul Arden at Central Hall, Westminster, London, 9 June 2009.

MacDonald, Kyle, p.215: from p.286, Kyle MacDonald, One Red Paperclip: The Story of How One Man Changed his Life One Swap at a Time, 2nd ed. (London: Ebury Press, 2008).

Millard, Rosie, p.158: from p.167, Rosie Millard, *The Tastemakers: U.K. Art Now 2002*, 2nd ed. (London: Scribner, 2002).

Miller, Harley, p.48: from p.7, Harley Miller, A Proper Living from Your Art – How to Make Your Painting Pay, 1st ed. (Findhorn Bay, Moray: Posthouse Printing and Publishing, 2000).

Miller, Jonathan, p.9: from an interview with Nicholas Wroe in *The Guardian*, 10 January 2009.

Monet, Claude, p.111: from p.40, Dana Micucci, *Artists in Residence*, 1st ed. (New York: The Little Book Room, 2001).

Nafi, Gulnur Mustafa, p.45: from a conversation with the author, February 2009.

Neal, Gareth, p.293: Gareth Neal in his talk 'Selling Collectable Design' at the 2009 Hidden Art Forum.

Parker, Cornelia, p.30: from p.142, Judith Palmer, *Private Views: Artists Working Today*, 1st ed. (London: Serpent's Tail Publishers, 2004).

Pearson Wright, Stuart, p.37: from p.198, Judith Palmer, *Private Views: Artists Working Today*, 1st ed. (London: Serpent's Tail Publishers, 2004).

Portas, Mary, p.130: from Zoe Williams' article for the *Guardian*, 'Margate Divided Over its Role in Mary Portas Reality Show', 15 June 2012.

Presley, Hovis, p.165. from p.15, Hovis Presley, *Poetic Off License: Holiday Annual*, 1st ed. (Bolton: D2, 1997).

Price, Barclay, p.98: from p.14, Barclay Price, Running a Workshop: Basic Business for

Craftspeople, 3rd ed. (London: Crafts Council, 2000).

Rae, David, p.267: from p.4, David Rae, Opportunity-Centred Entrepreneurship, 2nd ed. (London: Palgrave, 2015).

Rose, Walter, p.99: from p.14, Walter Rose, *The Village Carpenter*, 2nd ed. (Carmarthenshire: Stobart Davies, Ammanford, 2009).

Rose, Walter, p.230: from p.137, Walter Rose, *The Village Carpenter*, 2nd ed. (Carmarthenshire: Stobart Davies, Ammanford, 2009).

Sennett, Richard, p.30: from p.22, Richard Sennett, *The Craftsman*, 2nd ed. (London: Penguin, 2008).

Shaughnessy, Adrian, p.93: from p.67, Adrian Shaughnessy, *How to be a Graphic Designer Without Losing Your Soul*, 1st ed. (London: Laurence King, 2005).

Sibelius, Jean, p.155: from p.94, Bengt de Törne, *Sibelius: A Close-Up* (London: Faber and Faber, 1937).

Smith, Paul, p.225: from p.169, Lee McCormak, *Designers are Wankers*, 1st ed. (London: About Face Publishing, 2005).

Standage, Tom, p.257: from p.172, Tom Standage, *The Victorian Internet*, 2nd ed. (London: Bloomsbury, 2014).

Stern, Simon, p.187: from p.17, Simon Stern, *The Illustrator's Guide to Law and Business Practice*, 1st ed. (London: Association of Illustrators, 2008).

Sturt, George, p.223: from p.87, George Sturt, *The Wheelwright's Shop* (Cambridge: Cambridge University Press, 2000).

Thornton, Sarah, p.282: from p.24, Sarah Thornton, Seven Days in the Art World (New York: W.W. Norton & Company, Inc.); paraphrased by Grayson Perry: from Grayson Perry in the first Reith Lecture 2013, Tate Modern, 'Democracy Has Bad Taste – Playing to the Gallery', p.6 of the transcript, 15 October 2013.

Toos, Andrew, p.155: from p.3, Rick DiBiasio, *The Affluent Artist*, 1st ed. (New York: Morgan James Publishing, 2009).

Warhol, Andy, p.134: from p.328, Elizabeth Knowles, *Oxford Concise Dictionary of Quotations*, 4th ed. (Oxford: Oxford University Press, 2001); sourced from a volume released to mark Warhol's exhibition in Stockholm, February–March 1968.

Warhol, Andy, p.21: from p.92, Andy Warhol, *The Philosophy of Andy Warhol (From A to B and Back Again)*, (New York: Harcourt Brace Jovanovich, 1975).

Watson, Richard, p.250: special quotation made on request by Alison Branagan, by email on 2 July 2015.

Wells, H.G., p.250: from the chapter *The Idea of a Permanent World Encyclopaedia, World Brain* (London: Methuen, 1938).Westwood, Vivienne, p.107: from an interview with Iain R. Webb in *Wonderland* Magazine, April–May 2009.

Wilde, Oscar, p.15: from p.803, Rupert Hart-Davies (ed.), *The Letters of Oscar Wilde* (London: Hart-Davies, 1962).

Index

Abbing, Hans 15, 18 Beckwith, Harry 78 accountants 40, 47, 53, 240, 248 **BEIS 203** Adorn Insight 277 benefits 66, 67, 69, 165-167, 171, 238 agents 21-22, 24, 26, 40-42, 49, 117, 125, 127, Beuys, Joseph 19, 33 201, 211-214 Biviano, Alana 28, 148 Allen, Woody 72, 112 Blake, William 46 animators 11, 16 blogs/blogging 10, 37, 48, 100, 105, 109, 119, 121, Annual Investment Allowance (AIA) 232-233 127, 138, 139, 142, 153, 163, 251, 254, 259, anti-copying in design (ACID) 202 260-263, 261, 266, 276 Antonelli, Paola 267 Guest 263 Arts Council 156, 158, 159, 163 body language 131-132, 220 apps 10, 51, 52, 142, 225, 249, 257, 260, 265, 271, Bonheur, Rosa 189 273, 253, 284, 295 bookkeeping 37, 53, 61, 67, 77, 166, 222, architects 11, 16, 185, 195 229-230, 237-247, 249, 303 Arden, Paul 111, 205 Boone, Mary 93 Arnold, Matthew 260 Borkowski, Mark 153, 154 Art Loss Register 200, 203 Borowik, Damien 270, 271, 275, 278, 286 art school 11, 18, 22, 26, 27, 30, 35, 37, 46, 79, Bowie, David 27 117, 121, 168 Bradford, Tim 89, 259 artisan 18, 31, 270, 287 Branson, Richard 150 The Artists Information Company 7, 190 Brexit 50, 54, 294 Arts Thread 149, 252, 264 British citizenship 50, 155, 158 ASOS 95 British Film Institute (BFI) 156, 158, 159 assigning 174, 181, 183, 220 Brooks, Mel 237 assignment 101, 177, 178, 211, 220 Brownless, Alex 149, 264 Association of Illustrators (AOI) 17, 29, 44, 119, BSI British Standards 189, 193, 197 146, 311 business 9-28 Association of Photographers (AOP) 29, 119 accounts 52, 53, 66, 67, 166, 168, 222, 235, 237, ATA Designs 43 240, 247 awards 19, 41, 49, 100, 121, 123, 128, 136, 142, advanced 38, 283, 294 146, 156, 159, 207 angels 286, 288 bank 52-53, 60, 100, 226, 237, 239, 241, 242, Bacon, Francis 27 247 Banksy 95, 149 big 38-39, 281 barter 142, 167-168, 171, 215, 289, 303, cards 60, 105, 113, 117, 135, 144-145, 208, 304 231, 256, 259, 301 barcode 199, 203 costs 66, 69-72, 82, 84, 100, 105, 106, 108, 227, Baylis, Trevor 173 229, 231

consumer contracts 61, 103, 195, 196, 255, 284 expenses 73, 80-83, 106, 108, 167, 227, contracts 17, 20, 37, 100, 103, 177, 179, 209-214, 229-230, 232 247, 290 growth 9, 14, 39, 109, 281-287, 289, 294 Cook, Beryl 19 name 93-98, 102, 176, 178, 180, 182, 255, 308 plan 37, 50-52, 54, 61, 98-109, 112, 156-157, co-operatives 58 copyright 16, 28, 61, 78, 79, 81, 94, 95, 97, 101, 283, 286 103, 140, 168, 173-175, 177, 178, 183, 185, skills 26, 39 186, 188, 195, 210-211, 212, 220, 226, 260, start-up 28, 37, 39, 45-54, 57, 60-61, 66, 69-72, 274, 288, 290, 291, 302, 210, 312 106, 122 costing 61, 65-67, 73-88, 90, 100, 105, 242, 297, structures 56-59, 291-292 304, 309-312 template 102-106 Covey, Stephen 24 theory 37, 39 crafts 18, 34, 87 time cake theory 73-77 Crafts Council 34, 40, 156, 158, 159, 309, 310 visa/s 54-56 CRB check (see The Disclosure and Barring Service) Butler, Samuel 207 Creative Barcode 106, 260 buyers 21, 24, 26, 49, 104, 117, 122, 149, 206, 277 creative coding 274 BVN Creative 28, 148 Creative Review 60, 136, 150 credit (acknowledgement) 94, 95, 140, 161, 216, cancellation fees 188, 220, 226 221, 226, 260 capital allowances 233-234 cards 68, 69, 157, 242, 246, 252 cash-flow 66, 99, 106-107 unions 157 catalogues 32, 49, 60, 124, 135, 138, 149, 160, critics 22, 79, 117, 138, 142, 151, 205 161, 163, 184 crowdfunding 21-22, 37, 38, 52, 106, 155, 156, CE marking 61, 197-198, 288 158, 268–270, 273, 275, 278, 282, 286, 289, Childish, Billy 114 Clark, Ross 227 CV (Curriculum Vitae) 32, 37, 60, 124, 136-137, Cocker, Jarvis 27 139, 144, 207, 208 collaboration 248, 268, 285 collectives 58, 268 Dakin, Rob 275, 297 Colour Hive 277 Daniels, Monique 62 commission/s 12, 17–18, 20, 22, 24, 31, 37, 41, 46, database 105, 122, 151, 176, 188, 194, 225, 255, 60, 66, 73, 80, 81, 89, 90, 99, 101, 121, 136, 142, 274, 311 151, 178, 186–188, 196, 208, 209, 211–214, protection 194, 255, 274 219-221, 223, 237, 239, 241, 248, 251, 267, dealers 20, 22, 25, 40-42, 49, 84, 86, 111, 117, 281, 284, 290, 301, 303, 306, 310-312 122, 125, 136, 168, 198, 200, 201, 207, on sales 84, 86, 87, 209, 304 Community Interest Companies 59 211-214, 220, 284, 285, 293 debt 58, 67, 69, 150, 156-157, 196, 224-225, 232 Companies House 58, 59, 60, 97-98, 102 deed of partnership 58 company 12, 14, 24, 25, 34, 38, 46, 54, 56-60, 66, Degas, Edgar 66 93, 94, 96-98, 102, 162, 170, 176, 181, 186, degree shows 21-24, 112, 122, 142, 162, 165, 205, 213, 226, 237, 248, 256, 264, 286, 287, 168, 206, 215, 293, 300-301 291-292, 310 Delacroix, Eugène 31 competitions 115, 119, 121, 142, 159, 259, 263 demographics 162, 254, 258, 272, 276 competitors 34, 61, 104, 109, 178, 258, 262, 268, Design and Artists' Copyright Society (DACS) 168 confidence 26, 114, 131, 132, 205, 207, 216-217,

220, 246, 248, 288

confidentiality 106

design right 61, 81, 101, 103, 106, 173, 177-179,

182, 185, 220, 268, 274, 284, 288, 312

disability 63, 64 220, 226, 232, 241, 263, 283, 290, 306, The Disclosure and Barring Service (DBS) 309-312 196-197 fees, no 32-33 disruptive technologies 271 fees, penalty 224-226 Distance Selling (see Consumer Contracts) financial planning 37, 38, 61, 68, 106, 108, 289 domain names 96, 127, 251, 253 Finch, Patricia 190 Dominy, Katie 264 flyers 46, 60, 121, 136, 137, 163 Drapers 60, 276, 311 focus 12, 18, 19, 26, 30-33, 43, 99, 134, 158, 219, drawings (paper) 141, 151, 168, 179, 185 248, 287, 296, 308 drawings (PSB) 69, 80, 82, 106, 108, 238, 239, 245, FreeAgent 61, 240, 293 247 freelance 12, 15, 16, 28, 36, 46, 47, 60, 80, 89, 90, Durand-Ruel, Paul 111 136, 190, 191, 236, 253, 281, 285, 287, 290, Dury, Ian 27 Dyson, Sir James 6, 57, 294 Frost, Vince 111 funding 21, 32, 37, 52, 57, 59, 132, 155, 164, 165, ecology 176, 100, 201, 273, 284, 292 167, 286-287 eCommerce 103 The Future Laboratory 277 email 24, 28, 32, 36, 40, 74, 102, 112, 115-119, 124, 125, 130, 131, 136, 138-139, 140, 143. Galliano, John 65 149, 150, 159–162, 164, 167, 169, 170, 179, Genn, Sara 45 186-188, 196, 210, 214, 218, 223-225, 247, Google Analytics 109, 254, 263 251-252, 255-257, 259, 261, 271, 307, 312 grants 52, 59, 106, 108, 119, 155, 156, 157, Emin, Tracey 20, 172 158-159, 167, 232, 247, 281, 292 employing people 287 graphic designers 12, 28, 80, 111, 194 employment 27, 33-34, 36, 37, 47, 136, 165, 166. Griffin, Susan 124 230, 234, 287, 290 growth accelerator 286 full-time 16, 24, 25, 34, 69, 108, 234, 290 Grupe, Karl 109 part-time 12, 20, 24, 31, 34, 35, 41, 42, 46, 55, 69, 75, 106, 108, 166, 167, 234, 238, 239, 290 hallmarks 95 endorsement 33, 142, 205, 206, 219, 262, 304 hashtags 96, 258, 259, 266 enterprise agencies 48, 52, 108, 156, 157 health and safety 37, 38, 61, 194-195, 197 skills 9, 27, 37-39, 61 Hemingway, Wayne 20 entrepreneur(ship) 12, 24-27, 28, 39, 54, 55, 72, Hepworth, Barbara 19 109, 111, 120, 121, 150, 206, 267-268, 270 Hilaire, Belloc 287 eShops/eStores 10, 100, 127 Hills, Kathleen 139, 170 ethics 149, 201, 206, 274, 284 Hirst, Damien 93, 95, 111, 180 events 21, 24, 43, 57, 72, 79, 109, 113, 118, 119, Hitchcock, Alfred 149 121, 122, 127, 134, 135, 142, 143, 144, 155, Horn, Rebecca 190 163, 191, 206, 259, 263, 272, 277, 278, 300 hours 36, 48, 55, 69, 73, 165, 219 exclusivity 54, 78, 79, 212, 264 housing benefit 49, 69, 165, 166-167, 238 fairs 21, 22, 24, 38, 49, 55, 70, 77, 88, 100, 105, illustration 16, 17, 40, 78, 94, 175, 180, 311 123, 134, 140, 142, 144, 145-147, 151, 157, illustrator 11, 12, 16, 41, 45, 81, 89, 90, 119, 126, 179, 191, 201, 206, 208, 209, 225, 272, 276, 132, 136, 186, 187, 200, 209, 212, 311 283, 285, 286, 288, 293, 297, 300, 306 Independent Safeguarding Authority 196 Federation of Small Businesses (FSB) 60, 225 industry 62, 112, 198, 199, 252, 288, 326-334 fees 15, 17, 27, 61-66, 78-82, 100, 105, 121, Infographic CV 136 123, 181, 184, 186, 188, 210, 211, 218, 219, Information Commissioner 255

innovation 9, 10, 48, 70, 79, 105, 156, 185, 267, MacDonald, Kyle 215 Mackintosh, Charles Rennie 189 268, 270, 271, 273, 274, 276, 277, 278, 283 magazines 23, 43, 68, 89, 90, 100, 119, 121, 135, innovative 13, 25, 26, 179, 180, 182, 295 138-139, 140-143, 150, 161, 164, 170, 175, insurance 17, 37, 38, 60, 68, 70, 71, 103, 168, 184, 263, 277, 307, 310, 311 188, 189–194, 207, 213, 231, 232, 247, 287, Magritte, René 19 Intellectual Property Office (IPO) 96, 175, 178, maker's mark 94-95, 168, 175 Mango Lab 109, 286 179, 180 manufacturing 16, 21, 31, 38, 43, 72, 76, 77, 79, intellectual property rights (IPR) 56, 173, 179, 82, 83, 88, 170, 172, 178, 180, 181, 193, 197, 198, 201, 232, 268, 274, 277, 285, 288, 293, internship/s 32, 36-37, 40, 287, 290, 300 305, 306, 312 invoicing 67, 144, 196, 207, 222-226, 230, 235, margin 79, 84-87, 105, 293, 304-305 240-242, 247, 252, 290 Marinetti, Filippo Tommaso 19 IP tagging 94, 175, 259-260 mark-up 84-85, 87, 304 iZettle 225 market-led 13, 25 Jackson, Alexander Young 56 market research 25, 37, 51, 82, 100, 144, 155, 272, 276, 297, 302, 306 Jobs, Steve 281 market stalls 70, 191, 201, 236 Jobseeker's Allowance 49-50, 165 market traders 191, 201 marketing 28, 40, 61, 70, 76, 77, 99, 100, 105, 130, Karp, Ivan C. 209 134-136, 149, 150, 160, 161, 162, 164, 178, Kaye, Tony 205 195, 219, 220, 231, 232, 262, 285, 300-301 King, William Julian 287 campaign 23-24, 31, 37, 135, 138-143, 258 Klein, Yves 19, 149 copy 138, 137, 170, 264 Koons, Jeff 20 materials 37, 49, 70, 124, 134-137, 138-139, 141, 144, 148, 163 language 120, 133 statement 137, 148 late payment 176, 196, 224-226 timeline 23-24, 138-143 Lee, David 150 viral 135, 258 Levinson, Sydney 222 liabilities 57, 101, 168, 177, 187, 213 Massey-Stewart, Julia 109 liability 18, 58, 60, 103, 176, 190-193, 194, 223, McGowan, Mark 149 media 23, 57, 121, 125, 130, 134-135, 137, 139, 226, 228, 230, 232, 234, 237, 284, 287, 292 141, 143, 151, 160-161, 168, 170, 259, 261, licensing 16, 38, 61, 65, 78, 79, 81, 94–95, 99, 101, 262, 270, 276, 301 103, 175, 177, 181, 184, 186, 214, 220, 260, Media release (see press release) 281, 285, 288, 290-291 Mercury, Freddie 27 micro 288, 295 metadata 94, 175, 253, 260 limited company 12, 46, 56, 58, 97, 213, 226, 248, 256, 287, 291-292 description 283 tags 95, 175, 253 limited editions 79, 168, 195, 199 M.I.A. (Mathangi 'Maya' Arulpragasam) 27 loans 17, 38, 51, 52, 57, 100, 108, 156-158, 247, Michelangelo 190 286 Millard, Rosie 158 local press (see newspapers) Logan, Andrew 27 Miller, Harley 48 logos 62, 94, 95, 96, 98, 138, 162, 163, 175, 178, Miller, Jonathan 9 180, 181, 185, 226, 259, 260 Miller, Rebecca 27 Mix Magazine 277 loss 46, 100, 106, 176, 194, 234, 238 Mode Info 277 low income 69, 165-166

```
Monet, Claude 111
                                                     payment 16, 17, 46, 47, 67, 78, 108, 213, 223, 226,
money 19, 20, 25, 26, 30, 31, 32, 42, 46, 47, 52,
                                                          241, 242, 246, 295, 312
    53, 54, 55, 69–70, 73–78, 79, 82, 105, 106,
                                                        gateway 254-255
    108, 155, 156, 158, 159, 161, 162, 165, 168,
                                                        late 176, 196, 224-225, 226
    169, 187, 195, 196, 210, 212, 216, 217, 219,
                                                        service provider (PSP) 252, 255, 284
    220, 221, 223, 228, 230, 234, 237, 238, 240-
                                                        terms 181, 224, 226
    242, 247, 262, 269, 282, 286, 289, 297, 301
                                                     Payment Card Industry Data Security Standard
  management 17, 37, 61, 65-74, 93, 99, 100,
    237
                                                     Paypal 10, 100, 223, 224-225, 245-247, 252,
moral rights 174, 177, 183, 274
                                                          254-255
music 16, 26, 57, 174, 201, 205, 274
                                                     payroll 38, 287, 289, 291
                                                     pensions 167, 194
Nafi, Gulnar Mustafa 45
                                                     Pepper, Rob 151
National Insurance (NI) 37, 38, 46, 47, 50, 54, 68,
                                                     permission 95, 131, 140, 175, 178, 184, 260,
    80, 230-231, 233, 291, 292
Neal, Gareth 293
                                                     Perry, Grayson 282
negotiation 38, 41, 86, 100, 132, 205, 215-221,
                                                     Personal Survival Budget (PSB) 66-69, 80, 81, 82,
    268, 302-304, 310
networking 38, 43, 73, 76, 77, 89, 100, 105,
                                                     personal tax-free allowance (PTA) 229-231
    111-124, 127, 139
                                                     persuasion 207-209
  virtual 124-127, 258-260
                                                     PESTLE 272, 276, 283, 284
newspapers 138-141, 143, 149, 164, 232, 276,
                                                     photographer 11, 16, 32, 45, 90, 102, 108, 126.
    278, 310
                                                          135, 140, 142, 160, 174, 175, 184, 186, 194,
Nike 181
                                                          200, 232, 310
non-EU 50, 54-55, 165
                                                     photographing work 135, 138
not-for-profit company 57, 58, 59
                                                     photographs 13, 62, 94, 103, 109, 126, 131, 135,
                                                          140, 150, 162, 168, 175, 179, 180, 184, 205,
offsetting 229, 232
                                                          258, 259, 262, 302, 310
online trading (see trading online)
                                                     photography 16, 70, 170, 216, 264, 290,
opportunities 10, 16-17, 26, 28, 32, 33, 42, 43, 48,
                                                          303
    51, 62, 65, 109, 117, 118, 121, 170, 205, 207,
                                                     Picasso, Pablo 180
    264, 270-271, 301
                                                     pop-up shop 21, 38, 58, 70, 104, 122, 142, 192,
orphan works 94-95, 168, 175, 260
                                                          268-269, 282, 289
                                                     Portas, Mary 130
packaging regulations 199
                                                     portfolio 24, 31, 49, 113, 148-149, 165, 188, 208,
paid employment 33-36
                                                          211, 212, 216, 217, 232, 252, 262, 264
Parker, Cornelia 30
                                                       PDF 113, 116, 124-126, 137
partnership/s 9, 12, 51, 56, 58, 97, 102, 109, 268,
                                                       portals 10, 24, 28, 60, 119, 123, 127, 142, 148,
                                                          264, 267, 285
part-time employment 12, 20, 24, 31, 34, 35, 41,
                                                     postcards 135, 138, 144-145, 151, 163, 169, 208,
    42, 46, 55, 69, 75, 106, 108, 166, 167, 234,
                                                          232
    238, 239, 290
                                                     presentation 38, 100, 115, 124, 130-133, 151,
'passing off' 97, 184
                                                          155, 205, 216-217, 264
patent 6, 25, 57, 61, 78, 81, 103, 106, 173, 177,
                                                     Presley, Hovis 165
    178, 179–181, 182, 185, 220, 268, 281, 288
                                                     press 21, 32, 150
pay per click 253
                                                       campaign 138-139, 163, 278
PAYE (Pay As You Earn) 46-47, 90, 165, 166, 234,
                                                       free 139-141
    239, 291, 312
                                                       packs 208
```

page 262–263	106, 117, 144, 155, 159, 167, 184, 189, 207,
releases 100, 137, 140–141, 160, 161, 162, 163,	208, 216, 232, 264, 272, 276, 296, 302, 303,
164, 263	306, 309, 310, 312
Price, Barclay 98	Rhodes, Zandra 95, 180
pricing 15, 43, 65–66, 73, 78–88, 90, 100, 105,	rights 16, 42, 55, 57, 65, 78, 79, 81, 94, 98, 99,
123, 297, 304–306, 309	103, 140, 173–174, 177, 179–183, 186, 188,
print on demand (see product on demand)	195, 209–213, 219–221, 260, 263, 274–275,
printing 16, 72, 135, 136, 148, 232, 305	261, 281, 284, 287, 290-291, 295, 311
legal 199–200	resale 168
paper 48, 117, 151	risk 17, 25, 32, 38, 39, 56, 60-61, 79, 97, 99, 101,
3D 270, 274, 284	102, 118, 136, 176, 184, 186, 189–190, 192,
private company/ies 56, 58, 291–292	194, 198, 210, 216, 220, 238, 268, 273, 282,
product designer/s 16, 170, 268, 303	285, 286, 293, 297
product on demand 16, 49, 100, 271, 273, 285,	Rose, Walter 99, 108, 270
301–302	Rosenquist, James 19
professional development 36–37, 38, 122	royalties 16, 17, 78, 99, 177, 181, 183, 220, 239,
associations/bodies 18, 22, 37, 42, 48, 59, 60,	290–291, 295
62, 81, 100, 116, 117, 118–119, 123, 190, 209,	
213, 226, 326–334	sales 6, 12, 15, 19, 24, 32, 41, 46, 66, 77, 84, 85,
profit/s 12, 18, 54, 66, 72, 77, 80, 82, 83, 106, 156,	84-88, 100, 101, 106, 115, 119, 138, 169, 186,
158, 167, 168, 200, 212, 227, 229–234, 238,	196, 197, 205-208, 212, 213, 222, 228, 234,
285, 286, 289, 292, 294, 304	235, 237, 239, 241-244, 246, 247, 261, 268,
margin 79, 84–87, 105	291, 293, 294, 304, 309-310, 312
promotion 23, 38, 60, 76, 84, 100, 105, 121, 122–123,	search engines 253–254
130, 134–139, 149, 161, 256, 257, 259, 262	secure socket layer (SSL) 251–252
publicity 37, 62, 100, 105, 134–136, 151, 160, 163,	self-assessment forms 228
170	self-employment 24, 36, 37, 45-57, 66, 69, 93,
stunt 140, 149–150, 258, 301	100–101, 102, 166, 231
publishing 16, 170	registration 47–48, 53–54, 227–228
	selling 16, 20, 34, 37, 42, 46, 47, 49, 66, 76, 77,
Rana Plaza 189	82-88, 99, 101, 103, 104, 119, 127, 139, 149,
Rea, David 267	151, 160, 169, 174, 175, 181, 187, 195–196,
records 52, 53, 67, 73, 179, 192, 214, 222, 225,	197–198, 201, 207, 208, 220, 236, 252,
228, 241–247, 253	254-255, 264, 282, 284, 285, 293, 302, 303-
registered design 25, 179, 182, 185	305, 304, 305
registering	Sennett, Richard 30
as self employed 46, 47, 53–54, 57, 227–228,	SEO 109, 254
234	Shaughnessy, Adrian 93
designs 70, 79, 182	shopping carts 254–255
names 96–97	showcasing 21, 23–24, 32, 100, 122–123,
trademark 98, 180	136–137, 290
VAT 236	online 124, 127, 250, 259, 284
regulations 189, 194–199, 236, 253, 256, 268,	virtual 124
284, 288, 292, 295	Sibelius, Jean 155
reinvestment costs 69–70, 81, 82	Skype 10, 38, 112, 123, 145, 148, 218, 307
rejection 188, 205, 206–207, 216, 226	small business/es 120, 164, 225, 227, 228
research 15, 25–26, 37, 43, 48–49, 51, 59, 68, 69,	Smith, Paul 275
73, 74, 76, 79, 81, 82, 93, 100–101, 104–105,	social enterprise/s 57, 58, 292

social media 10, 23, 26, 28, 31, 32, 36, 37, 43, 48, Thornton, Sarah 282 49, 51, 60, 96, 100, 102, 105, 109, 112-117, time banks 167-168 118, 119, 123, 124-125, 127, 135, 139, 140, time valuing 72-74 143, 144, 145, 148, 149, 150, 151, 163, 164, Toos, Andrew 155 175, 186, 206, 211, 218, 250, 256, 257-261, toy designer 297 263, 264, 269, 270, 271, 274, 276, 278, 289, trade fairs (see trade shows) 295, 296, 301 trademark/s 25, 38, 61, 70, 78, 79, 81, 91, 93-94, sponsorship 37, 101, 106, 132, 155, 158-164, 170, 95-98, 101, 162, 173, 177, 180-181, 182, 185, 281 186, 220, 268 template letter 160-161 trade shows 38, 43, 49, 55, 77, 88, 105, 142, 157, Standage, Tom 257 170, 206, 242, 283, 286, 293, 297, 306 start-up costs 66-73, 100, 106, 231 trading online 42, 70, 187, 250-252, 255-256 Stern, Simon 81, 187, 209 trend forecasting 38, 105, 264, 272, 276-277 street entertainment 168-169, 200-201 licenses 201 unemployment 49-50 student visas 55 unique selling point (USP) 37, 104, 139, 160 Sturt, George 223 Universal Credit 49-50, 69, 165, 166, 238 stylists 22, 118, 139, 140, 142, 170, 277 unpaid work 32, 36, 150, 196, 263, 281, 303 Sumup 225 Van Gogh, Vincent 19 tax 36-38, 46, 47, 53, 54, 57, 60, 67, 68, 80-83. VAT 38, 79, 83-87, 101, 164, 213, 225, 226, 166, 167, 227-234, 237, 284, 291, 292 235-236, 288, 292-293, 304-306 Aid 228 vintage 142, 198 allowance (PTA) 80, 229-231 visas 54-56, 165 vision 26, 27, 38, 51, 61, 62, 282, 296 bands 280

166, 167, 227–234, 237, 284, 291, 292
Aid 228
allowance (PTA) 80, 229–231
bands 280
corporation 292
credit 49–50, 69, 106, 165–166, 238, 239
evasion 47–48, 201, 238
relief 166, 167, 229, 232, 233
returns 54, 67, 228
taxable income 47, 159, 168, 229–230
year 166, 227–229, 230, 231
see also VAT

Warhol, Andy 21, 134
Watson, Richard 250, 274
websites 22, 28, 37, 74, 100, 105, 121, 127, 135, 139, 141, 163, 175, 184, 250–256, 274, 285
Wells, H. G. 250
Westwood, Vivienne 19, 93, 130
WGSN 277
Whelan, Audrey 248
Wilde, Oscar 15
wills 177, 186–187
Wordpress 28, 251, 253, 254, 261–262
work experience 36–37, 116, 118
Wright, Stuart Pearson 37

Xero 60, 240, 247, 293

voice 114, 132-133

voucher codes 142, 171